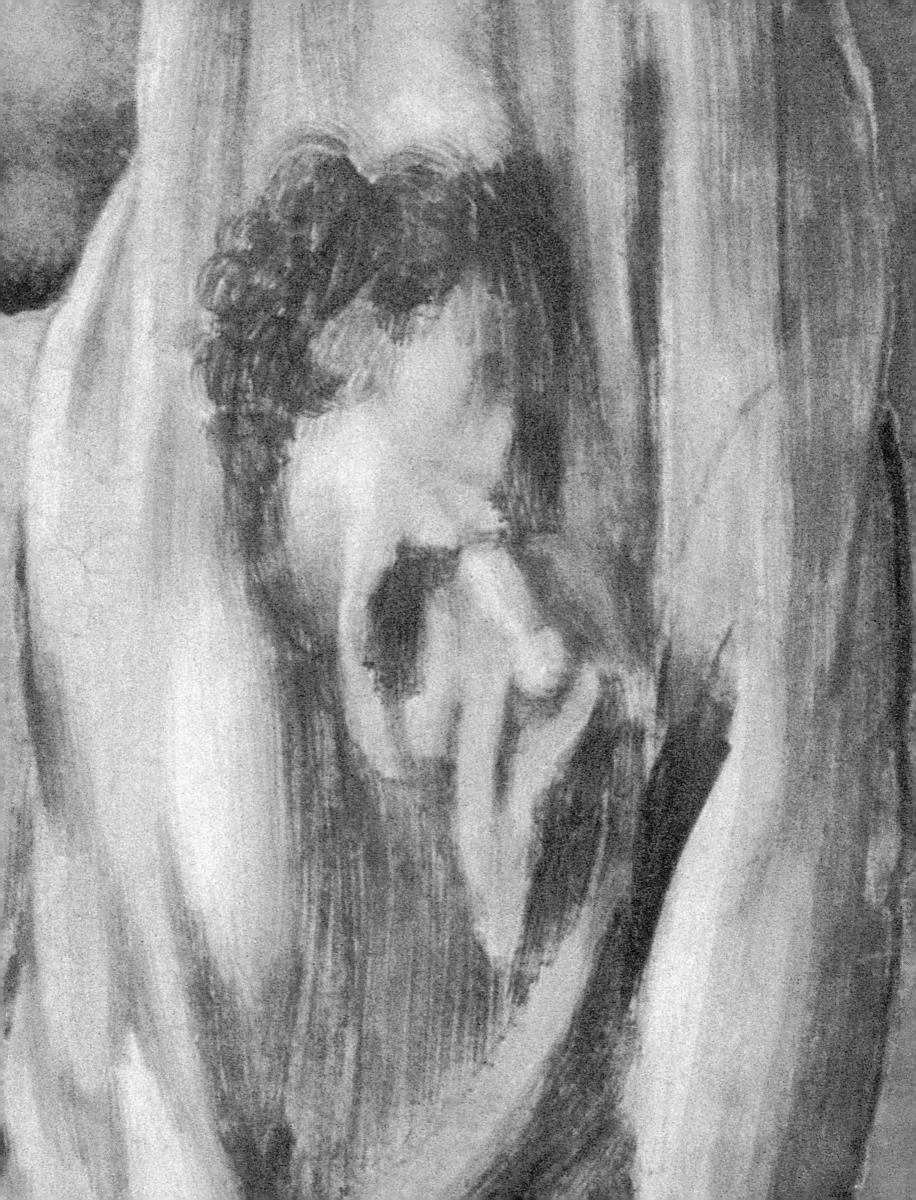

MICHELANGELO
THE LAST JUDGMENT

A Glorious Restoration

Foreword by Francesco Buranelli

Texts by
Loren Partridge
Fabrizio Mancinelli
Gianluigi Colalucci

Photographs by Takashi Okamura

Texts by F. Mancinelli and G. Colalucci translated from the Italian
by Lawrence Jenkens

Abradale Press
Harry N. Abrams, Inc., Publishers

Concept and Design: Massimo Giacometti

General Editor: Sandro Chierici

Project coordinator, English-language edition:
Ellen Rosefsky Cohen

Editor, English-language edition: Elaine B. Stainton

Design coordinator, English-language edition:
Dirk Luykx

Page 2: The *Last Judgment,* detail of Saint Bartholomew's flayed skin, traditionally identified as a self-portrait of Michelangelo
Pages 4–5: The *Last Judgment,* detail of the Trumpeting Angels

The Library of Congress has cataloged the Abrams edition as follows:
Partridge, Loren W.
Michelangelo—the Last judgment : a glorious restoration / by
Loren Partridge with contributions by Gianluigi Colalucci and
Fabrizio Mancinelli ; text by Colalucci and Mancinelli translated
from the Italian by Lawrence Jenkens.
p. cm.
Simultaneously published in Italian.
Includes bibliographical references.
ISBN 0–8109–1549–9 (clothbound)
1. Michelangelo Buonarroti, 1475–1564. Last Judgment.
2. Michelangelo Buonarroti, 1475–1564—Criticism and interpretation.
3. Judgment Day in art. 4. Cappella Sistina (Vatican Palace,
Vatican City). 5. Mural painting and decoration, Italian—
Conservation and restoration—Vatican City. 6. Mural painting and
decoration, Renaissance—Conservation and restoration—Vatican City.
I. Colalucci, Gianluigi. II. Mancinelli, Fabrizio. III. Title.
ND623.B9A69 1997a
759.5—dc21 97–16157
Abradale ISBN 0–8109–8190–4
Copyright © 1997 Ultreya/Edizioni, Milano
English-language edition copyright © 1997 Harry N. Abrams, Inc.

Printed and bound in Italy

Abradale Press
Harry N. Abrams, Inc.
100 Fifth Avenue
New York, N.Y. 10011
www.abramsbooks.com

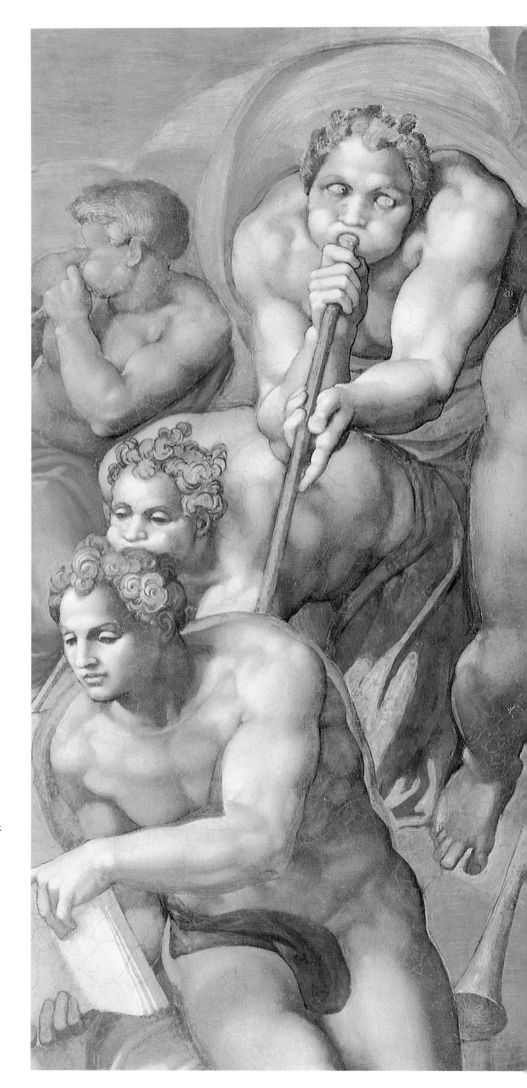

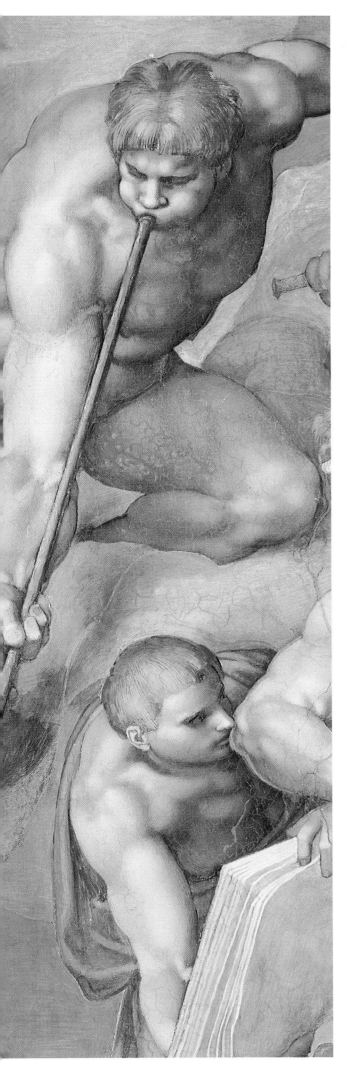

Contents

Foreword

THE ESSAYS OF Loren Partridge, Fabrizio Mancinelli, and Gianluigi Colalucci present some of the new information and ideas that have emerged from the campaign to restore Michelangelo's *Last Judgment* in the Sistine Chapel. They also examine the dependence of the fresco's iconographical solutions, which adhere to Counter-Reformation theology, on traditional imagery. These scholars emphasize both the great number of innovations that Michelangelo developed to convey the characters and events of the subjects, and the profound drama of the painting. This drama seems particularly poignant in light of the terrible religious travails of the Renaissance, beginning with the regime of the Catholic reformer, Girolamo Savonarola in Florence, and continuing with the Protestant movement and the war between the Papacy and the Emperor that culminated in the Sack of Rome in 1527.

The restoration of the *Last Judgment,* which began in 1990 and was completed in March 1994, was conducted by Gianluigi Colalucci, chief restorer of the Vatican Museums' painting laboratory, and his colleagues, the restorers Maurizio Rossi, Pier Giorgio Bonetti, and Bruno Baratti. The laboratory analyses were the responsibility of the Department of Scientific Research at the Vatican Museums and were run under the direction of Dr. Nazzareno Gabrielli. The entire staff of restorers at the Vatican Museums was coordinated and directed by two people unfortunately no longer with us, but whose names will always be linked to the recovery of Michelangelo's masterpiece. They are Carlo Pietrangeli, Director General of the Papal Monuments, Museums and Galleries from 1978 to 1995, and Fabrizio Mancinelli, chief curator for Byzantine, Medieval, and Modern Art at the Vatican Museums until 1994.

If the frescoes on the Sistine Chapel ceiling represent Michelangelo's consecration as a painter, there is no doubt that the *Last Judgment,* for the artist's contemporaries, stood as the culmination and watershed of his fame. Praised and criticized from the time it was unveiled, this innovative interpretation of Christian eschatology was for its author, already in his seventies, both an affirmation of his mastery of his art and the measure of the critical views of men of letters and connoisseurs of art. It was as if the intellectuals of the time, by praising or condemning the *Last Judgment,* were attempting either to question or to reaffirm the artistic primacy of Tuscany and the charismatic figure of the artist who now represented that superiority. Michelangelo, moreover, was already considered by many as an extraordinary person who, like an ancient emperor, was made divine by his own immortal works.

The debates and arguments over the *Last Judgment* that followed its unveiling in 1541 defined Michelangelo's personality to these critics. He was seen either as an artist absolutely without equal or as a supreme sculptor who, in translating his gifts as a modeler into painting, revealed his limitations. Those who praised the work early on—Tuscans like the Anonymous Magliabechiano and Anton Francesco Doni—were later supported by writers who justified Michelangelo's primacy as a painter based on his *Last Judgment.* Michelangelo Biondo, for example, in his treatise, *Nobilissima Pittura* (1549), reaffirmed Michelangelo's reputation "because one has not seen a painter nor heard that there are paintings as worthy or as famous . . ." as the *Last Judgment* which "many painters, Italian and foreign, have judged as the most beautiful and famous, indeed the most glorious, which has ever been painted in this world by any painter." The dedication "to Michelangelo Buonarroti" of the *Roma trionfante di Biondo da Forlì* (1548), declares him the master of the poetry of emotion, since in the Sistine fresco "all the affectations, all the complexions, the movements, all the postures, all the possible positions of the human body, all the emotions of the soul are expressed in the miraculous work of the ancients and in your [Michelangelo's] ordinary things, so natural, so alive, so typical that one might almost say that even nature itself has been added to them. Indeed every day we see your blind, maimed and crippled people and bodies of monstrous appearance . . . and none of them by you are out of proportion."[1]

The first criticisms of Michelangelo occurred at the same time as these expressions of appreciation. One critique, rooted in methodology, was expressed by Paolo Pino, a learned painter who defended the Venetian tradition of painting in his *Dialogo della Pittura* (1548). In this work he equated Michelangelo and Titian, calling both of them master painters, but he added, "if

Titian and Michelangelo were one person only, that is if the *disegno* of Michelangelo were added to the color of Titian, one could call him the god of painting." The assigning of equal value to the Tuscan and Venetian schools that this judgment implies is a substantial reappraisal of Michelangelo's absolute mastery. Even more pointed are the criticisms that focus on the "profane" and "immoral" qualities of the *Last Judgment*. These seem, however, to point up a weak spot in the fresco, a discordant creation of Michelangelo's, for which the artist himself was called into question. The criticisms of Aretino (1544) and Ludovico Dolce (1557) are the two poles around which the literature hostile to Michelangelo revolved, and which prepared the way for the dictates of the Council of Trent on the ecclesiastical control of religious images. The orders of the Council, issued just after Michelangelo died in 1564, authorized the modification of certain figures in the *Last Judgment* and the covering of the majority of images considered to be offensive to decency, and they made clear that the authority of the Church did not consider any artist, not even the most famous, above canon law.

Yet at the same time the Sistine Chapel was, as Vasari tells us, a true academy of art, since there was not an artist who came to Rome after the frescoes were unveiled who did not go there to copy Michelangelo's work. As a result, we have a considerable number of copies in paint, as well as drawings and prints, that document what the *Last Judgment* looked like before the censorial interventions. Perhaps it was the sensation that the bold iconography of the fresco produced among artists and intellectuals that made it an artistic *cause célèbre,* which then became politicized, as one can deduce from Pietro Aretino's hypocritical criticism. Aretino advised Enea Vico against making an engraving of the *Last Judgment* that Cosimo de'Medici had asked him for because of the "scandal that the licentiousness of Michelangelo's art would cause among the Protestants." Dolce's criticism in his *Dialogo della Pittura* was more subtle and measured. He dismissed the notion of the painting's offending against decency, but recognized in the fresco a "profundity of

the allegories" that "only the learned" could understand. The suggestion of heresy and scandal, which threatened the outright destruction of the fresco, led to the partial solution of adding loincloths, while the ideology of the composition found ever fewer interpreters.

The vivid debate over the criticism, interpretation, and conservation of Michelangelo's masterpiece has been drawn out over the centuries. It was revived with familiar topicality during the course of the recent restoration. This last intervention, however, is still drawing the approval of critics and scholars, who have many times and in a number of venues, publicly expressed their appreciation for the results achieved.

The *Last Judgment,* full and luminous, has thus been returned to its original significance; it is no longer obscured by the veils laid over it by Counter-Reformatory modesty and centuries of smoke, oils, and glue. During the restoration some of the loincloths which had been added by later censors were removed, however the decision was made to leave the evidence of the interventions ordered by the Council of Trent in those places where it was not possible to change it (as in the fresco repaintings of the figures of SS. Blaise and Catherine), and on the figures where the censorial additions could be documented to be from the sixteenth century.

The final effect of the restoration was admirably expressed in the sermon delivered by His Holiness Pope John Paul II on April 8, 1994, on the occasion of the mass celebrated in the Sistine Chapel to inaugurate the cleaned frescoes. The Pope described the Chapel "as the sanctuary of the theology of the human body. . . . If we stand in front of the *Last Judgment* dazzled by its magnificence and the terror of it, admiring on one side the glorified bodies and on the other those subjected to eternal damnation, we also understand that the whole vision is profoundly pervaded by the light and the logic of faith."

Dr. Francesco Buranelli

Acting Director General

Papal Museums, Monuments, and Galleries

1. The original reads: "tutte la maniere, tutte la carnagioni, i movimenti, tutte le posature, tutti gli stati possibili di un corpo umano, tutti gli affetti dell'animo, si vedono espressi negli antichi già miracoli, e in voi [Michelangelo] cose ordinarie, sì naturali, sì vivi, sì propri, che si potria quasi dire, che appena la natura stessa ci saprebbe aggiungere. Anzi ogni dì da lei veggiamo ciechi, monchi, zoppi et corpi tutti mostruosi . . . et da voi non pur un'ogna si può ritrovare fuori sua misura et proporzioni."

Michelangelo's *Last Judgment:* An Interpretation

Loren Partridge

* * * *

INTRODUCTION

MICHELANGELO (1475–1564) was the greatest master of the human figure in the Renaissance—and perhaps ever. By dissecting cadavers and meticulously studying earlier Greek, Roman, and Renaissance representations of the body, Michelangelo developed his keen intelligence and, almost certainly, photographic memory to hone a profound understanding of human skeletal and muscular structures. And he sharpened his sensitivity to the near limitless possibilities of human movement and expression. At the height of his powers when he painted the *Last Judgment*, he was able to communicate artistically through his figures' body language with a subtlety and nuance never achieved before and rarely since.

A full appreciation of Michelangelo's monumental fresco requires the viewer to perform the difficult but exhilarating task of empathizing with the artist's figures through patient and prolonged observation, of physically or mentally assuming their positions, and carefully reading, or better yet, feeling the effects of their postures, movements, gestures, and expressions. It is also extremely important to note groupings of figures and their interconnections, for within an overall unity Michelangelo created a series of paired groups and subgroups whose contrasting relationships are theologically as well as aesthetically meaningful. Given the complexity, variety, and abundance of figures, the viewer must be prepared for a considerable challenge. The effort

will reward those who immerse themselves in the work with endless visual pleasure and a clearer understanding of one of the greatest monuments of Western art.

The most significant recent interpretation of the *Last Judgment* understands the work as a "merciful heresy," an expression of the theological beliefs held by a group of contemporary Italian reformers whom Michelangelo knew, and some of whose writings were later condemned as heretical by the Roman church. The heresies expressed in the fresco, according to this interpretation, provoked a call by Counter-Reformation critics for the work's destruction. This tragedy was averted, so the argument goes, by Michelangelo's friends, who intentionally obscured the masterpiece's "true" meaning.

The *Last Judgment* certainly reflects the Italian movement for church reform, and it was savagely attacked by later critics. However, the fresco's theology, in my view, presents an entirely orthodox perspective. Literal-minded and prudish conservatives aimed their ire rather at the work's divergence from the visual tradition of Last Judgment representation, the inclusion of non-biblical subject matter, and especially the multitude of nude figures. The problem of nudity was addressed in 1564, when the Congregation of the Council of Trent ordered that the most offending body parts be hidden from view. In at least three different sixteenth-century campaigns beginning in 1565, a year after Michelangelo's death, and one or more in the fol-

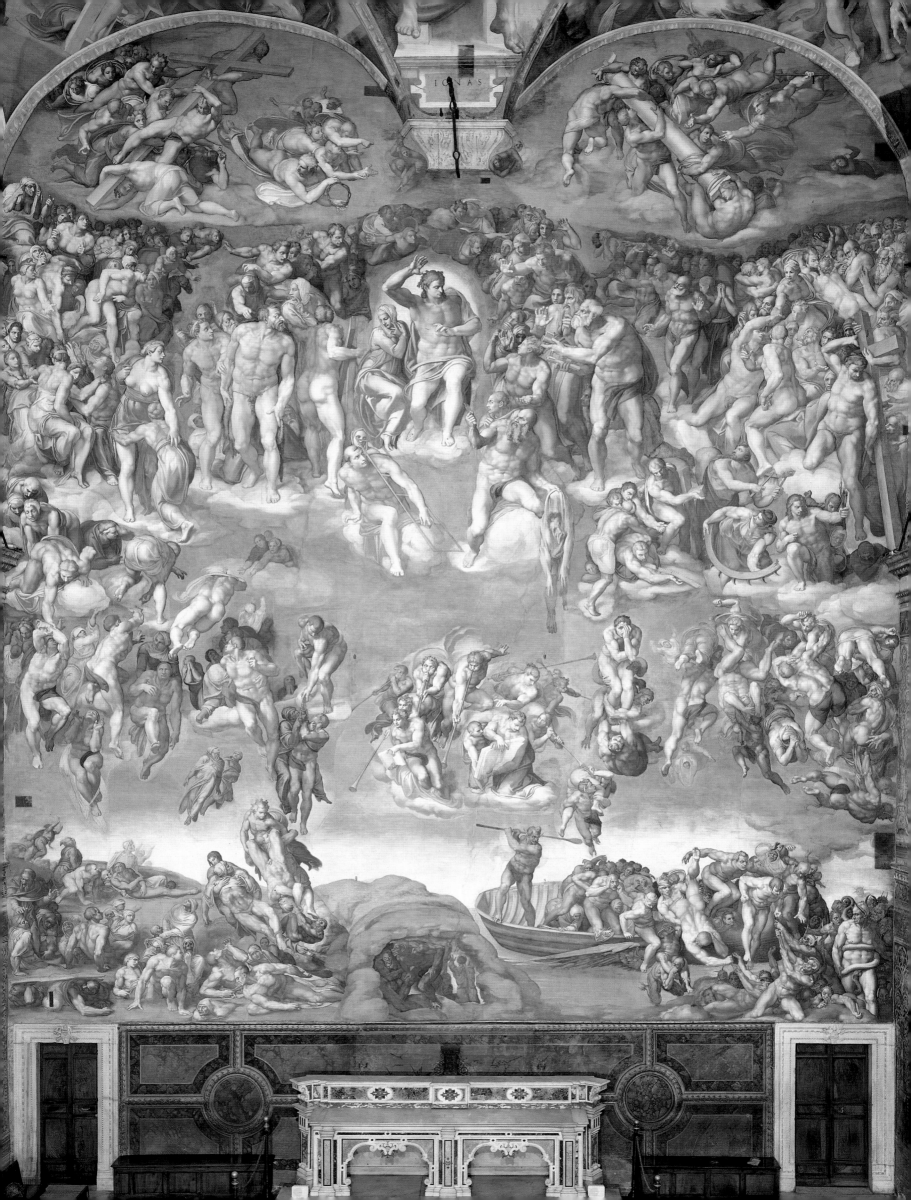

fig. 1

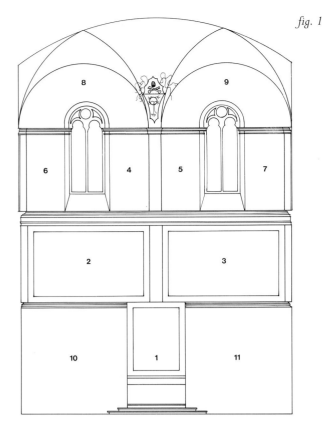

1. Reconstruction of the Sistine Chapel altar wall before Michelangelo's *Last Judgment*.

lowing centuries, two figures were repainted *a fresco* and the genitals and buttocks of nearly forty others were covered *a secco* by loincloths. Most of those added after the sixteenth century, about fifteen, were removed in the fresco's recent cleaning (1990–94).

* * * *

One of the largest and most important chapels in Christendom, the Sistine Chapel was built and decorated with frescoes between 1477 and 1483 by Pope Sixtus IV (1471–84), from whom it took its name, replacing an earlier chapel first documented in 1368. The Sistine Chapel was designed to house the ceremonies and rituals of a corporate body known as the *capella papalis* or Papal Chapel, which was composed of the pope and about two hundred high-ranking ecclesiastical and secular officials who met at least forty-two times a year and who participated in a minimum of twenty-seven Masses. The Papal Chapel was one of the chief institutions through which the papacy regularly displayed its majesty, authority, and power to Rome and to the world.

In about 1533, shortly before his death, Pope Clement VII (1523–34) commissioned Michelangelo to paint the *Last Judgment* on the wall behind the high altar, an area traditionally located at the east end of any chapel or church, but here in the Sistine Chapel— owing to the peculiarities of the Vatican site—rather unusually at the west (pl. 1). Pope Paul III (1534–49), Clement VII's successor, renewed the commission in 1534 and work began the next year. On 31 October 1541 (the Vigil of All Souls' Day), when Michelangelo was sixty-six years old, the fresco was unveiled— twenty-nine years to the day after the unveiling of his decoration on the ceiling above.

To create the surface on which to fresco the *Last Judgment* (c. 46 x 43 feet, or c. 14 x 13.18 meters; an area of c. 1,940 square feet, or c. 180.21 square meters), Michelangelo had two windows walled up, Pope Sixtus IV's della Rovere coat of arms below the ceiling figure of *Jonah* removed, the corbel underlying the coat of arms reduced in size, and the previous painted decoration on the entire altar wall destroyed (fig. 1). These painted works included the altarpiece depicting the *Assumption and Coronation of the Virgin* (fig. 1 [1]) and two large scenes that opened the fresco cycles depicting the Life of Moses and the Life of Christ—the *Finding of Moses* on the left and the *Birth of Christ* on the right (fig. 1 [2–3])—all three by Pietro Perugino (c. 1450–1523). Also destroyed were frescoes of the first four popes (or Christ, St. Peter, and the first two popes, according to some scholars) in painted niches flanking the windows (fig. 1 [4–7]), and Michelangelo's own lunettes of about 1512 with the ancestors of Christ—*Abraham, Isaac, Jacob, and Judas* on the left, and *Phares, Esron, and Aram* on the right (fig. 1 [8–9]). Finally, the *Last Judgment* preempted the spaces flanking the altar, which had been reserved for two tapestries commissioned by Pope Leo X (1513–21), designed by Raphael (1483–1520) in 1515–16, and woven by 1520 in the Brussels workshop of Pieter van Aelst (d. 1532): to the left the *Stoning of St. Stephen Condoned by Saul/Paul*, the first of six tapestries illustrating the life of St. Paul, and on the right the

Miraculous Draught of Fishes, the first of four tapestries illustrating the life of St. Peter (fig. 1 [10–11]).

Michelangelo ordered a unique and most unusual wall preparation to receive his fresco (fig. 2). Originally the wall inclined slightly backward, the top about 5½ inches (14 centimeters) farther back than the bottom. After Michelangelo's extensive changes, the wall sloped forward. To achieve this result workmen chiseled the wall's masonry back about 5⅞ inches (15 centimeters) at the top (fig. 2 [A–B]). They then progressed downward, gradually cutting deeper and deeper into the wall to a depth of about 23⅛ inches (59 centimeters) at the bottom (fig. 2 [C–D]). Finally, they faced the rough surface with bricks (fig. 2 [E–F]) of about 5⅞ inches thick (15 centimeters). When completed, the wall's top—with respect to a true vertical—overhung the bottom by about 11¾ inches (30 centimeters), an easily discernable forward inclination that produces a visual effect similar to the entasis or swelling of a classical column.

Michelangelo could only have justified this arduous task, which entailed the chipping away by hammer and chisel of about 81 cubic yards (62 cubic meters) of masonry before laying up about 44 cubic yards (34 cubic meters) of bricks, to achieve an important aesthetic effect, an effect that scholars have never before seriously considered (and to which I will return at the end of this essay). Giorgio Vasari (1511–1574) suggested in his biography of Michelangelo that the wall was canted to keep it free from dust and grime (such as the smoke from burning candles or incense used during Mass), a clearly illogical explanation. A forward-leaning wall, in fact, promotes the opposite result. And in 1543, just two years after the fresco's unveiling, Pope Paul III had to appoint an official "picture cleaner" for the Sistine Chapel frescoes, a post that remained consistently filled throughout the sixteenth century.

* * * *

Renaissance custom divided Christian history into three eras—*ante legem* (before the law of Moses), *sub lege* (under the law of Moses), and *sub gratia* (under grace or

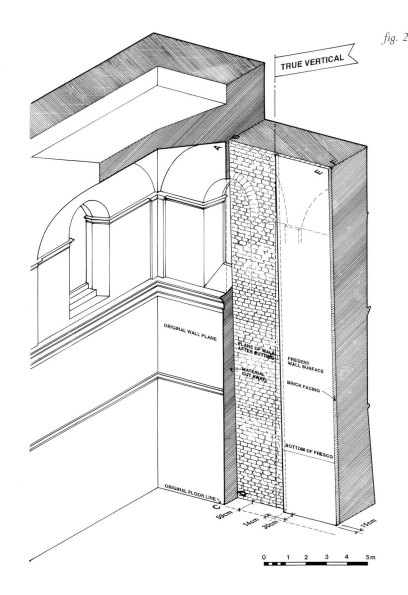

2. Diagram illustrating the preparation of the altar wall to receive Michelangelo's *Last Judgment*.

the law of Christ), each respectively illustrated in the Sistine Chapel by the scenes from Genesis on the ceiling, the Life of Moses on the walls to the left of the altar, and the Life of Christ on the walls to the right of the altar. The *Last Judgment* completed this program by depicting the end of history, and is appropriately viewed toward the west, the direction of the setting sun. It was not uncommon for large-scale Last Judgment scenes to occupy the entire west wall of a church or chapel as do, for example, those in the cathedral on the island of Torcello, near Venice (fig. 3) and in the Arena Chapel in Padua (fig. 6). But in these more conventionally oriented buildings (that is, with the high altar located at the east end) the reminder of humankind's final fate loomed on the inner facade wall before the worshipers exited the sacred space. Michelangelo's

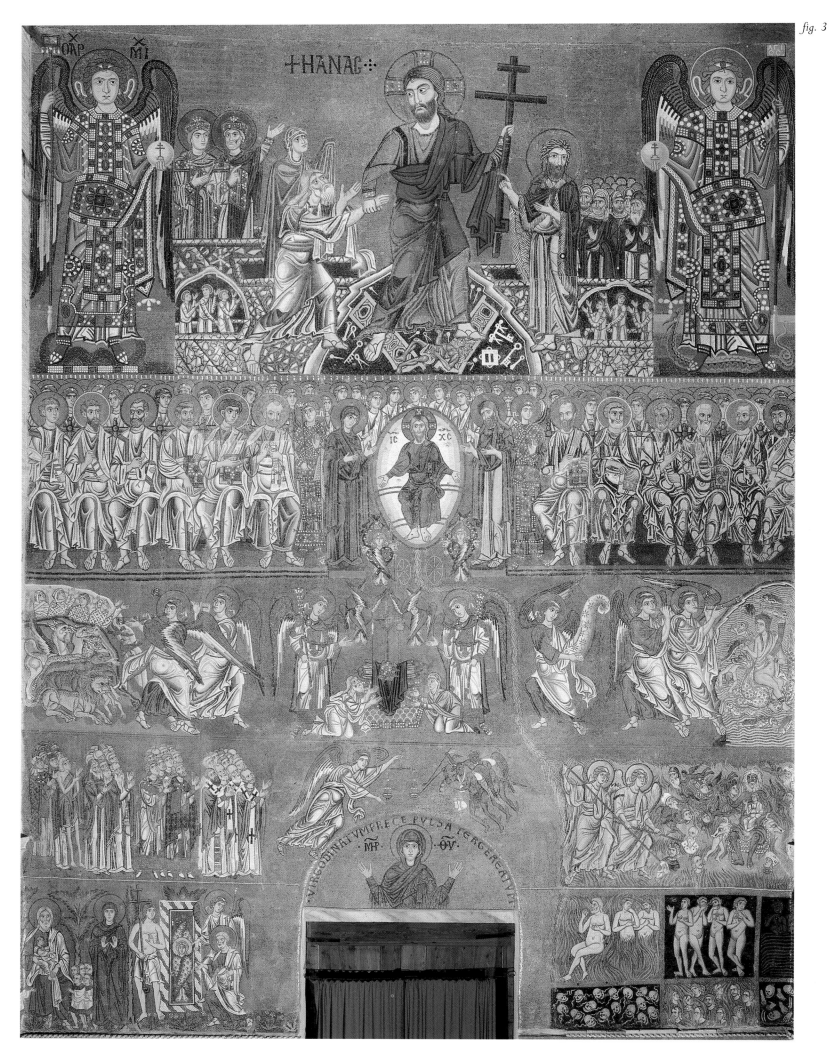

fig. 3

fig. 4

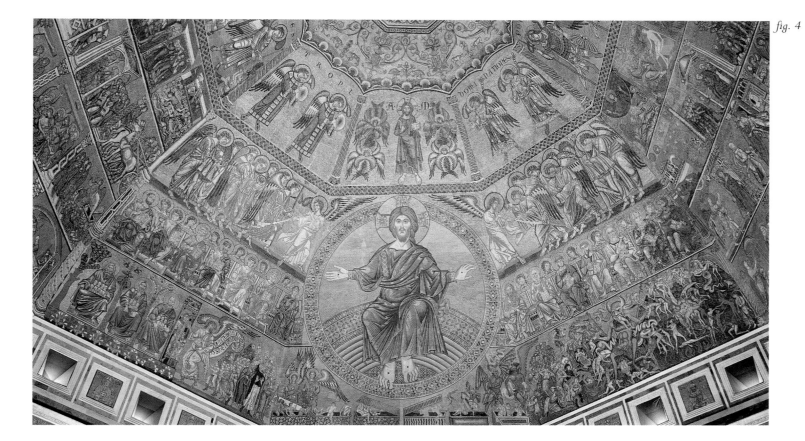

opposite:

3. Anonymous, *Last Judgment* [below the *Crucifixion* and *Christ in Limbo*], mosaic, Torcello, Cathedral, west wall, twelfth century, second half
Fourth band: (center) Christ enthroned in glory surrounded by angels, tetramorphs with beasts of the Evangelists and wheels of fire at Christ's feet; (left)
the Virgin, St. Peter, and five Apostles; (right) John the Baptist, St. Paul, and five Apostles; (background) angels. *Third band*: (center) prepared throne
with book, cross, crown of thorns, reed with vinegar-soaked sponge, and lance, flanked by the kneeling Adam and Eve and angels; four trumpeting
angels resurrecting the dead on land (left) and sea (right), one angel rolling up the heavens (right). *Second band*: (center) St. Michael weighing souls;
(left) ecclesiastics, martyrs, prophets, and ascetic women; (right) two angels forcing the proud into Hell, presided over by Satan. *First band*: (left) angel,
St. Peter, door to paradise, Dismas, the Virgin, tree of life, and souls in the bosom of Abraham; (right) punishment of six of the seven deadly sins of
lust, gluttony, sloth, envy, avarice, and anger (the seventh sin, pride, just above).

above:

4. School of Coppo di Marcovaldo, *Last Judgment*, mosaic, Florence, Baptistry, vault, c. 1270–75
Center: Christ enthroned in glory. *Third band*: (left) angels with trumpet, cross, crown of thorns, and nails; (right) angels with trumpet, whips, lance,
and reed with vinegar-soaked sponge. *Second band*: (left) the Virgin, St. Peter, and five Apostles; (right) John the Baptist, St. Paul, and five Apostles;
(background) angels. *First band*: (center) resurrecting dead; (left) angels (one with banderole with Matthew 25:34), saved, door to paradise, souls in
bosom of Abraham, tree of life; (right) demons, damned, Satan, torments of Hell.

positioning of his massively scaled Last Judgment behind the altar at the chapel's focal point was without precedent. For here, it dominated, even interrupted, the very beginning of the fresco cycles that illustrated the eras *ante legem*, *sub lege*, and *sub gratia*. Such preoccupation with the apocalypse was no doubt largely provoked by the overwhelming mood of pessimism and guilt that followed the brutal 1527 Sack of Rome, which Clement VII experienced personally, and also by the simultaneous attacks of Protestant and Catholic reformers alike on the abuses of papal power and corruption within the church.

Last Judgment representations were traditionally divided into four horizontal bands (figs. 3, 6). In Michelangelo's work (pl. 1) the bottom band depicts the resurrecting dead, the gaping mouth of Hell, and the damned framed by Charon and Minos. The second band presents the ascending elect, the trumpeting angels, and the descending vices. The third band, which shows the elect on high, highlights the "Ecclesia" group

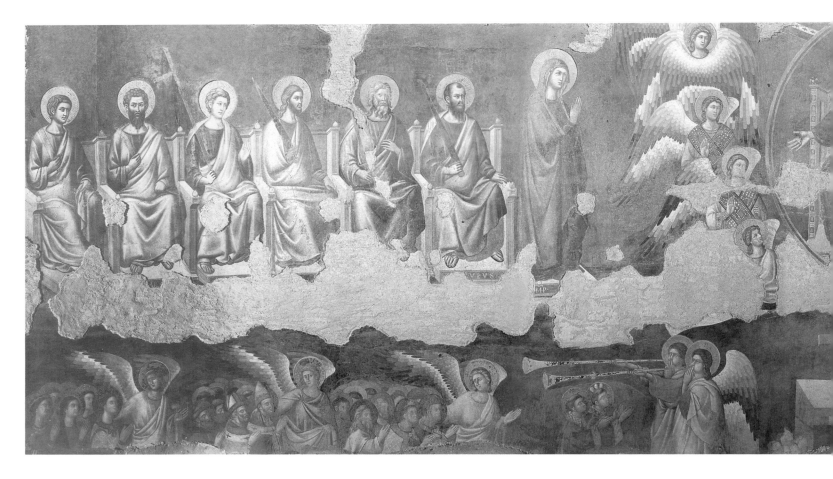

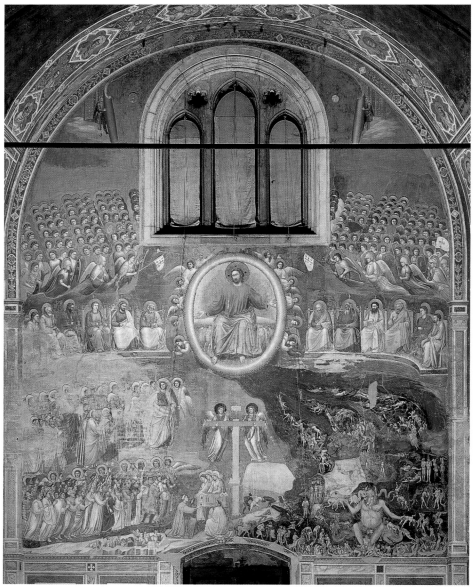

fig. 6

5. Pietro Cavallini, *Last Judgment*, fresco, Rome, S. Cecilia, 1290s

Top: (center) Christ enthroned in glory flanked by angels; (left) the Virgin, St. Paul, and five Apostles; (right) John the Baptist, St. Peter, and five Apostles. *Bottom*: (center) altar with cross, nails, lance, reed with vinegar-soaked sponge, and vase surrounded by innocents; (left) two trumpeting angels, Saints Stephen and Lawrence (under trumpets), angels directing the elect (including women) toward Heaven; (right) two trumpeting angels, angels driving damned to Hell.

6. Giotto, *Last Judgment*, fresco, Padua, Arena Chapel, west wall, c. 1305

Top: two angels rolling up the heavens. *Fourth band*: (center) Christ in glory enthroned on beasts of the Evangelists surrounded by angels, four trumpeting; (left) St. Peter, five Apostles; (right) St. Paul, five Apostles; (above Apostles) angelic hierarchy.

Third band: (center) two angels holding the cross; (left) Virgin and angel directing the elect toward Heaven; (right) torments of Hell. Second band: (left) angels directing the saved toward Heaven; (right) torments of Hell.

First band: (left) resurrecting dead, Enrico Scrovegni presents the Arena Chapel to three angels; (right) torments of Hell, Satan.

fig. 5

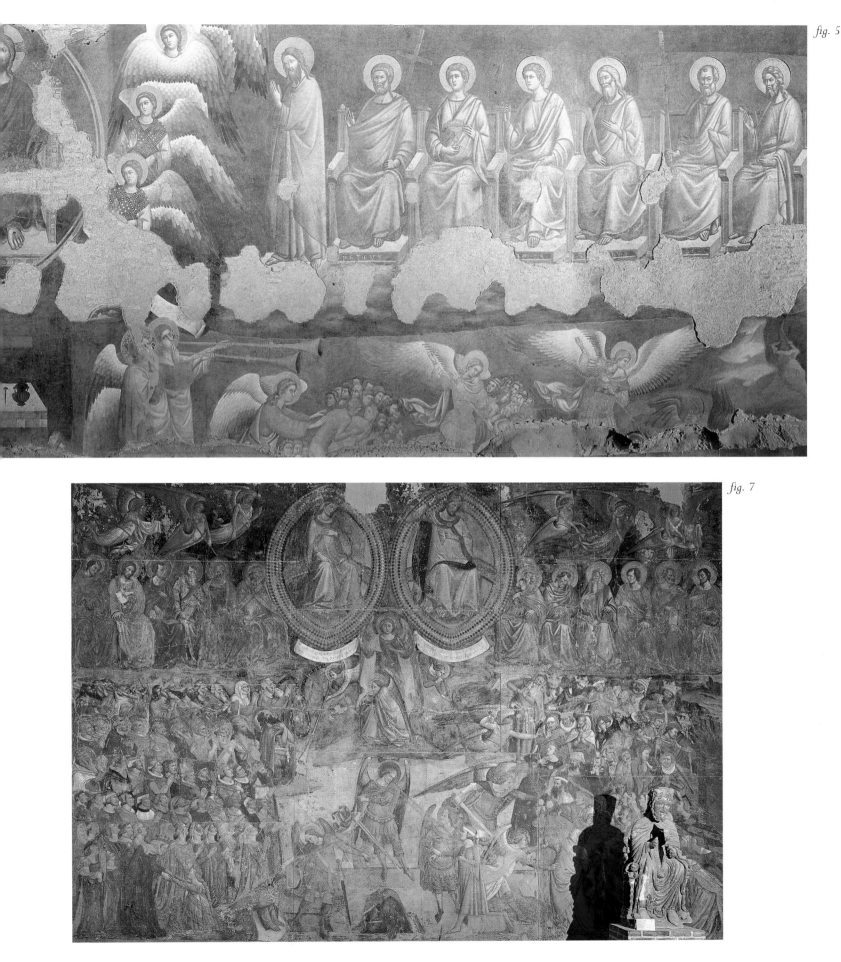

fig. 7

7. Francesco Traini, *Last Judgment*, fresco, Pisa, Camposanto, c. 1350

Third and second bands: (center) Christ and the Virgin enthroned in glory; (left, top) angels with vinegar-soaked sponge, lance, nails; (right, top) angels with whips, cross, and crown of thorns; (left, second band) St. Peter, five Apostles; (right, second band) St. Paul, five Apostles. *First band*: (central axis) angel with two banderoles (with Matthew 25:34, 41), two trumpeting angels, angels directing saved and damned to Heaven and Hell, resurrecting dead; (left) saved [top row: Adam and Eve, prophets, Old Testament figures; second row: John the Baptist, saints; third row: ecclesiastics and monarchs; fourth row: laymen; bottom row: women]; (right) damned.

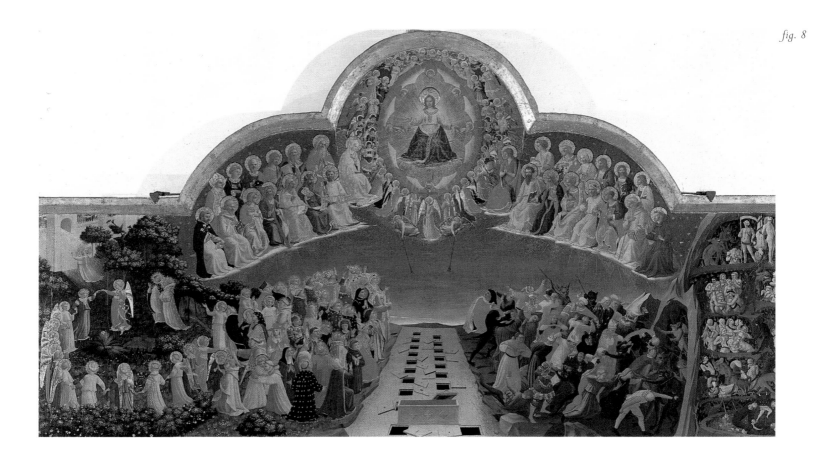

fig. 8

fig. 9

8. Fra Angelico Workshop, *Last Judgment*, panel,
Florence, Museo di San Marco, c. 1435-40.
Top: (center) Christ enthroned in glory surrounded by
angels, one holding cross, two trumpeting; (left) the
Virgin, St. Peter, Apostles, saints, and Old Testament
figures; (right) John the Baptist, St. Paul, Apostles,
saints, and Old Testament figures.
Bottom: (center) open tombs; (left) saved in paradise
with angels, one hugging a monk; (right) demons
driving the damned into Hell compartmentalized for
seven deadly sins, Satan at bottom.

9. Bertoldo di Giovanni, *Last Judgment*, bronze medal,
verso, inscribed ET INCARNE MEA VIDEBO DEUM
SALVATOREM MEUM (Job 19:26), New York, The
Metropolitan Museum of Art, c. 1468-69
Top: Christ in glory surrounded by angels, four
trumpeting, one with the cross (left), another with
the column (right).
Bottom: Two angels (center) assisting the saved (right)
and frustrating the damned (left) resurrecting from
their tombs.

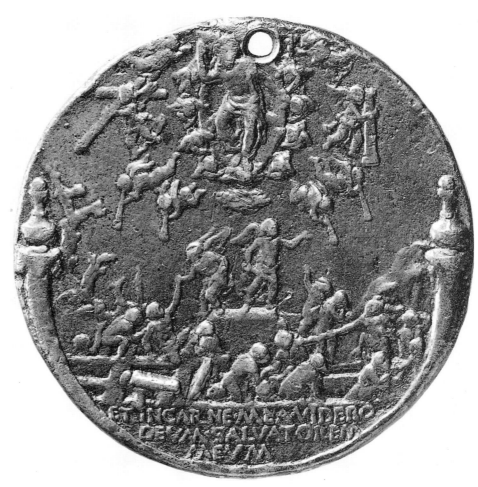

on the left, and a group with John the Baptist and another with St. Peter flanking Christ and the Virgin in the center; on the right the "Dismas" group joins a gathering of martyrs. In the two lunettes at the top, angels carry the instruments of Christ's Passion, the cross featured on the left, the column on the right. But Michelangelo's depiction of each band higher on the left and lower on the right, rather like a scale's balance beam slightly tipped on its fulcrum, remains unique. Michelangelo, in fact, transformed a familiar visual motif, that of St. Michael weighing souls (fig. 3), into a fundamental structural element of his entire fresco.

The tipped bands also reinforce the dramatic ascent of saved souls on the left and the descent of damned souls on the right. While all previous Last Judgment representations were by their subject matter dramatic (figs. 3–13), Michelangelo's was the first to feature such all-pervasive movement and such an abundance of active figures, over four hundred, in fact. Lacking its own frame, the representation also promotes, as none had before, the illusion of a non-existent wall and the Second Coming's unfolding in real time before the worshipers' very eyes.

10. Luca Signorelli, *Resurrection of the Dead*, fresco, Orvieto, Cathedral, San Brizio Chapel, right west wall, 1499–1504

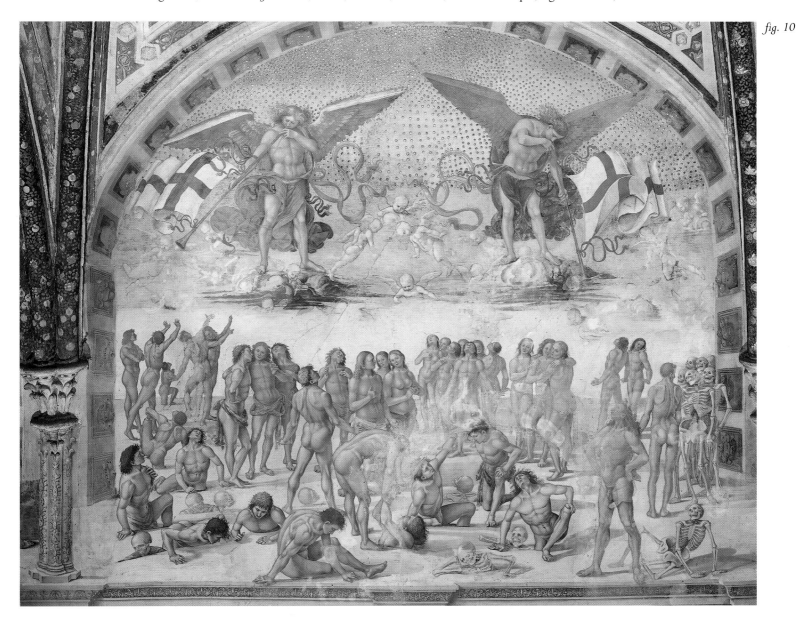

fig. 10

fig. 11

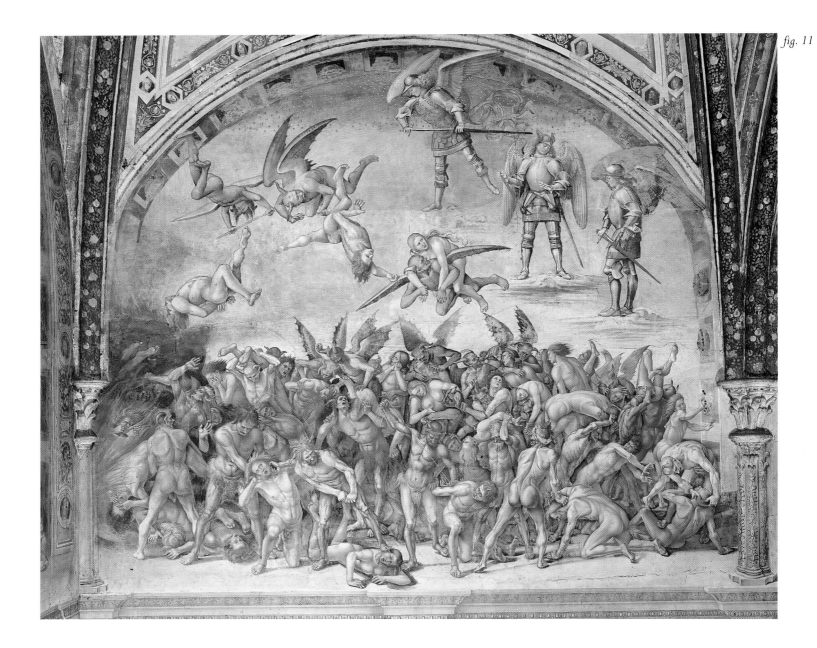

above:

11. Luca Signorelli, *Damned*, fresco, Orvieto, Cathedral, San Brizio Chapel, left west wall, 1499–1504
Three angels in armor oversee the descent of the damned and their torments in Hell.

opposite above:

12. Luca Signorelli, *Heaven and Hell*, fresco, Orvieto, Cathedral, San Brizio Chapel, south altar wall, 1499–1504
Left: The elect directed to Heaven by eight angels, six making music. *Right*: Two angels oversee the damned
ferried by Charon to Hell and condemned by the serpent-tailed Minos.

opposite below:

13. Luca Signorelli, *Saved*, fresco, Orvieto, Cathedral, San Brizio Chapel, right east wall, 1499–1504
Twenty-three angels—nine making music, two scattering flowers—celebrate and crown the elect,
directing them toward Heaven.

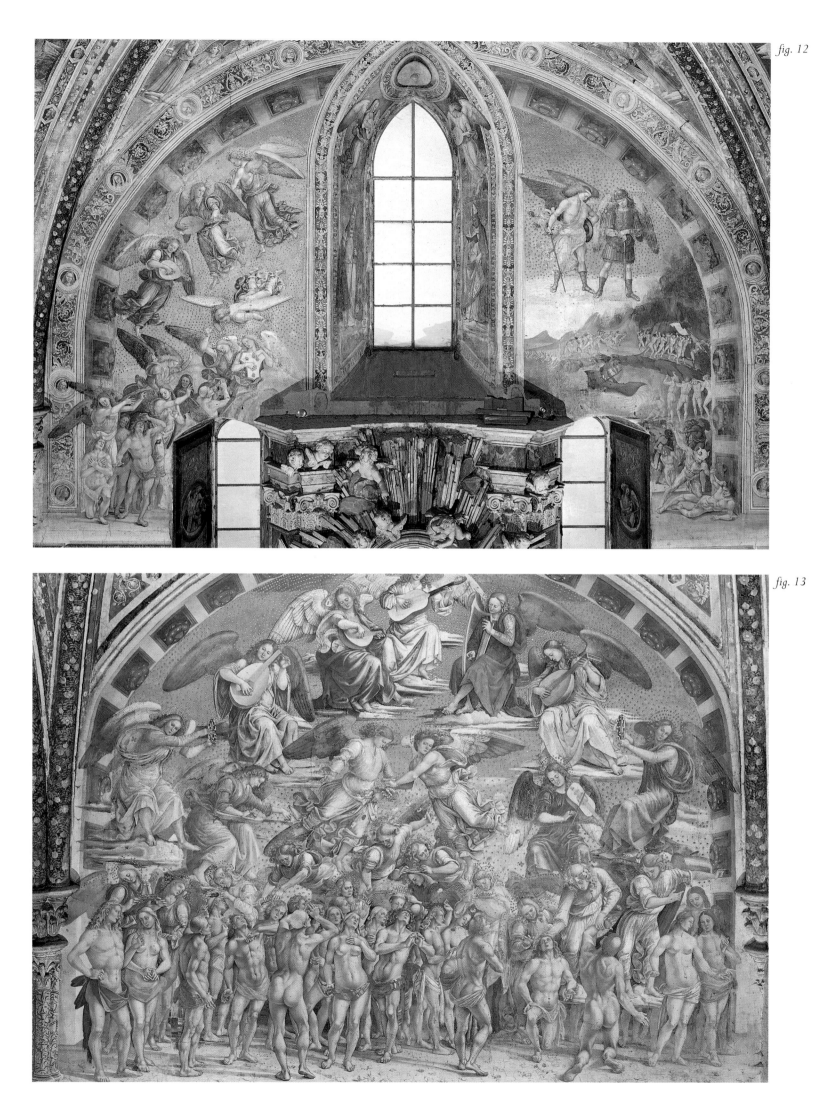

fig. 12

fig. 13

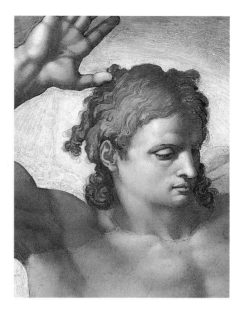

I

CENTRAL

VERTICAL

AXIS

Amen, I say to you, that you, who have followed me, in the regeneration, . . . the Son of man shall sit on the seat of his majesty . . .
(Matthew 19:28)

. . . and they shall see the Son of man coming in the clouds of heaven with much power and majesty.
(Matthew 24:30)

And when the Son of man shall come in his majesty, and all the angels with him, then shall he sit
upon the seat of his majesty: And all nations shall be gathered together before him, and he shall
separate them one from another, as the shepherd separateth the sheep from the goats: And he shall
set the sheep on his right hand, but the goats on his left. Then shall the king say to them that shall
be on this right hand: Come, ye blessed of my Father, possess you the kingdom prepared for you
from the foundation of the world. . . . Then he shall say to them also that shall be on his left hand:
Depart from me, you cursed, into everlasting fire which was prepared for the devil and his
angels. . . . And these shall go into everlasting punishment: but the just, into life everlasting.
(Matthew 25:31–46)

Let him weigh me in a just balance . . .
(Job 31:6)

Thou art weighed in the balance, and art found wanting.
(Daniel 5:27)

Christ and the Virgin Mary

THE RESURRECTED CHRIST—the embodiment of the Church Triumphant or heavenly church—dominated the composition in all earlier Last Judgment representations (figs. 3–9). But never before had Christ so clearly initiated and controlled the drama (pl. 2). This sense of sinful humankind's utter helplessness before divine omnipotence and omniscience reflects the tone of despair and doom that prevailed in the first decade or so after the Sack—a disaster that many Romans believed to be a punishment for their sins and for the abuses of the church.

Michelangelo's Christ reveals a more massive and muscular torso, broader shoulders and waist, and stronger limbs than in all previous portrayals. A silhouetting backlight further emphasizes his dense form. Grander than any classical Jupiter, this titan moves in a complex and ambiguous way. At first sight Christ appears to be standing, lifting his right hand, and rotating from his right to left. In so doing, he raises with his right hand—or so his movement implies—the saved souls on his right toward whom his consort, the Virgin Mary, casts her intercessory gaze. With his left he simultaneously draws the saved toward himself while turning away from them. Yet, at the same time he seemingly prepares to sit down on his celestial throne of clouds, ready to throw down his right hand and lash out with his left, as if to cast out the damned souls toward whom he looks. Christ's complex action—simultaneously spiraling up and down—generates the motion of the entire fresco. With humankind's final fate known from the beginning of time, Christ remains impassive—neither wrathful nor joyous (a point to which I shall return).

As an intercessor for humankind the Virgin traditionally sat or stood at the favored right hand of Christ (figs. 3–5, 7–8). But here she is depicted for the first time snuggled up against her son, her bulk amplifying his, and her glance standing in for his regard for the saved. Her serpentine posture—turned along the axis

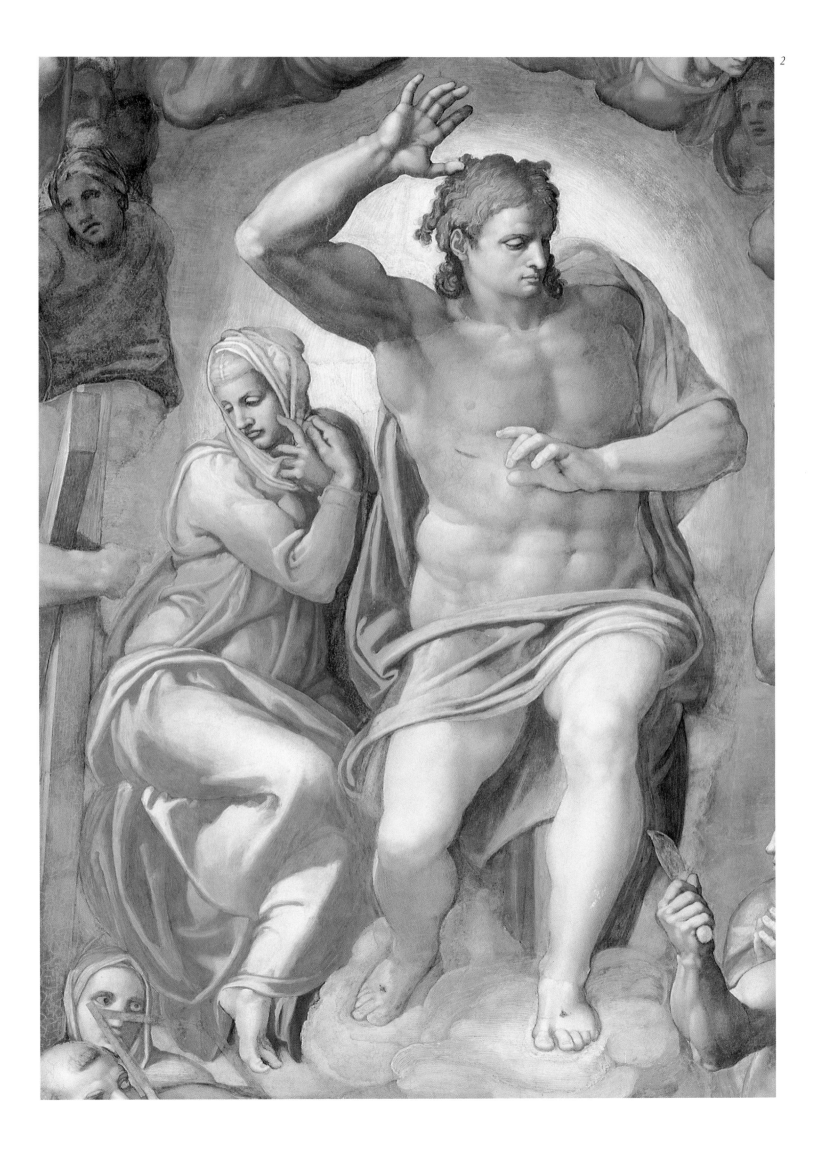

Souls surrounding Christ and the Virgin amplify Christ's awesome power and his complex action as he lifts the saved on the left into Heaven and drives the damned on the right into Hell. Above Christ's head two souls fly toward the right, one soaring upward, the other swooping downward (pl. 3). They respond to Christ (pl. 2), who, as he rotates from left to right, appears to be both standing and sitting, as well as raising and casting down his right hand, while drawing in and lashing out with his left. His magnetic force attracts one nude soul (pl. 4) who reinforces his gaze toward the damned, and another (pl. 5) who underlines with his body language the Virgin's intercessory regard for the saved.

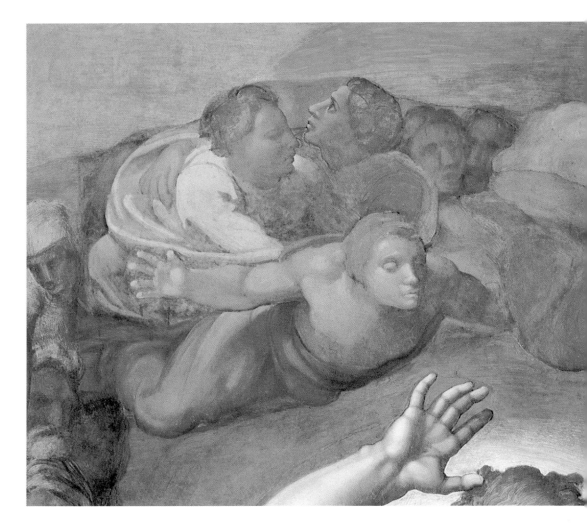

4

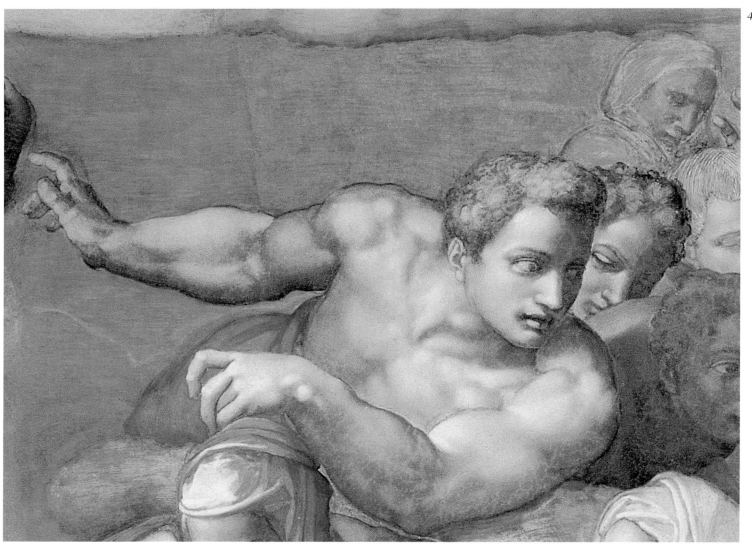

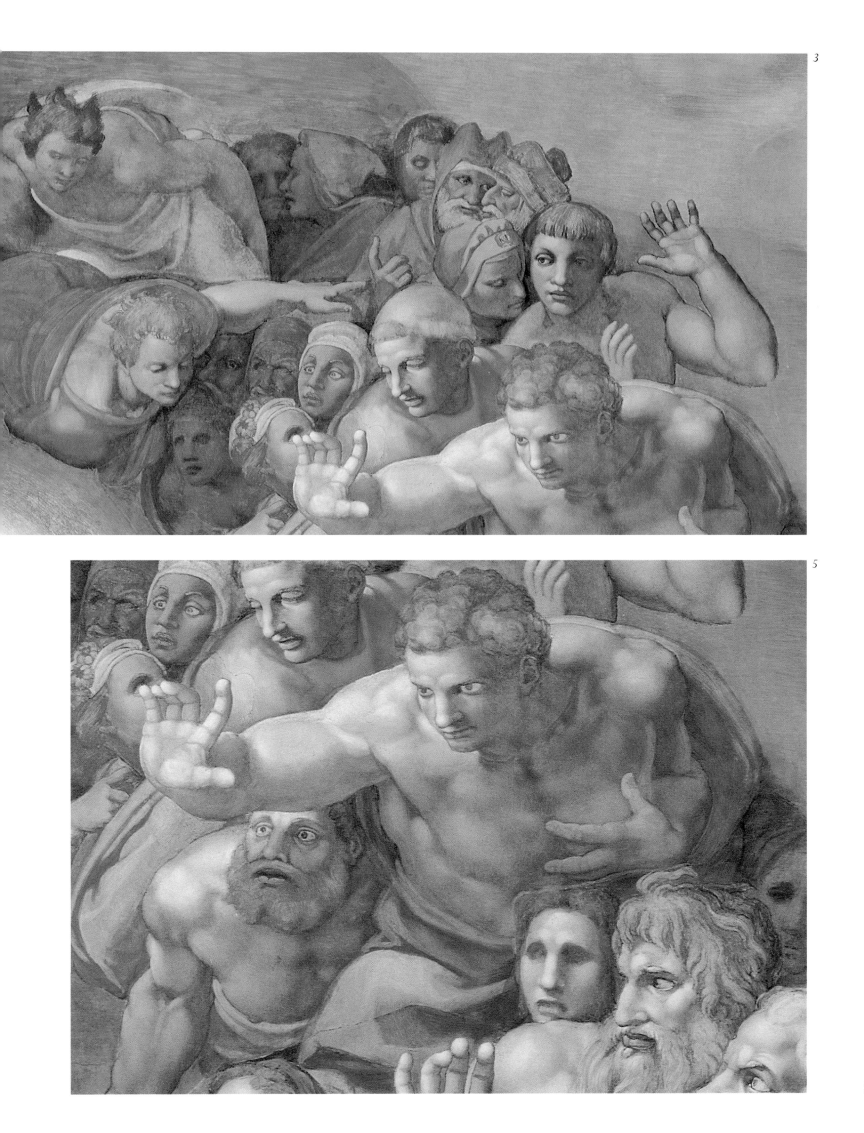

of the spine from her right to her left—also visually enhances Christ's rotational movement (pl. 2). Sharing so intimately his final triumph over sin and death, she would remind contemporary viewers of the chapel's dedication to the Assumption of the Virgin, symbolically the glorification of the Church Militant, or the earthly church. The act of crossing her arms to pull her scarf more securely over her head—as if "taking the veil"—would indicate, as does the ritual of a nun's consecration, her virginity, sanctity, and spiritual marriage to Christ. But no longer having a major role to play at the end of time, this embodiment of the Church Militant remains completely subordinate to Christ.

The figures arranged in an arc over the heads of Christ and the Virgin also echo their complex movements. The lavender-draped soul with a blue cap above Christ's raised right hand, for example, soars upward, while the orange-draped soul above his left hand descends (pl. 3). The two most prominent nude males to Christ's right (at the level of his raised hand) thrust their arms backward yet lean sharply toward Christ, following his gaze with wide eyes (pl. 4). By contrast, the body language of the corresponding male nude to Christ's left expresses his empathy with the Virgin's concern for the saved (pl. 5).

And he shall send his angels with a trumpet, and a great voice: and they shall gather together his elect from the four winds, from the farthest parts of the heavens to the utmost bounds of them.

(Matthew 24:31)

And I saw seven angels standing in the presence of god; and there were given to them seven trumpets.

(Apocalypse 8:2)

And I saw a great white throne, and one sitting upon it, from whose face the earth and heaven fled away, and there was no place found for them. And I saw . . . the books were opened; and another book was opened, which is the book of life; and the dead were judged by those things which were written in the books, according to their works. . . . And whosoever was not found written in the book of life, was cast into the pool of fire.

(Apocalypse 20:11–15)

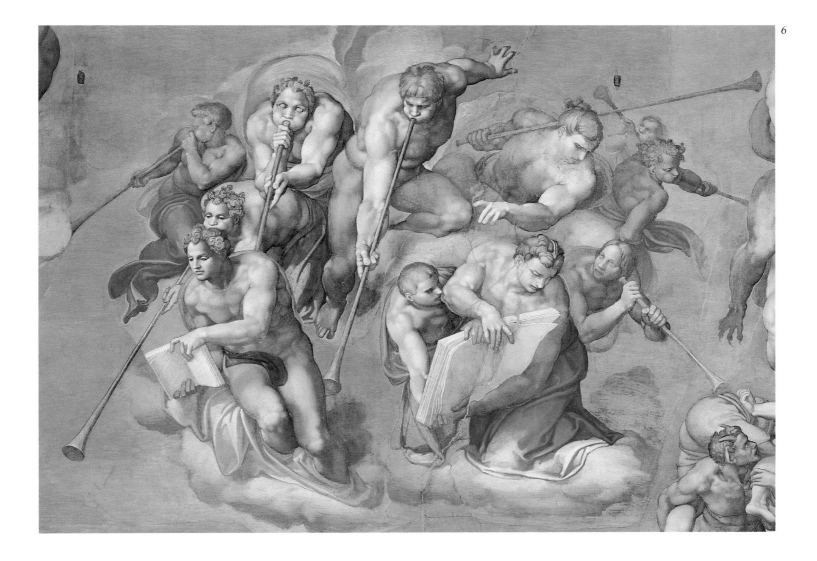

6

Trumpeting Angels

TRADITIONAL representations of the Last Judgment usually employed two, at most four, symmetrically arranged trumpeters, who awaken the dead (figs. 3–10). But Michelangelo's depiction—unprecedented in its dynamism—features eleven colorfully draped angels below Christ, eight

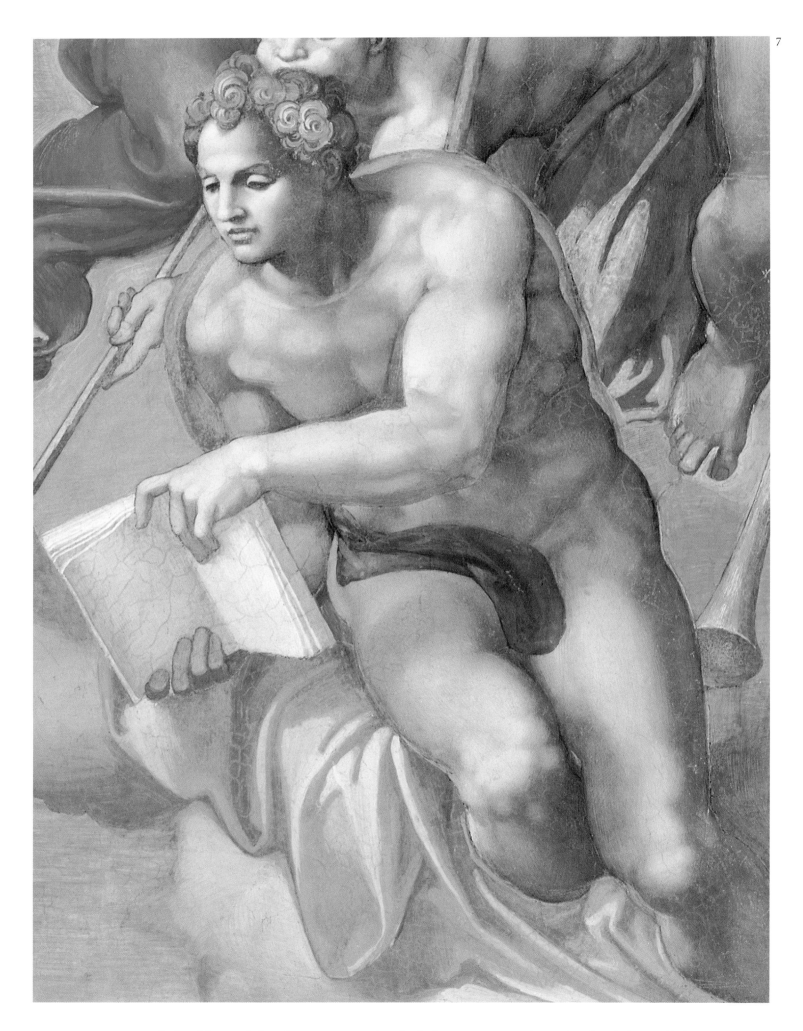

One angel (pl. 8) blasts mightily on his trumpet to awaken the dead. His companion (pl. 7), whose loincloth was added
after Michelangelo's death, displays to the resurrecting dead his small book inscribed with the names of the elect.
Simultaneously he flies upward, aiding the saved's ascent into heaven.

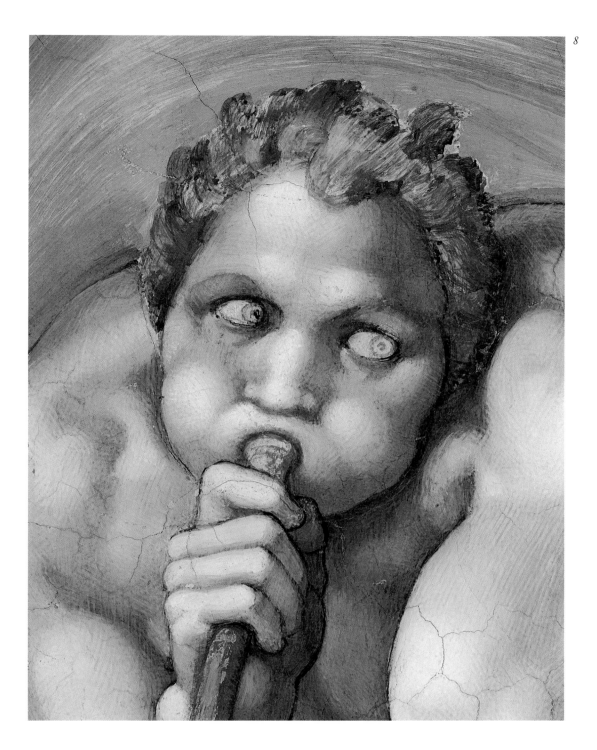

with trumpets, as a secondary energy locus to intensify the drama and to serve as the fulcrum for the second band (pl. 6). This group of wingless angels is divided roughly in half along a steep diagonal. The five on the left direct their glances, trumpet blasts, and small open book—inscribed with the names of the elect—diagonally *downward* toward the left to raise the dead (pls. 7–8). Yet, as if assisting the elect in their ascent, the two outermost angels appear to move *upward* in a maelstrom of bulging muscles and billowing draperies toward the central barrel-chested trumpeter (pl. 9). Kneeling on his tightly bent left leg on a cloud, this supercharged Herculean herald unleashes both upward and down-

ward across the arc of his shoulders and outstretched arms a thunderbolt of energy.

Within the right-hand subgroup of six angels (pls. 10–13), two have ceased to sound their trumpets (pls. 10, 13). One points, and the other glances leftward, drawing attention to a massive open book inscribed with the names of the damned—a book sufficiently weighty for two kneeling angels to support it (pl. 14). The tome and two trumpets are directed toward the damned, and the angels, for the most part, lean, twist, and look rightward and downward.

As a whole, then, the trumpeters—visible manifestations of divine will—reinforce Christ's control over

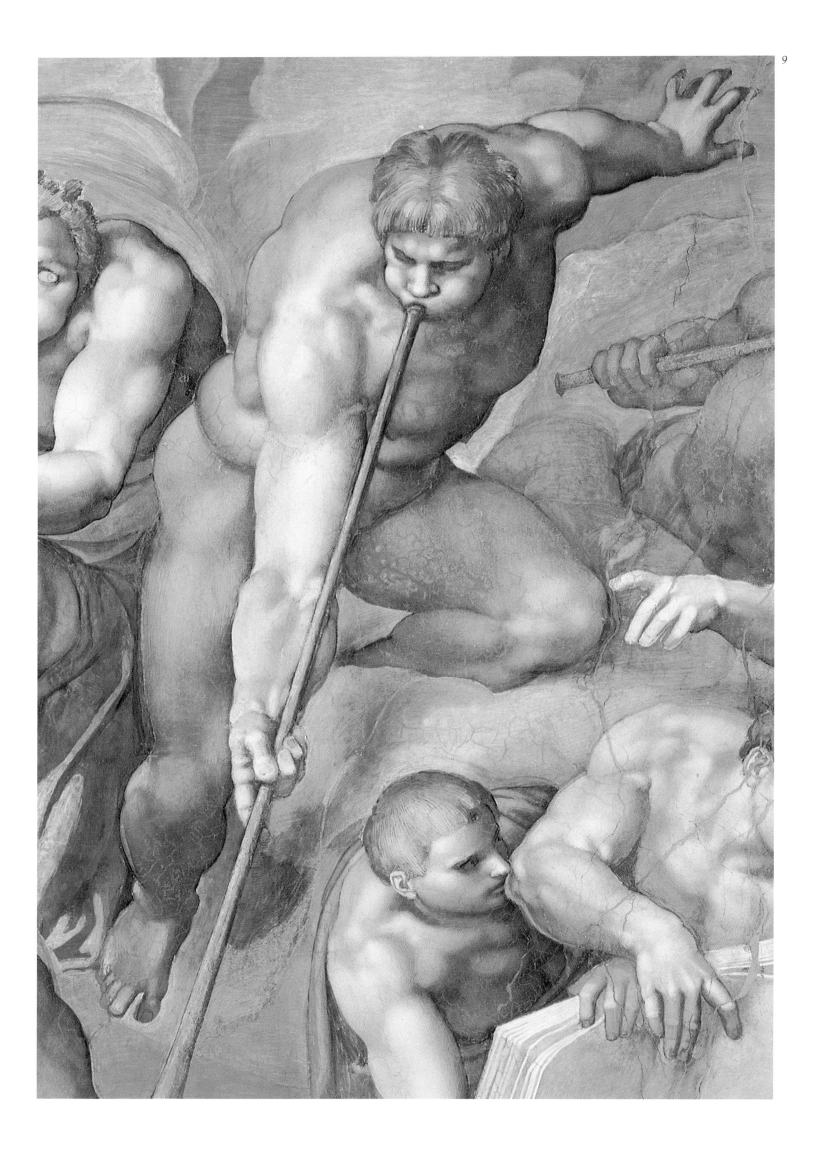

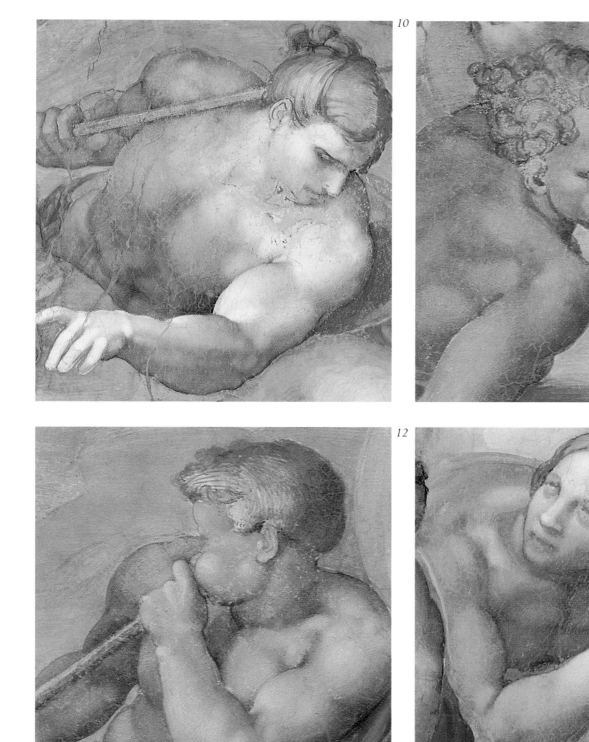

all the figures' ascent and descent. The two angels who have silenced their brass further suggest the drama's imminent end.

Although a single book of judgment appears on the prepared throne in the Torcello mosaic (fig. 3), angels had never before actively and prominently displayed two books, one small for the saved, one large for the damned. We can assume that Michelangelo followed

Apocalypse 20:12, which states that the dead will be judged "by those things which were written in the books [note the plural], according to their works." In so doing, he emphasized the necessity of works for salvation, a position made dogma by the Council of Trent in 1547 to counter the belief of Luther and many like-minded theologians, including some Catholic reformers, that faith alone sufficed.

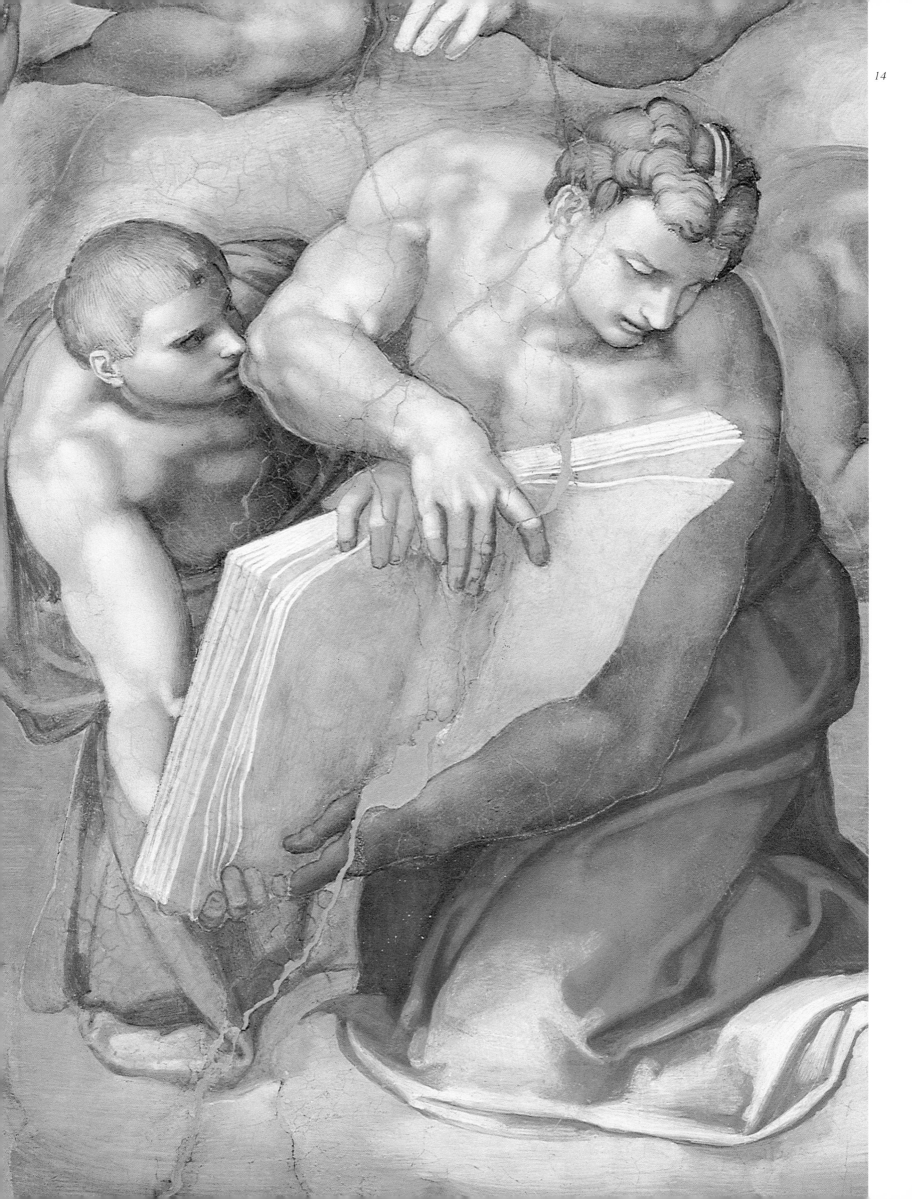

And there came down fire from God out of heaven . . . ; and the devil . . . was cast into the pool of fire and brimstone. . . .

(Apocalypse 20:9–10)

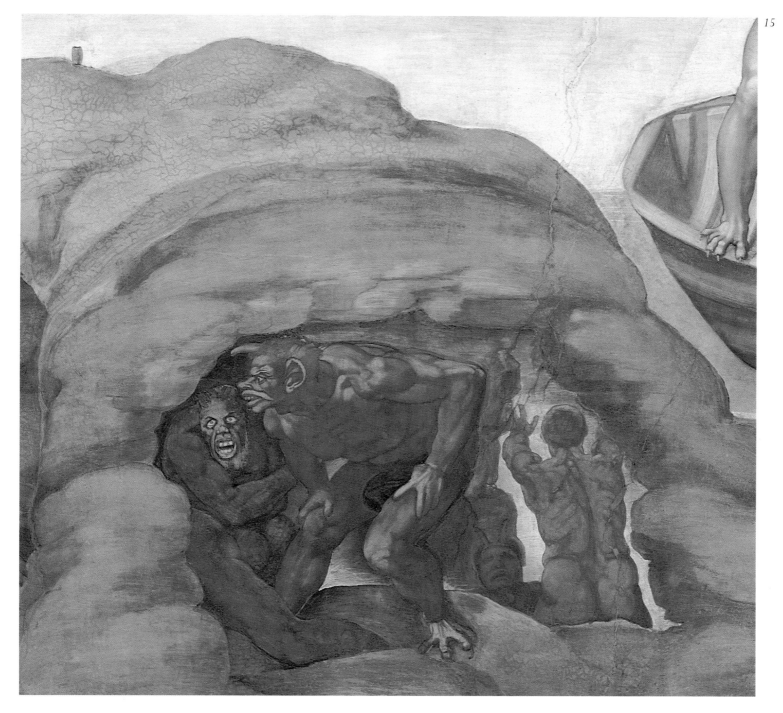

Hell's Mouth

TO DRAMATIZE one of the central polarities of the Last Judgment—good versus evil— Michelangelo positioned the cavelike mouth of Hell below Christ at the fresco's bottom (pl. 15). In this location it also served as the visual fulcrum for the painting's first band.

Three demons lurk to the left of the vertical axis that divides the fresco in half (pl. 15). A muscular, apelike monster squats in the center of this trio and snarls at the viewer from the cave's depth (pl. 17). To the right another grotesque, horned, and claw-footed demon crouches, hands on thighs (pl. 16), watching a kneeling companion whose left leg and buttock alone are visible. The latter stretches his arm through a side entrance of

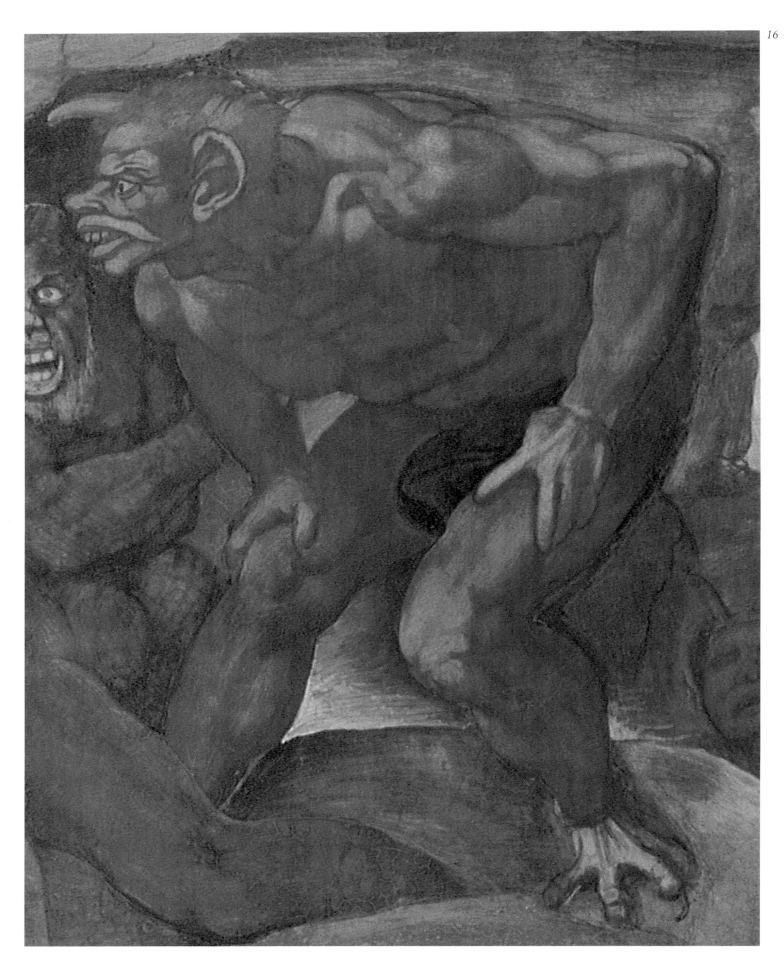

Even the demons at the bottom of the fresco's central axis visually support the drama's overall upward and downward movement. The grotesque horned devil in the foreground (pl. 16), for example, strains upward, yet is forced into a crouch by the constricting confines of Hell's mouth. His monstrous companion (pl. 17) must also squat in Hell-mouth's gloomy depths, as he snarls out at the viewer. The devils are free to move only downward into the fiery pit (pl. 18). The consecrated host elevated by the priest officiating at the altar just below would have been closely juxtaposed to these demons, thereby dramatizing the immediacy of sin and death, as well as the Eucharist's promise of redemption and regeneration.

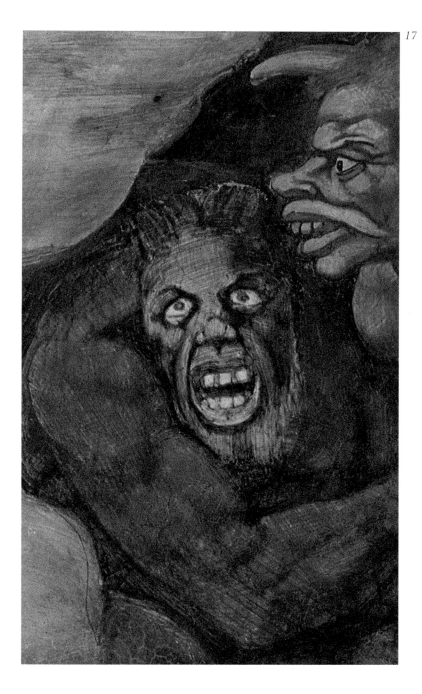

Hell's mouth to grasp a snake coiled around the legs of a soul who is lifted heavenward by an angel (pl. 48). The horned devil presses his back toward the top of the cave as if yearning to ascend with the saved toward whom he looks (p. 16). But, defeated and contorted by divine power, he and his companions are doomed to remain within the constricted confines of their cave.

The only freedom of action granted to the demons, in fact, is a descent into Hell. Thus, to the right of the central axis a rear-facing, fully erect devil marches in mock triumph downward—in accord with the fresco's general movement on the right—embracing the infernal fires with outstretched arms (pl. 18).

Mass, which was regularly celebrated below Hell's mouth at the original altar (the present one dates from the eighteenth century), reenacted Christ's redemptive sacrifice and mediated between the earthly Church Militant and the heavenly Church Triumphant. The resurrected Christ at the top, marked with the wounds of his crucifixion, appropriately balances the altar at the bottom of the central axis. But the Eucharistic rite had never previously been juxtaposed with so vast and vivid a depiction of the Last Judgment in seeming progress, nor had Hell's mouth ever been positioned at the level of the elevated host and the officiating priest's glance. In keeping with the climate of the times, these novel relationships between art and liturgy dramatized not only the immediacy of sin, but death's imminence, the Eucharist's urgency, and Christ's omnipotence.

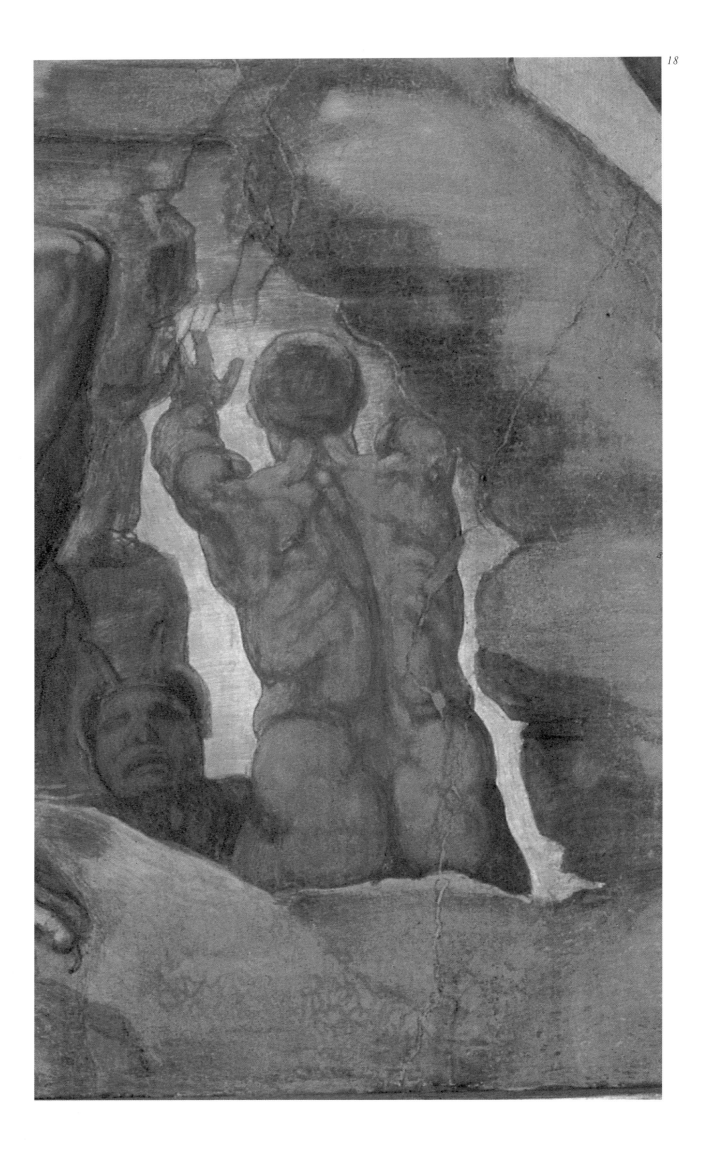

II

LEFT
LUNETTE

Angels Carrying the Cross
and Crown of Thorns

MICHELANGELO conceived the lunettes as two additional centers of energy to enliven his drama and amplify Christ's power. Instruments of Christ's Passion, especially the cross, were commonly represented in Last Judgment scenes just under Christ or near the top (figs. 3–9). They symbolized Christ's redemptive sacrifice, upon which the entire theology of final judgment depended. But Michelangelo's depiction of them as rotating with a multitude of angels, all inexorably drawn to Christ, was entirely novel.

The left lunette features the cross of the Crucifixion (pl. 19). Near the center of the cross two opposing nude angels extend their right legs above and below the upright beam (pl. 21). The visual linkage of their arms, heads, shoulders, and flanks defines a circular pivot around which the cross seems to turn. The implied rotation is clockwise, initiated by the weight of the right angel's torso suspended from his left hand, which grasps the cross. Just below him a lavender-draped angel, who digs his knees and feet into the clouds, continues this rotation by strenuously pushing the bottom of the cross leftward with his shoulder (pl. 22). His task is in turn facilitated by the counterbalancing weight of the rear-facing angel, who locks his hands just under the crossbar (pl. 21).

Simultaneous with its clockwise turning, the cross and the entire retinue of gesticulating, awestruck angels appear to be drawn toward Christ (pls. 20–22, 24–27). The subsidiary group of angels to the right most clearly defines the diagonal thrust of their trajectory (pls. 23, 28). These angels—most with outstretched arms, the foremost displaying the crown of thorns—align themselves like iron filings in a magnetic field and—drapery fluttering—glide toward Christ.

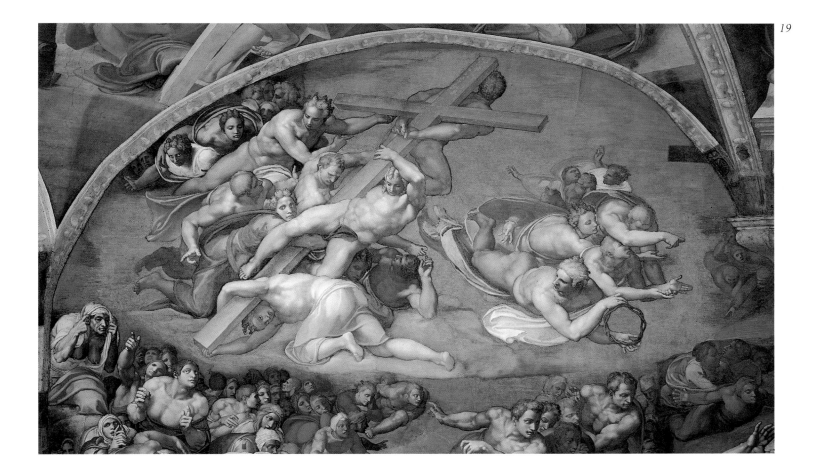

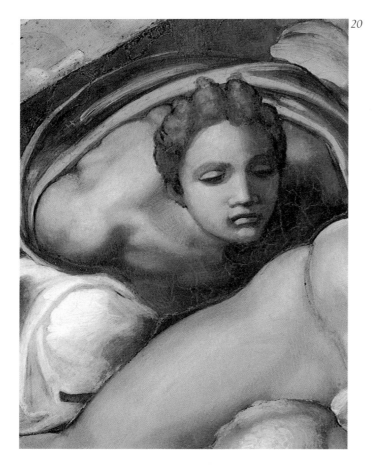

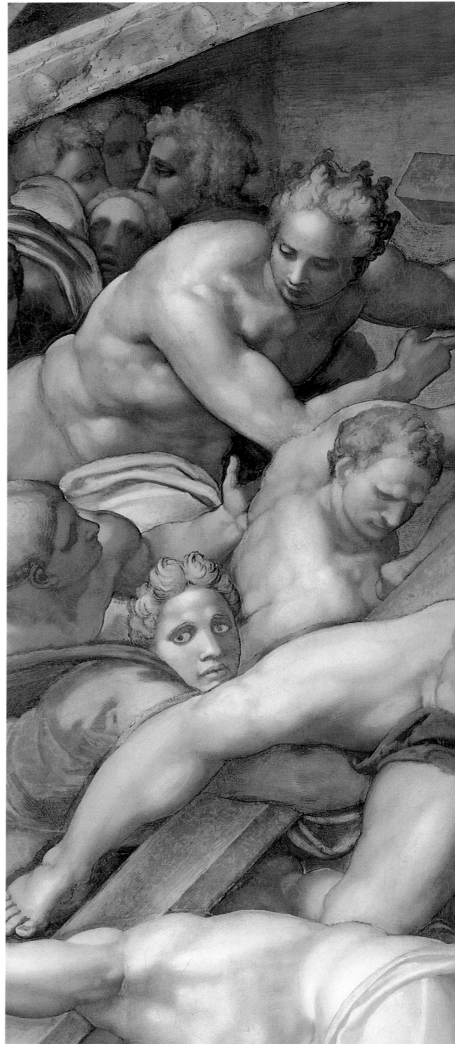

At the cross's center two opposed angels in similar postures—one with his right leg extended under the cross, the other with his stretched over it—define with their arms, shoulders, and flanks a pivot around which the cross rotates clockwise (pl. 21). The angel whose leg is on top of the cross—his loincloth is a latter addition—initiates the movement by gripping the upright beam with his left hand, from which he suspends his massive torso. The weight of the angel with his hands locked under the crossbar accelerates the rightward movement of the cross's top.

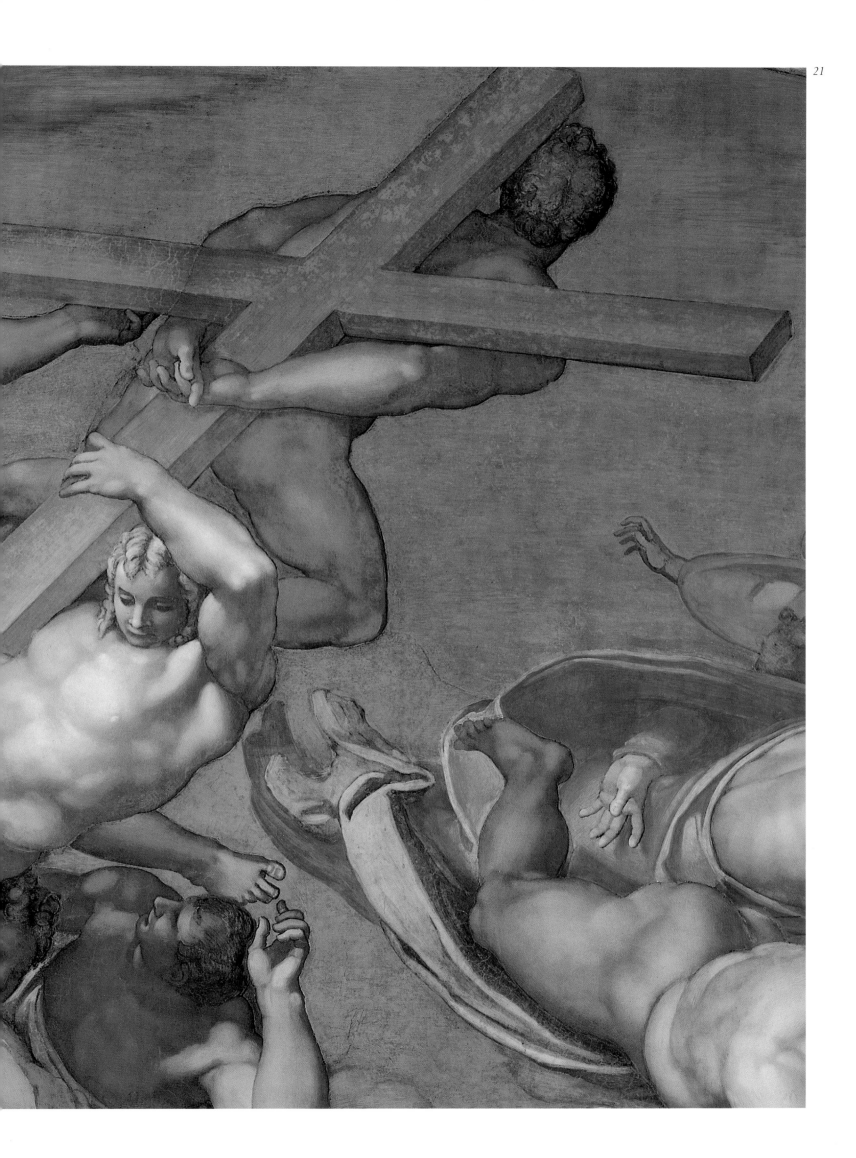

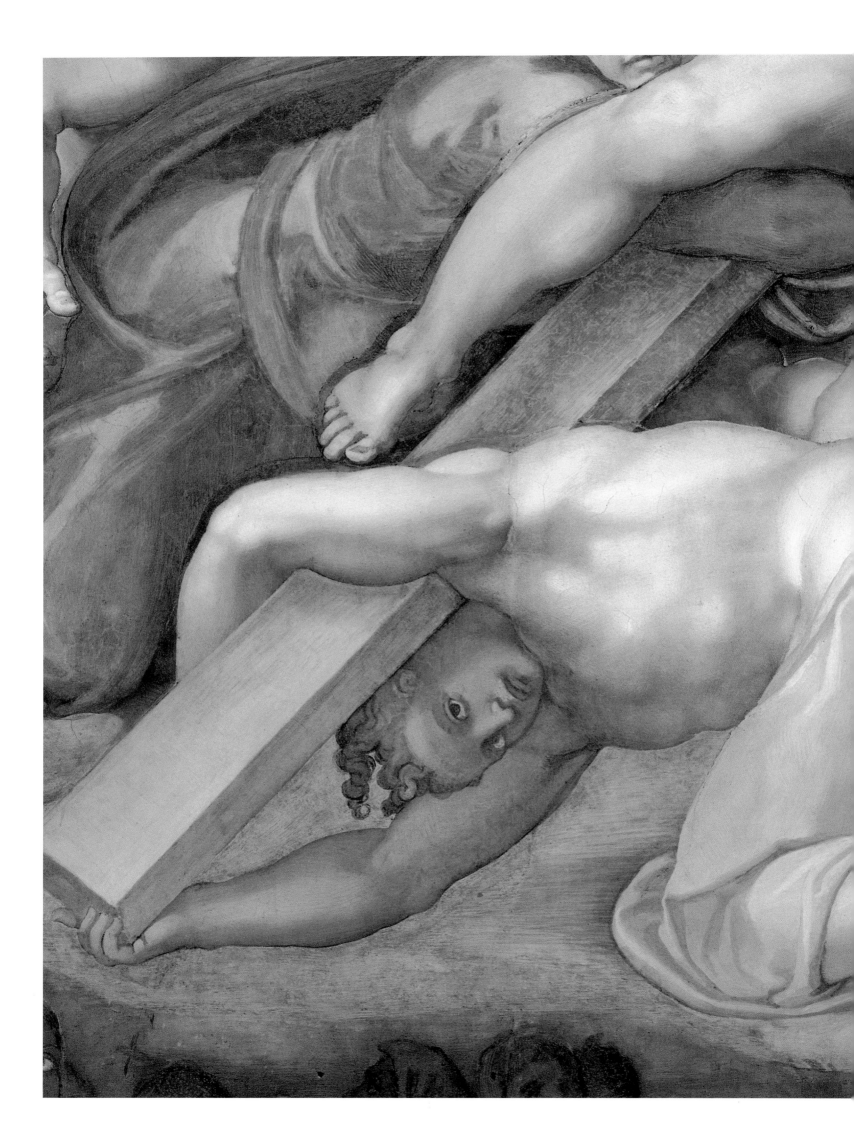

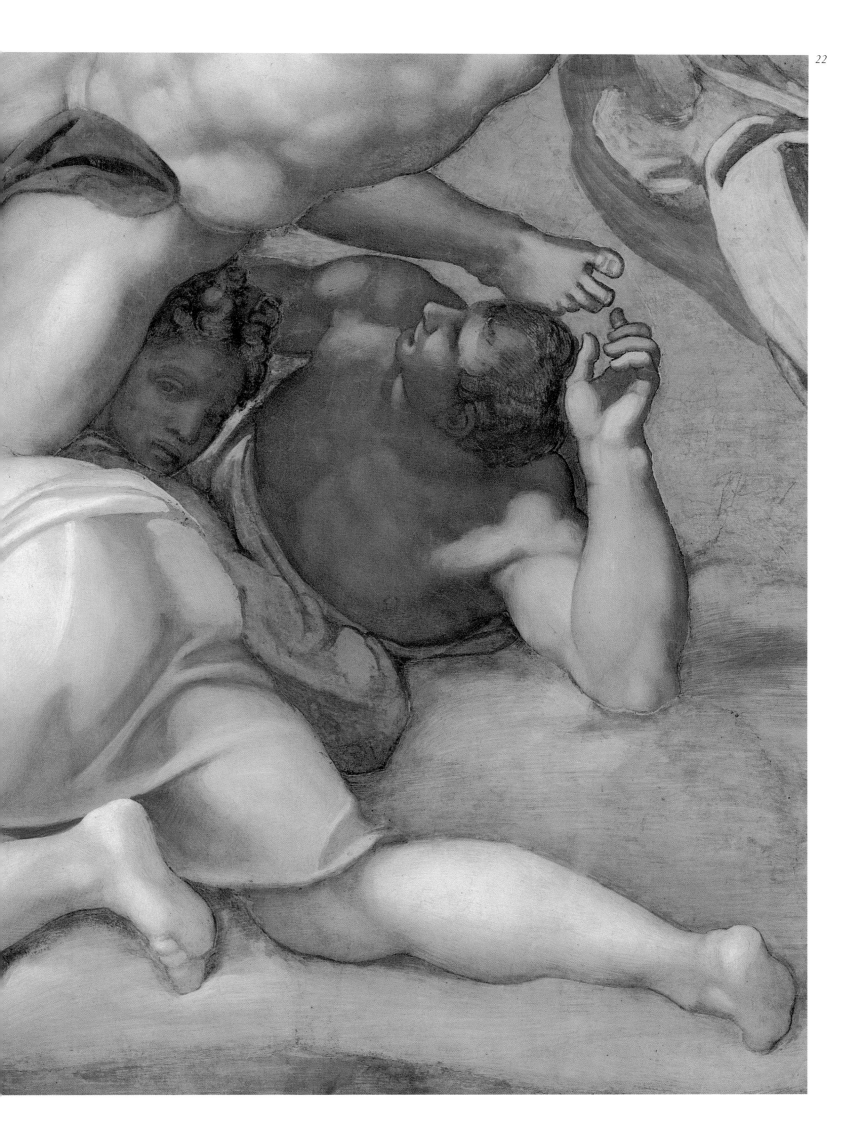

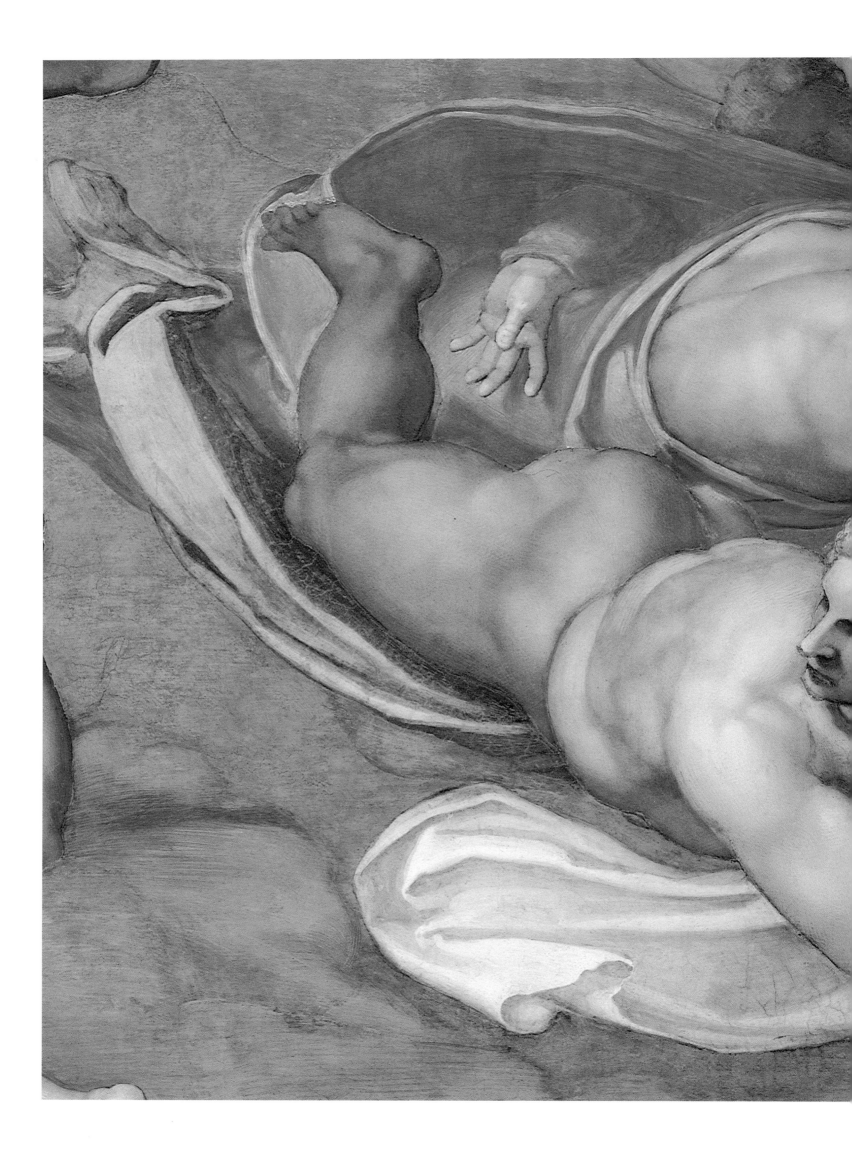

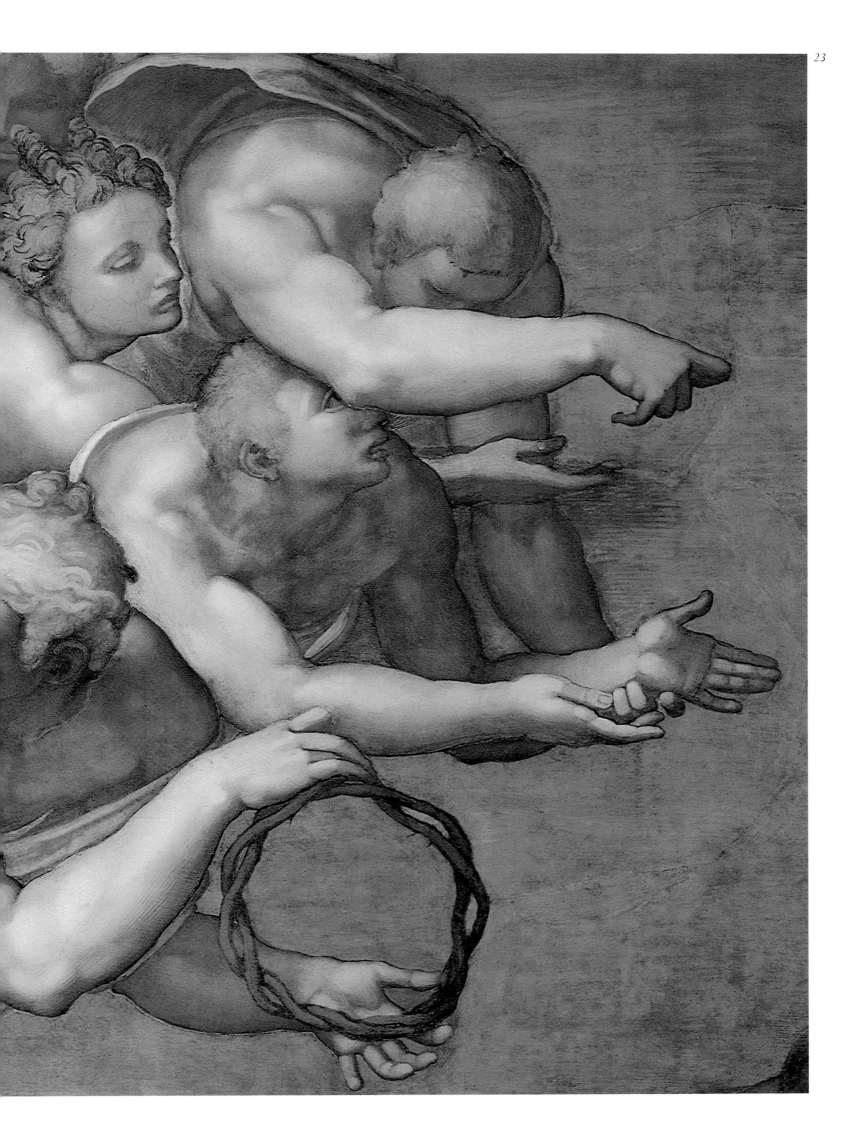

Because of the billowing drapery, the left hand wrenched across the buttocks of the angel in gold (pl. 23) appears disconnected from the angel's body, one of the rare vignettes in the entire fresco where Michelangelo seems to have slightly miscalculated. With the abundance and variety of the angels' expressions and gestures throughout the lunette (pls. 20, 24–28), Michelangelo diversified the drama and created countless countermovements to enrich the whole.

24

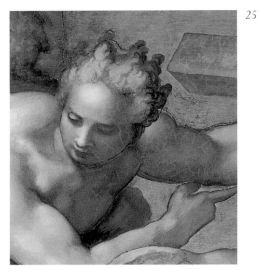

25

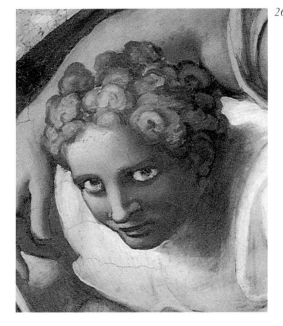

26

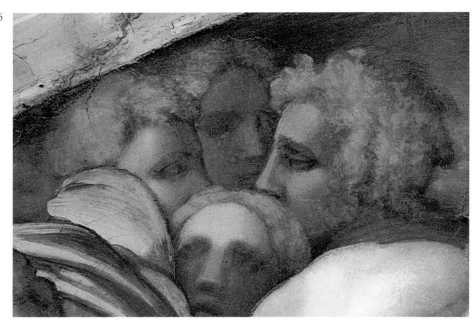

27

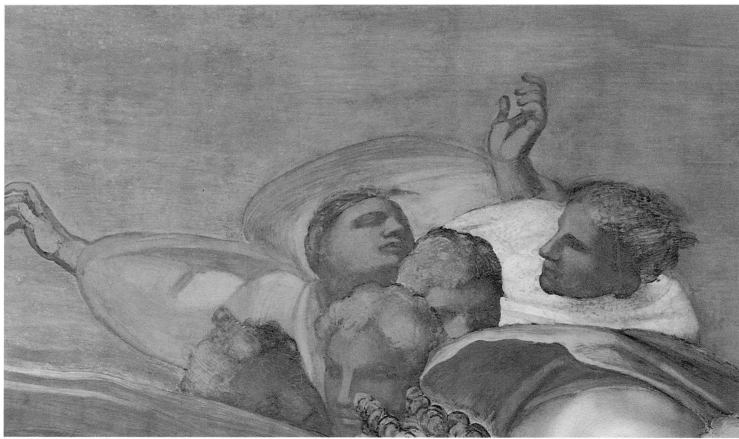

28

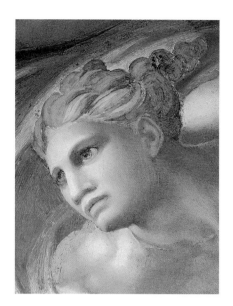

III

RIGHT
LUNETTE

Angels Carrying the Column, Reed, Sponge, and Ladder

THE COLUMN of Christ's Flagellation, the reed with the vinegar-soaked sponge mockingly offered to quench Christ's thirst during the Crucifixion, and the ladder with which he was lowered from the cross all figure in the right lunette (pl. 29). The reed with the sponge and the whips of Christ's Flagellation were often represented in Last Judgment scenes (figs. 3–5, 7). The ladder, however, while frequently depicted in Crucifixion scenes (although not, in fact, mentioned in the Bible), appears here—albeit subtly—for the first time in a Last Judgment. The column (also not mentioned in the Bible) to which Christ was believed to have been tied during his ordeal was, to my knowledge, represented only once before. The image appeared on a c. 1468/69 medal by Bertoldo (d. 1491), with which Michelangelo was almost certainly familiar, where it was paired with the cross as here (fig. 9). Michelangelo, no doubt, was drawn to his mentor's unusual motif for the very reason that drew Bertoldo: the column was the only one of Christ's attributes of sufficient size to visually counterbalance the cross.

In contrast to the right-leaning cross positioned mostly in the lunette's left half, farther from Christ (pl. 19), the column leans left and predominantly figures in the lunette's left half, closer to Christ (pl. 29). Yet, like the cross, it too rotates clockwise, as counterintuitive as this may initially seem. The central pivot is formed by the single nude angel who, balancing himself on his knee, holds the column with his right hand and seems to push the marble shaft upward with his left shoulder (pl. 32).

Climbing a stair-stepped cloud on his knees, the rear-facing angel above the pivot angel shoves the column's top toward the right with his shoulder, marking the direction of the column's rotation by the curve of his arched body (pl. 30). Another angel opposite him assists by drawing the column's top toward his chest (pl. 31).

The adjacent red-draped angel's rightward glance accents the rightward drift of the column's top, as does the action of his companion in green, who caresses the former's shoulder (pl. 36). This green-clothed angel kneels at the column's pivot point, discharging toward the upper right the energy of his body's coiled torsion as he struggles to liberate his left arm from his encircling drapery.

The column's lower half is pushed in the opposite direction by an angel in red, who hugs the shaft to his chest while flying leftward, his drapery trailing (pl. 33). He, in turn, is assisted by the nude angel—compact as a giant walnut—who hangs onto the bottom of the column and looks toward Christ (pl. 34). This angel's left leg, which breaks the almost perfect circular silhouette of his body, telegraphs the column's clockwise rotation, to which the seeming weight of his body contributes.

In contrast to the subgroup of angels who carry the crown of thorns in the lower right of the left lunette closest to Christ (pl. 23), two angels with outstretched

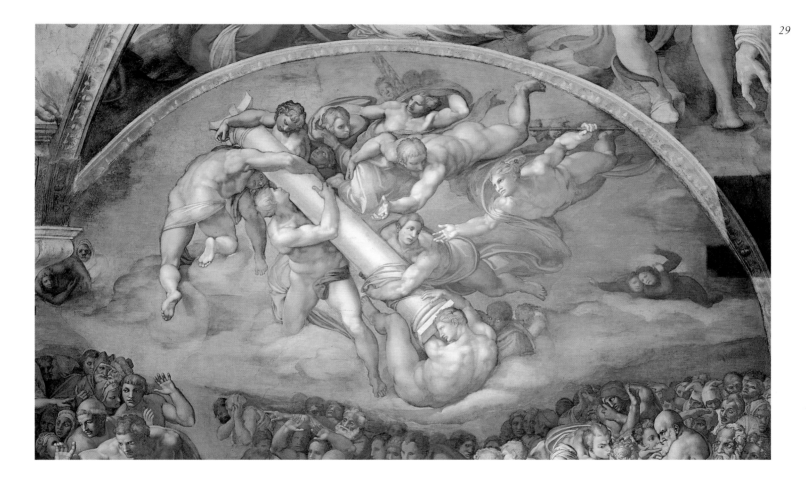

hands in the upper right segment of the lunette are positioned as farthest from Christ (pl. 35). One of them carries the reed and vinegar-soaked sponge as his fiery orange drapery arches rearward in response to his forward flight. Like their counterparts in the opposite lunette, their diagonal glide indicates the mystical path along which all the angels in the lunette (including those in pls. 38–39) are attracted toward Christ.

In these two lunettes Michelangelo created a dynamic force that presses down on the band of elect just below. The column group appears to press with greater might, tipping the entire band down to the right. In addition, by aligning the cross with Christ's upraised (and potentially down-flung) right arm and the column with his left upper arm and downward glance, and by depicting the Instruments of the Passion and the angels all drawn diagonally toward Christ as well, Michelangelo succeeded in enormously enhancing Christ's power. The clockwise rotation of both the cross and column further magnifies Christ's employment of this power to raise the saved and drive the damned to perdition.

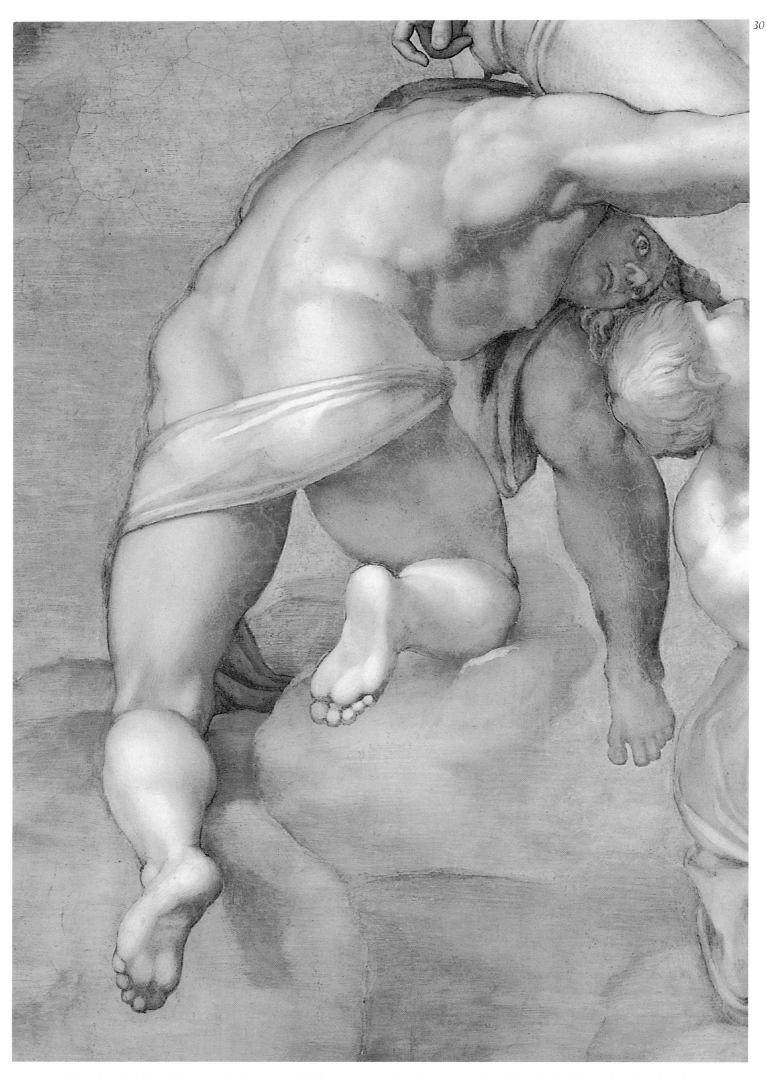

The column's leftward lean initially obscures its clockwise rotation. Kneeling on a two-level cloud bank, the angel at the column's top (pl. 30) shoves the Doric capital rightward, his movement signaled by the arch of his back. His companion (pl. 31) assists by

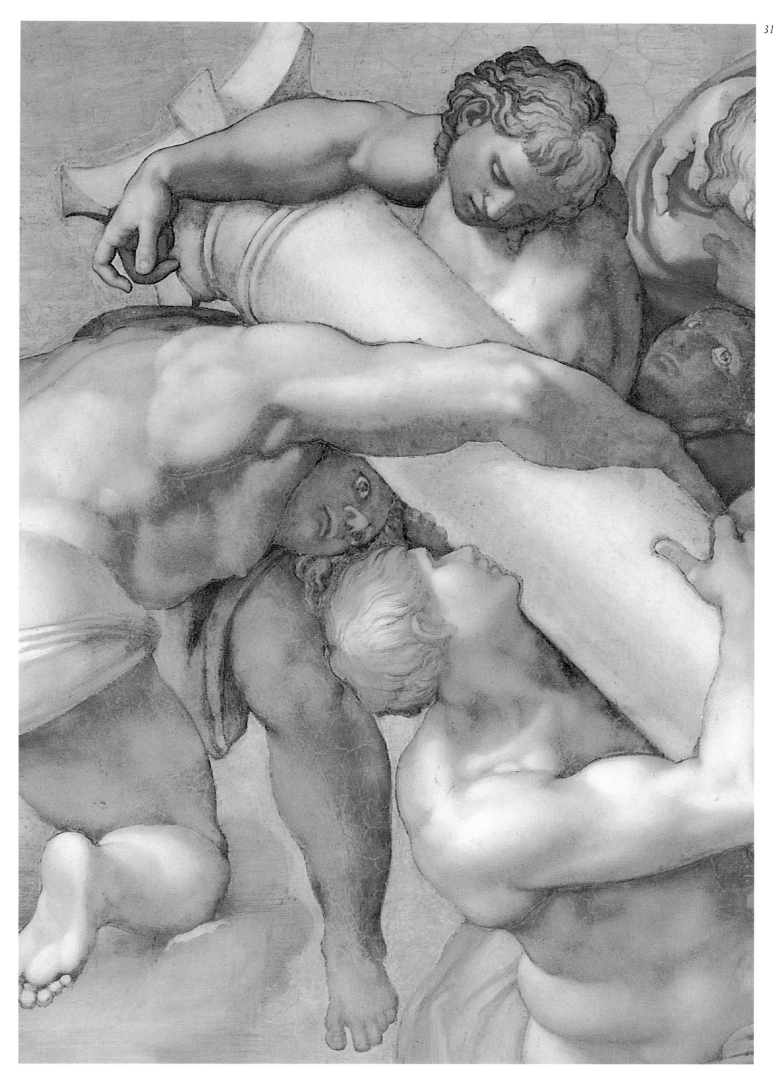

drawing the column's top toward his chest. According to the Renaissance theory derived from the Roman architect Vitruvius (first century B.C.), the sturdy Doric order was best suited to represent male deities—and thus fitting for Christ, the new Apollo.

1" />

32

The central angel (pl. 32)—his loincloth a later addition—braces himself on his right knee and pushes the shaft upward, thus forming the column's pivot. A red-draped angel (pl. 33) hugging the lower part of the shaft to his chest flies leftward. By the sheer weight of his body, a companion hanging from the column's base (pl. 34) contributes to its leftward drift, its direction telegraphed by his extended left leg.

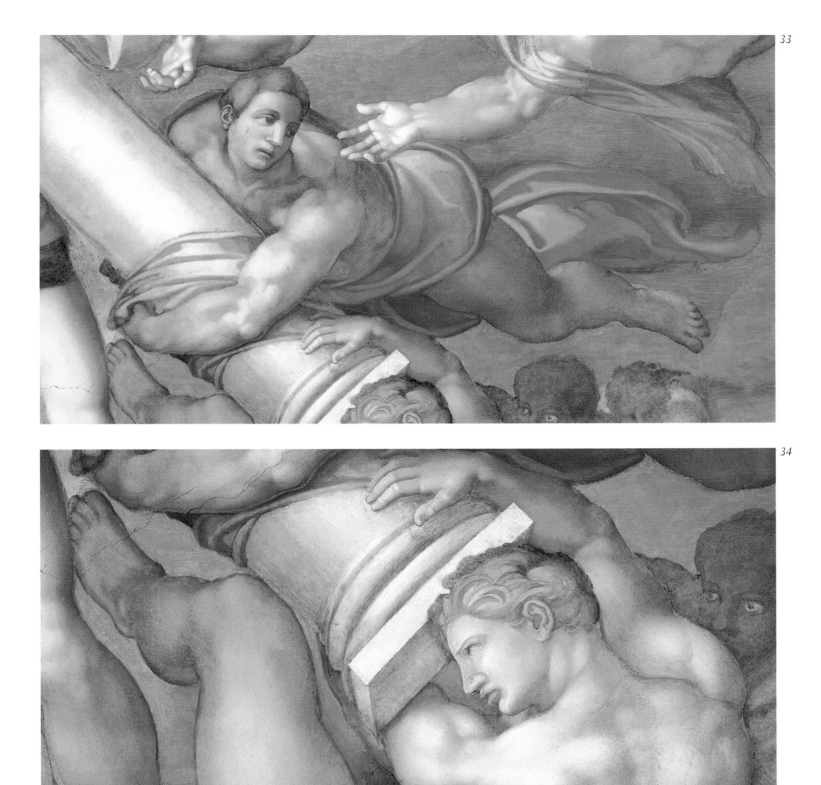

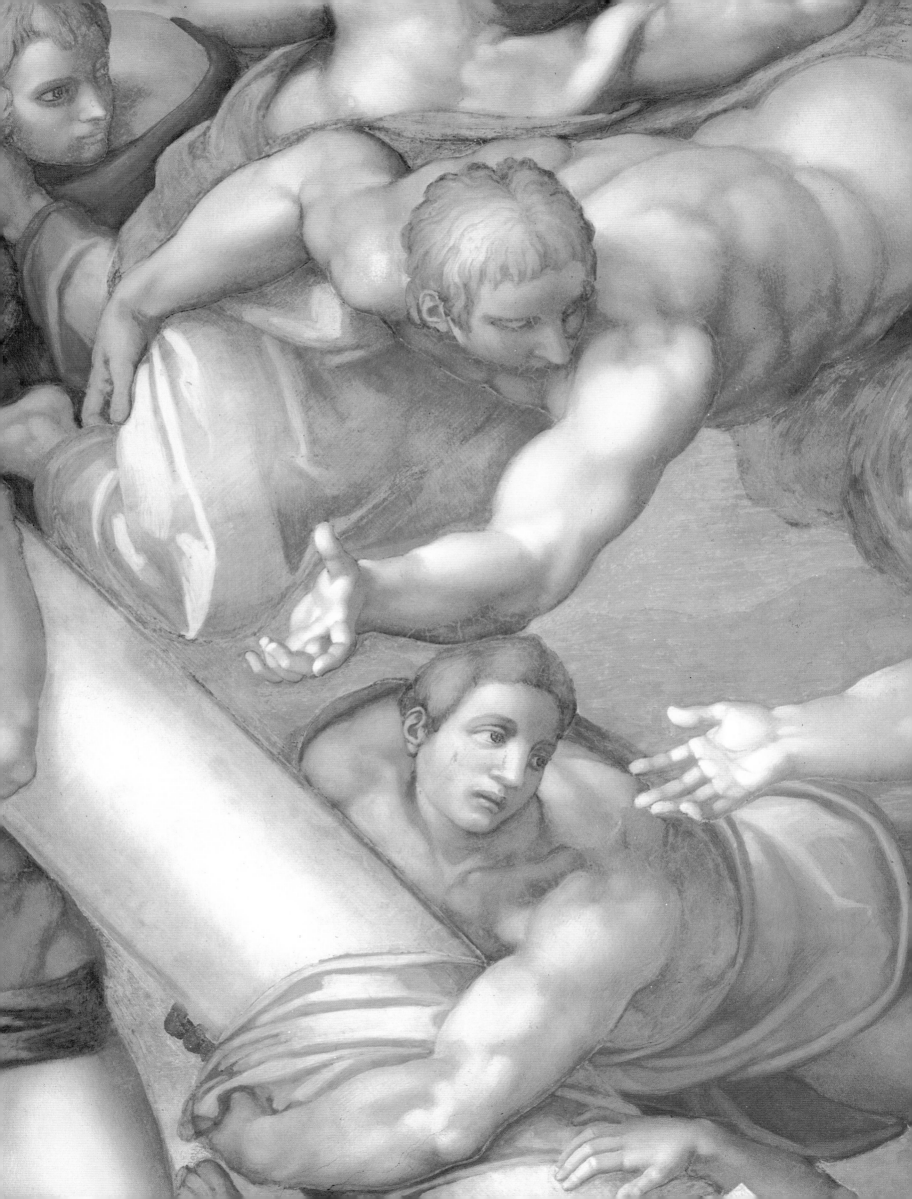

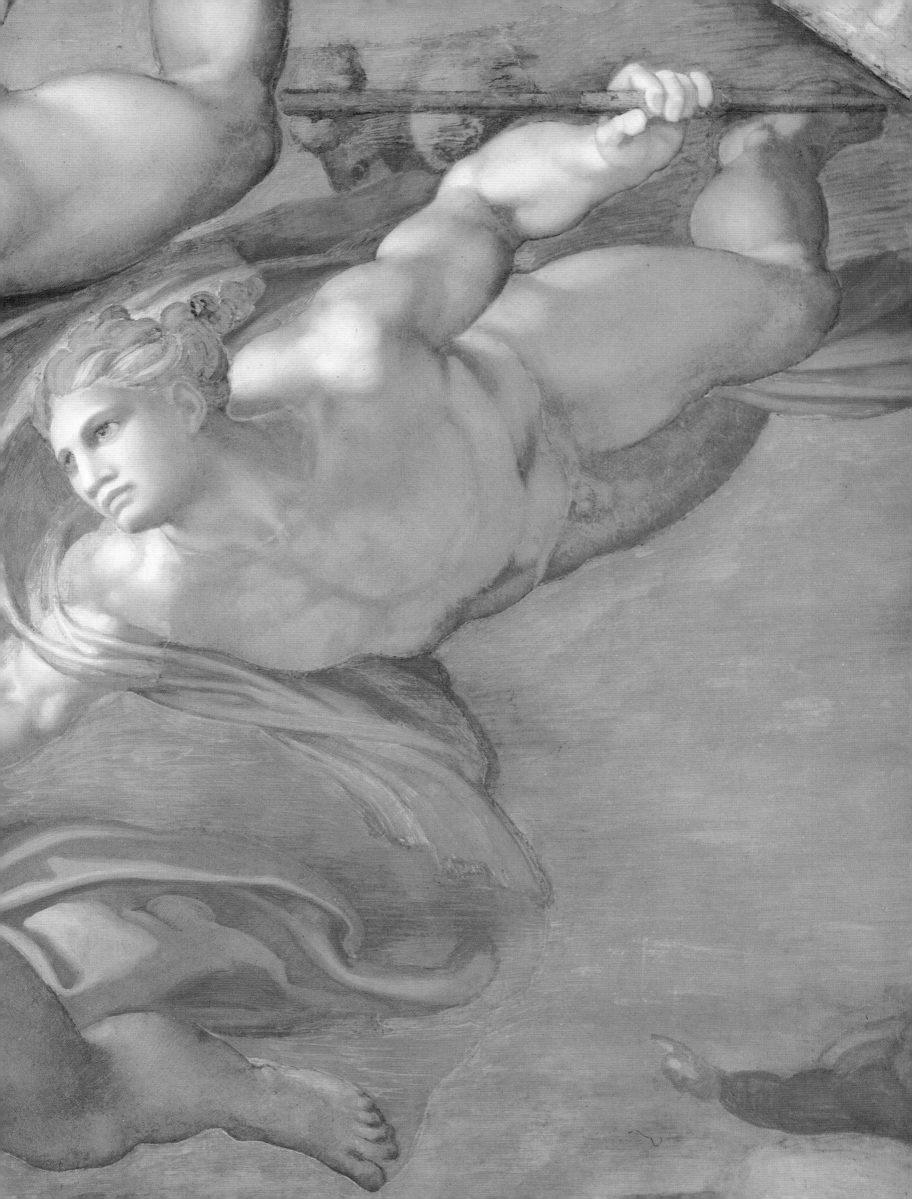

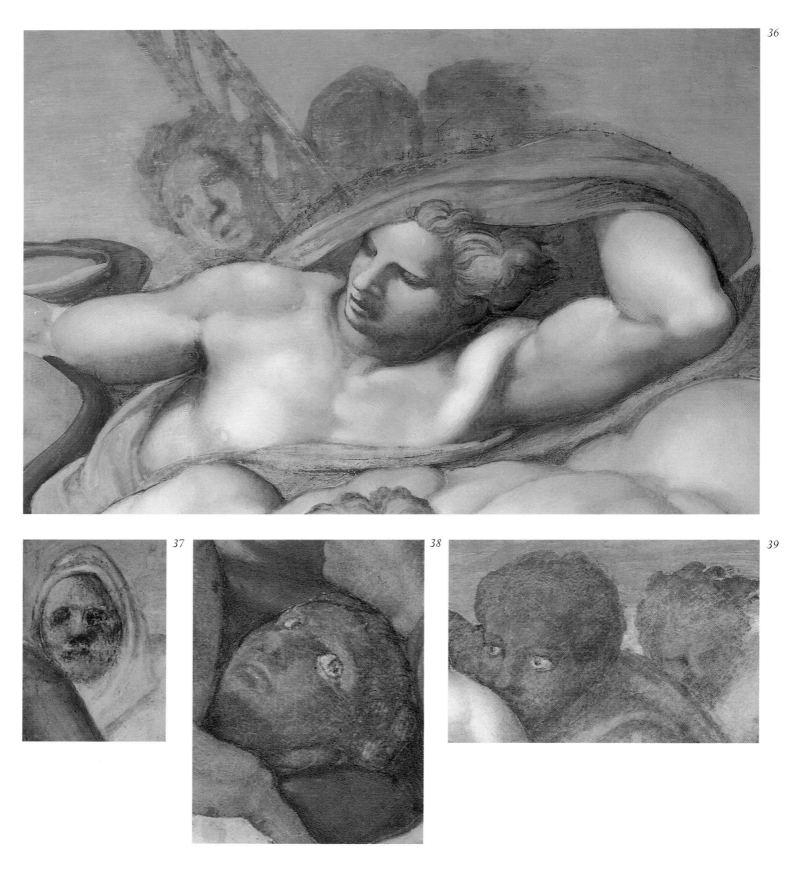

The angel kneeling on the column's center (pl. 36) visually reinforces the rightward movement of the shaft's top as he leans toward the right and struggles to liberate his left arm from the coils of his green drapery. The shadowy figure with the ladder directly behind him provides an enlivening, albeit minor countermovement to the left.

The two angels with the reed and vinegar-soaked sponge (pl. 35) glide diagonally toward Christ, defining the path along which all the angels in the lunette are attracted by Christ's mystical power, even as some are also caught up in a clockwise rotation. The angel just to the right of the corbel (pl. 37) has been (unconvincingly) identified by one scholar as a portrait of Michelangelo. The shadowed faces scattered throughout the lunette (pls. 38–39) extend the emotional range of the angels' response to Christ's magnetism. The rotation of a column of such scale and weight—unprecedented in earlier Last Judgment representations—further intensifies Christ's majesty.

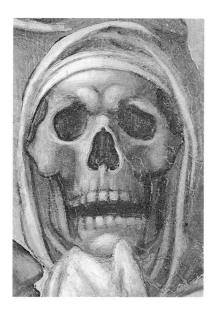

IV

RESURRECTION
OF THE
DEAD

Behold, I will send spirit into you, and you shall live. And I will lay sinews upon you, and will cause flesh to grow over you, and will cover you with skin: and I will give you spirit that you shall live, and you shall know that I am the Lord.

(Ezekiel 37:5–6)

And many of those that sleep in the dust of the earth, shall awake: some unto life everlasting, and others unto reproach. . . .

(Daniel 12:2)

So also is the resurrection of the dead. It is sown in corruption, it shall rise in incorruption. It is sown in dishonor, it shall rise in glory. It is sown in weakness, it shall rise in power. It is sown a natural body, it shall rise a spiritual body. If there be a natural body, there is also a spiritual body, as it is written: The first man Adam was made into a living soul; the last Adam into a quickening spirit. . . . In a moment, in the twinkling of an eye, at the last trumpet: for the trumpet shall sound, and the dead shall rise again incorruptible: and we shall be changed.

(I Corinthians 15:42–45, 52)

REPRESENTATIONS of the Last Judgment traditionally presented the breaching of the tombs near the bottom or lower left (figs. 4, 6–10). The depiction of two subgroups of resurrecting souls as here—thirty-two toward the left, seven on the right, divided by a fissure in the earth at the bottom—was, however, without precedent (pl. 40).

At the left, nearly all of the souls give the impression of raising themselves and actively cooperating with the drama initiated by Christ and his angels. In the lower left foreground, for example, one soul strains to lift a heavy slab of rock, allowing another to crawl out vigorously. Along a diagonal running from the fissure in the foreground to the base of the hillock in the upper left background, three male nudes—seen respectively from the front, back, and side—have each drawn one leg at a sharp angle out of the ground, planted both hands firmly on the earth, and begun to free the still entombed leg in order to stand up in response to the blare of the trumpeting angels toward whom they look (pls. 42, 44–45). This willful activity reaches a climax at the upper left on the horizon where two souls in billowing shrouds spring toward Christ, launching themselves off the hillock, significantly, at a point level with the side wall's lower cornice (pl. 43). The upward glances and gestures of the souls along the horizon in front of them—one wearing the pointed hood of a lay confra-

ternity, two others still in skeletal form—underline the direction of their ascent (pl. 44).

The seven souls toward the right, by contrast, appear utterly helpless (pls. 46–48). Gravitational pull crushes to earth the five nearest the fresco's bottom. Possessing the weight and density of living bodies, they give the impression, however, of completely lacking inner volition. A pair of devils clasps the other two souls—one ashen gray, the other hanging upside down. One devil who reaches out from the cave of Hell, as we have seen, tightly grips a snake coiled around his victim's legs; the other forcefully yanks his victim's hair.

But three angels liberate these two latter souls from the clutches of evil. A lavender-draped angel reaches under the armpits of the serpent-coiled soul, lifting him from behind (pl. 40). A green-clad angel struggles upward with the soul who hangs upside down and whose legs are bent at the knees over the angel's shoulders (pl. 47). So strong is the devil's grip (pl. 48), however, that a second angel—foreshortened, front-facing, and dressed in reddish orange drapery—assists by hoisting the soul under his knees.

It was traditional within depictions of the Last Judgment for angels to direct the elect toward Christ and salvation (figs. 4–6, 9, 12–13), but never before had they physically hefted them up as here (and, as we shall see, in the group of the ascending elect just above).

While contrasted in terms of motivation—propelled in one case by divine power, in the other by will—the two subgroups remain visually unified. The souls to the right lean leftward and configure a series of diagonals rising ever more steeply. The left subgroup's energy, as we have seen, builds momentum along a diagonal running from lower right to upper left, defined by the three nudes preparing to stand. The souls on or near the horizon then release this energy upward along a contrary diagonal. The diagonal vectors of force from both subgroups converge just above the horizon in two free-floating souls—corporeal but spiritual, shrouded

hope—further unites the two subgroups.

The divergent yet united subgroups symbolize the two contrasting but equally necessary elements of orthodox justification (which would soon be made dogma by the Council of Trent)—grace, gratuitously bestowed through God's mercy independent of human will, and works, performed by the faithful in willed cooperation with divine grace. Given the belief of Luther and many Catholic reformers in the futility of works in the face of human sinfulness and divine omnipotence, it is significant that Michelangelo chose to emphasize works within the group of resurrecting dead.

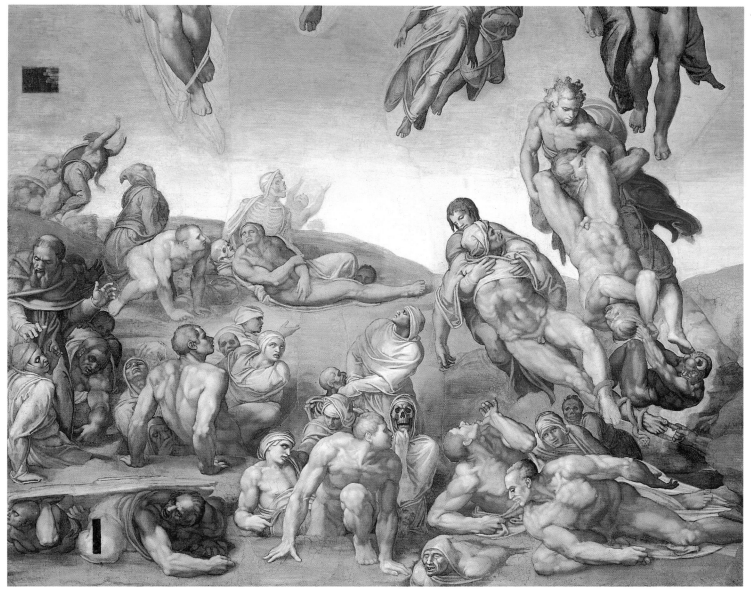

but resurrected—who are drawn ineluctably toward Christ (pl. 49). A common green ground—the color of growth, regeneration, and the theological virtue of

The artist also enriched the group's symbolic significance by introducing a bearded and tonsured cleric who stands erect at the extreme left, as if already resurrect-

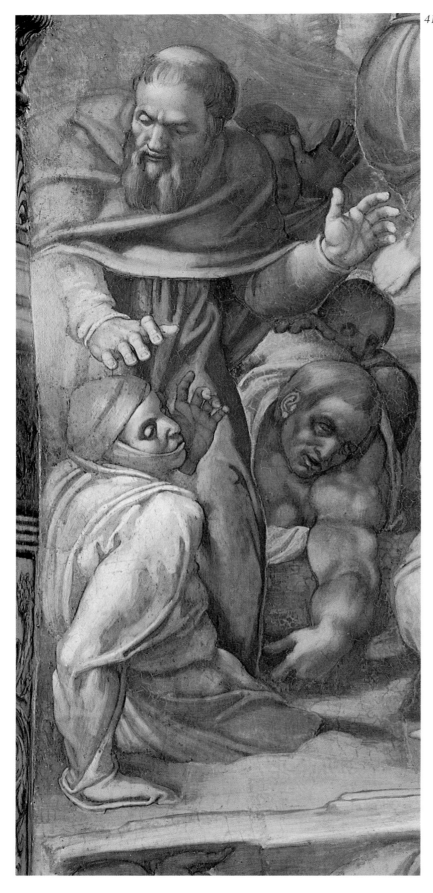

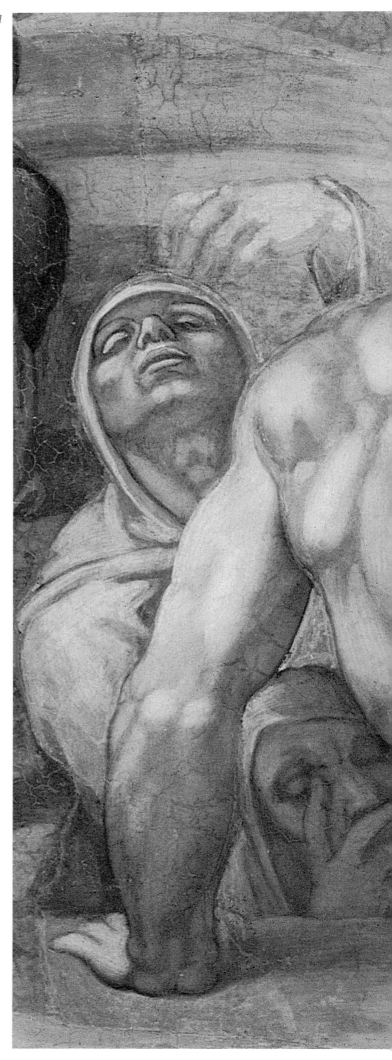

A tonsured priest (pl. 41) performs the ritual of laying on hands used in the sacraments of Baptism, Confirmation, and Extreme Unction, all appropriate in the context of the Last Judgment. He channels divine grace to a resurrecting soul with his right hand and indicates the path toward Christ with his left. Behind him a soul reaches out of his tomb to kiss the priest's foot, an act of obeisance and adoration that dramatizes an individual's need to collaborate by faith and prayer with grace. Watching the trumpeting angels in awe, a muscular and youthful soul (pl. 42) plants both hands on the ground behind his back and prepares to lift himself out of his tomb.

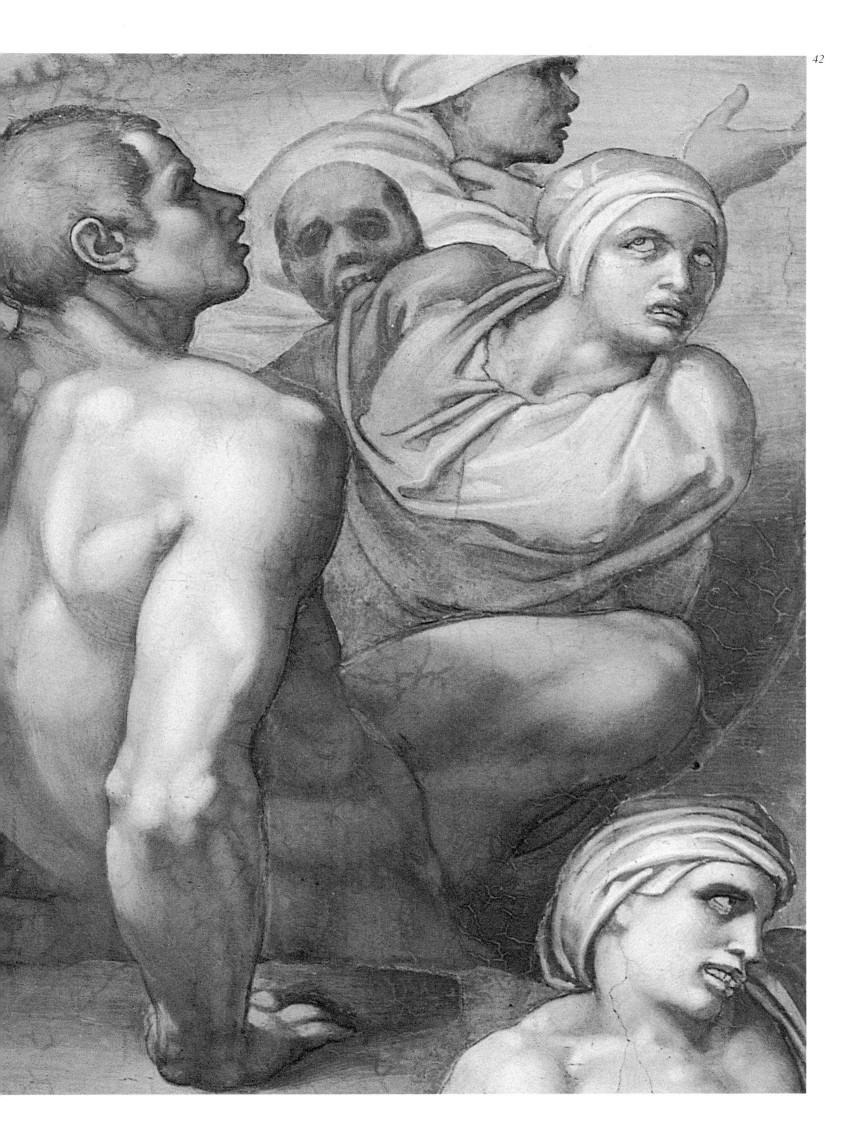

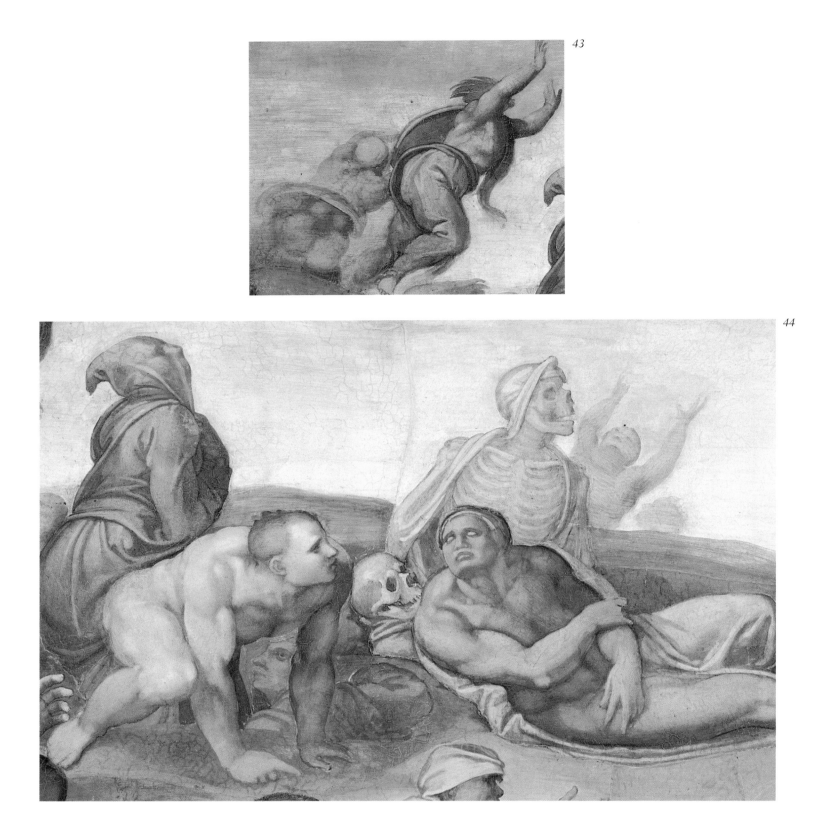

ed or perhaps, even more likely, alive at the moment of the Last Judgment (pl. 41). This priest, without precedent in Last Judgment representations, performs the ritual of laying on hands—a manner of blessing used in Baptism, Confirmation, and Extreme Unction, all highly relevant sacraments at the Last Judgment. This embodiment of the church channels divine grace to the shrouded soul awakening in front of him by the gesture of his right hand. With his left hand he indicates the path toward Christ and initiates the release of spiritual energy upward, precisely at the junction between the two contrary diagonals, which visually structure this subgroup. The soul who reaches out of his tomb to embrace the priest's foot demonstrates the cooperating faith and piety necessary to receive the salvific benefits of church sacraments offered by the priest.

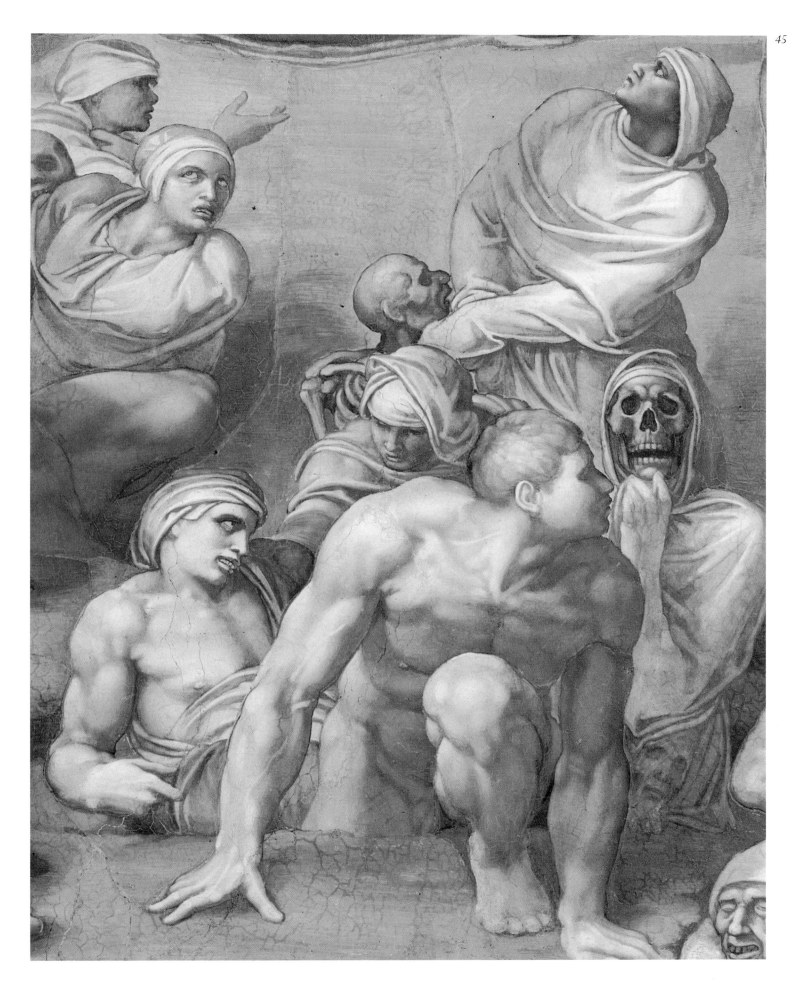

Most resurrecting souls (pls. 43–44) look toward Christ as two launch themselves heavenward, their anatomical uplift intensified by their juxtaposition with the painted south-wall cornice, itself implying architectural support.

The foreground nude soul (pl. 45) gazing at the trumpeting angels and preparing to stand embodies the necessary individual cooperation with divine will enacted by most souls in the left-hand subgroup.

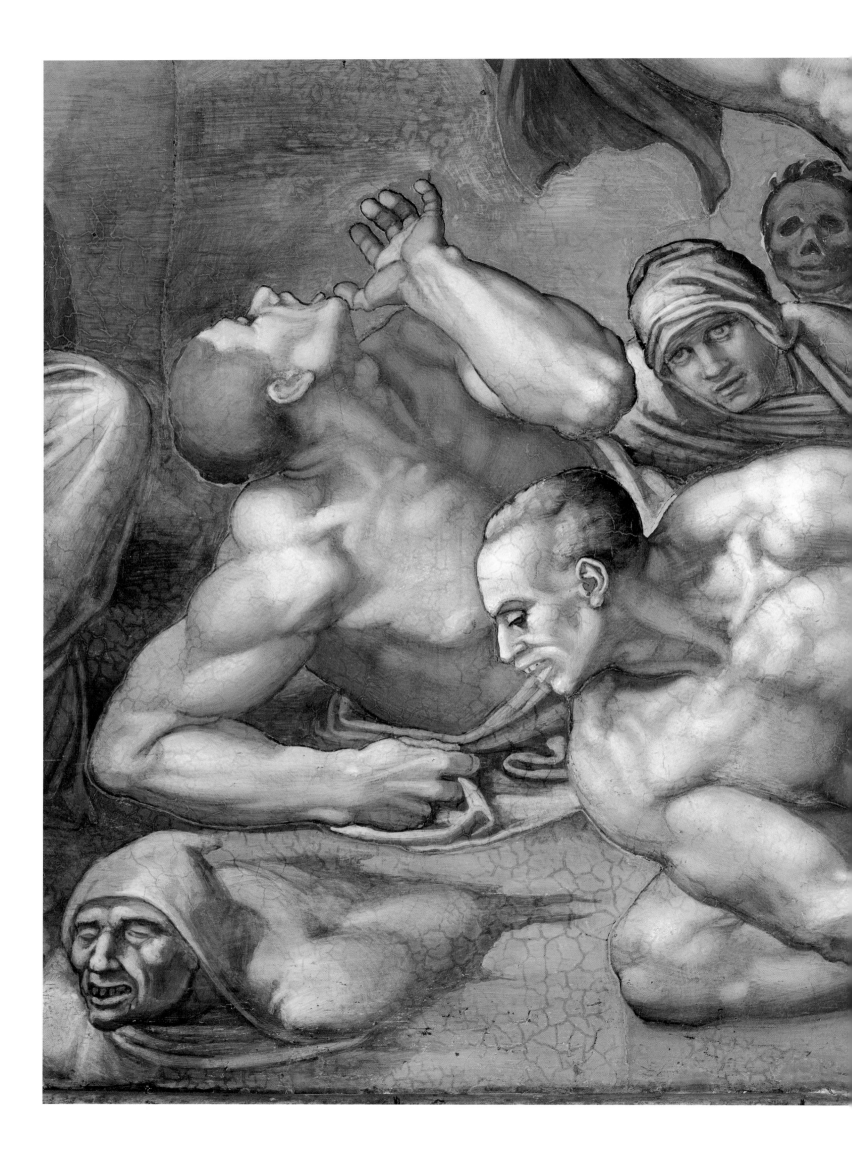

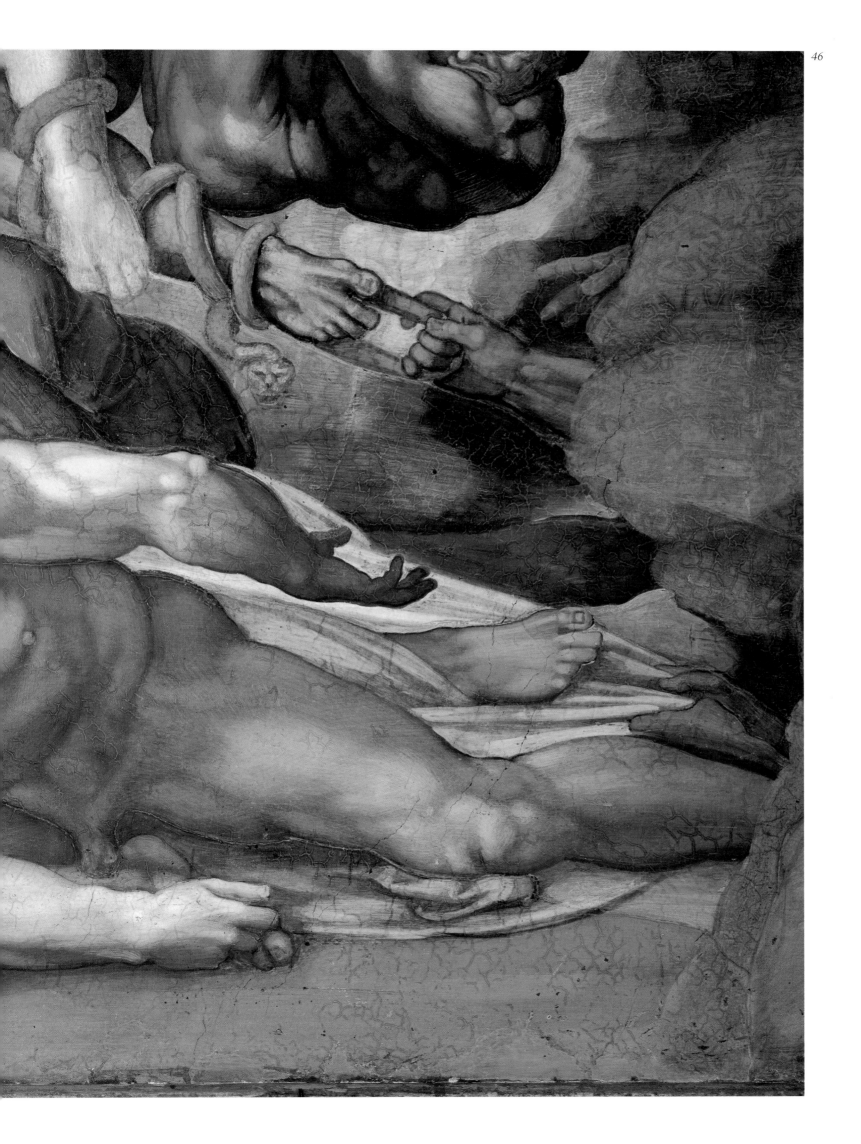

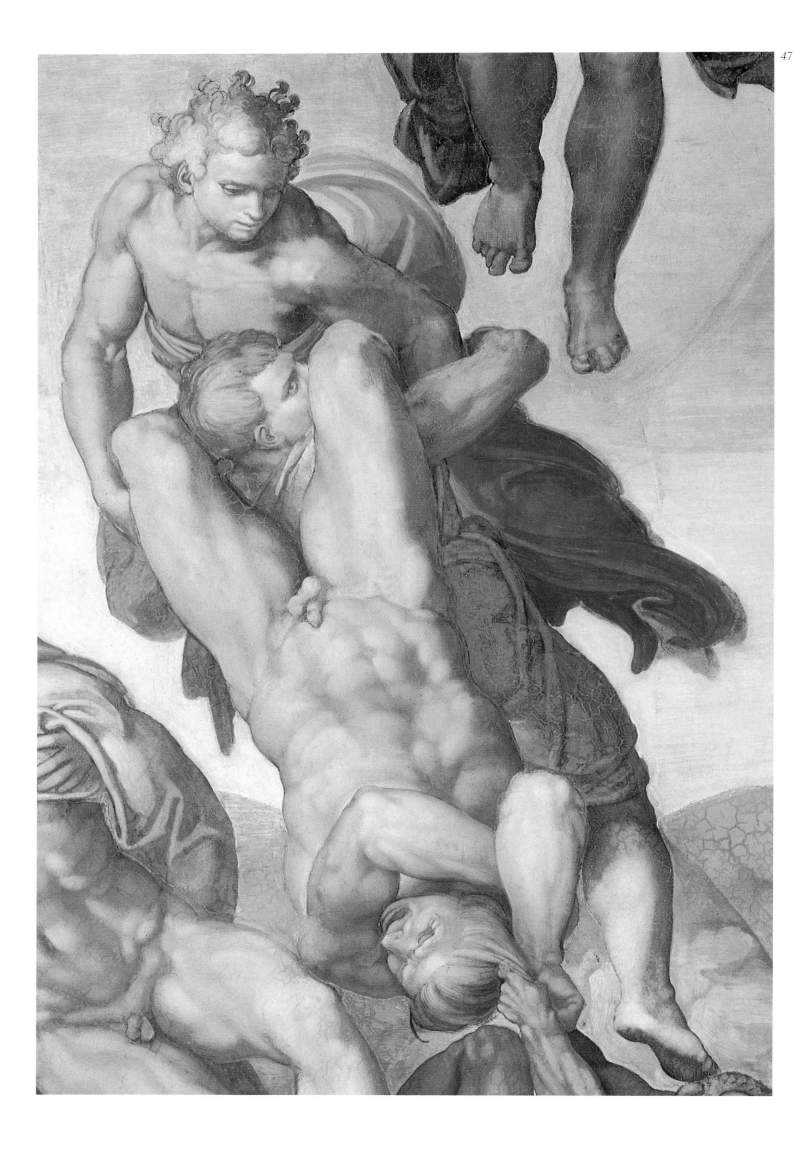

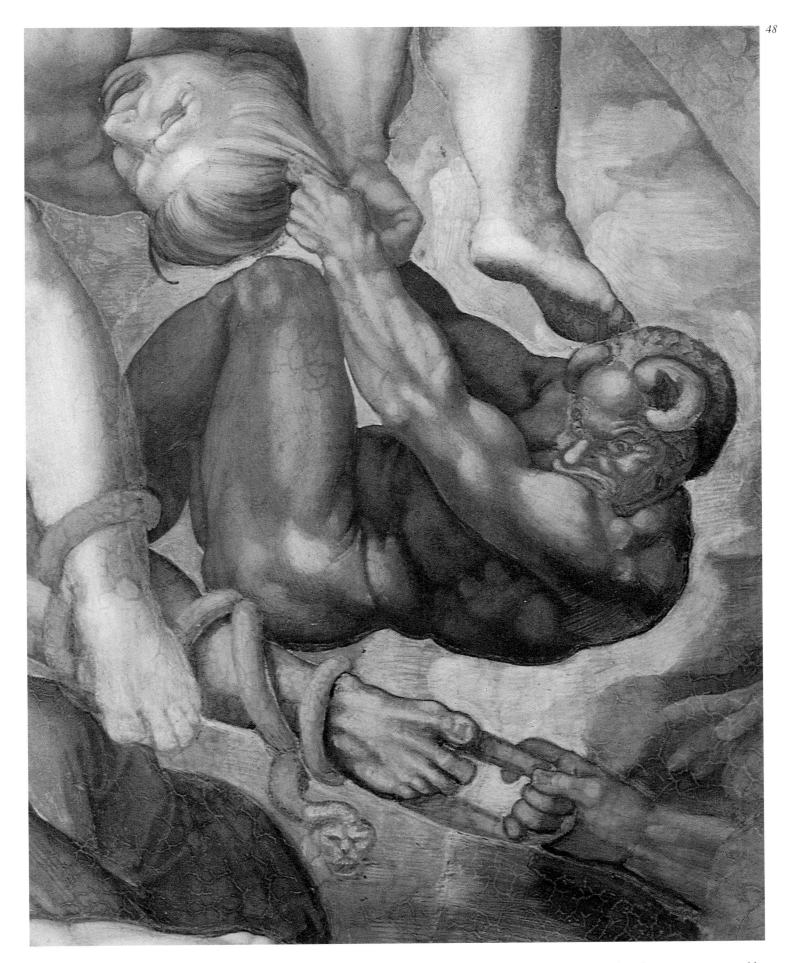

The souls in the right-hand subgroup (pls. 46–48), who are crushed by gravitational pull or tethered to the earth by grappling demons, appear incapable of acting alone. Only with the aid of angels—embodiments of divine grace—can they be liberated from the grip of death and evil, and even the angels must struggle to overcome the devils' tenacious grasp. Together the helpless and active souls embody the two essential components of orthodox justification—divine grace and personal responsibility expressed through faith, prayer, penitence, and works—and their necessary interaction. The unifying green ground symbolizes hope and spiritual regeneration.

Loincloths added sometime after the sixteenth century, just recently removed, once covered the genitals of the two souls—one ashen gray, the other more ruddy and suspended upside down—uplifted by the angels (pls. 40, 47).

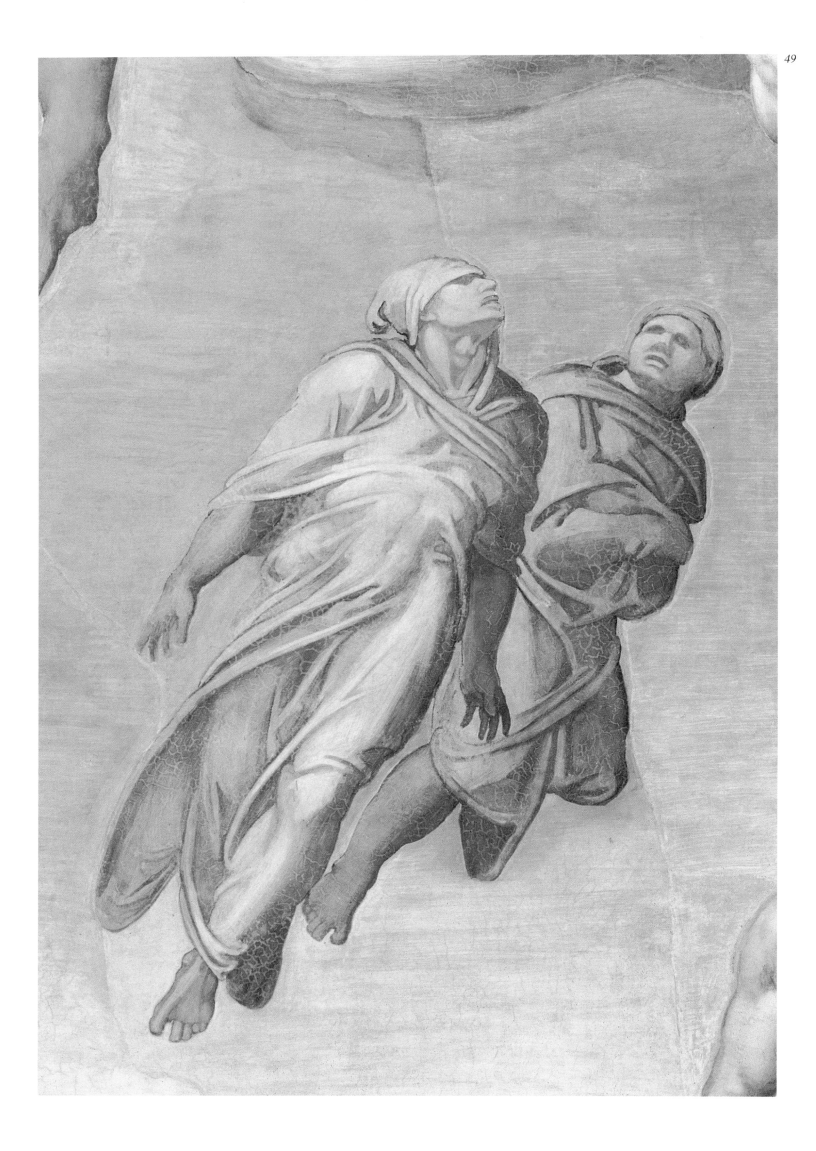

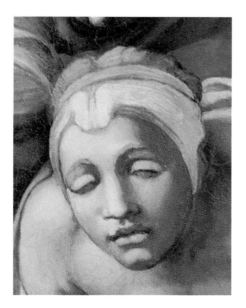

V

ASCENDING
ELECT

MICHELANGELO organized the ascending elect into two V-shaped subgroups, the smaller to the right, a larger on the left (pl. 50). Two souls fished up to Heaven by a graceful, powerful, and semi-crouching angel define the smaller V's right-hand diagonal (pls. 58–59). The lifeline of rosary beads—the first such image to appear in a Last Judgment scene—and the shadowy soul praying within a cloud cocoon just above explicitly represent the doctrine of prayer as crucial to salvation.

Furthermore, the souls snared by the rosary gape at the angel, one fervently kissing the beads, the other crossing his arms over his chest as if in gratitude. Together they convey the essential nature of prayer—entreaty, adoration, and thanksgiving (pl. 59). Both also embody faith, humility, and penitence—fundamental states of mind for effective prayer. Finally, the nude soul in the foreground is more passive, elevated without holding onto the rope of beads that encircles his torso, while his shrouded and swarthy (perhaps black) companion, his legs widely and awkwardly splayed, desperately clings to this lifeline.

The smaller V's left-hand diagonal sharply contrasts with its counterpart (pls. 60, 63). The souls here appear more self-possessed and mentally alert. The foreground nude has devised his own means of propulsion. He pushes off with his right arm from the blue-draped knee of a companion, who embraces him from behind, and pumps his left arm and legs in a running leap of sorts. Michelangelo here communicates the idea, also basic to the theology of prayer, that grace is bestowed only upon individuals who freely and willingly interact with their faith. Most of the self-propelled soul's companions gaze to the left, focusing their attention on the larger V-shaped subgroup.

A shadowed nude woman, ankles bound with a shroud, forms the point of the larger V (pl. 51). In a state of ecstacy—her raised hands framing an upturned face with open mouth and closed eyes—she is drawn upward by the mystical force emanating from Christ. To the left a massive frontal male nude (pl. 54) dangles from the hand of an angel (pl. 55), who reaches down over a cloud to lightly pluck him by the wrist. A companion angel with a white fillet and red robe kneels behind him and points the way toward Christ (pl. 50). Behind them three elect, one on all fours, peer down at this operation of salvation (pl. 53). The drama of angelic aid is echoed just under the foot of the green-filleted angel at the fresco's left margin, where a helping hand reaches through the cloud and grips the wrist of a rear-facing soul in white and olive green (pl. 50).

As a virtuoso variation on the angel angling with a rosary (pl. 58), Michelangelo executed the green-filleted angel, muscles rippling vibrantly under his skin (pl. 55). He also set him beside the cornice—just as he did the souls in the group below who spring upward from the hillock (pl. 43)—to associate architectural with muscular uplift and simultaneously contrast material with spiritual support.

To the right of the ecstatic woman at the V-point,

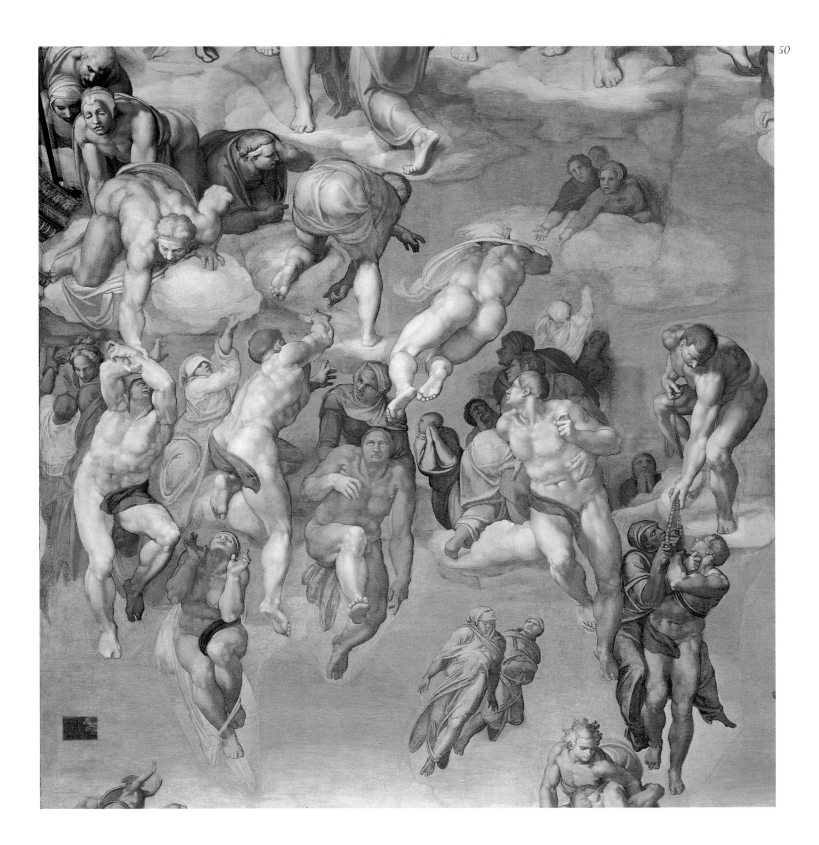

another frontal male nude, this one with right arm and leg raised and suspended in light, left limbs lowered and extended in shadow, dangles from the hands of a green-and-gold-clad angel who lifts him from under his armpits (pl. 52).

To his right and above four additional souls (pls. 56–57, 61)—all seen from the rear or side, each with one or both hands outstretched—give the impression of being pulled powerfully toward Christ along diagonal lines of force indicated by the arms of the red-and-green-draped souls, who reach over a cloud (pl. 62). That two of these four souls seem to be blinded, or partially so, by shrouds over their heads (pls. 56, 61) suggests the involuntary nature of their movement. The other two, furthermore, whose right hands almost touch, kneel clumsily on their left legs and tumble in ungainly concatenation, drawn by the mystical energy radiating from Christ (pls. 56–57).

Michelangelo thus indicates the total dependence on Christ's mercy of nearly all of the elect in the larger V by their lack of self-control and their movement through external force. The self-motivation of the souls of the smaller V, however, suggests that salvation also depends on individual free will—expressed through faith and works—interacting with divine grace. Michelangelo communicates the same message and visually enlivens the fresco by contrasting the dependence of the elect in the larger V with the autonomy of the souls in the larger group of resurrecting dead immediately below. And similarly, he contrasts the self-motivation of the elect in the smaller V with the helplessness of the souls in the smaller group of resurrecting dead just below.

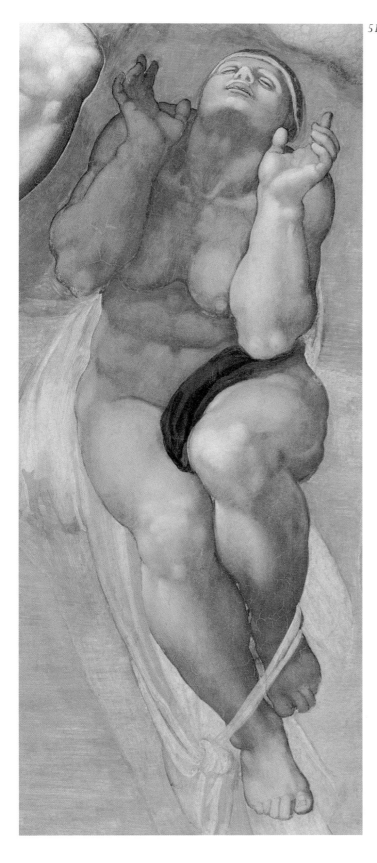

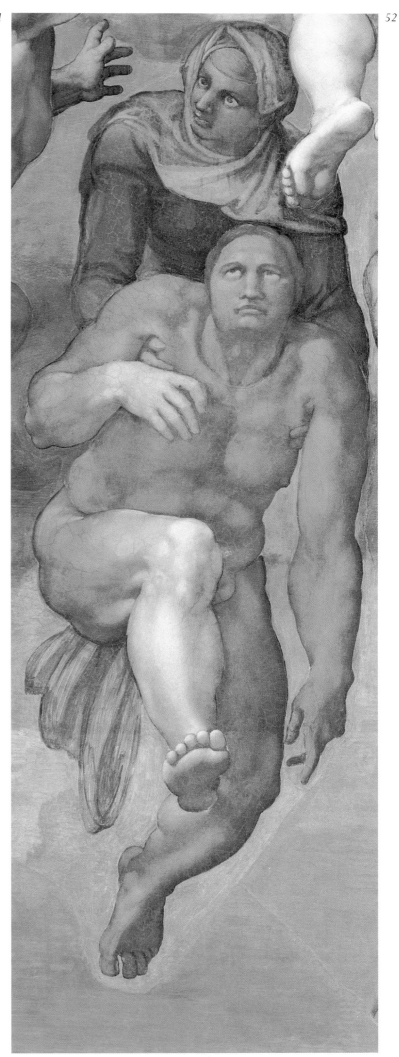

Drawn by Christ's mystical power, a nude woman (pl. 51) soars heavenward in a state of ecstacy, her feet still bound by her shroud. The swatch of drapery covering her genitals appears to have been painted by Michelangelo. A nude male (pl. 52), fully dependent on divine aid, dangles from the arms of an angel dressed in green who wears a gold veil.

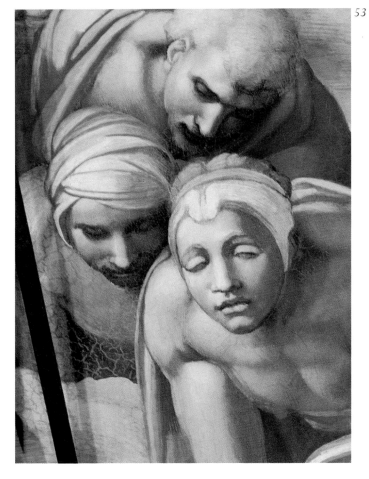

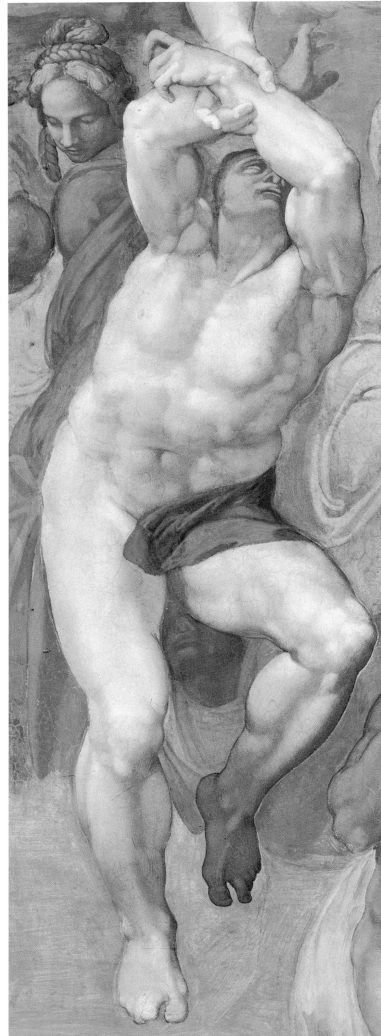

A trio of saved, one of them kneeling on all fours, peers down to witness the miracle of the resurrecting and ascending elect (pl. 53). All three seemingly focus on the massive male soul (pl. 54)—his sex subsequently covered by a loincloth—who hangs awkwardly from the grip of the angel in front of them. A green-draped female with an elaborate coiffe nestles against the soul's flank.

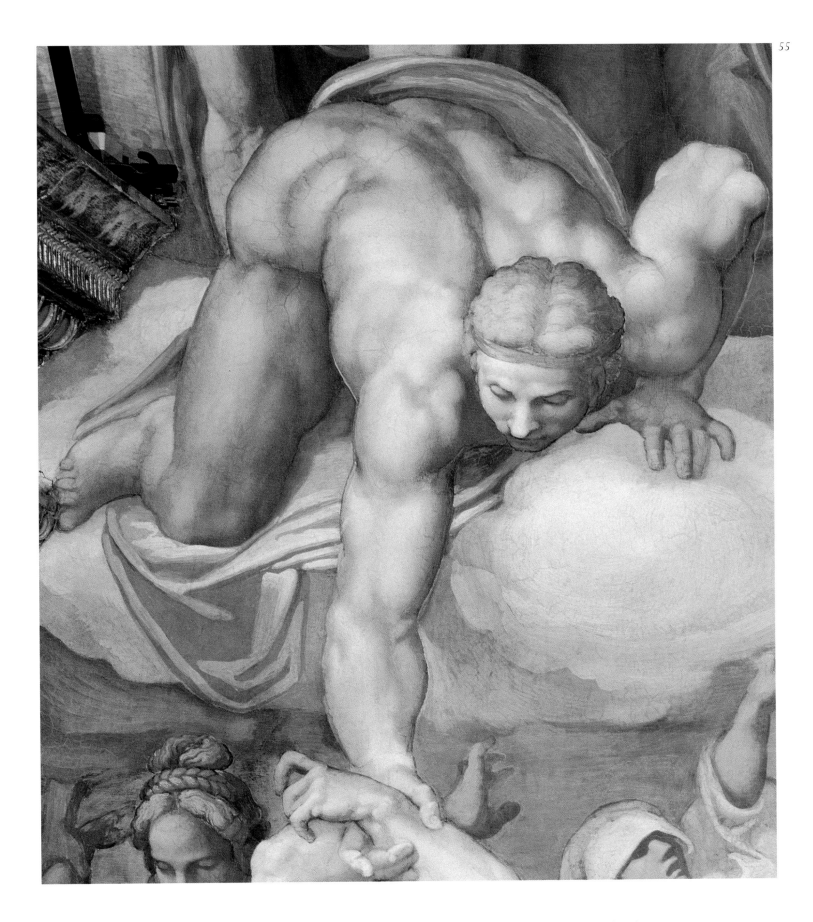

The youthful green-filleted angel (pl. 55) kneeling down and reaching over a cloud to lift the soul in plate 54 represents one of Michelangelo's most stunning embodiments of divine power. The angel's extraordinary arched back quivers with muscular vitality. His counterpoised and sharply flexed left arm and right leg framing his torso magnify his anatomical torsion and intensify the power of his titanic right arm. The blue drapery arching behind his vibrant body and unfurling underneath unifies his anatomy's straining efforts and adds a visual note of curvilinear grace to this efficient and potent celestial crane. Michelangelo also carefully positioned this angel next to the projecting south-wall cornice, both to underline his uplifting action and to contrast material with spiritual uplift.

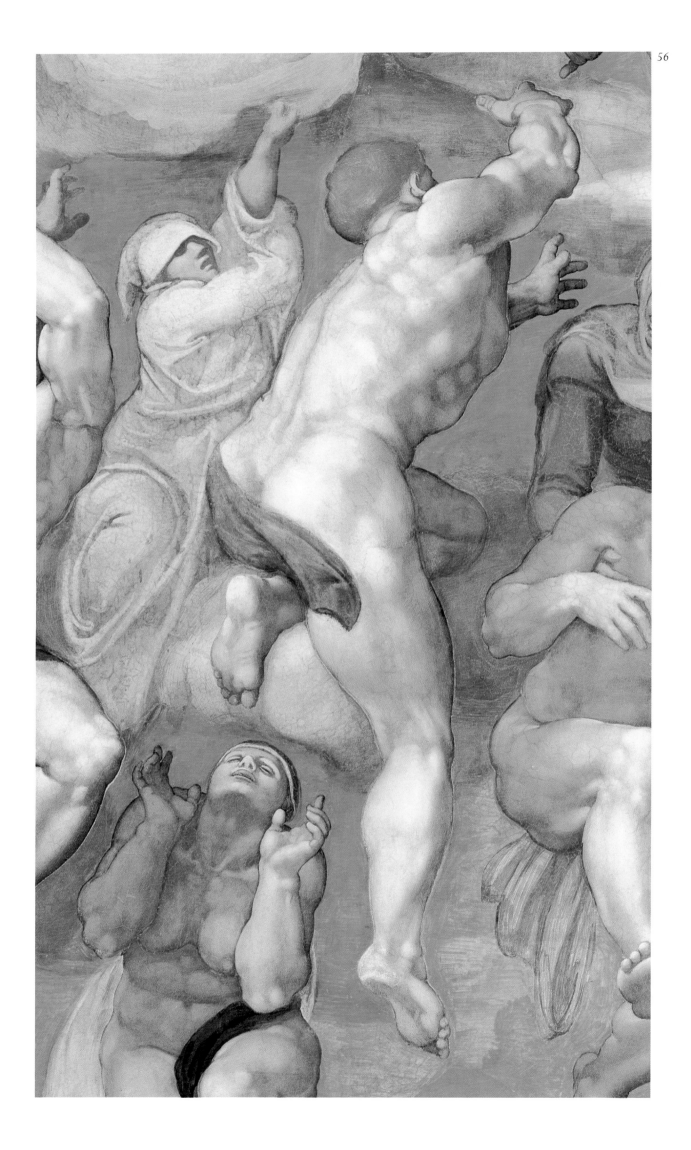

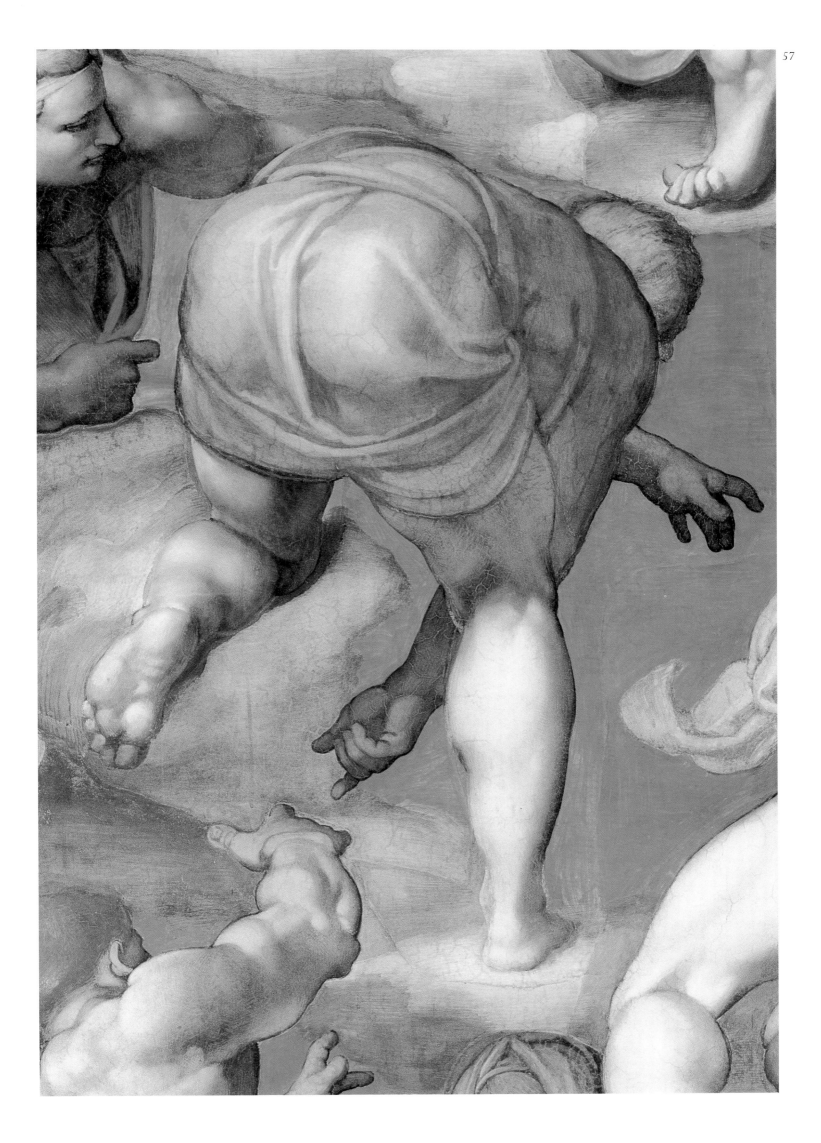

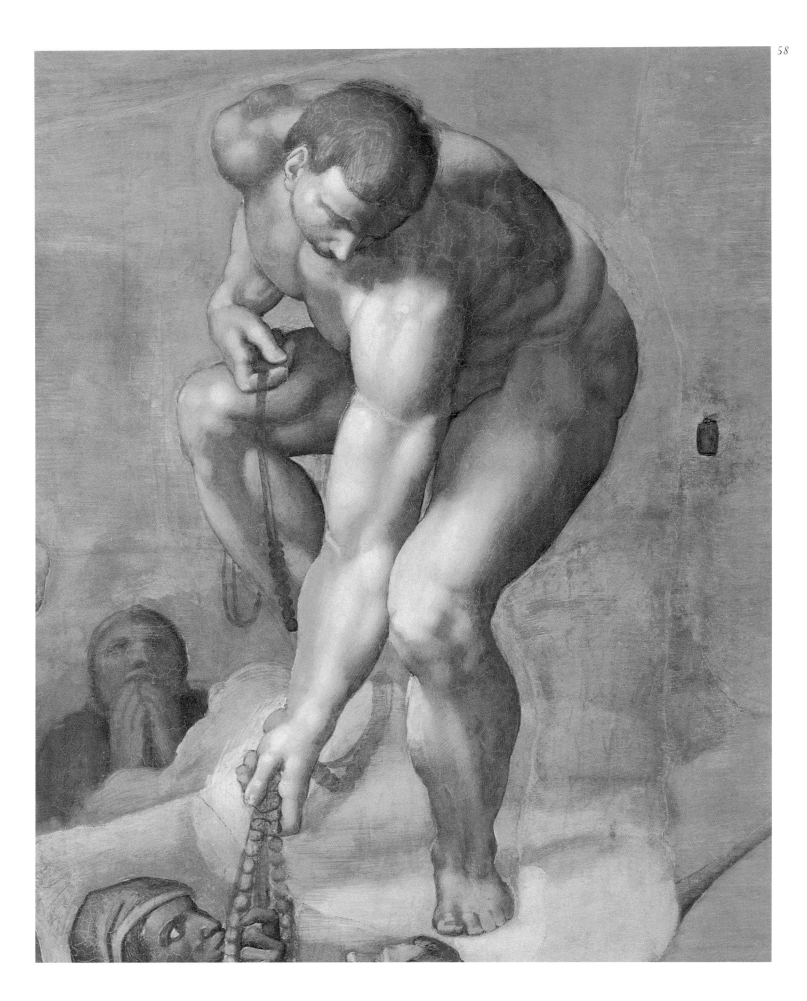

The crouching angel lifting two souls by a rope of rosary beads (pl. 58)—without precedent in earlier Last Judgment scenes—represents a virtuoso variation on the kneeling green-filleted angel (pl. 55), with whom he frames the group of ascending elect. His surpassing grace and effective aid also contrast dramatically with the grotesque deformity of the crouching devil in Hell's mouth and his futile effort to merely stand upright (pl. 16). The saved souls (pl. 59) gaze in awe and adoration at their divine rescuer, one fervently kissing the rosary, the other crossing his arms over his chest as if in thanksgiving. Together they enact the doctrine of prayer.

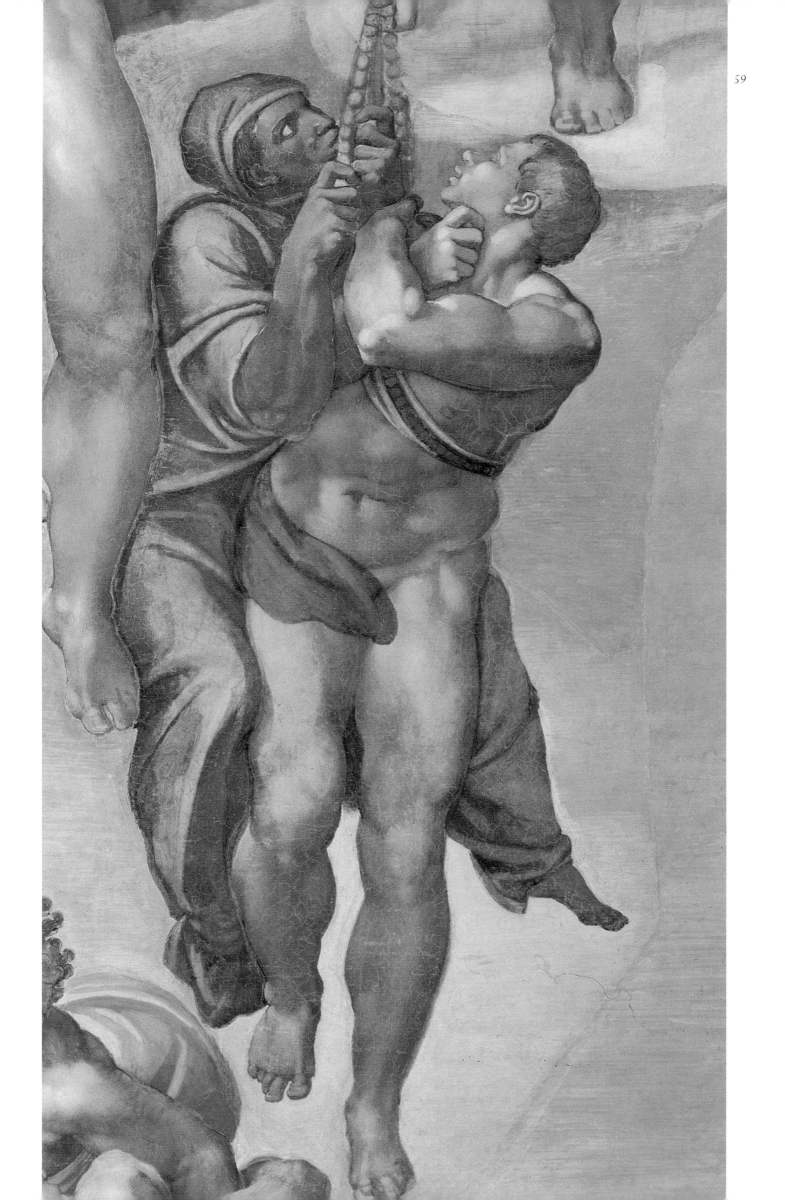

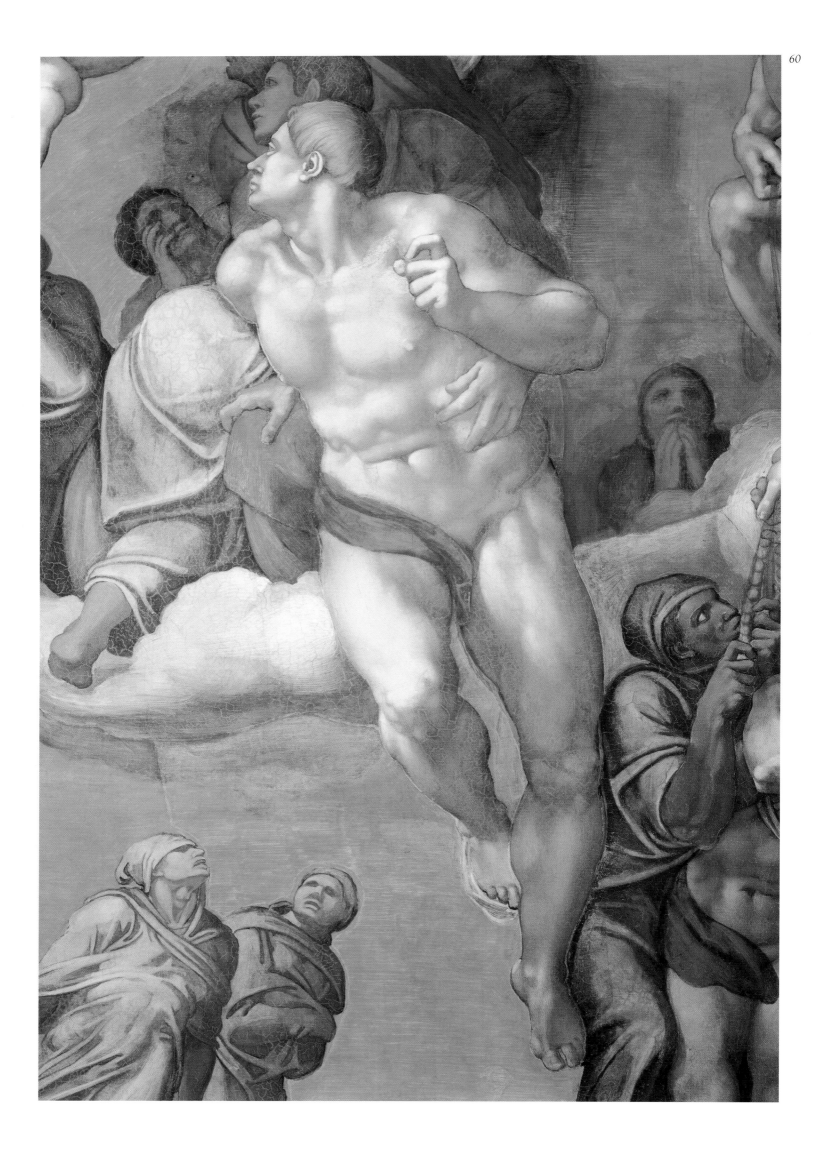

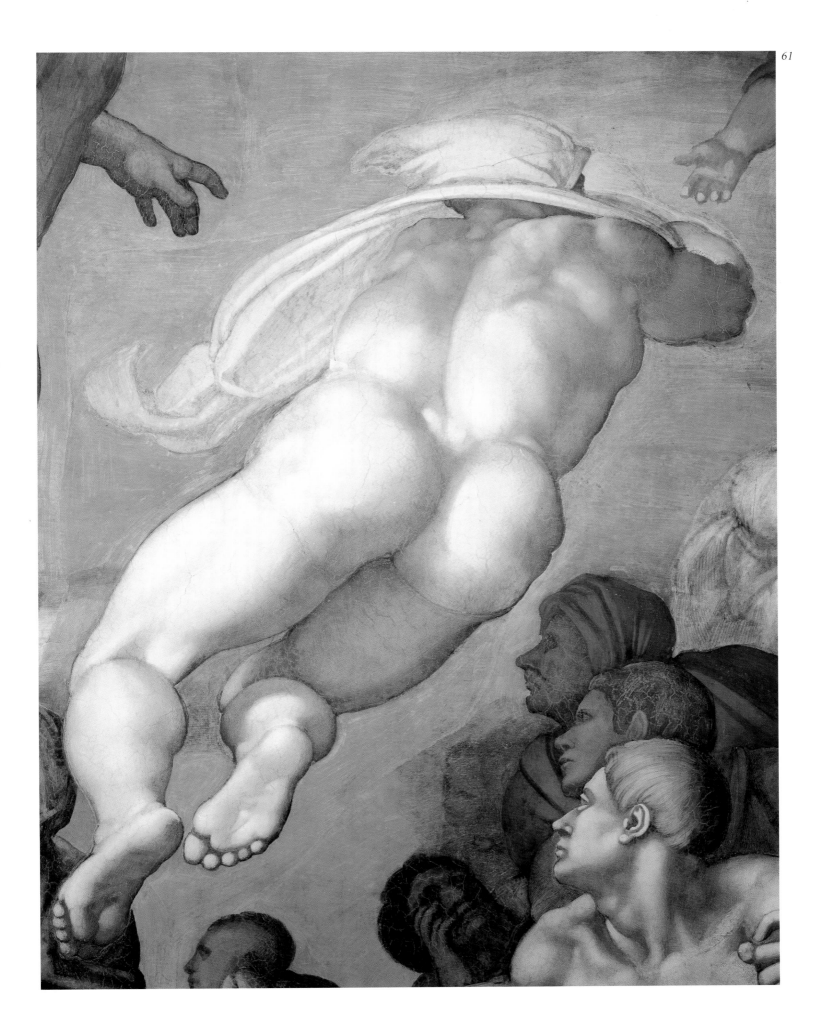

The self-motivated soul (pl. 60) contrasts sharply with his counterpart drawn diagonally upward by Christ's mystical force (pl. 61). This duo depicts the necessary intersection of human and divine wills for justification. Draperies shielding the souls' buttocks or genitals in plates 56, 59, and 60 were added after Michelangelo's death. The cloth that had covered the soul's buttocks in plate 61 was removed in the recent cleaning.

Two souls, one pointing, the other welcoming, reach over a cloud (pl. 62). Their arms indicate the diagonal vectors of Christ's energy along which other souls travel, two gliding upward with a shroud or confraternal hood covering their heads (pls. 61, 63), three others with outstretched arms kneeling on one leg and pulled chainlike toward Christ (pls. 56–57).

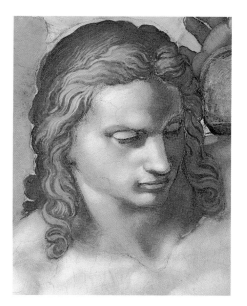

VI

MARTYRS

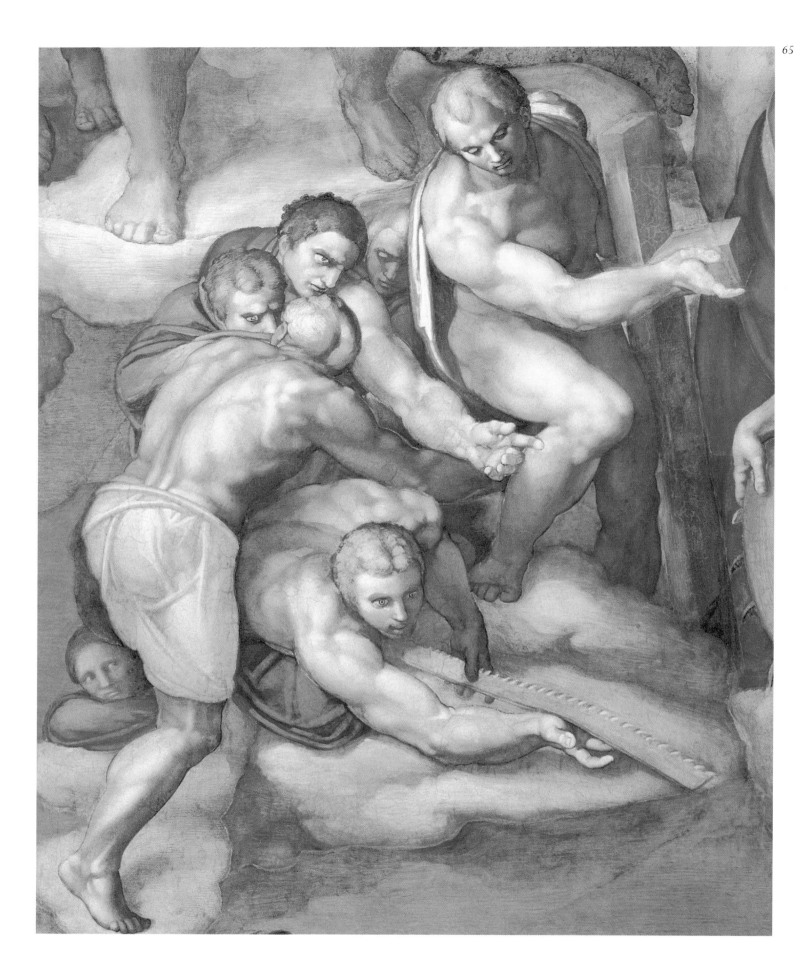

Near contemporary copies after the *Last Judgment* indicate that Michelangelo depicted St. Catherine nude and St. Blaise stooped over and looking down between his arms toward Catherine's backside. In 1565 Daniele da Volterra chiseled away Michelangelo's fresco corresponding to Catherine's green drapery and the entire figure of Blaise—including his burgundy drapery and the tufts of clouds under his armpit and behind his back—and repainted these areas *a fresco* (pl. 66). Blaise's physiognomy, the golden sheen of Catherine's drapery, and the leaden clouds are all uncharacteristic of Michelangelo's work elsewhere in the fresco. Most likely at the same time Daniele covered St. Sebastian's genitals *a secco* (pl. 67). For their efforts, Daniele and the fellow artists who followed him in adding loincloths to Michelangelo's figures were branded *braghettoni* (great underwear makers).

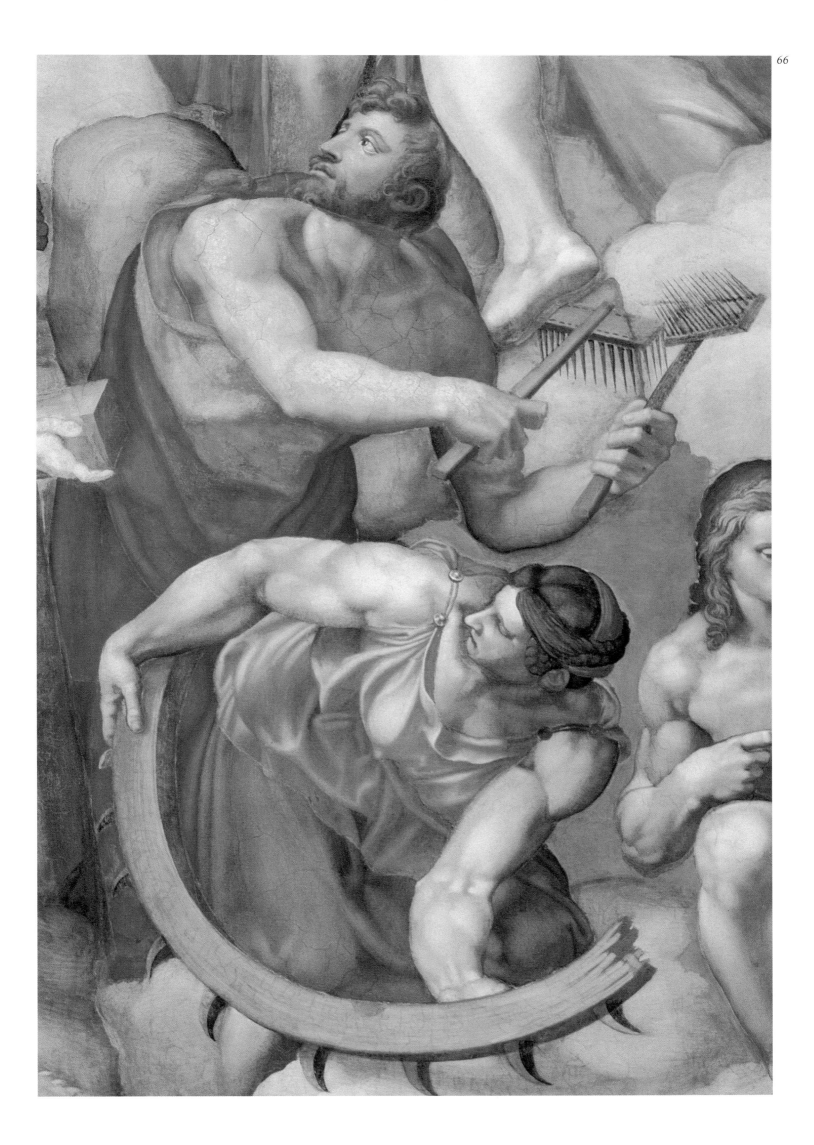

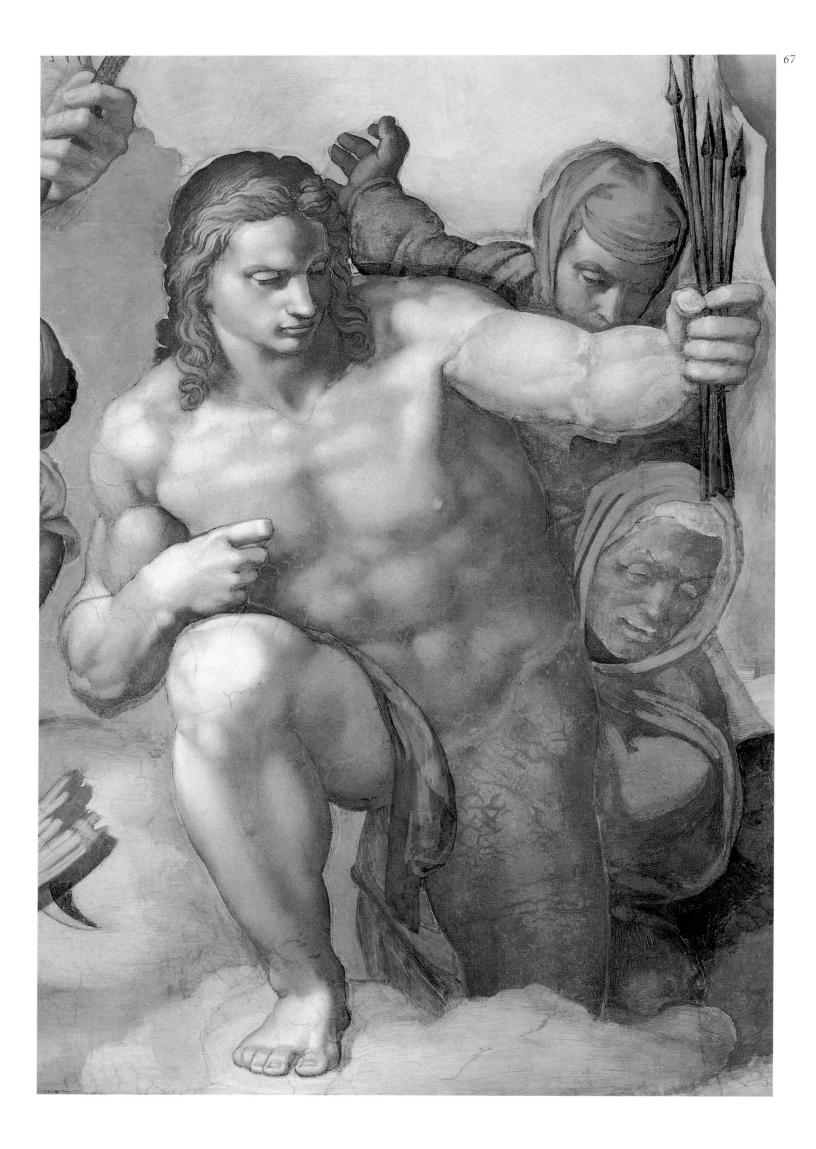

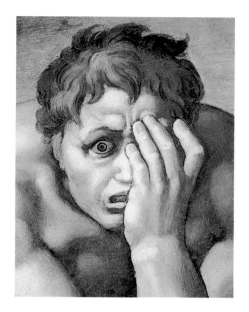

VII

DESCENDING
VICES

magnifies the burden of his vice. The devil's posture with right leg raised and left extended is a variation on that of the rear-facing ascendant nude to the left (pl. 72), but lacking the supporting cloud he suggests instead rapid descent.

Farther still to the right, a mighty, rear-facing nude insurgent—every muscle of his serpentine body knotted with effort—hangs by his right arm from the shoulder of a green-draped angel (pl. 74). He attempts in vain to protect his own face with his left hand from the kicks, shoves, and blows of his angelic opponent. A foreshortened angel in red, whose response to divine command is indicated by the direct alignment of his swooping descent with Christ's raised hand, backs up his aggressive companion (pl. 74).

Two demons, one scowling up toward Christ—below the red-draped angel and to the right of the personification of avarice—also respond to Christ's power (pl. 75). With their outstretched arms they direct downward toward hellfire a shrouded soul whose clasped hands raised to his bandaged forehead suggest regret and remorse.

At the extreme upper right, a lavender-draped angel drubs a condemned soul while his upended victim—draped buttocks skied, bent double over the angel's extended left arm—looks out between his legs wide-eyed and mortified, his mouth contorted into a howl (pl. 76). Two terror-stricken malcontents just below echo and amplify this damned soul's distress.

The most prominent gnashes his fist to stifle his suffering as his pain-splayed right hand gropes at his buttocks to reach the source of his agony—a tremendous tug on his testicles by a hefty demon (pl. 76). This tormentor (pl. 77) hangs at a strong angle from the sinner's scrotum with the full weight of his dense reddish body precipitating his victim toward the hellfire, at which he stares with a horned and flaming head. If punishment fit the sin, as was commonly believed, Michelangelo surely intended this doomed soul to personify lust.

Just above the testicle-tugger's flame-lapped pate, another head peers into the abyss (pl. 77). Its portrait-like character has led one scholar to suggest, probably correctly, that this (not Minos just below, as usually assumed) is a likeness of the aged Biagio da Cesena (1463–1544), Paul III's master of ceremonies, who, according to Vasari, Michelangelo painted Hell-bound for objecting to the scene's nudity. Here we have one of the earliest records of Counter-Reformation criticism that eventually led to the draping of a large number of nudes with loincloths.

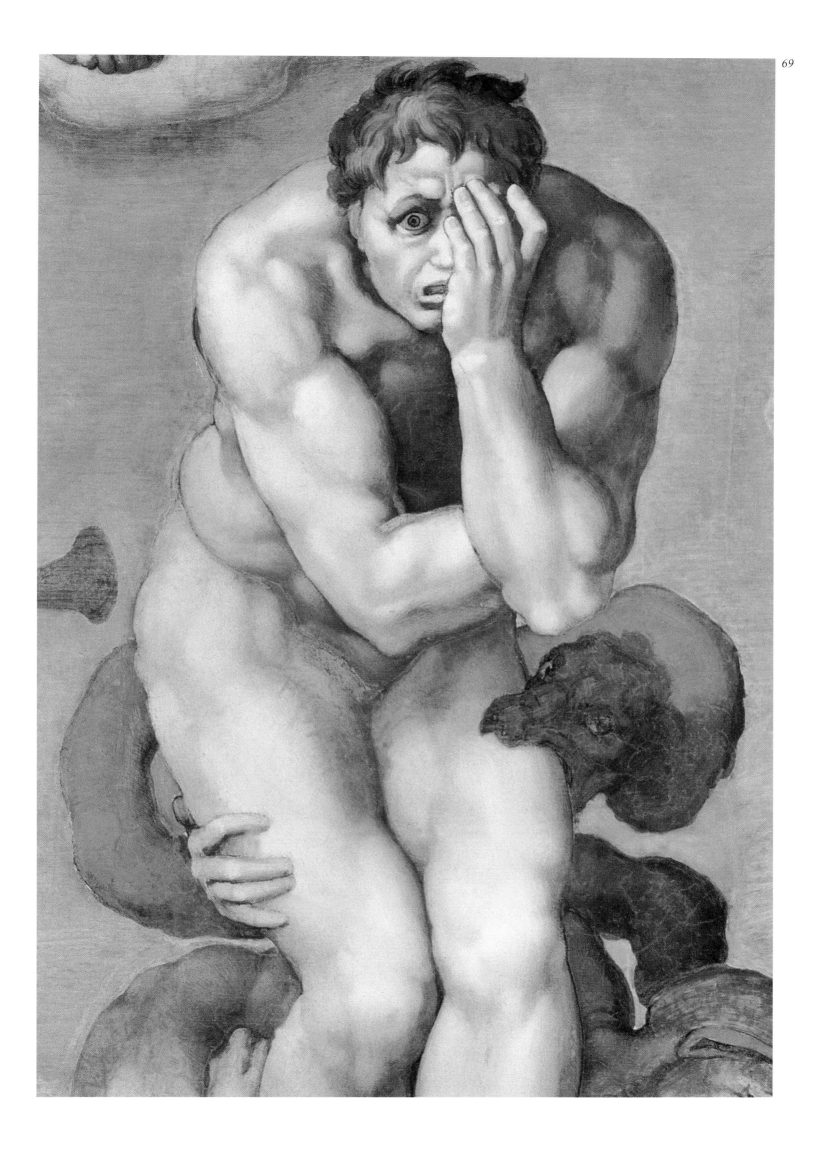

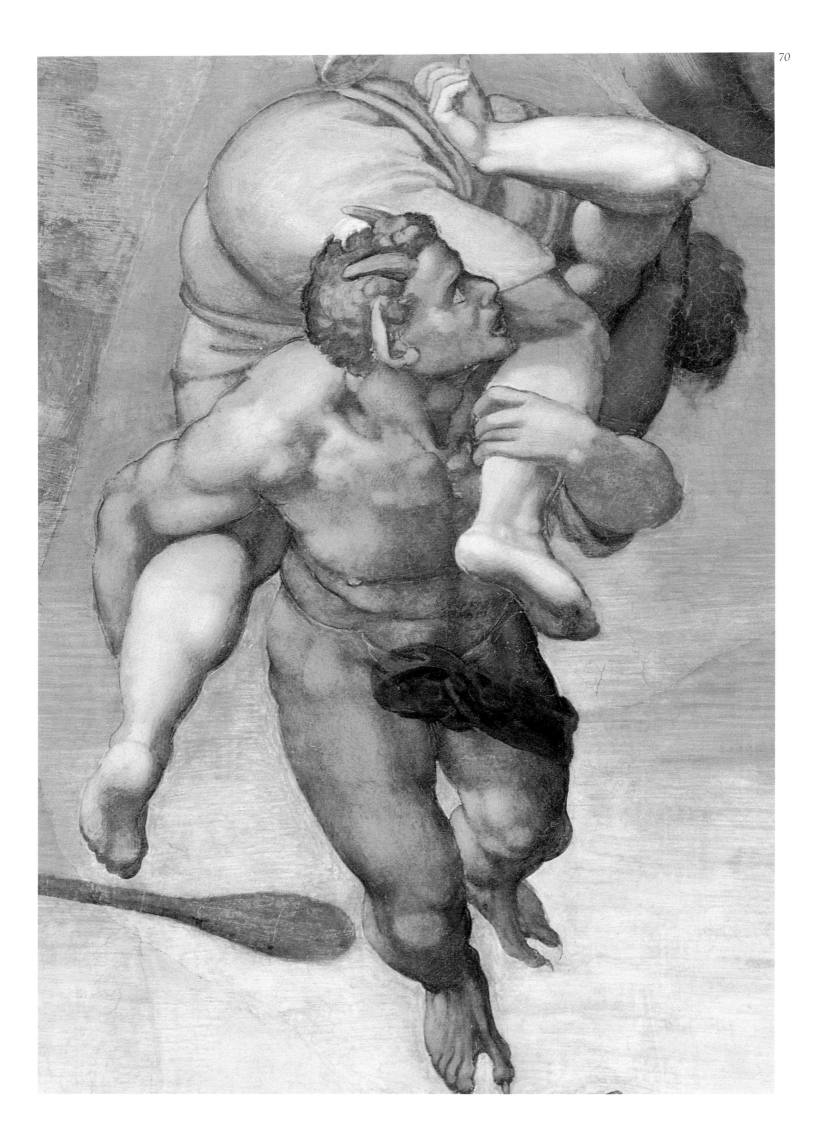

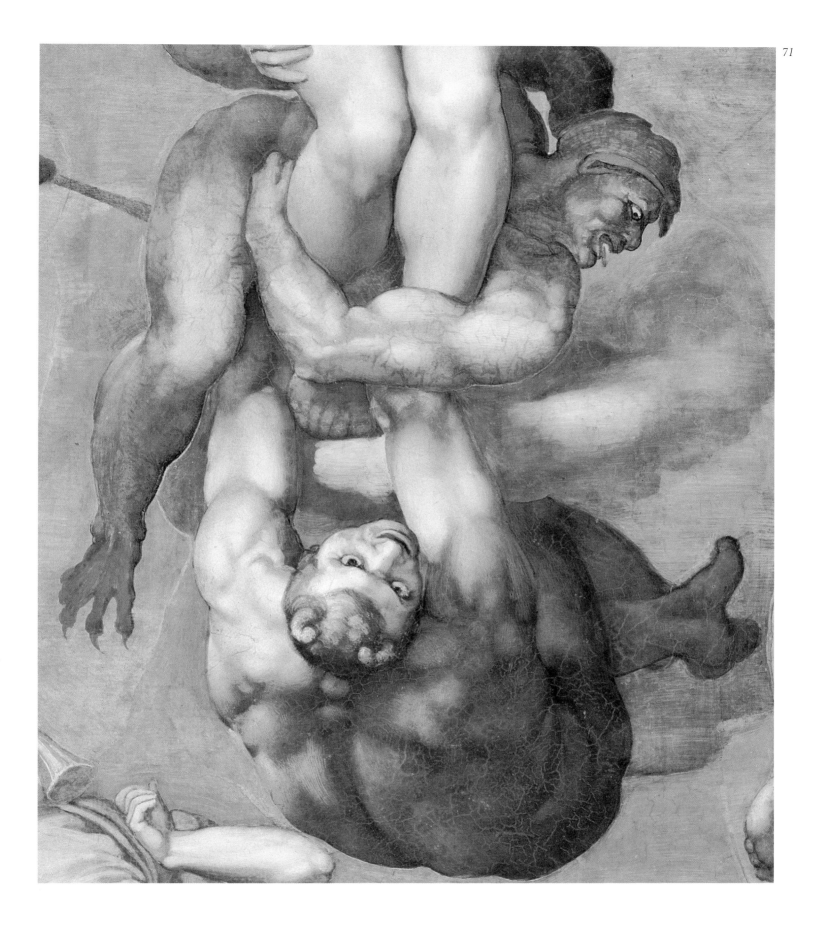

The damned soul sinking to Hell under the weight of a serpent and two demons—his loincloth now removed—remains one of Michelangelo's most gripping images (pl. 69). He hunches over in an awkward self-embrace, covering half his face with his left hand. As a green serpent chomps his thigh, his knit brow, gaping but unseeing eye, and down-turned mouth register utter horror at his fate, his misery heightened by an awkward posture that is neither sitting nor standing. His total passivity suggests that he embodies sins of omission or failure to exercise moral responsibility through inaction. Michelangelo may have intended to suggest more specifically that, unlike the martyrs just above him, this lost soul failed to imitate the self-sacrifice of Christ to expiate his sins, for the demons who grip his legs (pl. 71) monstrously parody the two angels holding the lower half of the cross in the lunette above (pls. 33–34). The devil with the blood-soaked clawed foot, sticking out his tongue gazes toward Hell's fire, the soul's ultimate destination.

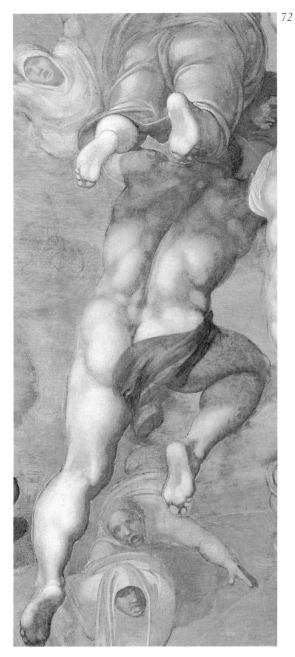

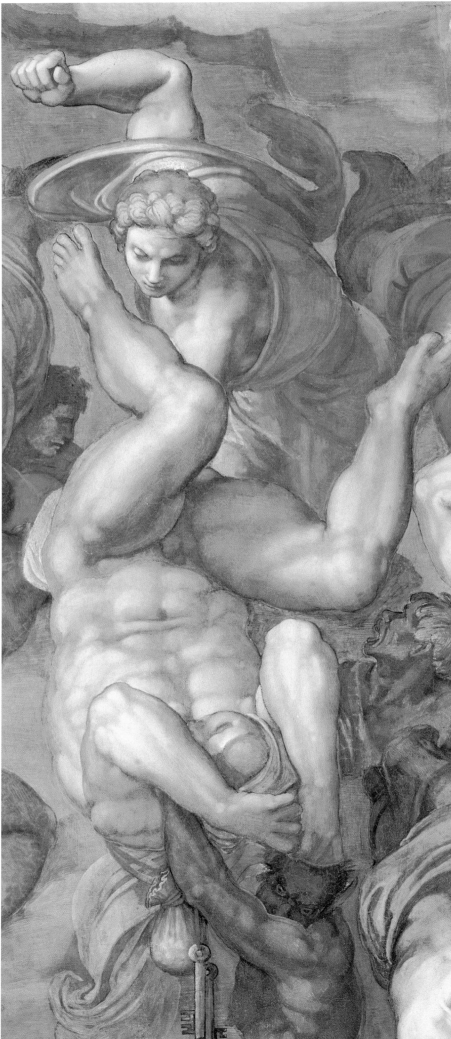

The gold coin bag and treasure-chest keys hanging
by a cord from the neck and shoulders of one sinner
(pl. 73)—his loincloth was removed during the recent
cleaning—symbolize avarice. Here for the first time in
Last Judgment representations Michelangelo trans-
formed medieval scenes of struggles between the vices
and virtues into an all-out battle between angels and
sinners, the sinners' aggression a sign of sins of com-
mission. The left sinner (pl. 72) kneels on a cloud and
lifts himself heavenward, but is stopped by the green-
draped angel hovering above. Another sinner (pl. 74)
clings mightily to the shoulder of the angel in green
who kicks, shoves, and beats him in the face.
Diagonally aligned with Christ, another angel (in red)
swoops down to assist in driving back this Herculean
challenger. The buttocks of both of the condemned
were covered after Michelangelo's death.

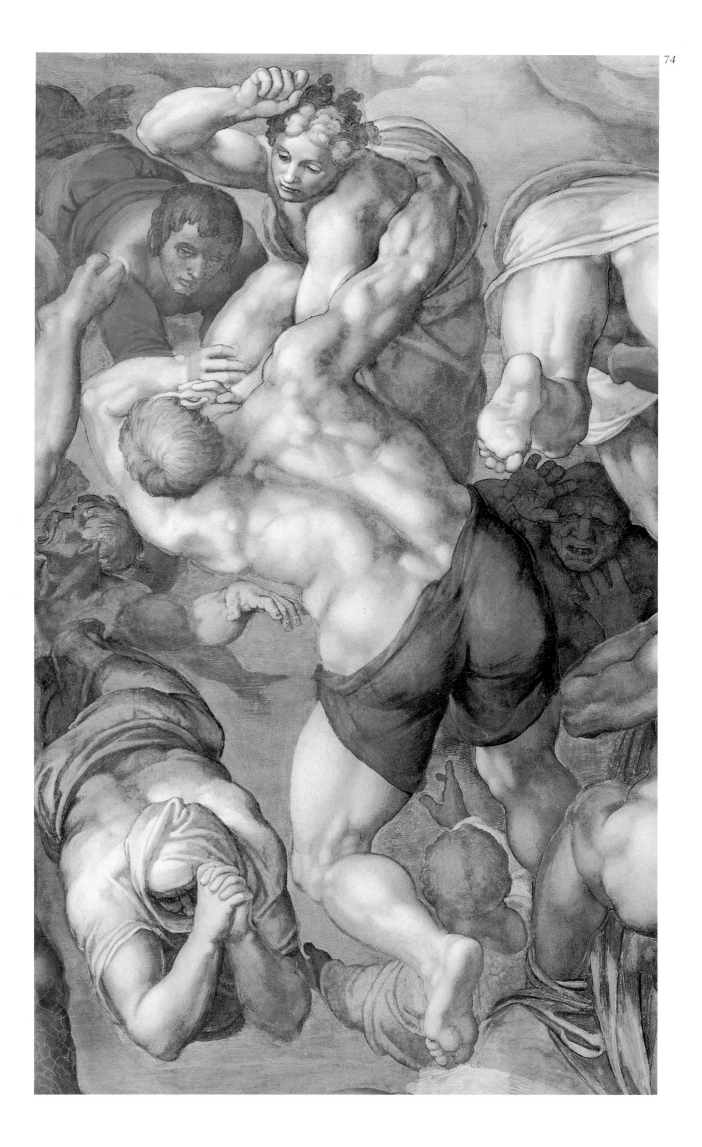

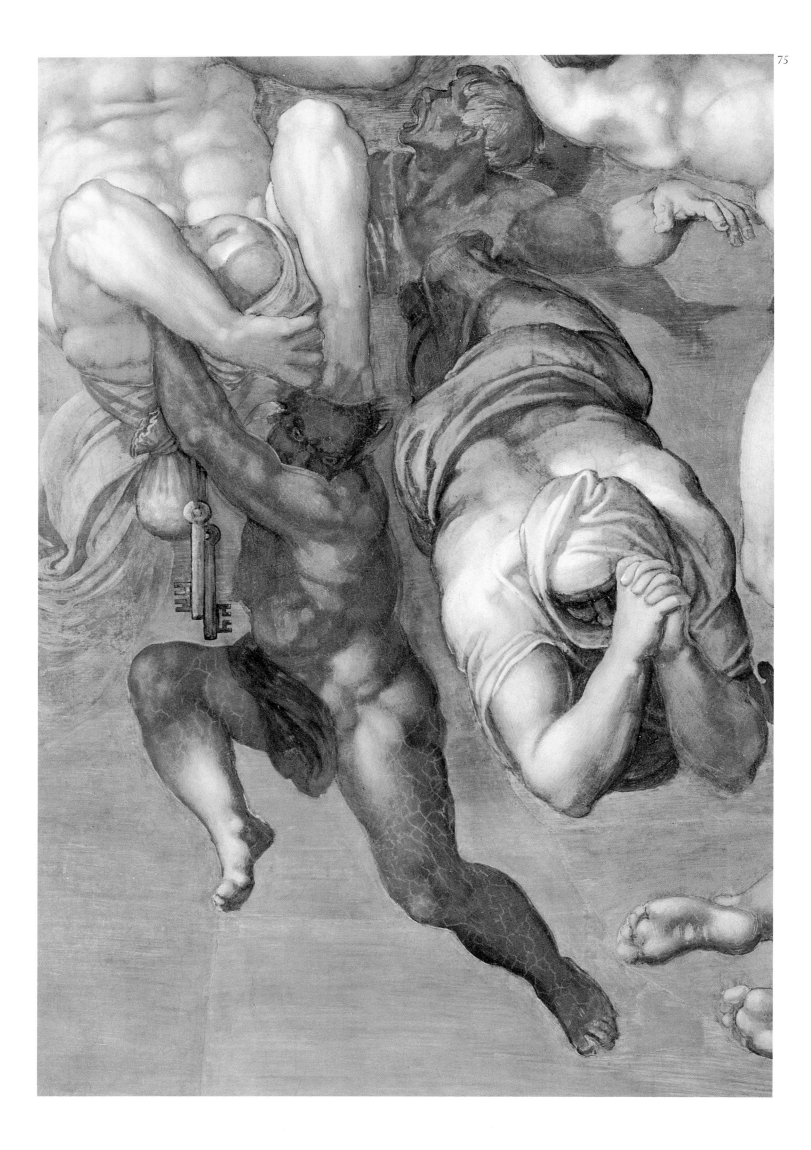

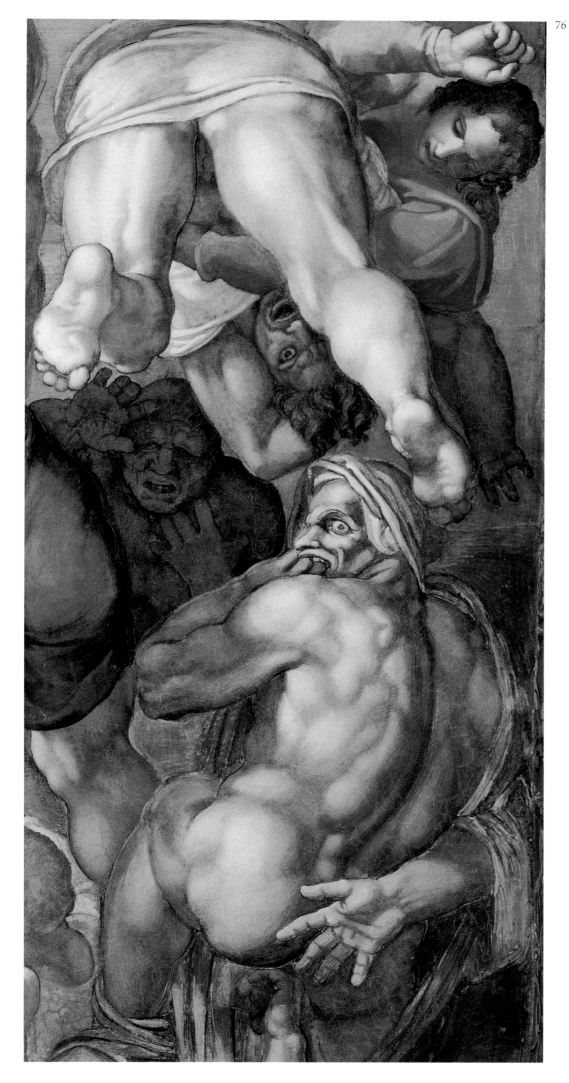

Draped over the arm of an angel who pummels him, a lost soul looks out from between his legs—his upside-down face contorted into a howl of fear (pl. 76). The damned soul just below, who surely personifies the deadly sin of lust, bites his fist to stifle the pain of a sharp tug on his testicles, which he gropes for with his splayed right hand.

The athletic demon's sheer muscularity and density visually intensify the misery of the lost soul whose scrotum he yanks (pl. 77). As this ruddy devil approaches Hell's fires, with his tail tucked between his legs, his horned head bursts into flames. The head just above may be that of Biagio da Cesena, who, according to Vasari, was depicted by Michelangelo as destined for Hell for having complained about the scene's nudity—an early foretaste of widespread negative reaction to the fresco. The work was spared destruction only by the addition of many draperies to cover offending body parts, of which the cloth covering the buttocks of the testicle tugger and the loins of two of his companions (pls. 70, 75) are prominent examples. With utmost economy of means Michelangelo captured the essence of despair by the gesture and expression of the shrouded soul in plate 78.

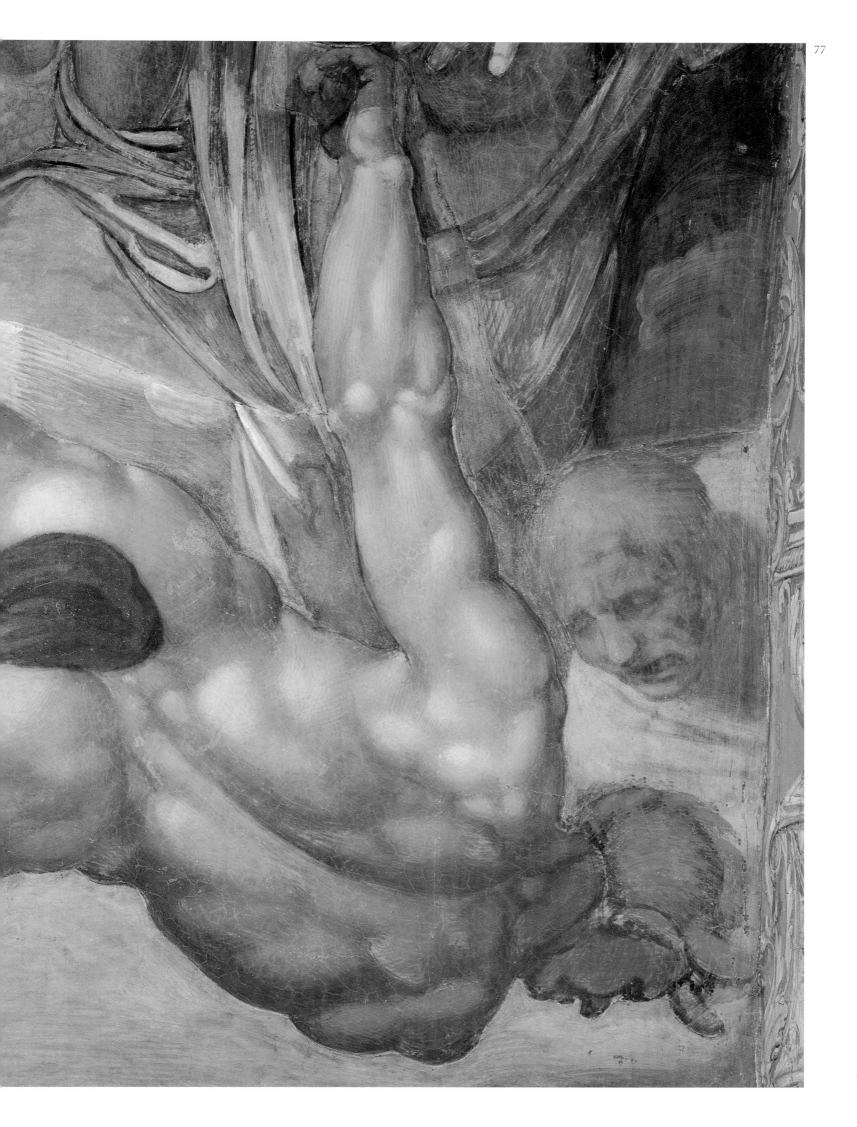

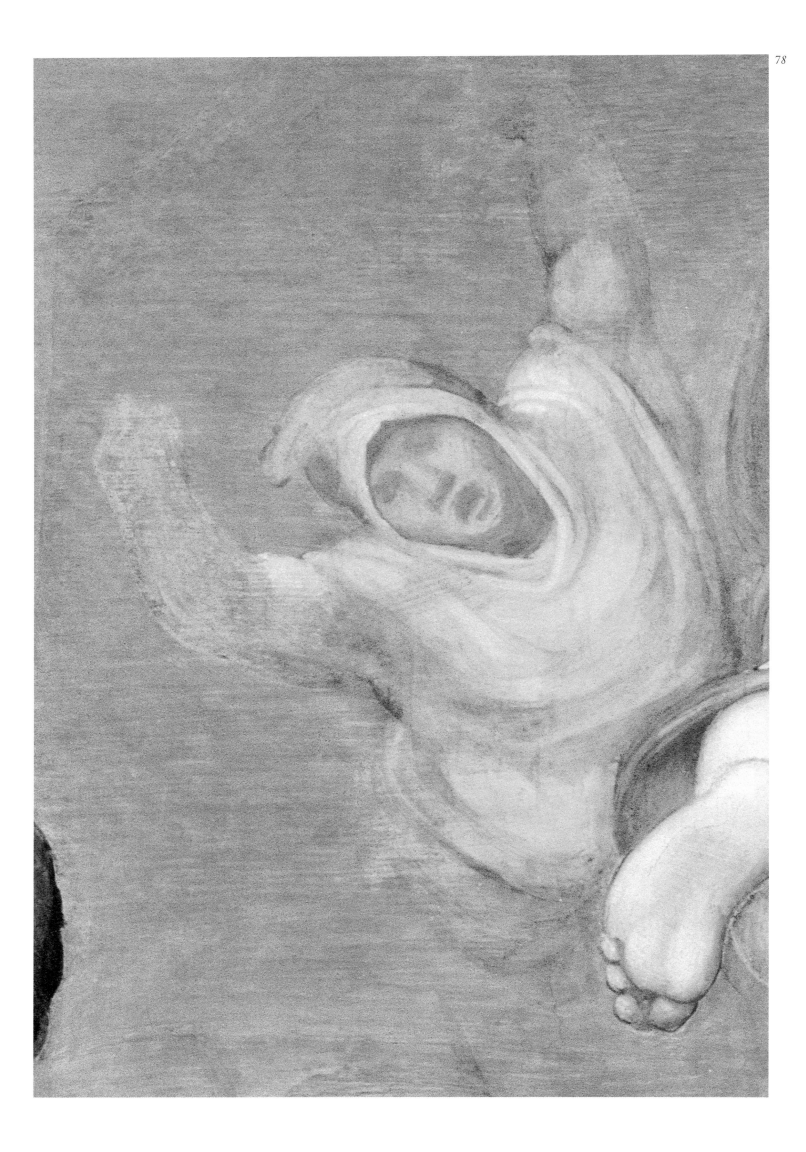

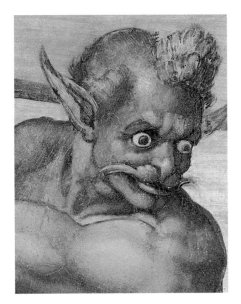

VIII

BOAT OF
CHARON
AND THE
DAMNED
WITH MINOS

Charon, the demon, beckoning before, with eyes of glowing coal, assembles all: Whoever lags, he beats him with his oar. . . .
Thus are they borne across the water dun; and ere they disembark on the far strand, on this another gathering is begun.

(Dante, *Inferno* 3:109–20)

There Minos, hideously grinning, sits, inspects the offenses at the entering in, judges and, as he girds himself, commits. . . .
Round him as many times his tail doth throw, as the degrees he wills that it should fall.

(Dante, *Inferno* 5:4–12)

THE GLOOMY gray group of the damned— the rapacious fire from Hell its only source of illumination—is again divided into two subgroups, one featuring Charon and the other Minos— two mythical figures derived from Dante's *Inferno*, which Michelangelo loved and, it was said by contemporaries, had mostly memorized (pl. 79). Similar to Signorelli, who represented these same two figures in the San Brizio Chapel in Orvieto (fig. 12), Michelangelo claimed by these references the intellectual and social status of a liberal arts practitioner. He also claimed for himself the poetic imagination of Dante and for his *Last Judgment* the epic stature of the *Divine Comedy*. Such literal-minded zealots of the Counter-Reformation, however, as Gilio da Fabriano, who wrote a blistering criticism of Michelangelo's *Last Judgment* in 1564, considered the inclusion of pagan figures and nonbiblical references an outrage in Christian art. Their presence in one of the most important chapels of all Christendom only intensified the critics' sense of impropriety.

The drama unfurls as Charon's winged boat arrives at Hell's shore, a poignant note of irrevocable finality indicated by the decisive separation between the boat and the left shore of embarkment where the saved are being resurrected (pl. 79). The cat-faced, seemingly demented Charon with gray-green pallor braces his right clawed foot against the gunwale, grips his oar with both hands, and whips around on the pivot of his left leg, threatening to bat the damned (pl. 80). In anticipation—and in contrast to the passivity of the damned souls immediately above—these condemned fearfully compact into a ball-like group, which forces the skiff to rise from the water. Yet, given the imminent sweep of Charon's oar toward their faces, we might expect the damned to be driven in the opposite direction.

But terror, not logic, motivates this weighty mass, and, indeed, Michelangelo has characterized most of the individual souls in various states of mental torment. One anxiously raises his right hand to ward off Charon's impending blow (pl. 81). Another crouches in sudden wide-eyed recognition of the menacing horror while raising his hands to ear and cheek as if refusing to acknowledge the truth (pl. 84). Yet another pounds his fists against his shrouded head in belated remorse for his sins (pl. 81). And still another—precariously straddling the gunwale just ahead of the boat's wing—tests the water with his right toes as he wavers tremulously between clinging to the boat with his companions or boldly stepping ashore to accept his fate (pl. 85).

The pent-up energy of the Charon subgroup releases toward Minos at the point where the seemingly unconscious soul is hauled over the gunwale and dragged ashore feet first by a kneeling devil nibbling at his victim's calf (pls. 82, 91). To the right another mammoth muscular soul, desperately trying to disengage a hook around his neck, is wrenched headfirst out of the boat

by a demon with a cockscomb of sorts (pls. 82–83). A companion all the while clutches his legs and struggles in vain to anchor him in the boat (pl. 82). Farther to the right, a V-shaped trio of impassive nudes pitches headlong out of the boat as a pair of demons assists gravity by yanking with all their might on a grappling hook (pls. 82–83). Their victim is forced by the hook into a poorly executed jackknife, fast deteriorating into a belly flop on top of a demon lying in wait with eager, outstretched arms onshore. With a grimace of pained resignation, his companion to the left slumps into an

from reclining to kneeling to standing (pls. 83, 86, 90, 92). Rising diagonally toward Minos, these wretched minions magnify his perverted power and visually counterbalance the graceful angels besting the vices and amplifying Christ's majesty (pl. 68). The angels, however, execute Christ's will freely from spiritual platforms in the sky, while the devils' power always remains circumscribed by the earth's gravity, created by and subject to divine will.

The Prince of Hades (pl. 92) is traditionally referred to as Minos, for he recalls Dante's description in the

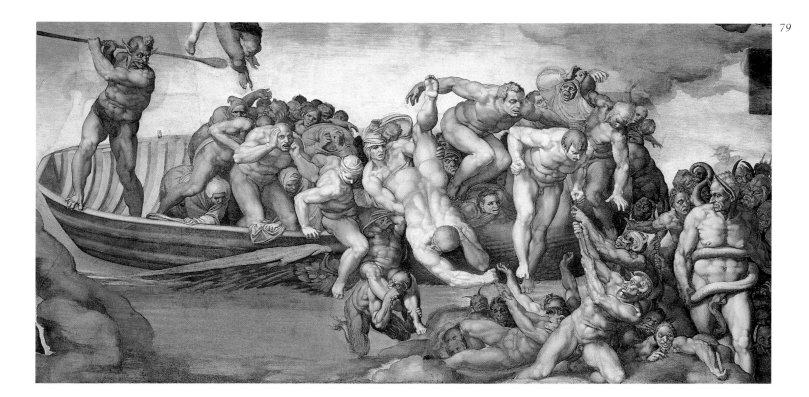

awkward swan dive. The third, to the right, leans into an ungainly cartwheel, his fall visually completed by the soul just behind, whom a demon, delivering a sharp neck-wrenching jerk with his hook, pulls headfirst over the boat's prow. Although we can all but hear the gray-shrouded soul above this threesome shriek in despair (pl. 87), in general these particular souls appear relatively unemotional and unthinking, as if buffeted by demonic forces beyond their control (pls. 82–83, 87–89). By contrast the descending vices just above struggle powerfully against their fate (pl. 68).

On Hell's shore grotesquely deformed, leering, skull-biting demons writhe in a crescendo of postures

Inferno of the classical judge of the underworld who indicated by the number of loops of his serpentlike tail the circle of Hell to which each soul was consigned. But the serpent coiled around Michelangelo's massive, muscular, and graceless monster does not form part of his anatomy. We can understand him equally well, then, as Minos' biblical equivalent, Satan or the Devil, the proud leader of the fallen angels who attempted to overthrow Christ. Compared to Christ in his majesty, omniscience, and omnipotence, however, Minos/Satan appears pitifully small, his ass ears and stupor signaling ignorance and sloth. Rather than Christ's solace, he offers scorn and disdain, his upper lip curled savagely

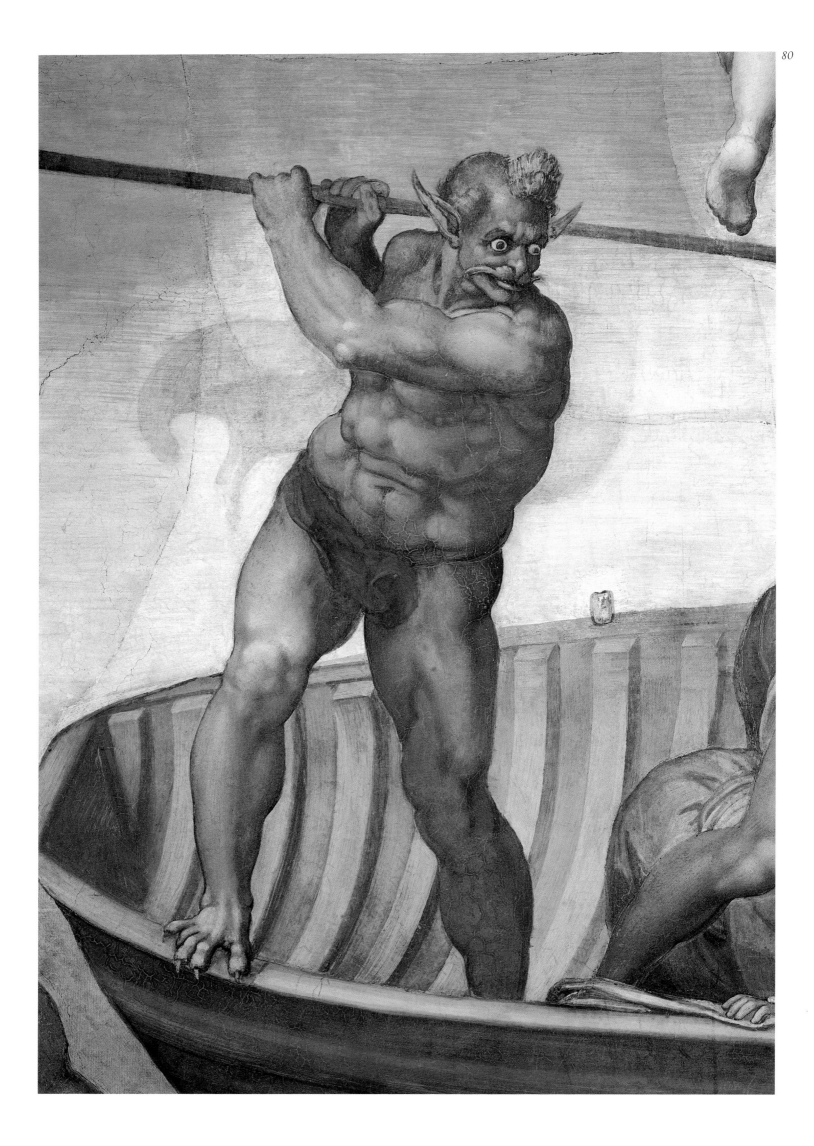

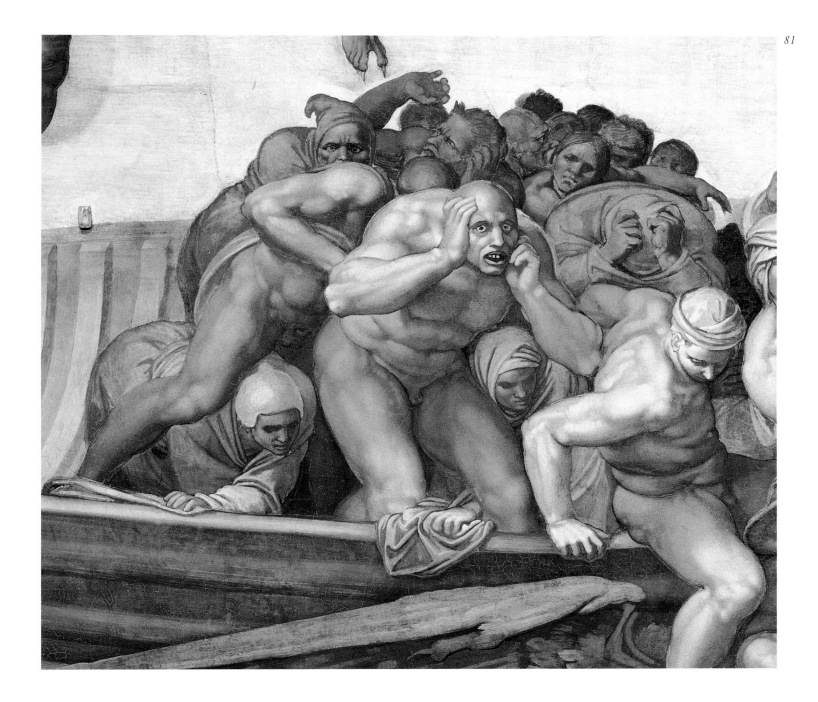

over his canine tooth. His sagging, serpent-coiled dugs—as sterile as they are unnatural—serve as sad substitutes for Christ's fecundity. But, most dramatically, in place of Christ's love for humankind, expressed by the attractive force of his hands, Satan—mesmerized by his own sexual gratification—steadies with his right hand a caressing snake performing a perverted act of poisoned fellatio.

The saga, however, does not end here. In response to the anxious devil with cauliflowerlike head who gestures behind him to the boatload of condemned souls, Satan points with this left hand back in the opposite direction to the hellfire—their ultimate destination (pl. 92). By this gesture, which conforms to the general

downward movement on the fresco's right side, the embodiment of total and utter evil betrays that even he is subject to predetermined divine will that moves and controls the entire drama.

The implosive subgroup toward the boat's stern (pl. 81) and the more explosive one toward the prow (pls. 82–83) suggest a contrast between a mental and physical experience of the torments of Hell, between a willed and unwilled entrapment by sin. As a whole the group of damned constitutes the negative counterpart to the resurrecting souls opposite (pl. 40), where, as we have seen, one subgroup is saved by, and the other actively collaborates with, divine grace.

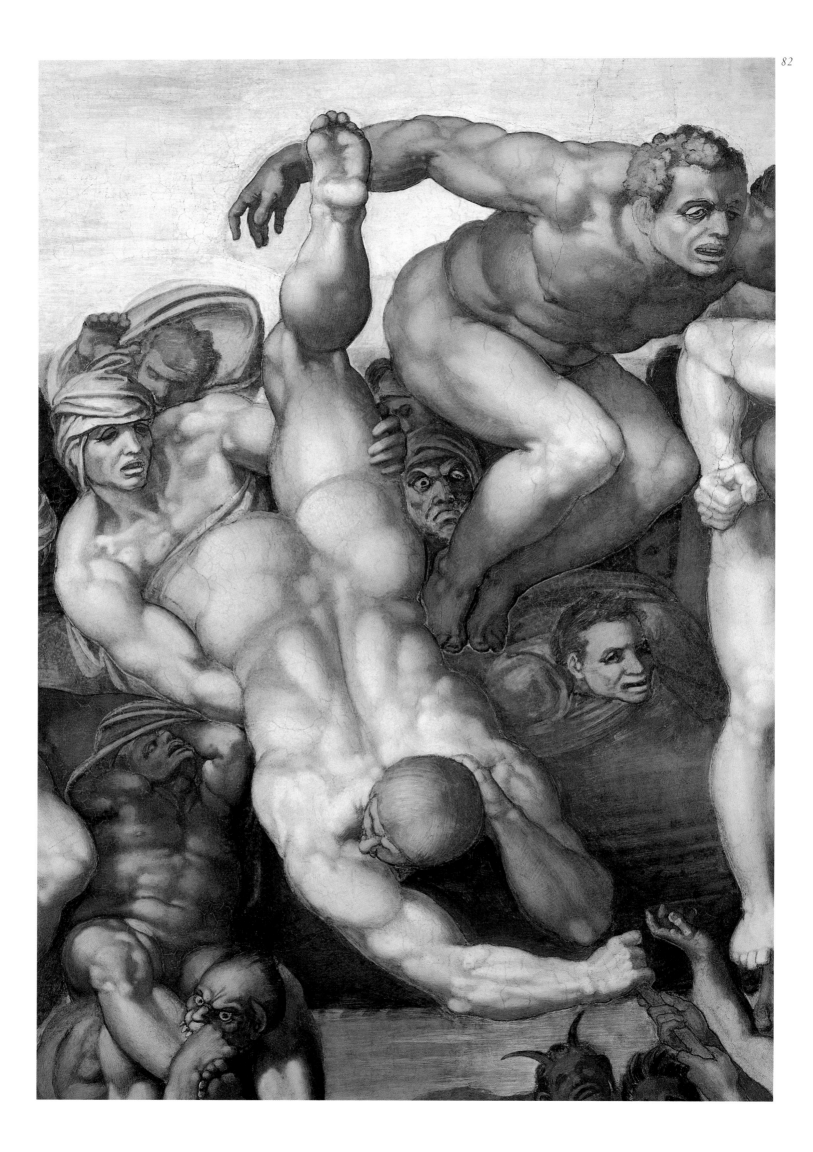

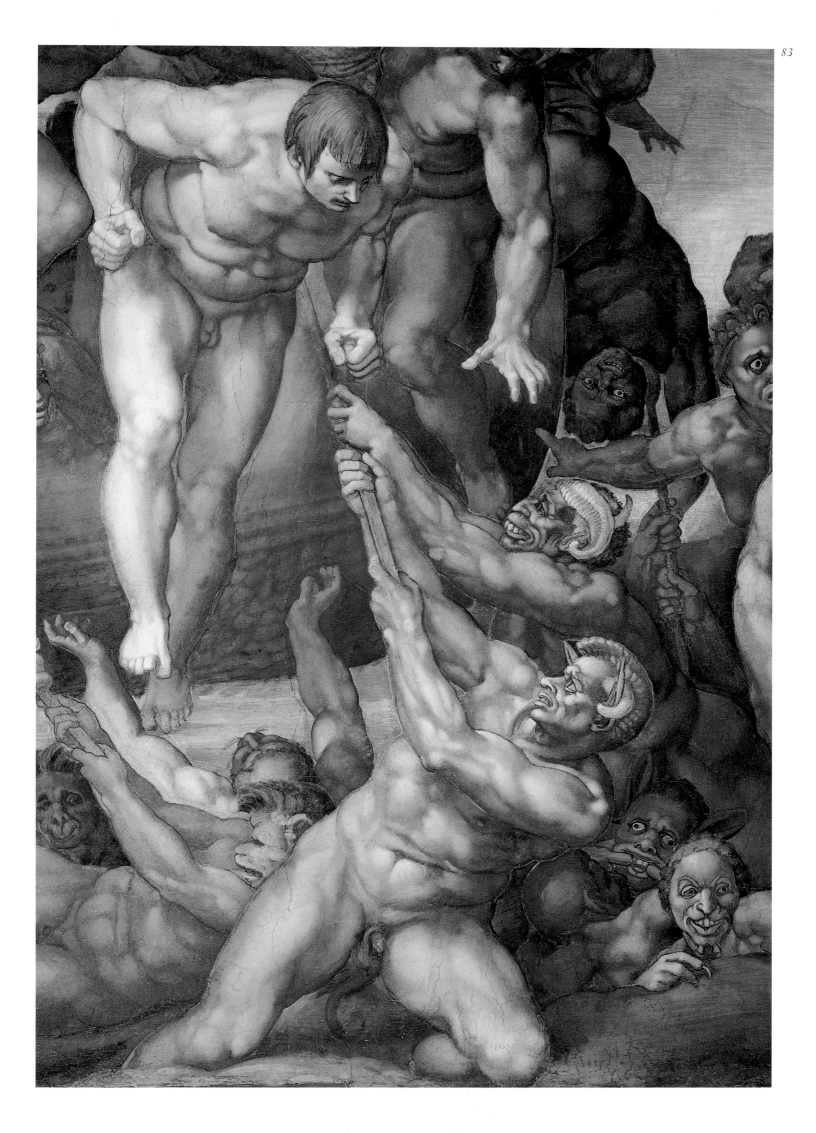

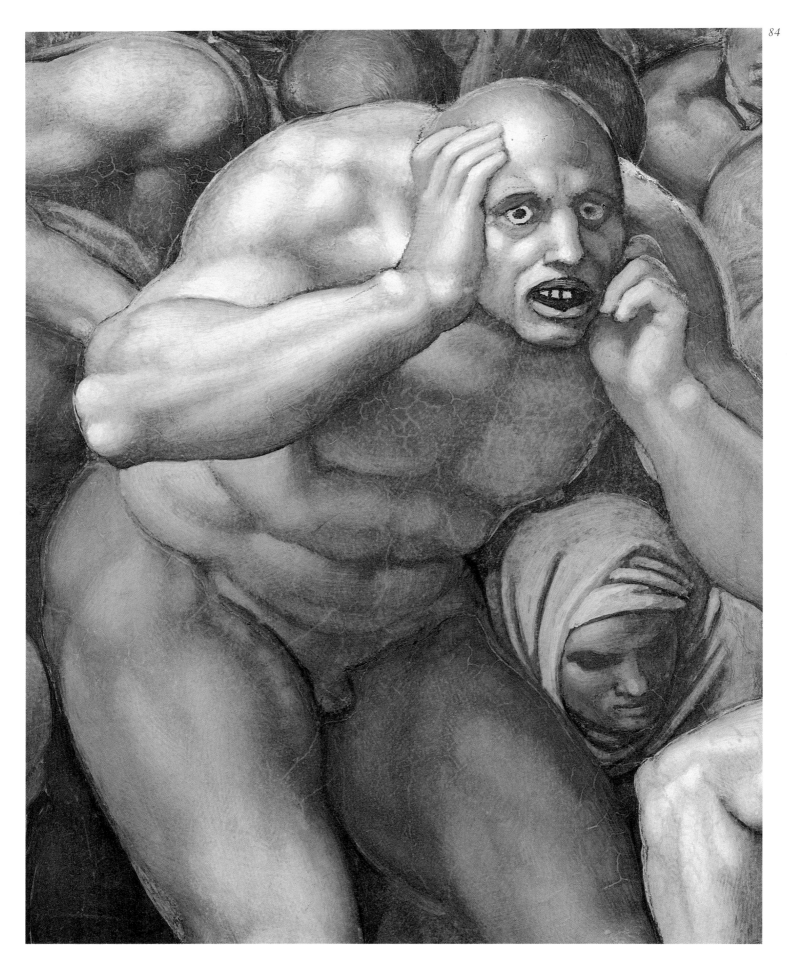

Michelangelo's depiction of Charon (pl. 80) and Minos (pl. 92)—figures from classical mythology inspired by Dante's *Divine Comedy*—opened the artist to attack by Counter-Reformation critics, who objected to nonbiblical subject matter appearing in what was arguably the most important chapel of Christendom. Charon's loincloth was one result of the critics' clamor.

Placing his hands on ear and cheek as if to emphasize hearing and touch, the pop-eyed, openmouthed bald nude (pl. 84) expresses disbelief at what his five senses register. His companion straddling the boat's gunwale (pl. 85) tests the water with his toe, yet hesitates to accept his fate.

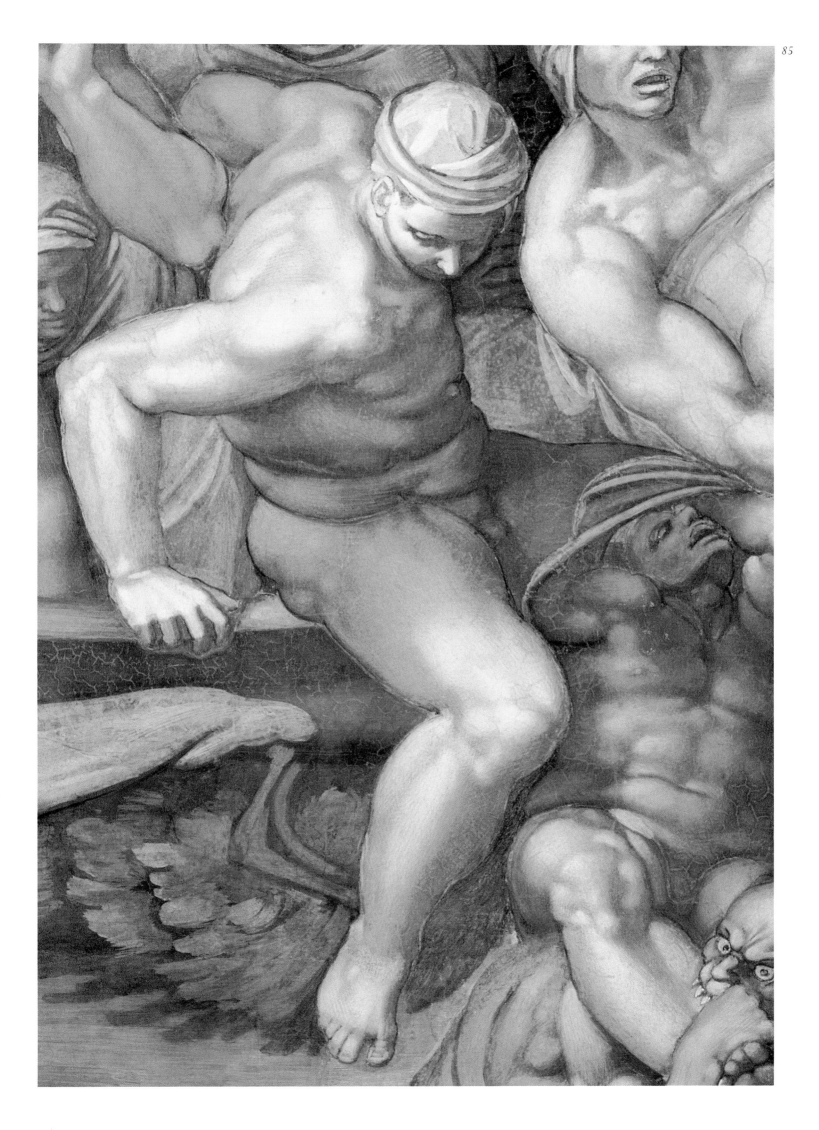

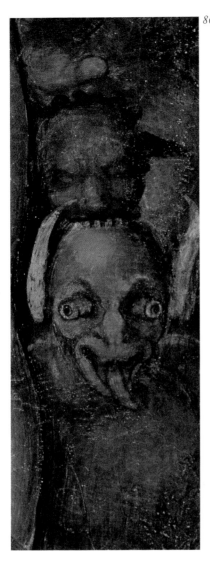

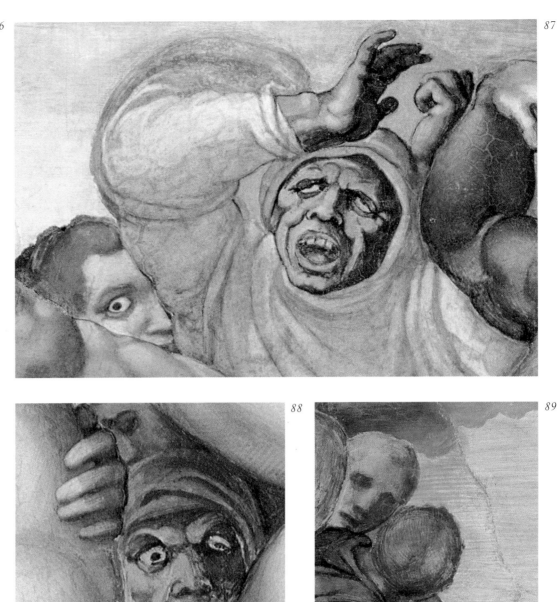

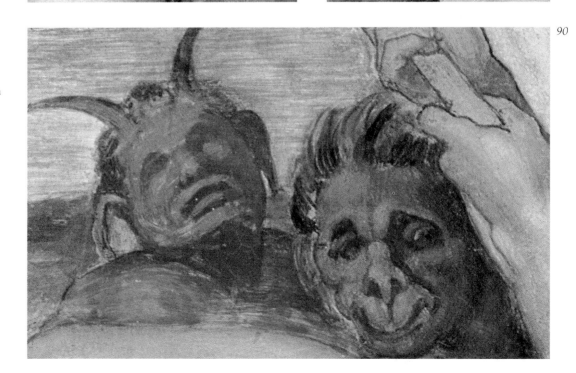

Amplifying the power of Minos, whom they serve, the grotesquely deformed devils jeer, leer, and bite—even each other—while others grapple the damned souls with hooks, yanking them headlong over the side of Charon's barque. The condemned souls' expressions range from anger, denial, remorse, and terror to shrieking despair. The genitals and buttocks of five damned and four demons, including Minos, are now exposed (pls. 81–85, 91–92), their post-sixteenth-century coverings having been removed in the recent cleaning.

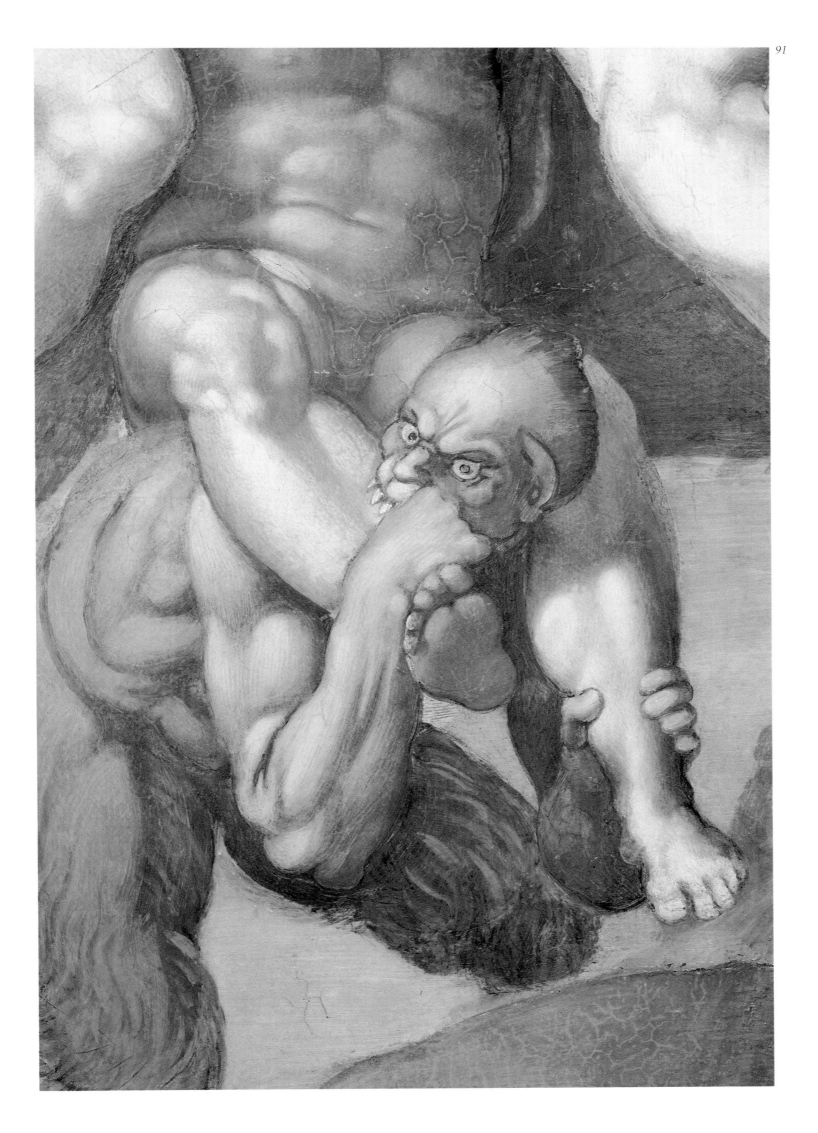

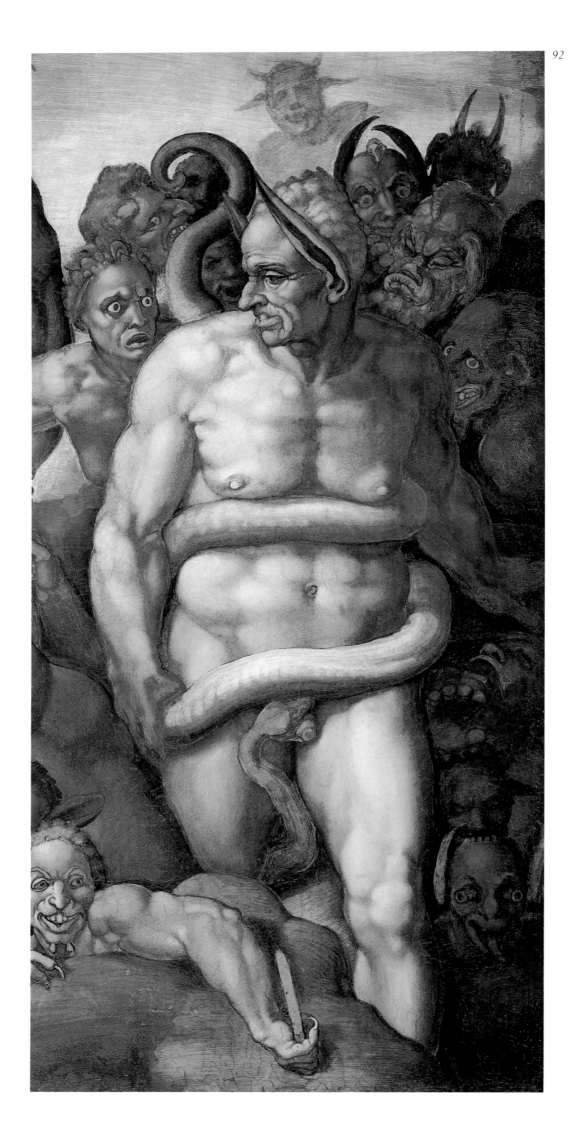

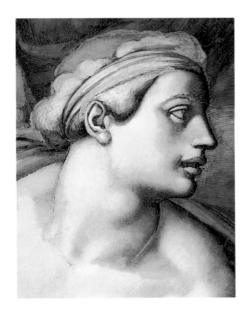

IX

THE ELECT:
"ECCLESIA" GROUP
TO THE LEFT,
"DISMAS" GROUP
TO THE RIGHT,
SAINTS AROUND CHRIST

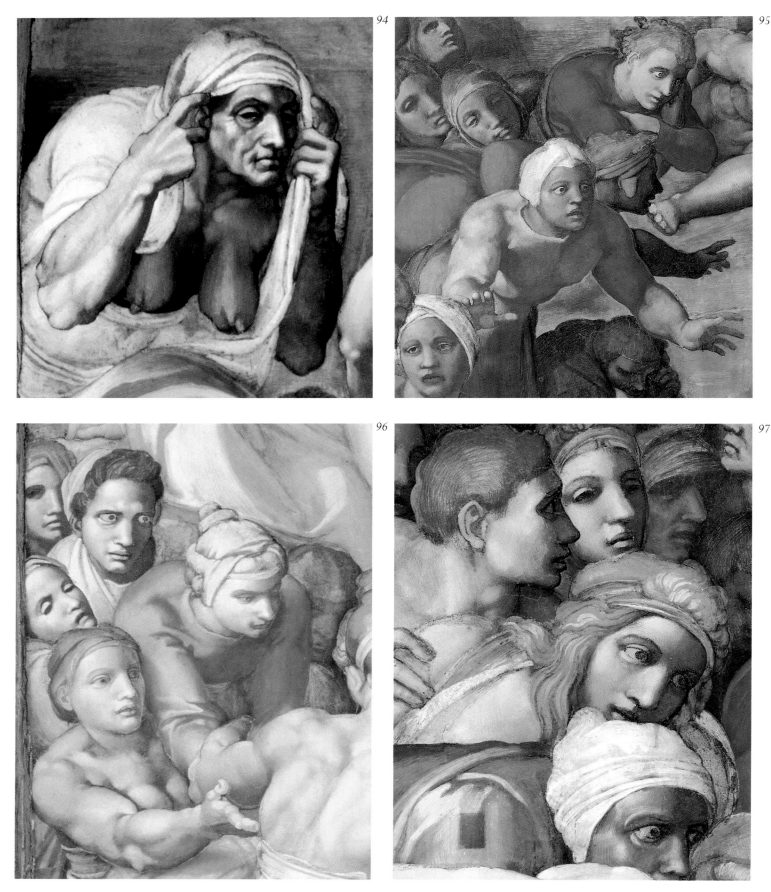

Women constitute the majority of the elect in this group, a privileged position without precedent in Last Judgment representation. Michelangelo represented most of the souls in the back row (pls. 93–95, 97–98) as relatively small, quizzical, isolated, or awkward. One woman is elderly, her infertile, desiccated breasts pendent between the white veil she holds over her head (pl. 94). The women in the second row (pl. 99) are still somewhat inarticulate, but larger, more mature, posed in stronger torsion, and interconnected by gaze and gesture. Michelangelo depicted the women in the next row (pls. 96, 100) as larger still and far more muscular, powerfully twisting and leaning to affectionately embrace one another. The group climaxes in a woman of striking scale, potency, and purpose focused on Christ (pl. 101). Reading diagonally from the elderly woman to this amazon reveals a crescendo of corporeal grace and autonomy by which Michelangelo visually expressed the process of the soul's transformation from the imprint of material imperfection to spiritual perfection. The nude woman leaning forward in an ungainly manner to speak to her companion (pl. 99) once held a swatch of drapery (now removed) between her hands to cover her pudenda.

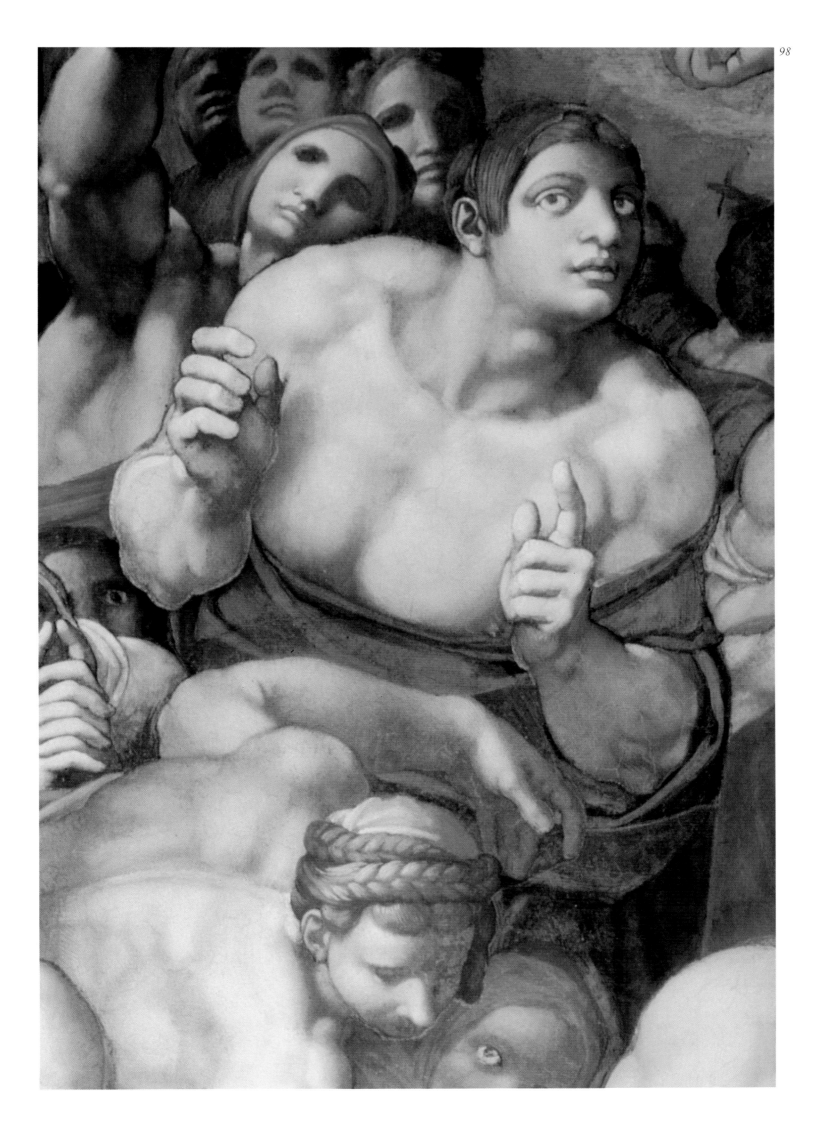

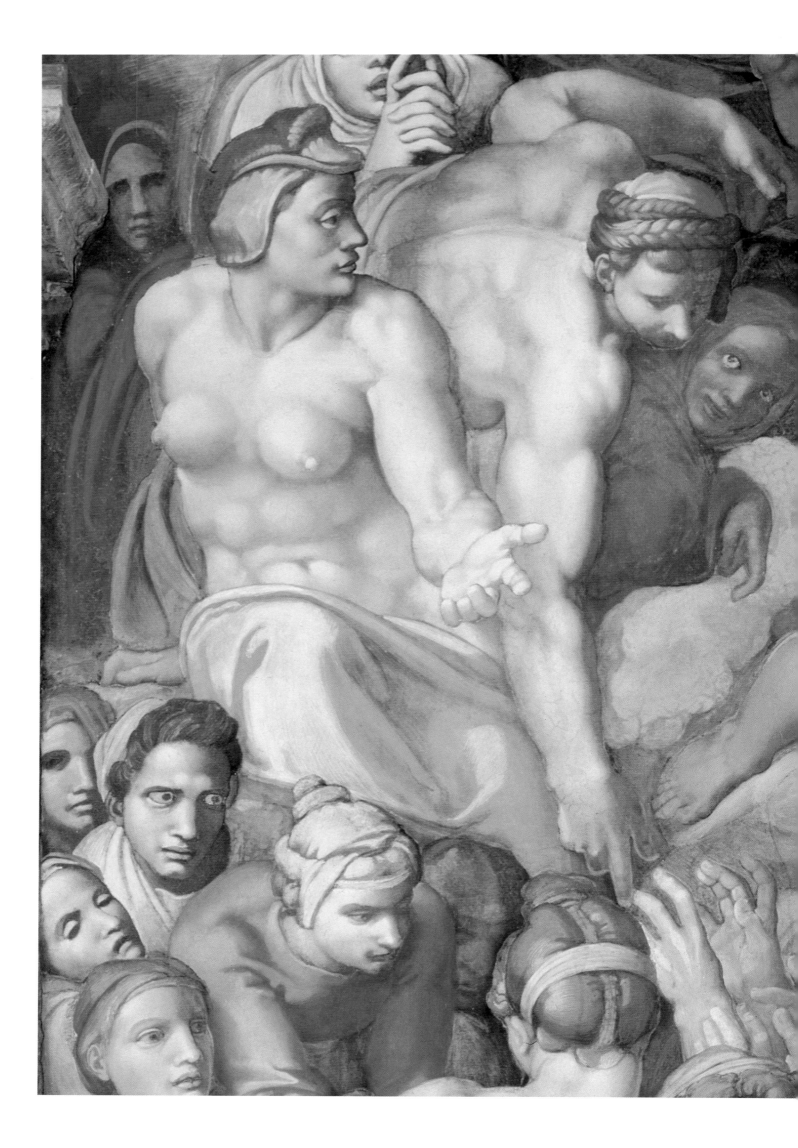

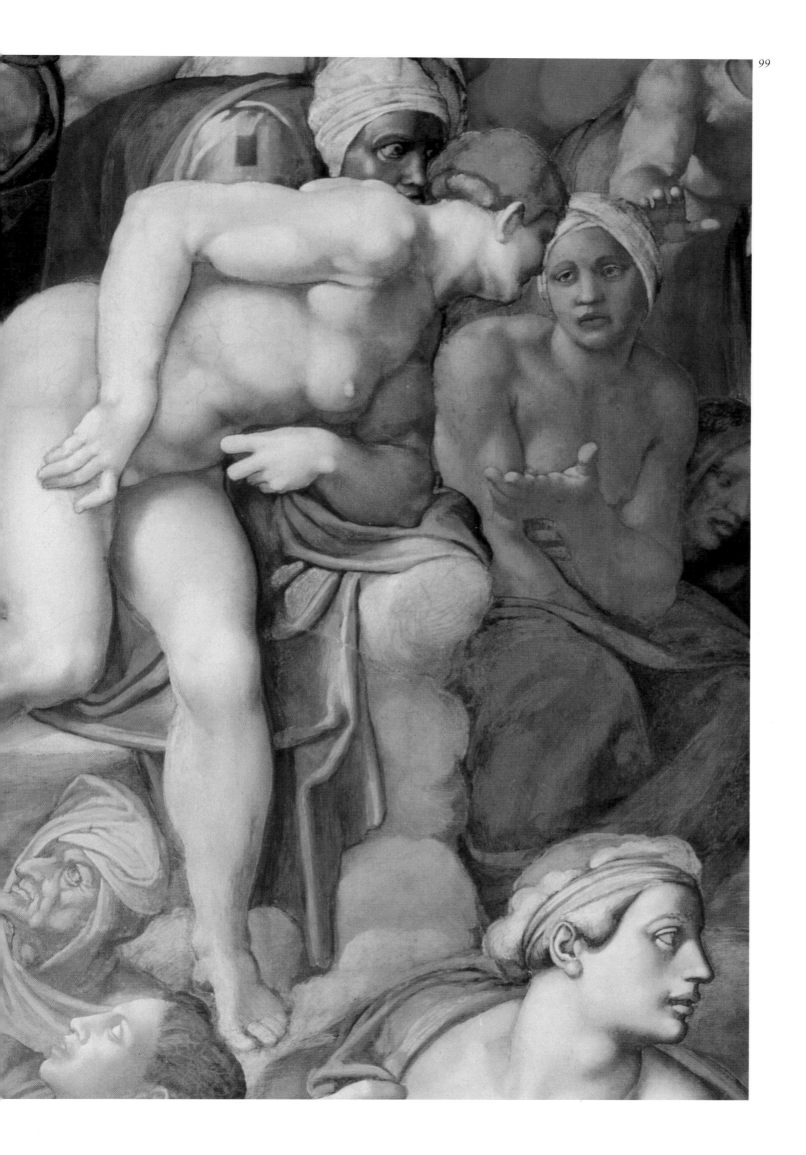

connected (pl. 100). One seated woman—partially draped in yellow-green and lavender, shoulders bared, wearing a blue cap crossed with a ribbon and a gold band—represents a variation on Michelangelo's Libyan Sibyl on the ceiling. The other, whose legs and partially obscured head are draped in blue, recalls his Cumaean Sibyl. They twist their torsos around in opposite directions, reaching toward the women behind them. Two of these in turn lean forward to lovingly take the arm of the "Libyca" (pl. 96), while another (pl. 100)—a draped variation on the blue-caped nude just above (pl. 99)—inclines almost horizontally forward, while looking out at the viewer, to affectionately encircle the neck of the "Cumaea."

The group culminates in a final subgroup (pl. 101). A youthful, powerful, and purposeful woman of exceptional size, dressed in green with a band of blue underlining her full breasts, gazes adoringly toward the Virgin and Christ and rests her left hand on the belt of a woman who embraces her thighs. Unprecedented in the visual tradition, she seems to be, as often noted, symbolic of *Ecclesia* or the earthly Church Militant, and thus a stand-in for the Virgin herself. How appropriate, then, that her hair and white fillet create a kind of aura or halo of sanctity; that her taut breasts, highlighted by heavenly blue, and her broad thighs, draped in the green of fertility and hope, express the potential for spiritual regeneration; and that her gesture offers solace and protection.

While caressing and genuflecting—the ritual act of obeisance performed habitually by worshipers before the Eucharist—the supplicant dressed in the color of faith (white) and charity (red), in turn, calls equally appropriately to mind the responsibilities of each individual for justification: faith, works, love, humility, prayer, and Eucharistic devotion.

The entire group of plate 93 undergoes a transformation as the viewer follows the figures from left to right, background to foreground. Age yields to youth, small to large, and inarticulate becomes articulate. We also observe the development from dependency to self-control, isolation to community, and puzzlement to love—all of which crescendo in "Ecclesia," focused on Christ. The movement from left to right supports the band's overall movement across and down. The background to foreground development expresses—in terms of ever greater corporeal perfection—the progression toward beatific vision mediated by the church.

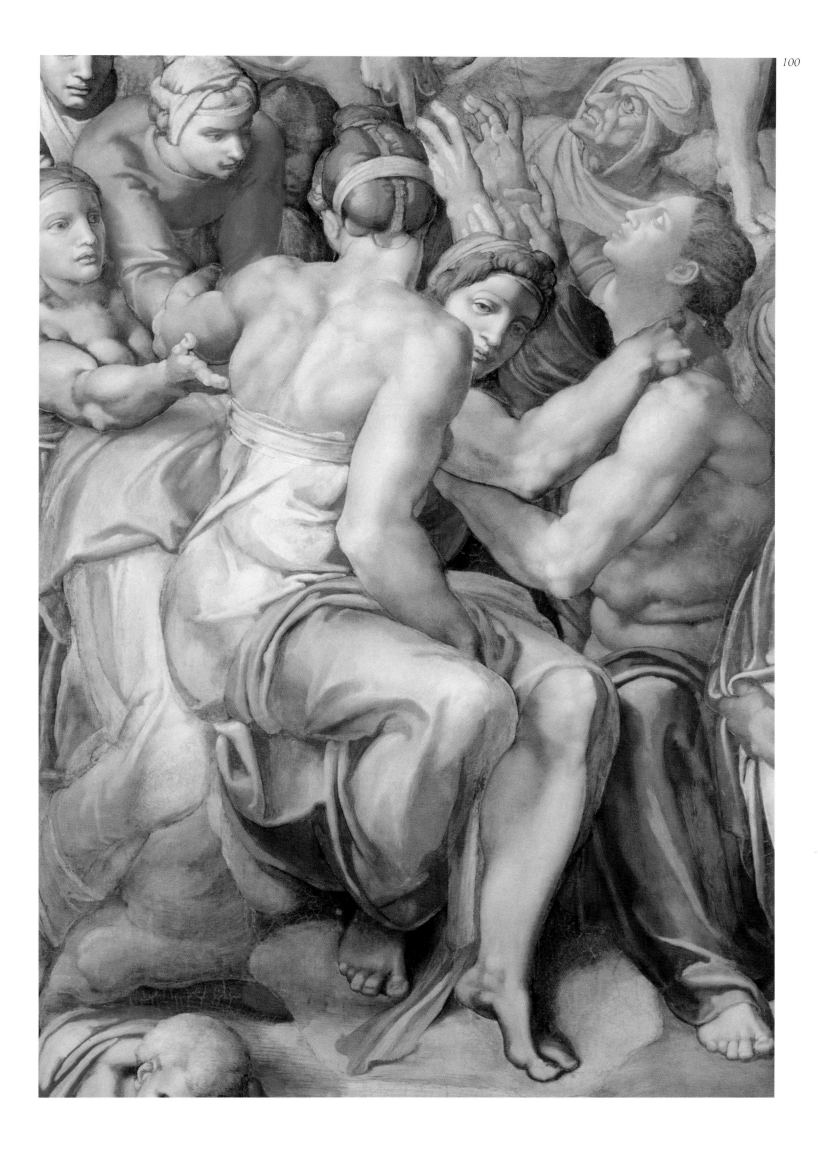

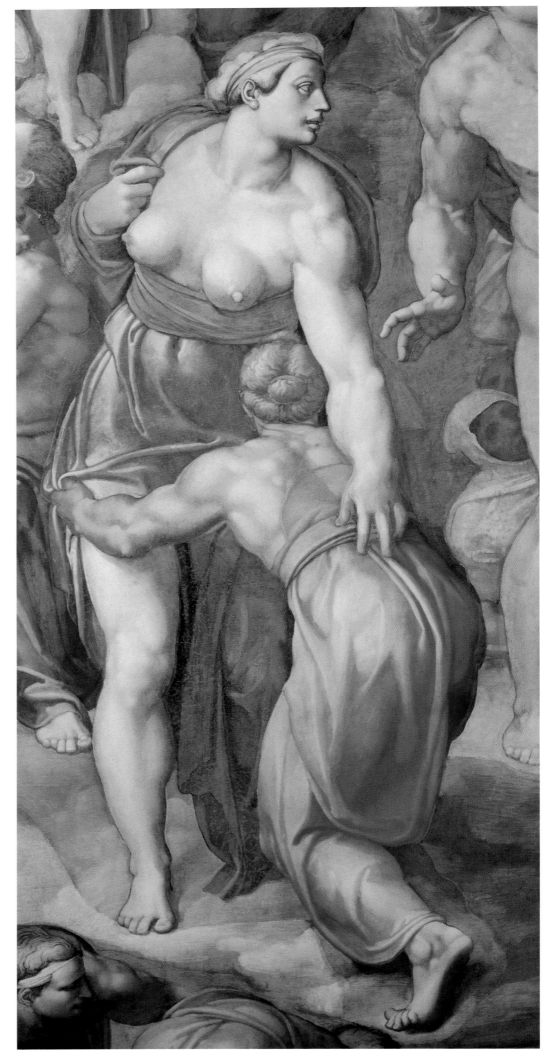

This noble figure whose filleted hair suggests a halo embodies "Ecclesia" or the Church Militant, and thus a stand-in for the Virgin toward whom she gazes (pl. 101). Her green drapery, broad hips, and full breasts underlined by celestial blue appropriately signal spiritual fecundity and regeneration. She offers protection to a supplicant, the embodiment of the church's faithful. The supplicant's genuflection, as if before an altar, symbolizes Eucharistic devotion and humble faith. Her adoring embrace of "Ecclesia" as well as the red and white colors of her costume, intimate love, prayer, and good works.

And Jesus said to him [Dismas, the Good Thief]: . . . *this day thou shalt be with me in paradise.*
(Luke 23:43)

"Dismas" Group to the Right

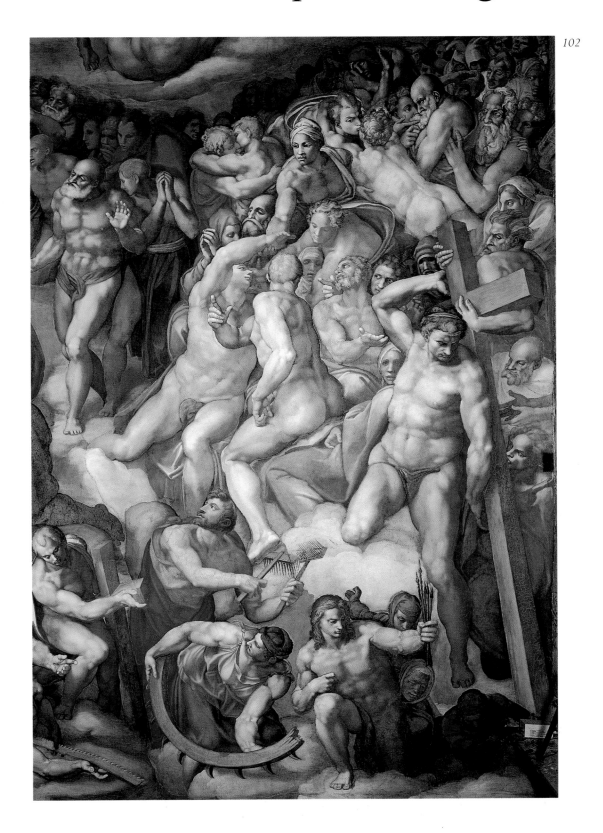

MALES CONSTITUTE almost entirely the group of elect positioned at the far right, which roughly falls into four subgroups (pl. 102). At the upper left shadowed background figures in a triangular wedge rather randomly and inelegantly gesture or look toward Christ. At the wedge's lower point a bearded elder responds to the light, into which he hesitantly steps, with a quizzical expression and upraised palms that seemingly imply both wariness and welcome (pl. 105). His companion, a woman out of step with him, wears a white-belted purple dress and a blue cap. With arms raised and hands prayerfully joined she moves boldly forward, yet averts her eyes from the light by turning her head to her right and looking downward. Some scholars have identified this couple as Adam and Eve, who traditionally figure with the elect (figs. 3, 7).

A row of embracing and kissing nude or seminude males at the upper right, who emerge into the light from a dense crowd of shadowed souls in the distant background, constitutes the second subgroup (pls. 104, 106, 109). To the left a tightly clinched pair of vigorous blonds hugging each other exchange kisses on their left cheeks (pl. 106). Still farther to the right another yellow-haired youth, seen from the rear lunging diagonally upward from lower right to upper left, encircles the neck of still another towhead, who in turn receives his companion with open arms and puckered lips, planting a kiss on his left cheek. To this pair's right a muscular and meditative bald man draped in green holds his white beard with his right hand in a gesture long associated with the presence of divinity (pl. 104). Michelangelo employed this very gesture, for example, in his c. 1515 marble *Moses*, to whom, in fact, this figure bears a close resemblance. Just to his right a blond youth appears to kiss the elder's beard, drawing it to his lips with his hand. Another white-haired, bearded old man, who looks even more like Michelangelo's marble *Moses*, places his hand on the bald figure's side near his armpit. He, in turn, is embraced by the golden-haired, green-draped youth to the extreme right who, resting his hand on "Moses'" left shoulder, peers out from behind. Images of flaxen-haired saved souls embracing and kissing in joy were not uncommon in Last Judgment representations (fig. 8). Michelangelo's expression of bliss, however, truly striking in its unrestrained and blunt intensity, far surpasses all previous attempts to evoke ecstasy.

Below the blissful band a third subgroup (pls. 107–8, 110) features a pair of larger, more mature, seated male nudes of exceptional vitality who, by the complex torsion of their toned bodies, recall the later *ignudi* on the ceiling (pl. 107). Like the seated women whom they balance in the corresponding location within the female group on the fresco's opposite side (pl. 100), they twist around to lovingly engage the souls behind them. The frontal male to the left seated on blue drapery (pl. 107) turns back to offer his right hand to a turbaned young man who reaches down from amidst the kissers (pl. 106).

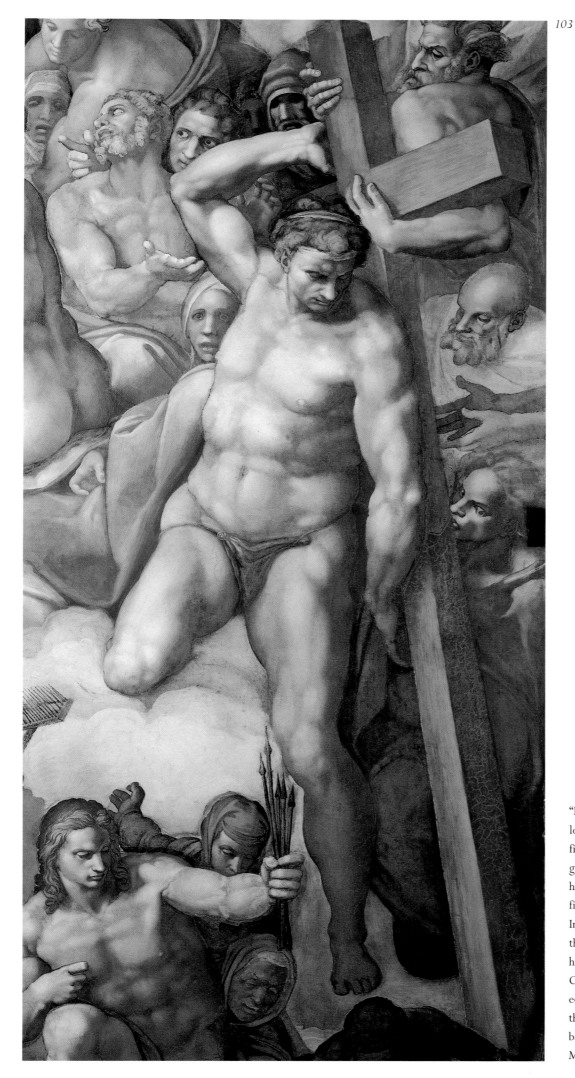

"Dismas" (with a subsequently added loincloth) represents the culminating figure of the primarily male right-hand group of the elect (pl. 103). He lowers his cross onto the north-wall cornice, finally unburdened at the end of time. In stature, gesture, and glance, and by the presence of a female companion at his side, "Dismas" so closely resembles Christ that Michelangelo surely intended him to be Christ's stand-in, and thus a sign of the Church Triumphant balancing "Ecclesia," the Church Militant, on the fresco's left.

Just below the turbaned soul, a fair-haired youth with gold drapery fluttering across his back eagerly thrusts himself forward to caress the cheek of the hand-offering athlete, while simultaneously hugging to his chest with his left arm a soul, perhaps a nun, wearing a wimple (pl. 108).

The seated duo's rear-facing soul turns his blond head sharply to his right, as if speaking to the saved behind (pl. 107). The curled fingers of his left hand rest lightly on his left thigh. Drawing his right arm across his chest, he points up with his index finger as if to indicate the subject of their discussion, the miracle of the Last Judgment.

Seated just to the right of this soul, a bearded, gray-haired man, his legs draped in red shot with blue (pl. 108), looks upward, right palm upturned, and draws the attention of nearby souls to the fourth sub-group to the right, dominated by a cross-bearing male.

This massive counterpoised giant—left leg and arm extended, right leg and arm raised and flexed—at once stands and kneels on a stepped cloud bank as he guides his cross toward the top of the cornice on the right wall (pl. 103). In doing so he ends the band of the elect's rightward drift and downward tilt, and signifies theologically the unloading of the burden of the cross at the end of time. This nude may well have been intended as Dismas the good thief, who was crucified with Christ and who was often prominently featured in previous Last Judgment representations (fig. 3). But clearly his heroic stature, raised right arm, thick blond hair, and downward glance—all of which relate closely to the figure of Christ—reveal Michelangelo's intent that "Dismas"—independent of any historical identity—stand in for Christ and his sacrifice on the cross. The fully draped woman snuggled against his side, who recalls the Virgin with Christ (pl. 2), serves to reinforce

this intention. As a sign of the Church Triumphant, "Dismas," therefore, appropriately balances "Ecclesia," the opposite group's corresponding figure (pl. 101), who symbolizes the Church Militant.

This interpretation is further supported by the bearded, gray-haired figure lifting the cross at the top (pl. 103), who recalls Simon of Cyrene, often shown helping Christ carry the cross in scenes of the Road to Calvary. In addition, a soul draped in gold kisses the middle of the cross's upright (pl. 111), an act of veneration appropriate only for the true cross, a fragment of which was contained within the cross originally set on the altar below. Like "Ecclesia's" supplicant (pl. 101), these figures signify the responsibilities of the faithful—active imitation of Christ through contrition, prayer, works, and Eucharistic devotion. The close juxtaposition of this subgroup with the martyrs just below also emphasizes the importance of *imitatio christi* in the economy of salvation.

As we saw with the group of women opposite (pl. 93), this group also develops anatomically in terms of form, movement, and gesture from background to foreground and from left to right without, however, conforming to any rigid pattern: i.e., from small to large, old to mature (or young to mature), incohesive to cohesive, ineloquent to eloquent, or hesitant to decisive. Again, as in the group of women, Michelangelo's compositional strategy both supports the fresco's general movement and expresses in terms of the ever greater perfection and purposefulness of embodied souls the spiritual regeneration mediated through the church by means of Christ's redemptive sacrifice. The very pairing of a primarily female group on one side with a group predominantly male on the other itself signals the church's regenerative potential.

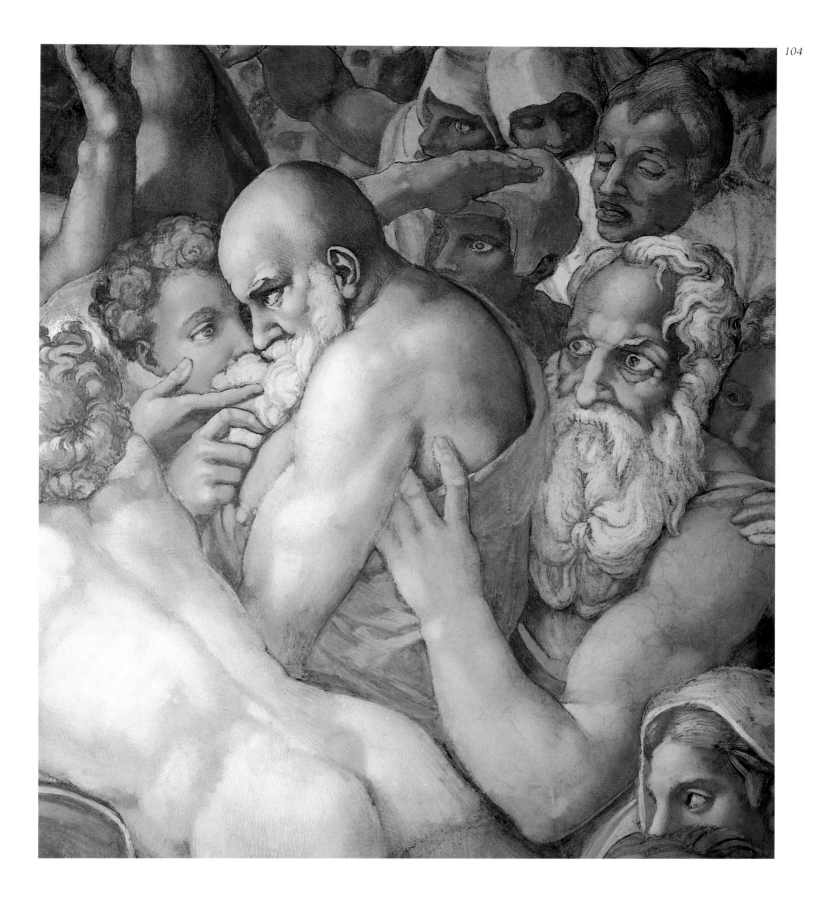

The bald elder stroking his beard and his bearded companion embracing him from behind (pl. 104) both recall Michelangelo's marble *Moses* on the Julius Tomb, an appropriate reference, for Moses's gesture of fondling his beard indicated the presence of divinity. The youth in front reinforces the significance of the elder's beard by drawing it to his lips and kissing it.

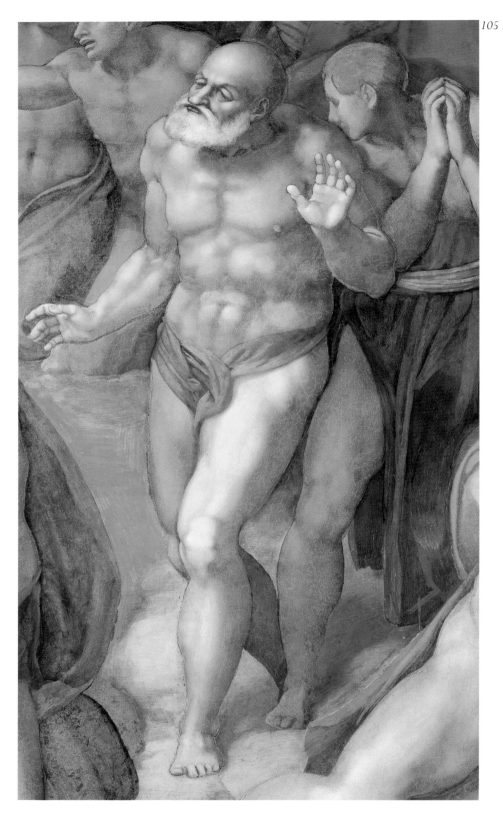

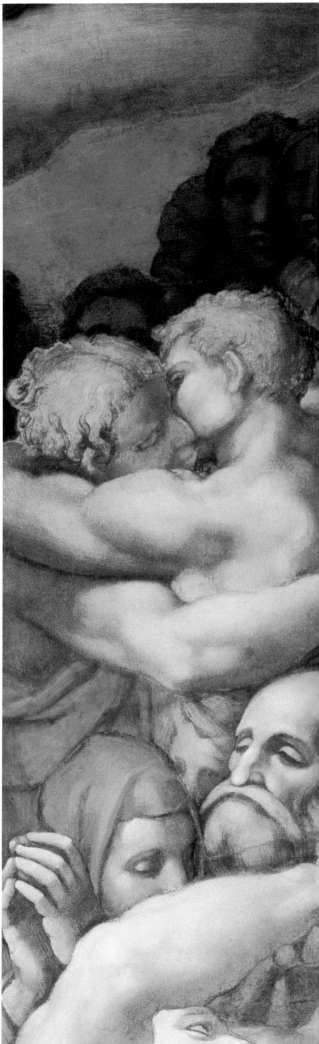

Souls kissing in ecstasy for the joy of being saved never did so with such fierce ardor in earlier Last Judgment scenes (pl. 106). From amidst the kissers a turbaned youth reaches out to take the hand of a soul below. The loincloth of the bearded elder stepping cautiously toward Christ (pl. 105) was painted after Michelangelo's death.

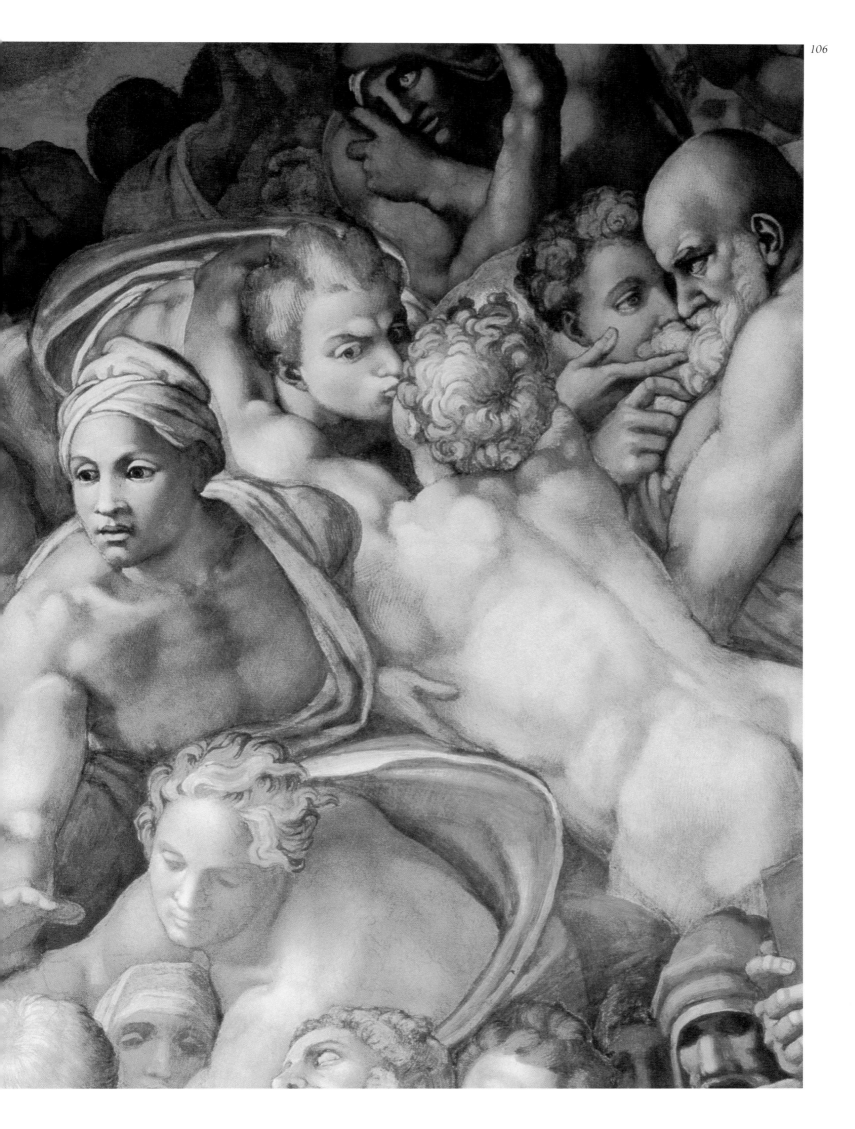

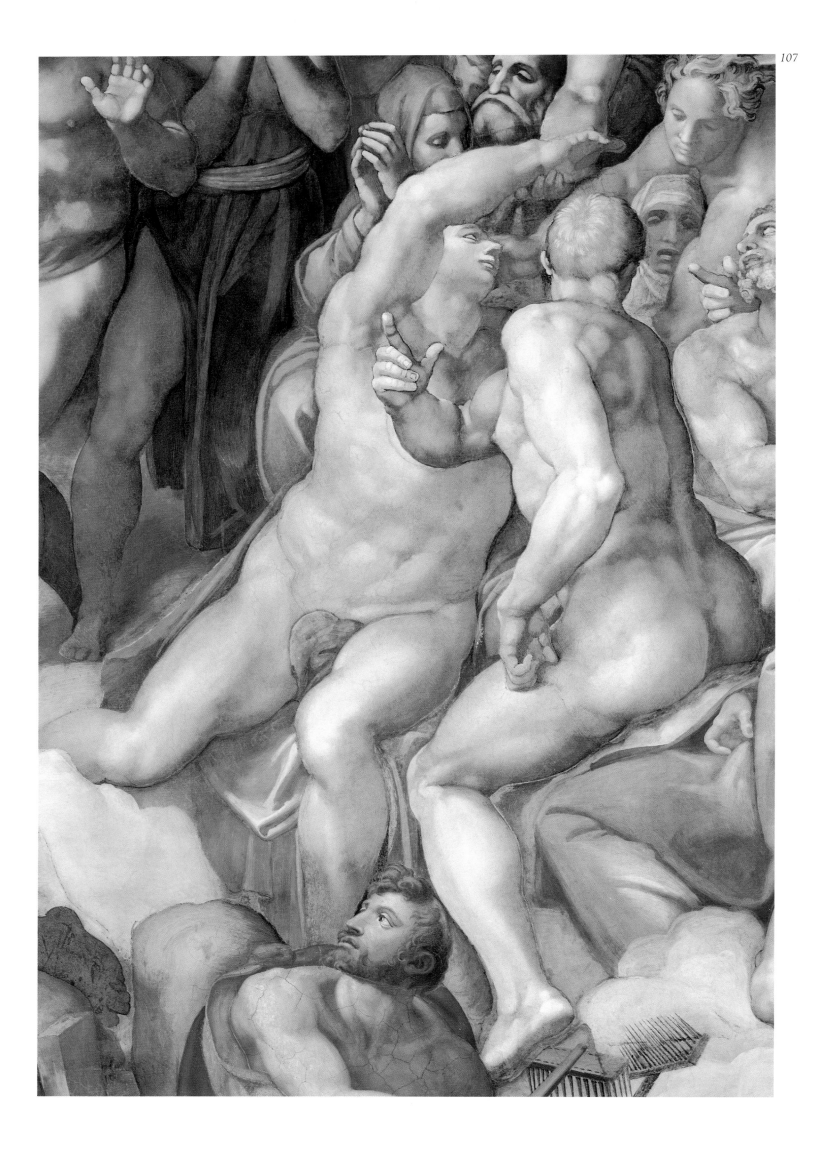

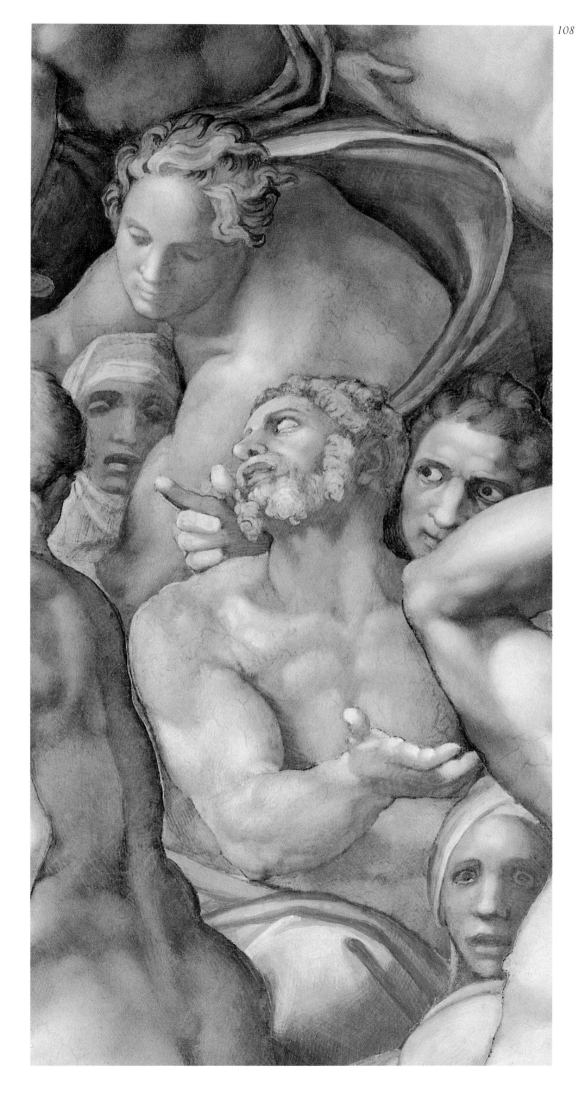

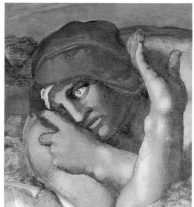

108 109

110

111

The men lovingly engaging one
another (pls. 107–8) are more
evolved in muscularity, torsion, and
elegance than are the souls behind
them (pls. 104–6, 109), an evolution
culminating in the mighty and nimble
"Dismas" (pl. 103), a sign of Christ
and the Church Triumphant. By this
progression from background to
foreground and from left to right,
Michelangelo expressed the process
of spiritual regeneration in terms of
embodied spirits becoming ever more
powerful, graceful, and resolute.
The blue loincloth (pl. 107) is a
post-Michelangelo addition.

Saints around Christ

THE FORMIDABLE, brightly lit figure to Christ's right (pls. 112–13), who has stepped briskly forward on his left leg with lowered arms and head angled sharply toward Christ in open-mouthed and wide-eyed awe, has been identified as John the Baptist by both of Michelangelo's biographers, Ascanio Condivi (1525–1574) and Giorgio Vasari. His camel-hair tunic, which he draws close to his body with both hands, as if to emphasize his asceticism, traditionally symbolized John's penitential life in the wilderness. Furthermore, John the Baptist was almost always represented in Last Judgment scenes on Christ's left, paired with the Virgin on Christ's right (figs. 3–5, 8). As the last of the Jewish prophets, the precursor of Christ, and the first of the Christian saints, he embodied the crucial transition from Judaism to Christianity, from the Old Testament to the New. He also represented the preacher and exemplar par excellence of penitence, and the great baptizer of multitudes and of Christ himself. But Michelangelo was the first to place John on Christ's favored right side and represent him as larger even than Christ.

Michelangelo's reasons for the unprecedented emphasis on John become clearer with close observation of the surrounding figures' actions and formal relationships. To John's left we see a rear-facing nude male standing with his weight on his left leg, right leg drawn back, and head turned to his left (pl. 113)—a posture, if seen from the rear, nearly identical to John's except for the position of the arms. He reaches out to the green-draped woman with a white veil in front of him and supports what appears to be an X-shaped cross, the traditional attribute of the Apostle and brother of Peter, St. Andrew. But beyond whatever historical identity may have been intended, he, like "Dismas," recalls the figure of Christ and imitates his sacrifice. The formal and iconographic parallel between his bent right arm, holding the sacrificial cross while pointing his finger toward Christ, and Christ's bent left arm, his finger pointing to the wound in his side, highlights the relationship between the two. Furthermore, the woman toward whom this stand-in for Christ reaches with his left arm bears a striking resemblance to the Virgin (pl. 2).

Like the Virgin's, her body is fully draped (the green color of her drapery even matches the swatch of green behind the Virgin's right hip), and her head is veiled in

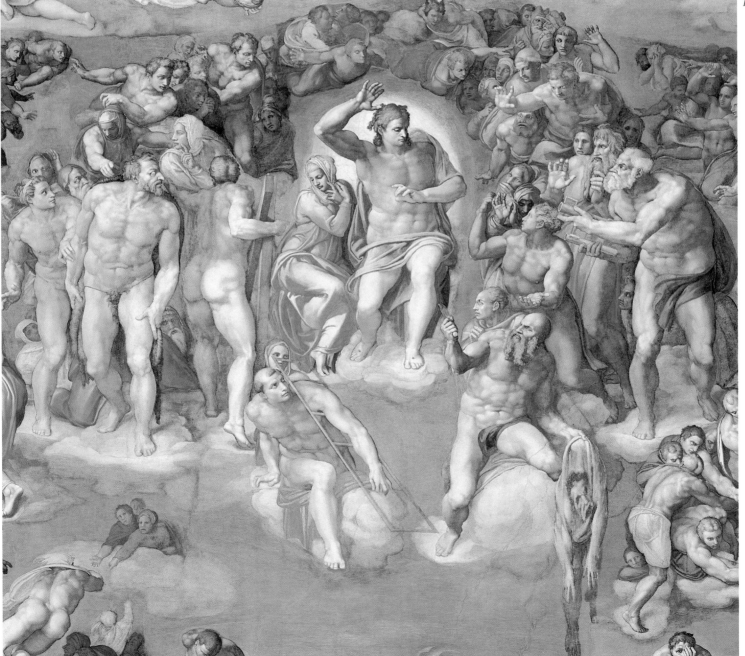

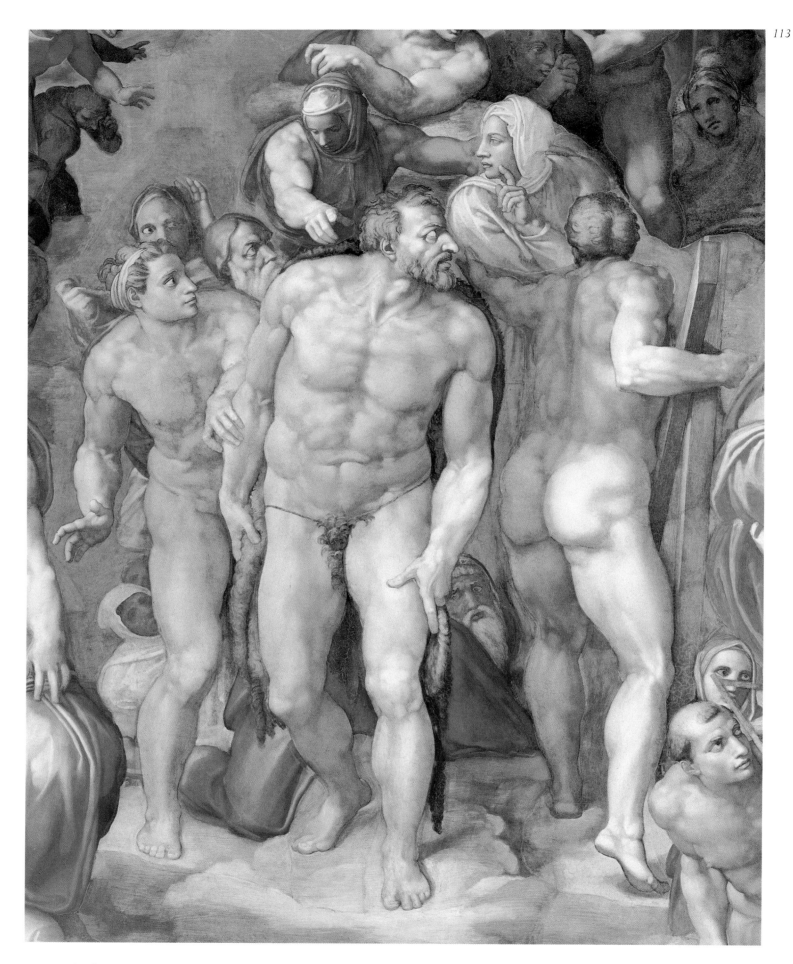

John the Baptist, precursor and baptizer of Christ—unprecedented in his scale and location on Christ's favored right—wears a hair shirt, a symbol of penitence (pl. 113). His rear-facing companion, perhaps St. Andrew, holds an X-shaped cross to imitate Christ's sacrifice. Together they suggest the essential sacraments for salvation—Baptism, Penance, and the Eucharist. St. Peter (pl. 114), the church's founder, returns his keys of authority to Christ, indicating the completion of the Church Militant's role at the end of time. The genuflecting youth in front of Peter signals good works—prayer, contrition, and Eucharistic devotion. The loincloths of John, Bartholomew, and Peter are later additions; the drapery once covering the buttocks of "St. Andrew" was recently removed.

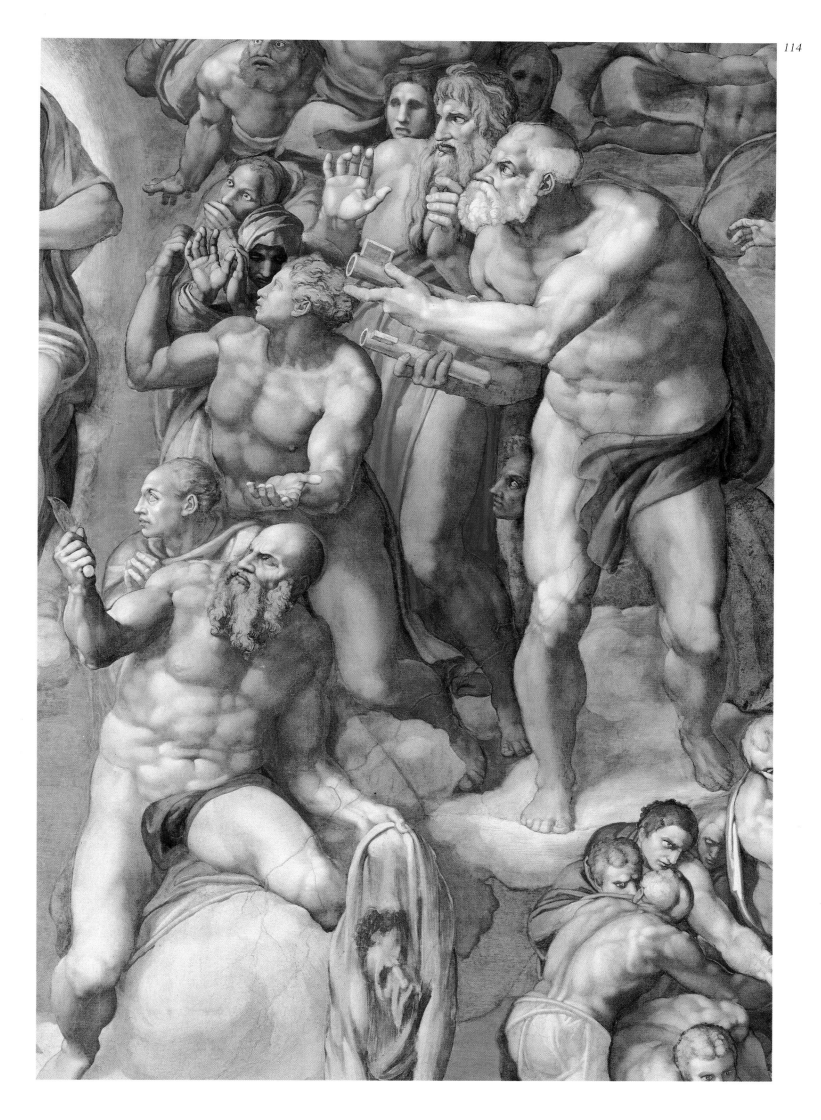

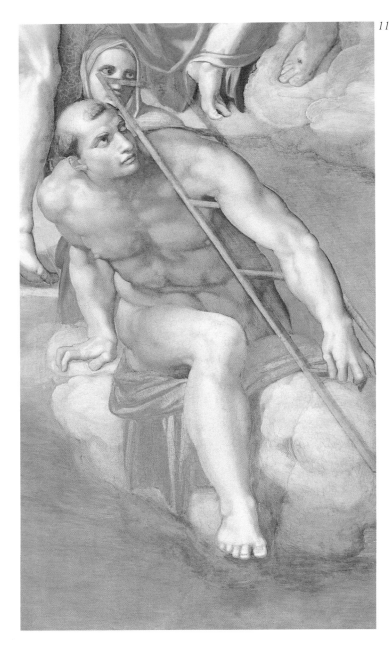

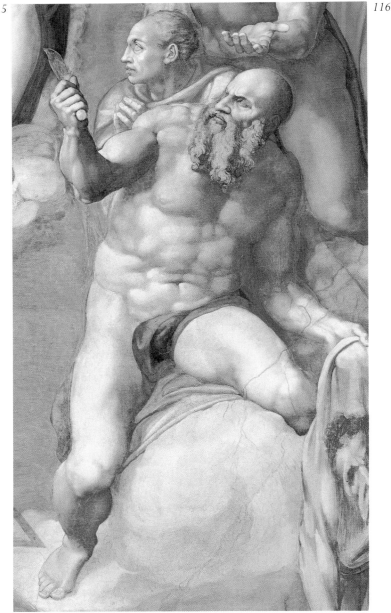

white and turned to her right; she crosses her arms over her breasts, raises her left index finger to her cheek, and turns and inclines her shoulders downward (pl. 113). These parallels clarify the reason why this stand-in for the Virgin looks toward the "Ecclesia" group. As she does so, a muscular bare-armed figure to her right, wearing a wine-red cowl shot with blue, rests his arm on her shoulder and draws her attention to John the Baptist (pl. 113).

A nude youth with a white fillet poised slightly behind draws John's attention in turn to "Ecclesia" (pls. 113, 119). He follows John's gaze toward Christ, but leans forward and rightward on his weight-bearing leg to better grasp John's arm, as if to turn him around to meet "Ecclesia," toward whom he gestures. The bearded man's head between the shoulders of John and

the youth wearing a gold cap that rather looks like the pope's traditional *camauro,* and strongly resembling portraits of Michelangelo's patron, Pope Paul III, may well accent the reference to the church.

The strongly penitential mood of post-Sack Rome surely accounts for Michelangelo's depiction of John as a hair-shirted ascetic at a scale and in a location that are without precedent. The formal links to "Ecclesia," Christ, the Virgin, and their stand-ins also insist that this penitent baptizer be understood within an ecclesiastical and sacramental context. Here he would signify Baptism, which cleanses the soul of original sin by divine grace, and Penance, which cleanses the soul of personal sin by individual confession, contrition, and prayer. John's cross-bearing companion would symbolize the Eucharist as well as remind worshipers that

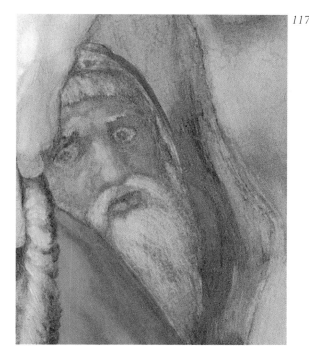

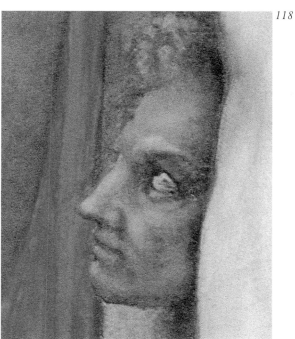

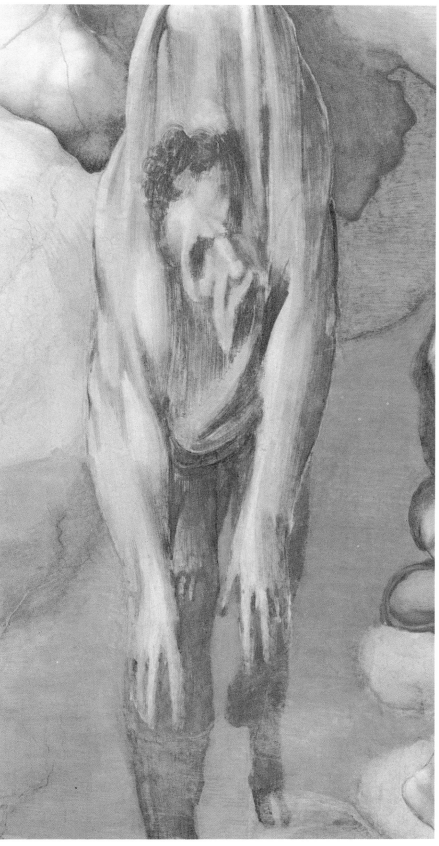

The kneeling figures behind John the Baptist and Peter (pls. 117–18) may represent Adam and Eve. If so, clustered around Christ, who brings time to a close, are representatives of the three canonic eras encompassing all Christian history: *ante legem* (before the Law of Moses), *sub lege* (under the Law of Moses), and *sub gratia* (under the grace of Christ). In an unprecedented pairing, Michelangelo honored SS. Lawrence and Bartholomew at the feet of Christ (pls. 115–16). Having lost their flesh in martyrdom—by burning and by flaying—both saints dramatically highlight the fresco's principal theme of the enfleshment of the resurrected souls. Ironically Michelangelo represents himself as Bartholomew's flayed skin (pl. 120)— the only excoriated, non-enfleshed soul in the entire fresco—as if to suggest his unworthiness before Christ. Yet Bartholomew pleads his case as intercessor and Michelangelo offers up the fresco—"signed" by his self-portrait—as a good work for his justification.

Baptism was made efficacious by Christ's sacrifice. All three sacraments—Baptism, Penance, and the Eucharist—were deemed essential by orthodox Catholics for salvation. Michelangelo thus rejected the beliefs of contemporary Protestant and some Catholic reformers in justification by Baptism and faith alone.

Finally, the Torcello mosaic, where Adam and Eve kneel on either side of Christ's prepared throne (fig. 3), suggests that the bearded elder dressed in red kneeling behind John quite likely represents Adam (pls. 113, 117), and the corresponding figure in green kneeling behind St. Peter, Eve (pls. 114, 118). If so, Adam, the first human of the era *ante legem*, and John, the bridge between the eras *sub lege* and *sub gratia*, both figure appropriately close to Christ, who is drawing time and history to an end.

* * * *

Larger than Christ, exceptionally energetic, and semi-nude, St. Peter, with his characteristic short beard and keys, stands to Christ's left (pl. 114). He bears his massive weight on his right leg and draws back his left to counterbalance the sharp turn of his upper torso and head toward Christ. Staring with piercing eyes, he thrusts his gold and silver keys at Christ, as if boldly returning the symbols of power Christ had consigned to him (Matthew 16:18–19). The red-draped figure behind—almost certainly St. Paul with his characteristic long beard—who recoils from Christ's awesome majesty with a confused expression of surprise and fear, reflexively jerking up his hands and shoulders in self-defense, highlights by contrast Peter's forthrightness. As cofounders of the Roman church, Peter and Paul faithfully figured—or nearly always so—in Last Judgment scenes paired on either side of Christ, with Peter usually (but not always) favored at Christ's right (figs. 3–8). But here the unprecedented "reconsignment" of the keys by Peter, as well as the equally unprecedented displacement of one of the church's co-founders to Christ's left by John the Baptist, implies that at the end of time the Church Militant will play a less crucial role than personal justification. Indeed, the

blond youth directly in front of Peter alludes to the same point.

Like Peter, the youth gazes fixedly at Christ, his audacity heightened by the two shrouded souls behind him, one turning away from Christ and cowering in back of his raised and shielding hands, the other popping a hand over his mouth and cringing with wide-eyed disbelief and amazement before Christ (pl. 114). Furthermore, one can easily imagine the wavy-haired youth speaking to Christ (his mouth, after all, is open) as he raises his right hand in direct appeal—his gesture just shy of either a full-fisted or openhanded affront by the slight downward curl of his fingers and backward pull of his forearm. Simultaneously he extends his left hand out from his body, palm up, as if in offering. What he appears to offer, somewhat quizzically, is his personal justification, achieved by participation in Eucharistic sacrifice, prayer, and penitence.

Michelangelo visually spells out the nature of the youth's offering (pl. 114). First, he has the youth genuflect, as if in reverence to the Blessed Sacrament, yet here before Christ's actual mystical body. The gold-draped soul in front of him, who looks across at "Ecclesia" with the fingers of both hands conjoined, suggests the youth's faith and prayer. And directly under his outstretched offering hand, St. Bartholomew thematizes the youth's penitence and self-sacrifice, a connection that Michelangelo made explicit by the close formal correspondence of their bodies. In fact, if Bartholomew were rotated slightly toward Christ and his legs transposed, his posture and gestures would echo our petitioning, offering, and genuflecting youth.

At Christ's feet Michelangelo paired St. Lawrence with a gridiron (pl. 115) and Bartholomew with knife and flayed skin (pl. 116). Both look up at Christ and lean away from the center, creating a dynamic V-shaped configuration that assists aesthetically in the ascent of the saved. Furthermore, as one critic has noticed, not only does Lawrence's gridiron graze the Virgin's foot, but its lack of the traditional legs lends it the appearance of a ladder. As vessel of the Incarnation

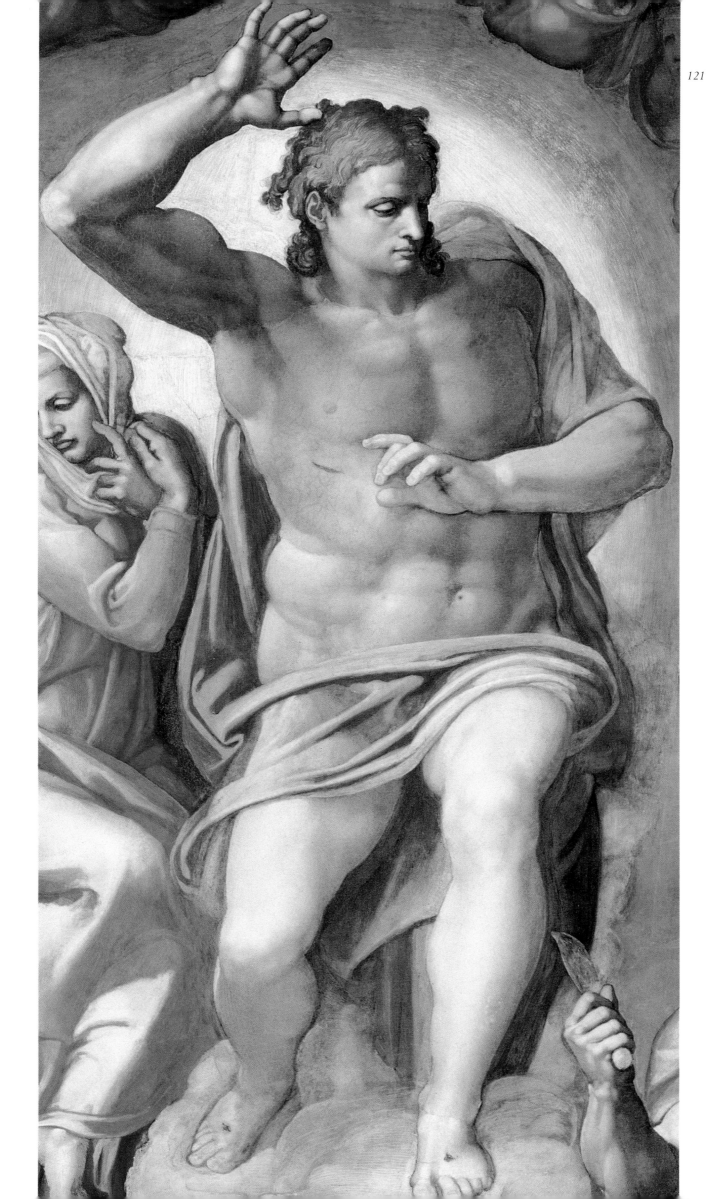

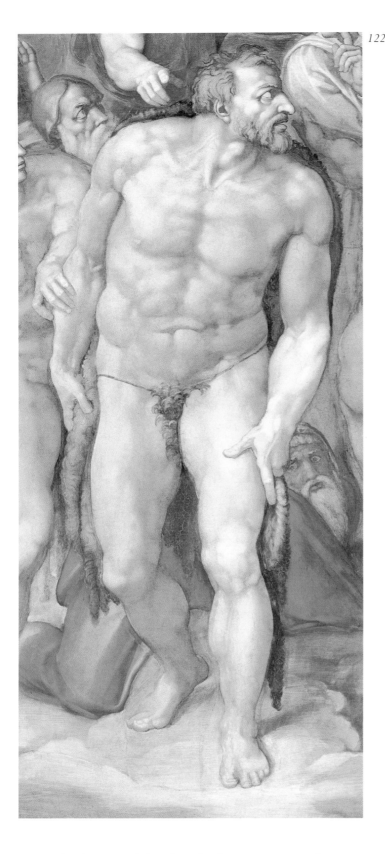

and embodiment of the church, the Virgin was often referred to as the *scala* (stairway or ladder) *del paradiso* by which the Holy Spirit descended to earth to become flesh and the souls of the faithful would ascend to paradise. Michelangelo was familiar with this iconography, as his c. 1491 marble relief of the *Madonna of the Steps* in the Casa Buonarroti illustrates. According to the doctrines of merit and intercessory prayer, the two martyrs would also serve the faithful as a pathway to Heaven by

their exemplary virtue and closeness to Christ.

Lawrence and Bartholomew also aid, both visually and theologically, the descent of the damned. They lean downward and gesture with one arm toward the damned. Theologically, they are those "that were slain for the word of God," and thus entitled to call out for Christ to "judge and revenge" their blood (Apocalypse 6:9–10). The gold-draped soul behind Lawrence sighting down the gridiron at Minos enacts this call.

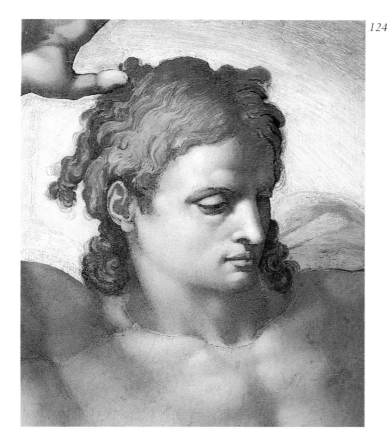

St. Stephen, the first Christian martyr, was often represented below Christ as one of the elect, and Lawrence, the patron saint of Rome, was coupled with Stephen by Cavallini in his Roman *Last Judgment* (fig. 5). But Michelangelo was the first to pair Lawrence and Bartholomew and then to feature them so prominently. Why did he do so?

Just as the nearby group of martyrs illustrates (pl. 64), the two saints emphasized the importance of good works for justification. The ultimate offering of one's life in imitation of Christ's sacrifice was in fact the most highly esteemed of works. Thus martyrs were ranked above all other saints and every consecrated altar had to contain relics of martyrs, as decreed in 1215 by the Fourth Lateran Council. In addition, the respective feast days of Lawrence and Bartholomew—August 9 and August 24—frame the August 15 feast of the Assumption of the Virgin to which the Sistine Chapel is dedicated. But surely the most important reason for their selection was their loss of flesh—one by burning, the other by flaying—in the course of their martyrdoms. Their deaths reinforced the belief that, despite one's physical mutilation or dismemberment, the resurrected soul would be newly enfleshed with the imprint

of the individual's physical body intact.

Despite several subtle hints that contemporaries might have noticed, it was not until 1925 that the clean-shaven face in Bartholomew's flayed skin was recognized in print as Michelangelo's self-portrait (pl. 120), a suggestion that found almost universal acceptance. The likeness is indeed remarkably close to the many known portraits of the artist. Michelangelo, however, plays with the pun on *pelare* (to shave or to skin) for he, like Bartholomew, was bearded.

This spirited note, however, does not undermine Michelangelo's serious intention. Representing himself as the only soul to be excoriated, and not enfleshed, among the elect at the Last Judgment suggests his disillusionment with his aging body and his sense of unworthiness to face God—ideas the artist expressed in any number of his poems. At the same time, Bartholomew acts as Michelangelo's intercessor, pleading his case for salvation before Christ, expressing the hope revealed in other poems that he might shuck off his "earthly prison" and be regenerated for all eternity. The portrait also functions as a signature, implying in effect Michelangelo's desire to submit the fresco itself for his justification. The artist offers up, fearfully and humbly, as a good

work, the enormous physical and intellectual self-sacrifice required to conceive and execute this paean to the majesty of Christ.

* * * *

A comparison between John the Baptist and the common Lysippian type of *Hercules Resting* (pls. 122–23) indicates, as often noted, that Michelangelo's canon for the principal figures in the *Last Judgment* was derived from the most exaggerated of classical nudes, those that were large-scaled, thick limbed, broad shouldered, strong muscled, and blunt featured. Michelangelo even employed this Hellenistic canon for Christ, but represented him as far more dynamic, autonomous, and graceful than any classical figure or, indeed, any other of the fresco's figures.

Christ alone is engaged, as even the most minute detail of his anatomy reveals, in literally earthshaking action (pl. 121). He alone moves with cohesive and counterbalanced suavity through his own volition, free of any response to outside forces. He alone is emotionally impassive, unengaged with other psyches.

Christ was customarily portrayed in Last Judgment scenes as emotionally neutral, but Michelangelo rejected the Savior's traditional mature physiognomy, beard, and long straight hair (figs. 3–8). He substituted instead a more youthful, clean-shaven, and curly-haired head derived from the famous *Apollo Belvedere*, then as now in the papal collection of antiquities (pls. 124–25). While this reference to the pagan sun god earned Michelangelo the wrath of later critics, his intent was to project a more graceful, beautiful, and radiant Christ. Furthermore, it was a common Renaissance trope to understand Apollo as the classical prefiguration of Christ. Just as Christ is shown gathering together and bringing to an end all human history beginning with Adam, so too he has subsumed in his person classical myth and religion, evolving into the new and true *sol iustitiae* (Sun of Justice) at the final judgment.

To underline his Apollonian grace and effulgence, Michelangelo replaced the traditional glory of angels and the geometric aureole surrounding Christ (figs. 3–9) with a simple yellow backlight about the same size and shape of the walled-over windows. He thus created a new spiritual window—materially impossible under the corbel supporting the vault pendentives—through which, rising mystically in the west, shines the sun of the first day of eternity.

* * * *

Our conclusion leads us to a consideration of Michelangelo's reasons for his exhaustive effort to reverse the wall's slope. First it should be noted that in every group within the fresco the figures generally become larger, more massive, and fleshier the nearer they are to the surface. In addition, as the elect ascend from the bottom toward the top they gain in size from approximately 4½ feet (c. 1.37 meters) to more than 8 feet (c. 2.44 meters). The wall canted toward the viewer and thickening toward the top underlines Michelangelo's figural development in terms of scale, density, and corporeality. Together, then, the wall and the narrative mutually reinforce Michelangelo's expression of the long-debated belief—proclaimed dogma by the Fifth Lateran Council in July 1511—that resurrection was a process of enfleshing individual souls, of embodying unique spirits.

The recovery of a psycho-corporeal individuality at the end of time required the damned to suffer Hell through torments of the flesh and mind, and the saved to enjoy bliss as rational and sentient bodies. At the fresco's bottom, then, the saved and the damned respond to natural law (gravity and pain, for example) as would material beings. Even above the horizon and the pull of gravity, the souls continue to emote and act, whether voluntarily or involuntarily, in terms of organic bodies with skeletal, muscular, and psychic structures intact. To avoid obscuring anatomic action, Michelangelo even omitted the angels' customary wings (figs. 3–13).

In the band of the elect, as we have seen, the souls develop from background to foreground in anatomic scale, muscular power, willful self-control, and significant action as they assume more and more the "image

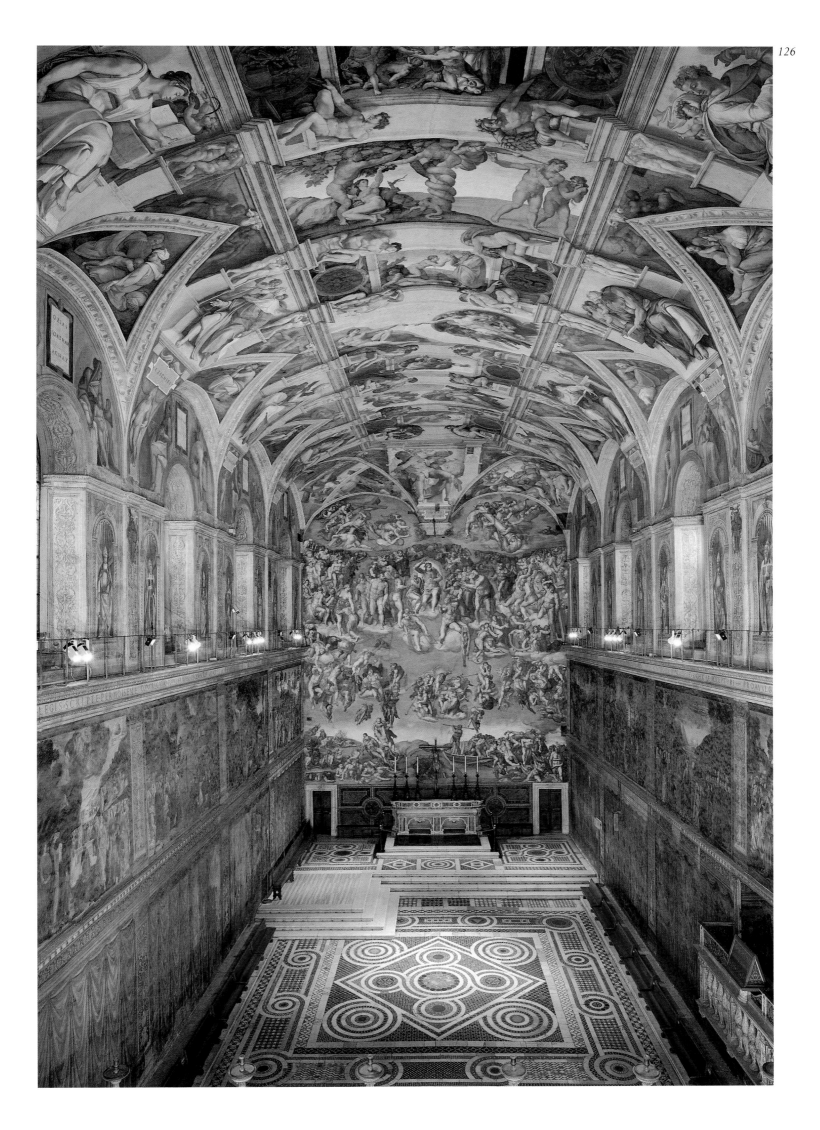

and likeness" of Christ. And even as the most evolved figures of "Ecclesia," John, Christ, Peter, and "Dismas" all step forward, the wall pushes them closer to the viewer. In other words, the sloping wall cooperates with the evolution of the elect in size, strength, will, and purpose.

As the saved gain in corporeality toward the fresco's top, paradoxically they assume greater spirituality. For example, they are often lifted as if weightless by angels and drawn toward Christ. Contrary to the natural law of gravity, they are suspended above the earth with mere clouds serving as the necessary footing to leverage their organic movements. But the most striking indication of enfleshment as a process of spiritualization results from Michelangelo's staging of the entire drama in a way that wholly contradicts the structural and organizational logic of the rest of the chapel (pl. 126).

The fresco's bottom, with the resurrecting dead, Hell's mouth, and the damned, features a total of about one hundred eight souls, which correspond to the unpopulated section of painted tapestries. The band that presents the ascending elect, trumpeting angels, and descending vices contains some seventy-four souls and, aside from the lunettes, is the least densely populated. This band, however, appears at the same level as the narrative cycles with the lives of Moses and Christ, which feature the largest numbers of figures by far. The lunettes, whirlwinds of energy and excitement, are animated with some fifty-one angels; by contrast, Michelangelo's earlier lunettes that present the ancestors of Christ each contain a mere two to seven figures, who are engaged in the most mundane of activities as

they wearily wait for the coming of Christ. The band of the elect, while the most densely populated with about one hundred ninety souls, corresponds to the level of the windows, each of which is flanked by a pair of popes. Finally, all the earlier decoration in the Sistine Chapel adorns walls that slope back and become thinner at the top and that are subdivided by pilasters and entablatures that convey a sense of structural strength and solidity. Contrary to reason and building practice, however, the *Last Judgment* wall slopes forward, grows thicker at the top, and lacks architectural articulation.

One final and most important effect of the sloping wall remains to be discussed. As the congregating elect become more corporeal, Michelangelo rendered them more colorful and light-filled. In response, the wall physically presses them into the actual light streaming in from the windows, especially from the south (left), from which all of the figures are uniformly illuminated—an effect made dramatically evident by the fresco's cleaning and the elimination of artificial light. The natural light becomes one with divine light. A mystical sun rising in the west illuminates Christ, the Apollonian sun god, whose radiance transmutes the corporeality of the elect into spirit.

"Again therefore, Jesus spoke to them, saying: 'I am the light of the world: he that followeth me, walketh not in darkness, but shall have the light of life'" (John 8:12).

"For all you are the children of light, and children of the day: we are not the night, nor of darkness" (1 Thessalonians 5:5).

X

POSTSCRIPT:
PERINO DEL VAGA'S
SPALLIERA
FOR THE
LAST JUDGMENT

SHORTLY AFTER the unveiling of Michelangelo's *Last Judgment* in 1541, Pope Paul III commissioned Perino del Vaga (1501–1547) to design a tapestry to serve as a *spalliera*, as Vasari terms it, to fill the space between the doors under the fresco. Perino painted two nearly identical tapestry cartoons on canvas for which there is a stunning preparatory drawing in the Uffizi Gallery in Florence and for which he received two payments in November of 1542 (figs. 14–15). It is unknown why the tapestry, which according to Vasari was to have been woven in Flanders of silk and gold thread, was never executed. The cartoons, in any case, remained in the Vatican Belvedere until the mid-eighteenth century, when they were transferred to the Palazzo Spada. Somewhat abraded and water stained, they are still today displayed as a frieze high on the walls of what has become the second room of the Galleria Spada.

Previous scholars have universally believed the two cartoons to be fragments, but careful measurements taken directly from the paintings (fig. 16) and the Sistine Chapel demonstrate that either one would fit precisely between the doors under the *Last Judgment* (fig. 17). The lintel of the door to the left bears the coat of arms of Clement XI (1700–21), but all evidence suggests that the present doors are largely identical in size, location, and material to the doors present in 1542. The doors are nearly 8 inches (20 centimeters) higher than the canvases, however. On the reconstruction (fig. 17) I have filled the gap with a molding corresponding to the one crowning the tops of the lunettes above the fresco. In front of the tapestry design I have also reconstructed an altar standing on a platform that corresponds in type (freestanding table supported by columns) and height (47 inches, or 1.2 meters) to one proposed by John Shearman on the basis of evidence supplied by the diaries of the papal masters of ceremonies Johannes Burchard (1483–1506) and Paris de Grassis (1504–21). Rather than a 13-foot (4-meter)-long altar, as suggested by Shearman, I have proposed instead one of 11.8 feet (3.6 meters), nearly identical in length to Paris de Grassis's measurement of an altar in Bologna in 1510. The aesthetically pleasing way in which the winged victories and the herms of the tapestry design would have framed such an altar table, including its columnar supports, and the painted base under the winged victories would have extended its platform, confirms this modification of Shearman's proposal.

Differences in internal measurements may explain why Perino painted two cartoons. It would appear that he measured the available space between the doors and then executed a bilaterally symmetrical design (figs. 14, 16 [top]). The left door is slightly narrower than the right, however, resulting in the displacement of the centerline of the space between them (fig. 16 [line AA])

14. Perino del Vaga, *Tapestry Cartoon for the* Spalliera *under Michelangelo's* Last Judgment *[with papal keys and tiara above escutcheon in center]*, canvas, Rome, Galleria Spada, 1542

15. Perino del Vaga, *Tapestry Cartoon for the* Spalliera *under Michelangelo's* Last Judgment *[with basket of fruit above escutcheon in center]*, canvas, Rome, Galleria Spada, 1542

fig. 14

fig. 15

about 3 inches (8 centimeters) to the left of the altar and altar wall's centerline (fig. 16 [line BB]). This presumed first design, therefore, would not have quite symmetrically framed the altar. A second canvas was thus painted in which 3 inches (8 centimeters) were subtracted from the design's right side and the same added to the left (figs. 15, 16 [bottom]). If this hypothesis is correct, the tapestry-weaving process would not have allowed for the design's reversal. While the discrepancy might at first appear insignificant, just consider the disturbing visual effect produced by a painting hanging a mere half inch (1 or 2 centimeters) out of true on a wall.

Two canvases, in fact, may well have been intended from the beginning—one to send to Flanders and the other to fill the space temporarily—which may also explain the use of canvas rather than the traditional paper. Why Perino substituted a basket of fruit above the central escutcheon in the corrected design (fig. 15) for the papal keys and tiara in the presumed first design (fig. 14) remains, however, a mystery.

The reconstruction (fig. 17) shows Perino's subtle integration of his *spalliera* design with the entire altar wall. The artist linked the lintels of the flanking doors with a painted cornice, and by selecting pairs of victories and herms to support the cornice, he multiplied fourfold and rhythmically varied the support offered by the doorjambs. On the design's right end he painted a narrower pilaster and on the left a wider version to accentuate the doors' unequal widths. In so doing, he produced a visual support for the upward movement on the left and the downward movement on the right that

fig. 16

16. Diagram illustrating differences in measurements between Perino del Vaga's two tapestry cartoons.

17. Reconstruction of Perino del Vaga's *Spalliera* design under Michelangelo's *Last Judgment*.

concluded in the figure of Minos/Satan standing on the right lintel. By means of the recessed panels at each end, which approximate the door openings in size and shape, he created a subtle transition to the central figures who, following Michelangelo, he illuminated from the left. This compact grouping—unified by festoons, broken cornice, cartouche overlaying the cornice, and the figures' responsive postures and gestures—builds

out from the wall in three planes and at once integrates the altar with the wall decoration and emphasizes its crucial central axis.

The earliest sources—Giorgio Vasari, Agostino Taja, and Filippo Titi—all recognized the beauty of Perino's design, citing its *bizzarrissime fantasie* (wildly imaginative fantasies), *graziosissime figurine* (exceptionally graceful figures), and *ornati pregiabilissimi* (unusually worthy

fig. 17

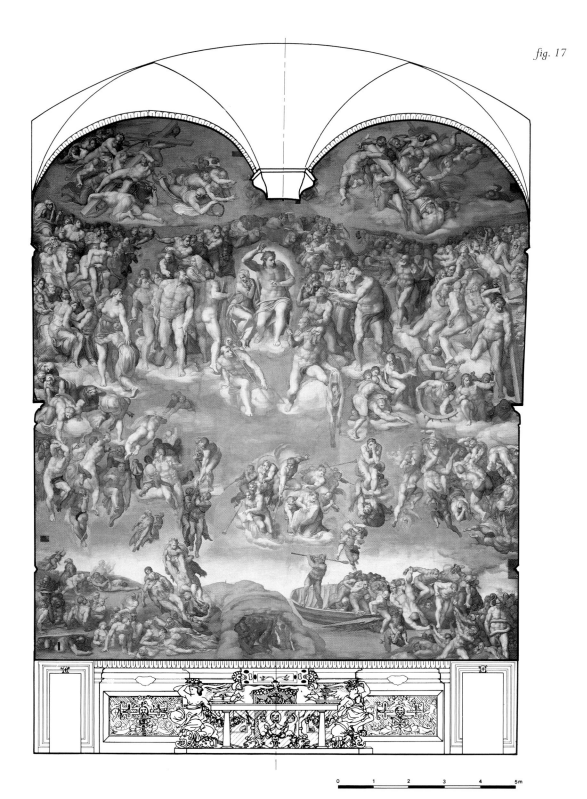

ornaments), but these commentators, along with modern scholars, have remained silent about the design's content.

The winged infant angels and the sphinxes within the large recessed panels, however, aptly symbolized the presence of divinity and divine wisdom. The lily stalk with three white blooms held by each infant recalled the Annunciation and also constituted the *impressa* (personal device) of the patron, Pope Paul III, one interpreted by contemporaries as expressing God's justice and promise of salvation. The lions in the center of each panel probably alluded to Christ, who by long tradition was believed to possess leonine strength and magnanimity. The winged victories seated on piles of Roman armor signaled the end of struggle, peace, and victory and served to thematize Christ's triumph over sin and death. Classical herms evoked Hermes (or Mercury), the messenger of the gods and the guide of souls to the underworld, and were deities used to mark boundaries and embody those liminal transitions from one place or one state to another. Mediating between Heaven and Hades, between here and hereafter, these demigods were highly fitting in the context of the Last Judgment. Finally, within the smaller recessed panels the seashells and the flower-and-fruit festoons that united male herm with female victory appropriately suggested fertility, regeneration, and immortality.

While sculptural and complex, Perino's figures are less anatomically energetic and psychologically intense than Michelangelo's. The *spalliera* design's organization and content relate closely to the *Last Judgment*, as we have seen, but possesses little of its illusionism and immediacy. Perino expresses himself rather by graceful refinement of classical motifs, elegant linear rhythms, and arresting color. So subtle, sophisticated, and rich was its design that Perino's *spalliera*, despite its stylistic differences, would have made a worthy accompaniment to Michelangelo's intense cosmic drama.

Author's note
The biblical quotations in the text are taken from the Douay-Rheims translation of the Latin Vulgate; those from Dante's *Divine Comedy,* from Laurence Binyon's verse translation.

I offer my sincerest thanks to Peter Schmitt, who drew figures 1–2; to Janice Eklund, who drew figures 16–17; to Carolyn Van Lang, who modified all four; and to Melvin Klein, who calculated the volume of the masonry Michelangelo had removed to prepare the wall for the *Last Judgment*, as well as the volume of the wall's brick facing. My special thanks to Leslie Martin, whose expert editing produced a far more readable text, and who was unwavering in her support of this project even at a difficult time of transitions. To her I dedicate this essay with love.

Fabrizio Mancinelli

THE PAINTING
OF THE
LAST JUDGMENT:
HISTORY,
TECHNIQUE,
AND
RESTORATION

"Michelangelo's *Last Judgment*: Technique and Restoration"

Fabrizio Mancinelli

THE COMMISSION given to Michelangelo to paint the *Last Judgment* in the Sistine Chapel was the result of the initiative of Pope Clement VII (Giulio de'Medici, 1523–34), and it seems that the Pope and the artist had been discussing such a project from the time of their meeting in Florence on 22 September 1533.[1] According to Vasari, Clement wanted Michelangelo to paint, "on [the wall] behind the altar . . . the Last Judgment, proposing that in this picture he should display all that the art of design is capable of affecting; while on the opposite wall, and over the principal door, the pontiff directed that the Fall of Lucifer, and that of the angels who sinned with him, should be depicted, with their Expulsion from Heaven and Precipitation into the centre of Hell."[2] The work Clement envisioned was, then, to have been a much more complex project than what Michelangelo eventually executed and one which perhaps had its origin as far back as the pontificate of Julius II (Giuliano delle Rovere, 1503–13).[3]

Clement, however, was fated to see only the compositional drawings for the fresco, which would be painted during the pontificate of his successor, Paul III (Alessandro Farnese, 1534–49). After Clement's death in 1534, Michelangelo sought to be released from, or at least to delay, the Sistine commission, as he wanted to return to the still incomplete project for Julius II's tomb. He reminded Paul of the contractual agreements made with the Duke of Urbino. The pope, angry, is said to have exclaimed, "For thirty years I have had this wish, and now that I am pope will you disappoint me? That contract shall be torn up, for I will have you work for me, come what may."[4] Just as he had at the time of Julius II, Michelangelo was forced to yield to papal will. Paul "commanded him to continue the paintings ordered by Pope Clement, without departing in any manner from the earlier plans and inventions."[5]

Despite Vasari's suggestions, it seems unlikely that Michelangelo had finished many "drawings and cartoons" before Clement's death.[6] Initial planning for the project must have begun, however, in the spring of 1534, and before the Pope died on 25 September of that year, Michelangelo showed him what Condivi called a "cartoon" and what must in fact have been a reduced-scale model of the composition. Two studies survive from this phase of the project—one in the Musée Bonnat at Bayonne (fig. 1) and the other in Florence at the Casa Buonarroti (fig. 2). The first shows only the Judging Christ and the figures surrounding him, and the second the composition in its entirety. The Casa Buonarroti drawing is particularly interesting because it seems to indicate that at first Michelangelo wanted to preserve both the lunettes, which he himself had painted in 1512 at the end of his campaign to decorate the chapel's ceiling, and Perugino's *Assumption* altarpiece. There is no trace of the former on the Florentine sheet, but the frame of the latter is clearly visible at the bottom center of the drawing, flanked by souls ris-

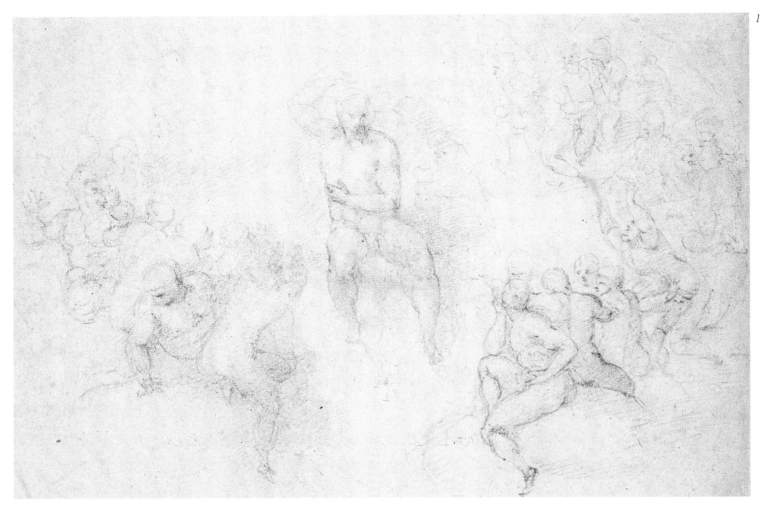

above: fig. 1. Michelangelo, Study for the *Last Judgment* (c. 1533–35), Musée Bonnat, Bayonne

opposite: fig. 2. Michelangelo, Study for the *Last Judgment* (c. 1533–34), Casa Buonarroti, Florence

ing up from the dead and the damned being cast into Hell.[7]

This composition has many of the elements found in the final, painted version. Most importantly, it shows that dynamic definition which differentiates Michelangelo's *Last Judgment* from any previous rendition of the same subject. The postures of Christ and the Virgin are clearly delineated in the drawing, and the complex psychological relationship between them is also definitively resolved. Yet both the gesture of the Redeemer and the Virgin's pose have a sense of violence and excitement which is toned down in the fresco, where the emotional elements of the subject are internalized in the figures rather than made so explicit.

In order to bind the artist firmly to him, Paul III, in two papal briefs dated 1 September 1535, made Michelangelo "supreme architect, sculptor and painter of our Apostolic Palace . . . and a member of our household with each and all the favors, prerogatives,

honors, duties and preferences that are enjoyed and can be or are accustomed to be enjoyed by all our familiars." The Pope also granted the artist a lifetime appanage of 1,200 *scudi* a year—a remarkable sum—of which 600 came from tolls collected from the Po crossing near Piacenza and the other 600 of which was paid by the Datary—the curial official who handled such disbursals—in installments made every two months or so.[8] The brief makes it clear that this income is paid "for the picture of the story of the Last Judgment which you are painting on the altar wall of our chapel, . . . and for other works by you in our palace if this work will have been done."[9] Michelangelo had nothing more to worry about financially. He was now a member of the papal household, and his salary payments, as the two briefs indicate, would continue until his death.

If Clement had indeed intended, as the sources indicate, that Michelangelo paint both the *Fall of the Rebel Angels* and the *Last Judgment* in the Sistine Chapel, then

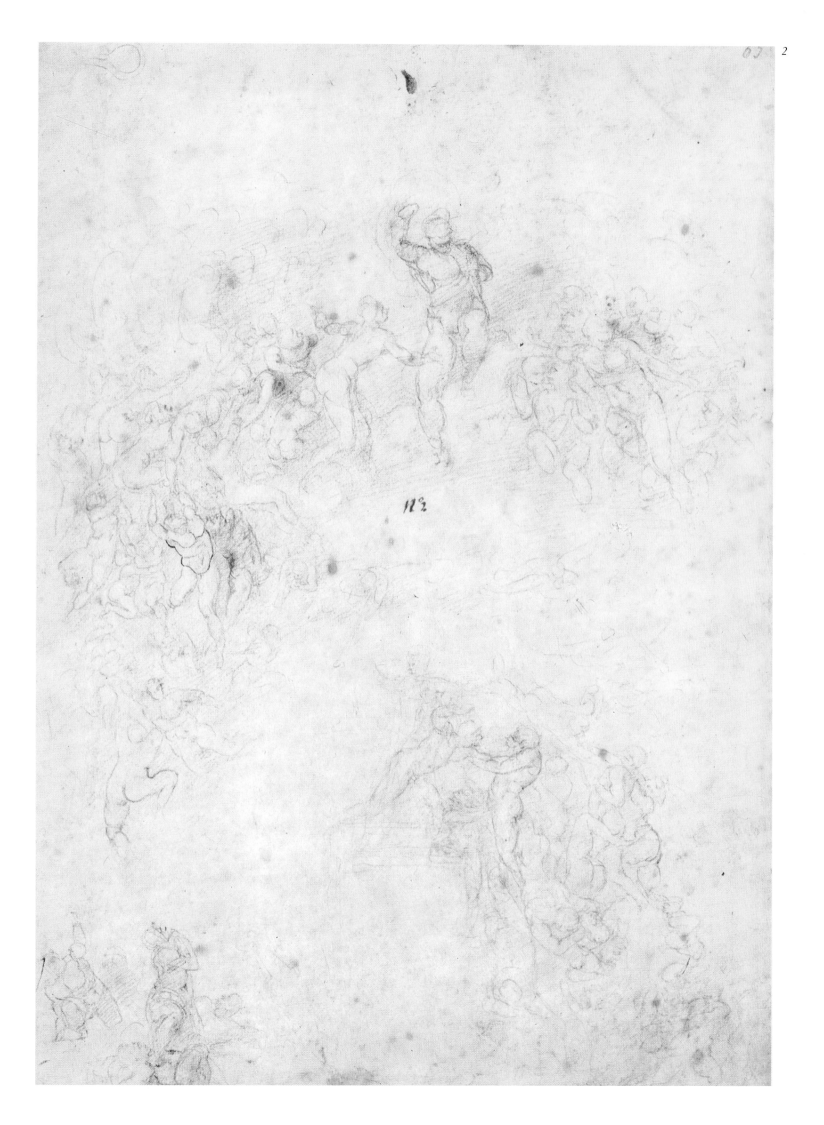

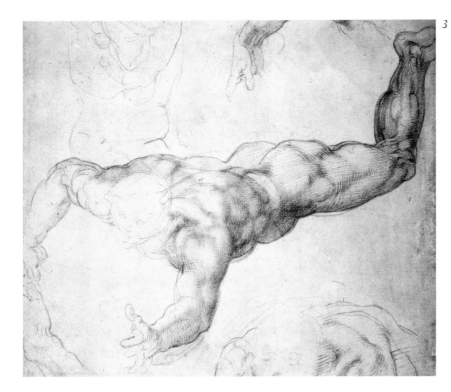

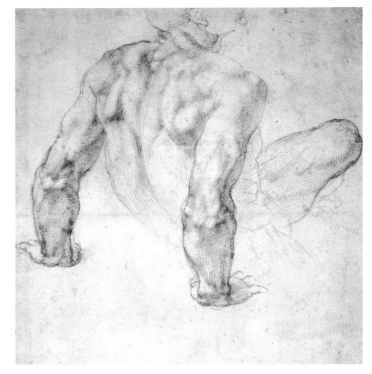

Paul III limited the task to the latter subject, but kept its unusual placement on the altar wall as his predecessor had planned. Clement's desire was probably not the result, as the sources suggest, of improbable aesthetic concerns; it was more likely conceived to give expression to the impact of the Sack of Rome on the church and as a testament to his own distress and dismay "in the face of events which seemed to overturn every certainty."[10] De Vecchi stresses that Clement's impulse was not without "symbolic significance that likely went well beyond the understanding and the intentions of the pontiff," but to which his successor subscribed in full.[11]

Work on the fresco began on 16 April 1535 with the construction of the scaffolding followed by a period of several months during which at least a part of the pre-existing decoration was demolished. This included Perugino's two frescoes, the *Nativity of Christ* and the *Finding of Moses*, as well as his *Assumption of the Virgin* altarpiece, the two lunettes Michelangelo painted during Julius II's pontificate, and the four standing popes flanking the two windows which had once been set in the wall. Payments for the scaffolding and the preparation of the wall for the fresco stretched from 16 April 1535 until April 1536. These documents testify to a long and rather laborious preliminary phase which was mostly if not entirely the result of the disputes between Michelangelo and Sebastiano del Piombo. Vasari relates these events, reporting that Sebastiano had persuaded the pope "to make Michelangelo execute the work in oil, while the latter would do it in no other manner than fresco. But Michelangelo saying neither yes nor no, the wall was prepared after the fashion of Fra Sebastiano, and Buonarroti suffered it to remain thus for several months, without doing anything to the work. At length, and when pressed on the subject, he declared that he would only do it in fresco, 'oil-painting' being an art only fit for women, or idle and leisurely people like Fra Bastiano.' The preparations made by Sebastiano were therefore removed, and everything being made ready for the painting in fresco, Michelangelo then set hand to the work. . . ."[12]

Vasari's story is confirmed by the documents. Sebastiano's plaster preparation was removed from the wall on 25 January 1536, more than nine months after work had begun.[13] On 13 February a payment of ten *scudi* was made "to Master Gioanni Fachino, brickmaker, for the brick lining of the Sistine Chapel, which Michelangelo was to paint."[14] Payments for pigments began on 18 May 1536 and attest to a series of purchases which continue beyond the Sistine project to the Pauline Chapel frescoes. These entries are, for the most part, rather general; they refer to the amount of the purchase

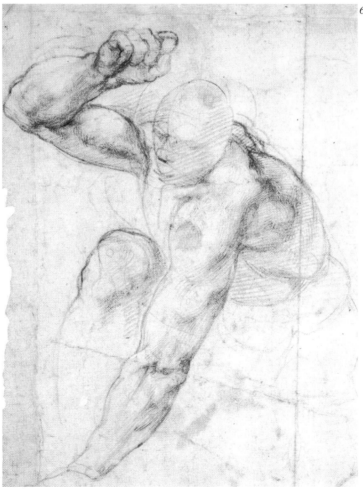

fig. 3. Michelangelo, Study for one of the angels in the right lunette of the *Last Judgment* (c. 1535–36), British Museum, London

fig. 4. Michelangelo, Study for a figure in the *Last Judgment* (c. 1538–40), British Museum, London

fig. 5. Michelangelo, Study for the *Last Judgment* (c. 1538–40), Windsor Castle, Windsor

fig. 6. Michelangelo, Study for a figure in the *Last Judgment* (c. 1538–40), British Museum, London

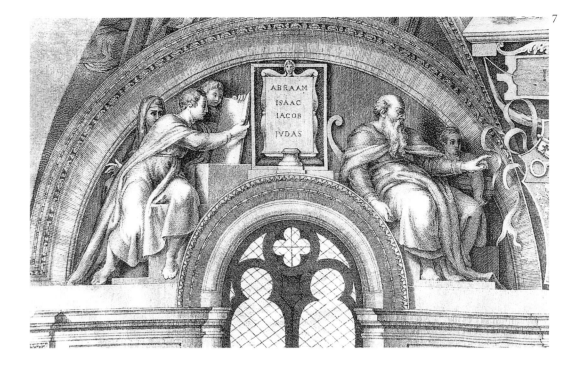

but do not mention the specific colors ordered. Exceptions are made, however, for the blues, which are almost always the very expensive lapis lazuli, the so-called ultramarine, which Michelangelo used for the vast expanse of the sky. This presented the artist no personal financial difficulty because all the expenses of the project were covered by the commissar of papal works, the Commissario alle Fabbriche Pontificie, Jacopo Meleghino. The first purchase of ultramarine was made in Venice and the rest in Ferrara, Meleghino's native city, and it was to him that the bills were sent. On 21 September 1537 ten pounds of azurite, called *azuro todescho* (German blue) in the document, were requested from Ferrara; this seems to be the only exception to orders for ultramarine.

There are numerous payment documents related to the *Last Judgment*, a situation very different from the Sistine ceiling project, about which most of what we know comes to us indirectly and usually from Michelangelo's own correspondence. These documents give us precise data about the artist's salary, the pigments ordered, and the scaffolding used to paint the fresco.[15] We owe this abundance of financial information to the fact that the papacy was here responsible, as it had not been for the ceiling, for all expenses incurred in executing the *Last Judgment* and that these obligations were paid by the commissar of papal works.

The brick curtain-wall Michelangelo ordered for the *Last Judgment* provided him with a support different from the tufa masonry of the ceiling. It was built early in 1536, and it projects about twenty-four centimeters beyond the underlying wall. This is more or less what Vasari reported: "Michelangelo now caused an addition to be made to the chapel, a sort of escarpment, carefully built of well-burnt and nicely chosen bricks, and projecting half a braccio at the summit, in such a way that no dust or other soil could lodge on the work."[16] It seems very unlikely, however, that this is the reason for the slight outward lean of the upper part of the wall. Given the careful attention the artist devoted to the foreshortening of his figures and to their complex articulation in space, as well as the nature of the *pentimenti*, or corrections, he made, it is more plausible that the sloping curtain wall was designed for its optical effect.

As on the ceiling, a layer of fine plaster or *intonaco* was laid over the coarser *arriccio* on the altar wall. There is, however, no *intonachino* here—no final and even thinner coat of plaster—as there is on the vault. It is sometimes replaced by a white or whitish preparatory ground, and the area of the sky was prepared with a thin glaze of red ocher so light that it seems almost pink. The *arriccio* is about seven millimeters thick and the *intonaco* about four. In the upper parts of the lunettes the plaster layer is thinner, since there is no

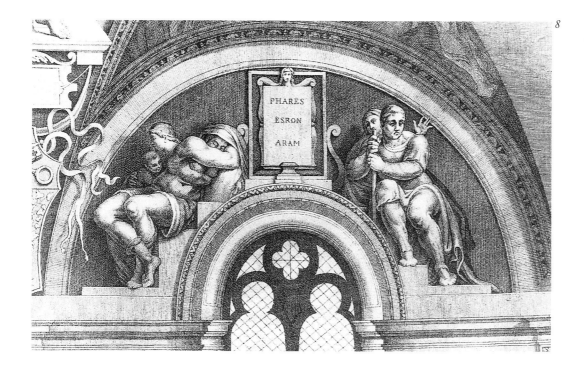

figs. 7–8. William Young Ottley,
The two lunettes destroyed to make
room for the *Last Judgment:*
left, *Abraham-Isaac-Jacob-Judas;*
right, *Phares-Esron-Aram.*
Engravings from *Italian School of
Design,* London, 1823.

under-layer of *arriccio.*

The plaster mixture is made up primarily of three
parts *pozzolana* (volcanic ash) to one part lime. The *gior-
nate* (areas of wet plaster laid down for a single day's
work), on which figures were to be painted, were
sometimes also prepared with marble dust, to give
them a smoother and more compact surface, and per-
haps also a lighter base tonality. For the most part all
the *intonaci* are well-worked and compact—*stretti,* to
use the restorer's term. This phenomenon is especially
easy to see in raking light. According to Biagetti the
fresco was executed in 450 *giornate,*[17] but in fact the
number is 449.

Michelangelo's basic technique for the *Last
Judgment*—once Sebastiano del Piombo's suggestion
that oil be used was, for the most part, rejected—was
that of the ceiling: true or *buon* fresco. This was just as
the artist had wanted to do it, in spite of Sebastiano's
interference. Exceptions to this general similarity,
however, are frequent,[18] and the two projects, the ceil-
ing frescoes and the altar wall, were conceived and exe-
cuted differently on many levels: the brushstrokes; the
palette; the use of painting *a secco*—color applied to the
dry plaster—in the *Last Judgment*; and the preparation
of the *intonaco* itself, which was already discussed
above. Oil was used only on the lower part of the wall,
in the area occupied by the demons; this allowed the

artist certain metallic green and blue tones that would
have been impossible either in fresco or with tempera.
In terms of color and brushstrokes, the *Last Judgment* has
almost none of the limpid, transparent colors, the liq-
uid brushstrokes, or the glazes of the ceiling; instead we
find richly colored impastos laid down with loaded
brushstrokes that are always quick and rough (fig. 10).

The technique of underpainting the figures, depend-
ing on whether they were to be seen in highlight or
shadow, with terra verde, umber, or *verdaccio,* was rela-
tively rare on the ceiling and disappears completely in
the *Last Judgment.* It is replaced by the use of a localized
brown tone—usually painted in umber—for the entire
figure which is then modeled with highlights and
halftones (fig. 11).

There are numerous corrections, additions, and *secco*
finishing touches, often remarkable for their dimen-
sions, across the fresco, and many of these were exe-
cuted some time after Michelangelo had moved on to
another part of the painting. In these instances the color
was almost always removed but without scraping away
the *intonaco,* as had been done on the ceiling, and then a
ground, usually lime white, was painted on top of it.
These *pentimenti* were intended to reposition and en-
large or reduce parts of figures, sometimes substantial-
ly; they might also have been meant to modify or per-
haps add areas of highlight (figs. 12, 13). In some

163

instances the composition of a figure was transformed in its translation from the cartoon to the damp plaster. This is obvious when the outline of a specific detail, an arm for example, changes at the seam between *giornate*, a sure sign that the design of the figure was altered as the artist was painting. The changes to the left leg and foot of one of the wingless angels in the upper part of the right lunette (between the angels dressed in green and orange) as well as to the right arm of the Judging Christ are examples of this kind of modification.

Unlike the *pentimenti* on the ceiling, made only to adjust the proportions of individual details to correct their dimensions, most of those on the *Last Judgment* appear, because they alter the figures' positions and sense of movement, to have been undertaken for dynamic and perspectival reasons. The corrections to the angel in the right lunette, at the base of the column, and to the elect soul between SS. Peter and Bartholomew are typical. In both cases the figure's head has been turned toward his left shoulder and depicted in full profile, significantly changing the original relationship between head and shoulder and therefore the entire composition of the figure.

Following the normal procedure of fresco painting, elements like the trumpets, which occupy several *giornate,* were painted *a secco.* The same is true for pigments that could withstand the causticity of the hydrated lime ground that was used for such additions; this

164

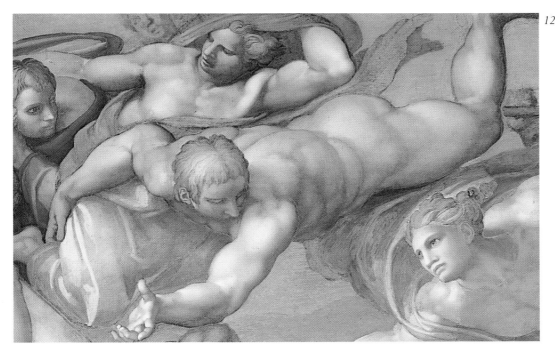

fig. 9. The *Last Judgment*, detail of the *intonaco* of the left lunette under raking light, before restoration

fig. 10. The *Last Judgment*, detail of two of the elect below the right lunette

fig. 11. The *Last Judgment*, detail of an elect soul below the left lunette

fig. 12. The *Last Judgment*, detail of the right lunette

fig. 13. The *Last Judgment*, detail of a *secco* correction to the left foot of an angel in the right lunette, before restoration

seems to be the case for the yellow mandorla behind Christ. The numerous finishing touches lost in past cleanings were also, presumably, executed *a secco*. They would have made less evident the variations in tone visible today, especially in the broad expanse of sky and in places where adjacent *giornate* were sometimes painted several months apart (fig. 14). Such finishing touches might also have masked the now very visible seams between one *giornata* of sky and the next on the lower part of the fresco. If this were the case, then they have been lost in part because of past cleanings of the painting and in part because of the combined action of flaking due to the contracting layer of glue and abrasion caused by frequent dustings.

The reddish-brown outlines of figures added in the background of the upper part of the fresco and frequently painted over several days' work were also executed *a secco* (figs. 12, 15). These were apparently not part of the original cartoon, in which, because of its size, Michelangelo included only the principal figures. Yet they have an essential function in that they consolidate the structure of the composition by completing it and, more important, by giving it a greater sense of depth. They were painted only after the principal figures, and they were added with a rapid, sketchlike technique that creates the impression of the progressive blurring of the image. This technique is characteristic of Michelangelo's style from the time of the ceiling fres-

coes. Typical examples are the sketchy figures in the background of the right lunette which hold the ladder and the reed with the vinegar-soaked sponge and those behind the group of elect souls just below the lunette.

Michelangelo's palette in the *Last Judgment* also varies somewhat from that of the ceiling frescoes. Mars brown and yellow, lead orange, and ivory black, which were used only in the early stages of work on the ceiling, are not to be found on the altar wall. For the blues, Michelangelo no longer used blue smalt or *smaltino*; they have been replaced entirely by lapis lazuli and sometimes very small quantities of azurite. On the other hand we do find red lake, *giallolino,* and orpiment on the *Last Judgment*—colors that either cannot be used or are only rarely employed (as in the case of *giallolino*) in fresco painting. The rest of Michelangelo's palette on the altar wall is the same as that of the ceiling. The whites are lime white, the reds and yellows are predominantly ochers, the browns umber and burnt sienna. The blacks are vine black and the greens terra verde with the one exception of St. Catherine's robe—repainted by Daniele da Volterra—which is a malachite pigment.

The pigments identified, together with the technique with which they were used, document Michelangelo's increased pictorial sensibility, which was most likely the result of his contact with Venetian painting and his close relationship with Sebastiano del Piombo. The addition to his palette of lake, azurite, *giallolino,* and orpiment is particularly important in this sense, as is the use of azurite for a specific purpose and not simply as a substitute for the more expensive lapis lazuli. The choice of lapis lazuli (ultramarine) to create the intense blue tone of the sky is also significant, since it is so important for the overall effect of the fresco. Michelangelo's decision to use the costly pigment must also have been influenced by the fact that the expenses of the *Last Judgment*, unlike those of the ceiling, were all covered by the pope.

As has been noted, a cartoon was made for all the principal figures except those few in the background

that were executed *a secco* and composed directly on the wall itself. The cartoon was surely preceded by small compositional sketches and perhaps, as on the ceiling, by studies drawn directly on the *arriccio*, although no traces of these have come to light. On the upper part of the *Last Judgment* the cartoons were transferred to the plaster by pouncing, a technique of dusting a drawing, which had holes pricked along its lines, with powdered charcoal, to replicate its outline on the wall. The paper used seems to have been quite thick since the edges of the pricked holes left circular marks in the plaster (fig. 18). On the lower part of the fresco, executed at the end of the campaign to decorate the wall, the method of transfer changed to indirect incision, a technique Michelangelo had also used in the later narrative scenes on the ceiling (fig. 19).

The sequence of *giornate* indicates that Michelangelo began painting in the left lunette, and that he started, as was his habit, with a group of background figures. Work proceeded to the right lunette, and then to the central group of figures, including the Judging Christ and the Virgin. The marked disparity in the levels of the wall surface between the lunettes and the area below suggests that after the second lunette had been completed there was a break in the progress of the project. The reason for the interruption is not obvious, although this time may have been used to prepare the cartoons for the band of figures that include Christ, the Virgin, and the elect.

The extremely regular sequence of *giornate,* which proceed without skipping over any part of the wall surface, indicates that Michelangelo painted his fresco in an orderly fashion. He most likely worked with the assistance, especially but not exclusively in the preparatory phases of the project, of Francesco Amadori (called Urbino, active 1530–55), whose presence on the scaffolding is documented by the surviving payment records. Where Urbino enjoyed a freer rein, his intervention is revealed by an immediate and evident decrease in the quality of the painting. The group of resurrected souls in flight on the left side of the

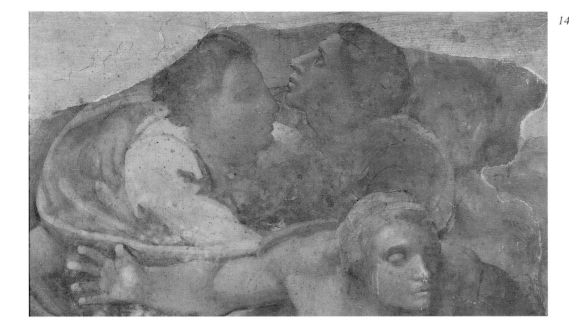

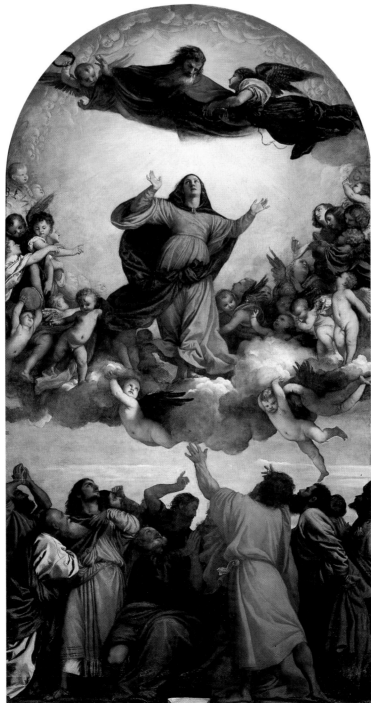

fig. 14. The *Last Judgment*, detail of the *giornata* seams in the group of figures below the corbel beneath the *Jonah*, before restoration

fig. 15. The *Last Judgment*, detail of the right lunette

fig. 16. Titian, *The Assumption of the Virgin* (1518), S. Maria Gloriosa dei Frari, Venice

167

composition is a good example of Amadori's work, for here the lesser quality of the execution of some of the figures is inexplicable unless we allow for the possibility of the presence of an assistant. Given the location of these figures, it is possible that Michelangelo was working here when he fell from the scaffolding and injured his leg. At first, "in the pain and anger this caused him," he refused to see a doctor. Treated forcibly, however, by his friend and doctor, Baccio Rontini, Michelangelo healed rapidly and "his malady overcome, and having returned to work, the master laboured thereat continually for some months, when he brought it to an end, giving so much force to the figures...that they verified the description of Dante,—'Dead are the dead, the living seem to live.' The sufferings of the condemned and the joys of the blessed are exhibited with equal truth. . . ." The accident nonetheless probably obliged Michelangelo to give Urbino greater freedom in executing his designs.

On 15 December 1540 the scaffolding was partially dismantled and the upper part of the painting uncovered, perhaps in order to check the correctness of the foreshortenings from the floor. This issue of the effectiveness of foreshortened figures had really only been a problem in the last bay of the ceiling frescoes. At the end of October 1541, on All Saints' Day—the anniversary of the unveiling of the ceiling—the *Last Judgment* was revealed to the public, provoking scandal, but also very strong admiration. As Vasari described it, "He gave it to public view on Christmas-day [in reality 31 October], and (as I think) in the year 1541. This he did to the amazement and delight, not of Rome only, but of the whole world."[19]

As with all the narrative scenes in the Sistine Chapel, the *Last Judgment*, situated on the wall behind the altar, is conceived as a vision that takes place outside the space of the chapel. Because Michelangelo's composition lacks any illusion of concrete structure, it is as if the wall itself has suddenly disappeared, allowing us to see beyond it to the last day of humankind. This vision takes place in a space which the viewer can understand,

and the similarity between the two spaces is emphasized by the figure of Simon of Cyrene (identified as "Dismas" in the preceding essay), on the right side of the composition, who obviously belongs to the space of the representation, but appears to place his cross on the cornice, a structural element of the chapel itself, that runs beneath the figures of the popes. The crowds of the elect and the damned, as well as the resurrected souls themselves, clearly come from outside the scene. Their existence beyond the real space of the chapel is both indicated and emphasized by the figures who are only partially visible at the edges of the fictive space as well as by the presence beside Simon of Cyrene of the hands of a figure evidently standing beyond the wall.

The composition is conceived as an architecture of figures arranged, although with numerous variations, according to the hierarchical order of traditional *Last Judgment* compositions. These bodies are articulated on different planes and in depth, and they are caught up in the slow, inexorable movement impelled by the imperious but calm gesture of the Judging Christ.[20] He is represented at the center of the composition, rising up from his throne of clouds, a serene and inscrutable expression of omniscience on his face. His arm is raised as if he were simultaneously calling for attention and trying to quiet the agitation around him. Beside him the Virgin turns her head in a gesture of compassion, her body moving in the opposite direction from that of Christ's, as if to underscore the difference in their roles. Yet she no longer intercedes as she does in the Casa Buonarroti drawing; here she limits herself to waiting, with trepidation, for the outcome of this judging.

Above, in the lunettes, two groups of wingless angels carry aloft the symbols of the Passion. On the left they display the cross and the crown of thorns, and on the right the column of the flagellation, the ladder, and the reed with its vinegar-soaked sponge.

The saints and the elect crowd around Christ and the Virgin; they gather slowly into a circle, waiting. Significantly, neither group demonstrates with expressions or gestures the happiness or relief that one might expect

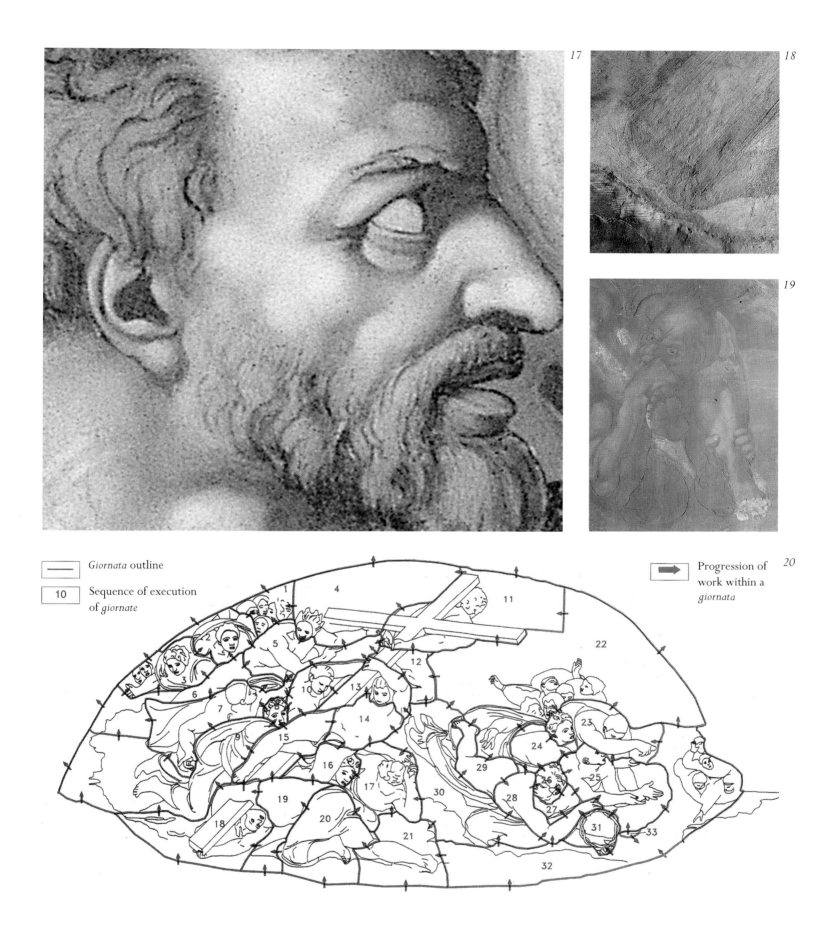

Giornata outline

10 Sequence of execution of *giornate*

Progression of work within a *giornata*

17

18

19

20

fig. 17. The *Last Judgment*, detail of the figure identified as either St. John the Baptist or Adam. Traces of *spolvero* are visible on his hair and beard

fig. 18. The *Last Judgment*, left lunette, detail in raking light of the *spolvero* at the base of the cross and on the hand of the angel holding it up

fig. 19. The *Last Judgment*, detail in raking light of one of the demons below Charon's barge

fig. 20. The *Last Judgment*, diagram of the sequence of *giornate* in the left lunette

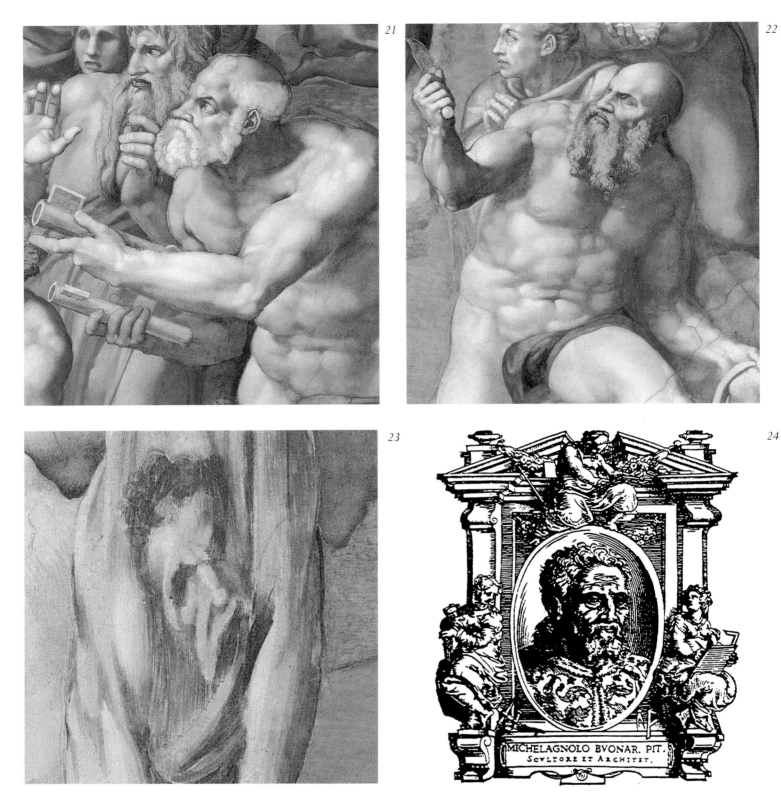

fig. 21. The *Last Judgment*, detail of the figure identified as St. Peter

fig. 22. The *Last Judgment*, detail of the figure identified as St. Bartholomew and traditionally considered a portrait of Pietro Aretino

fig. 23. The *Last Judgment*, detail of St. Bartholomew's flayed skin, traditionally considered a self-portrait of Michelangelo

fig. 24. Cristoforo Coriolano, *Michelangelo Buonarroti*, a woodcut from the second edition of Vasari's *Lives*

from them; instead, they seem anxious. Contrary to all traditional representations, Michelangelo has painted the moment immediately before his verdict is announced. Among the figures in this band we find, from left to right, Adam, with an animal skin over his shoulders (the historical sources identify this figure as John the Baptist), St. Andrew with his cross, St. Lawrence with his gridiron, the flayed St. Bartholomew carrying his own skin, St. Peter with his keys, and beside him a figure who is perhaps the Baptist (identified as St. Paul in the preceding essay). Below them are Dismas, the good thief with his cross (identified as St. Philip in the

preceding essay), Simon Zelotes with his saw, St. Blaise with the wool carder's combs, St. Catherine of Alexandria with her broken wheel, St. Sebastian kneeling and holding arrows in his hand, and behind him, Simon of Cyrene carrying the cross. Above and to the right the old man with a knotted beard must be Moses, and at the far left the ancient, blind woman who pulls a veil away from her face is reminiscent of the Cumaean Sibyl on the ceiling.

At the center of the band of figures below are the trumpeting angels. To the left resurrected souls ascend heavenwards while below them other souls emerge from their graves, some with great effort and some still as fleshless skeletons. To the right angels and demons battle as they pitch the damned toward Hell, while below, in a clear reference to Dante's *Inferno*, a text Michelangelo knew well, the condemned souls are forced from the ferry by Charon, who beats them with his oar, and by demons armed with hooks. The recent restoration has revealed that this boat has wings and feathers. The souls it disgorges are to be herded in front of Minos, their judge. He is represented in the lower right corner of the fresco, his body wrapped in the coils of a serpent, which he uses to indicate the circle of Hell to which he consigns each damned soul.

There are only a few contemporary figures portrayed in the fresco, and all of them were directly connected with Michelangelo. The young elect soul, with prematurely gray hair and dressed in red, at the extreme left of the composition at about the same level as St. Blaise may well be a representation of Tommasso Cavalieri. It has been suggested that St. Peter is a portrait of Paul III (fig. 21) and St. Bartholomew of Pietro Aretino (fig. 22), while that saint's flayed skin is usually seen as a self-portrait of the artist (fig. 23).[21] Because he stands so close to Michelangelo's own image, it may then be possible to identify the balding figure behind St. Bartholomew as Urbino, the assistant who worked closely with the master on the *Last Judgment* and who seems most likely to have been responsible for those rare passages which seem of lesser quality than the rest of the work.

Michelangelo may have included Aretino's portrait in the *Last Judgment* as an attempt to soften his own rejection of Aretino's offer, made on 15 September 1537, of a compositional idea for the fresco. The artist explained his refusal by saying that "having already completed the better part of the fresco, I cannot put your imagination to proper use."[22] This gesture of homage, if that is what it was (especially since Michelangelo then included his own image in the skin of the flayed saint), did not have the desired effect, for in 1545 Aretino was among the fresco's most virulent critics. In a letter Aretino wrote to Michelangelo in November 1545, he asks the artist, among other things, "So then, that Michelangelo stupendous in his fame, that Michelangelo renowned for prudence, that Michelangelo whom all admire, has chosen to display to the whole world an impiety of irreligion only equaled by the perfection of his painting?"[23]

Aretino was not alone in his condemnation; there were calls for censoring the painting even before it had been finished. For example, Biagio da Cesena, papal master of ceremonies, was asked what he thought of the work when he went up on the scaffolding with the pope. He replied that "it was a very improper thing to paint so many nude forms, all showing their nakedness in that shameless fashion, in so highly honoured a place," and added "that such pictures were better suited to a bathroom, or a road-side wine shop, than to a chapel of a pope." Vasari then relates the artist's reaction: "Displeased by these remarks, Michelangelo resolved to be avenged; and Messer Biagio had no sooner departed than our artist drew his portrait from memory, without requiring a further sitting, and placed him in Hell under the figure of Minos, with a great serpent wound around his limbs, and standing in the midst of a troop of devils: nor did the entreaties of Messer Biagio to the pope and Michelangelo, that this portrait might be removed, suffice to prevail on the master to consent; it was left as first depicted, a memorial of that event, and may still be seen."[24] Whether true or not,

171

Paul III's amusing reply to his master of ceremonies was recorded by Domenichi, "Messer Biagio, you know that I have authority in heaven and on earth, but this authority does not extend into Hell. You will be patient if I cannot liberate you from there."[25]

This episode and Aretino's letter are evidence that the debates over the *Last Judgment* were extremely heated, even during Paul III's reign. Nonetheless the Pope, given the particular nature of the work and its placement on the altar wall, in 1543 created the position of *mundator*, or cleaner, and charged its holder with the responsibility of "cleaning away the dust and other kinds of dirt, as previously mentioned, from the paintings in the said chapel of Sixtus, both those on the ceiling of events fulfilled and those on the wall of events prophesied [the *Last Judgment*], and to make all efforts to keep them free from dirt."[26] The *mundatores* are well documented through the pontificate of Gregory XIII (Ugo Buoncompagni, 1572–85), and their activity testifies to the careful and constant maintenance the work received. Thereafter the documents refer to a *custos*, who most likely had an assistant, although it is not clear when exactly this office was established.

The next documented intervention on the *Last Judgment* was not undertaken either for maintenance or restoration but was instead intended to censor it, following the decree issued by the Council of Trent on 21 January 1564. The Council ordered that those parts of the fresco which were held to be obscene be covered.[27] The measures recommended to correct the painting in the Sistine Chapel and those in other churches, however, varied; they ranged from simple censoring to the complete destruction of the offending work. Thus it was something of a juggling act to save Michelangelo's masterpiece which, under Paul IV (Gian Pietro Carafa, 1555–59), was threatened with total demolition with the excuse of enlarging the chapel in the direction of the sacristy. On the other hand, it may have been a foreordained decision, for Paul IV had already asked Michelangelo to "mend" the painting. The artist had replied, sarcastically, "Tell His Holiness that this is a mere trifle, and can be easily done; let him mend the world, paintings are easily mended."[28] The task of censoring Michelangelo's work was entrusted to Daniele da Volterra, who was neither a stranger to nor an enemy of the master, but a member of his entourage, a pupil, and a longtime friend. Michelangelo never saw the results of the vote taken by the Council of Trent; he died on 18 February 1564.

The documents that record Daniele's intervention indicate that he did his work in 1565. The Council's vote was taken on 21 January 1564; the first payments for the scaffolding were made on 23 August 1564; the scaffolding was taken down in December 1565; and the final two payments to Daniele's heirs—he died in 1566, like Michelangelo, on 18 February—were made on 15 December 1567. Indeed, the record of the final payment specifically mentions the date of 1565 for Daniele's work.[29]

The additions to the fresco had been planned the year before (1564); the first payment for the scaffolding was made on 23 August 1564 to the Florentine carpenter Master Zanobio di Mariotto. The next payment—this time for the necessary wood—on 7 September, makes it clear that this work was for the *Last Judgment* scaffolding: "17 scudi and 60 baiocchi paid for other wood taken to make the scaffolding on the *Last Judgment* wall in Sixtus's Chapel." After the advance he was given in August, Zanobio was paid for his work on 12 November, and again on 20 January, 7 April, and 23 June 1565. He received the balance owed him, including the work to dismantle the scaffolding, on 8 December 1565; in the meantime there had been a second disbursement for wood on 7 April 1565. That payment says explicitly, ". . . for building the scaffolding in Sixtus's Chapel to facilitate the painting of the *Last Judgment*."[30]

The final payment makes it clear what Zanobio's scaffolding looked like. It says that it was "forty-two palmi high, built in three stages one above the other, the first entirely covered with planks, with a door to climb through, this scaffolding being twelve palmi deep

25

26

fig. 25. The *Last Judgment*, detail in raking light of the repainted head of St. Blaise done in fresco by Daniele da Volterra

fig. 26. The *Last Judgment*, detail in raking light of the loincloth, executed in tempera, covering one of the angels holding up the cross

fig. 27. The *Last Judgment*, detail of the figure of St. Catherine of Alexandria repainted in fresco by Daniele da Volterra

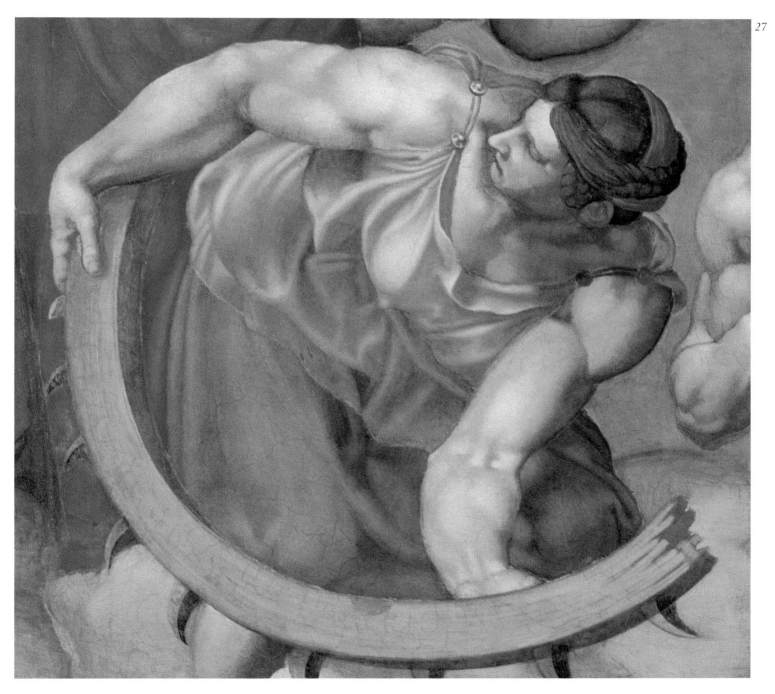

27

and sixty palmi wide, with a parapet in front and curtains pulled in front, with four ladders by the wall. . . ." Thus the scaffolding was, essentially, 9.37 meters high, that is, tall enough to reach the figures of SS. Blaise and Catherine as well as the slightly higher figures of Adam (or the Baptist) and Simon of Cyrene. It was 13.4 meters wide, which is the width of the *Last Judgment* wall, and 2.68 meters deep. It had three platforms placed one over the other, and the base, from the lowest platform to the floor, was faced with wooden planks. The

fig. 28. Ambrogio Ficino, Copy of *Minos* from the *Last Judgment* (c. 1586), Metropolitan Museum of Art, New York

fig. 29. Federico Zuccari, *Taddeo Zuccari Copying Michelangelo's Last Judgment* (after 1590), Galerie de Bayser, Paris

fig. 30. Cherubino Alberti, engraving of one of the elect from Michelangelo's *Last Judgment* (1591), Vatican Library, Rome

fig. 31. Ambrogio Brambilla, *The Sistine Chapel* (1582), Vatican Library, Rome

upper parts were screened by curtains, and the scaffold fitted out with parapets. Four ladders located by the wall gave access to the three platforms. The document then says that the scaffolding was disassembled, evidently before 8 December, when the payment for this work was made. The reason for taking down the scaffolding, however, was not the completion of the work but of the death in December 1565 of Pius IV (Giovan Angelo de'Medici, 1559–65) and the need to use the chapel for the conclave to elect his successor.

Daniele da Volterra's work seems to have been limited to the band of figures around Adam, SS. Blaise and Catherine, and the gigantic figure of Simon of Cyrene. The *braghe*—loincloths or underwear—added to these images were executed using two separate techniques. For Adam and Simon of Cyrene small cloths were designed and then painted on the figures *a secco*. SS. Catherine of Alexandria and Blaise presented a different problem. It was not so much their nudity but their postures which were troublesome; St. Blaise's pose was considered particularly ambiguous. Daniele modified the position of Blaise's head, turning it toward

Christ. This involved a radical change in the original composition, and because the figures spanned several *giornate*, Daniele was forced to scrape away a large part of Michelangelo's fresco—that is, all of Blaise and a large part of Catherine—and repaint the modified figures in *buon fresco* (figs. 25, 27). St. Catherine was modestly covered with a green robe, although Daniele preserved her head, arms, and the wheel from the original.

Given the extent of these changes, both figures were executed in *buon fresco*; Michelangelo's plaster was removed, and Daniele's design was transferred from the new cartoons to the wall by incision. A different technique was used for the animal-skin *braga* which covers Adam/St. John the Baptist's groin and for Simon of Cyrene's small loincloth. These are most likely Daniele's work, and because they are small they were painted in tempera, as were all the loincloths added later.

The censoring of the *Last Judgment* did not end, however, with Daniele da Volterra's additions. According to Bottari, in his 1760 commentary on Vasari's life of Michelangelo, Daniele was not able to finish the task

assigned to him, and after his death "St. Pius V gave the job, at Cardinal Rusticucci's request, to Girolamo da Fano."[31] Girolamo, however, "although he was worthy preferred to pursue his own amusement and depended on Carnevali." This information has never been confirmed in the documents, but in the course of the cleaning a series of numbers and letters were discovered at the very end of Charon's oar. The date 1566 can be seen on the rounded end and immediately beside it, on the shaft, the initials "D.C." The date and initials seem to confirm Bottari's information. Domenico Carnevali painted the missing loincloths, but he also cleaned that area of the fresco where he was working, repainting, among other things, St. Lawrence's gridiron and the trumpets of the angels beneath the Judging Christ.

The numerous tempera additions to the *Last Judgment* must have been painted by different people at different times, since there is an obvious disparity in their quality and because their fluorescence under ultraviolet light varies. The difference in the colors and in their composition, confirmed by their fluorescence under ultraviolet light, attest to the fact that interventions to censor

the fresco continued even after the pontificate of Pius V (Antonio Ghisleri, 1566–72).

The many sixteenth-century drawings and engravings, apparently derived from the original fresco and not from copies, that reproduce some figures without their *braghe* long after Daniele da Volterra's death also make it clear that such alterations were made to the *Last Judgment* at various times. Examples include Ambrogio Figino's drawing of Minos (fig. 28), dated about 1586, Federico Zuccari's drawing of his brother, Taddeo, copying the *Last Judgment* (fig. 29), probably executed after 1590, as well as some of Cherubino Alberti's engravings, particularly his 1591 series (fig. 30). Furthermore, the loincloth which now covers St. Peter's nudity is a repainting of an earlier and smaller drapery which is still clearly visible underneath. Thus there were several interventions of this type, undertaken at different times. They continued at least into the eighteenth century when J. Richard reports in his *Description historique et critique de l'Italie* (1766) that in 1762 he had seen "some very mediocre artists at work covering with draperies the most beautiful nude figures on the wall

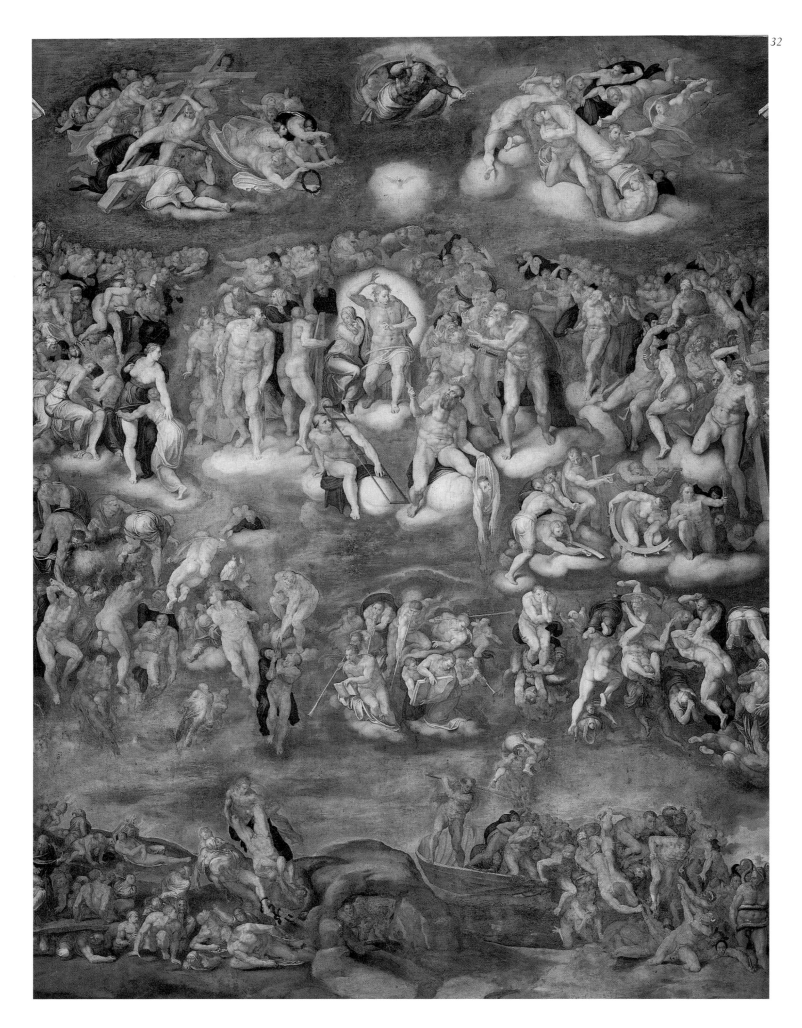

fig. 32. Marcello Venusti, Copy of the *Last Judgment* (1549), Capodimonte Museum, Naples

fig. 33. Giulio Bonasone, Engraving of the *Last Judgment* (c. 1546–50), Istituto Nazionale per la Grafica, Rome

fig. 34. Giorgio Ghisi, Copy of the *Last Judgment* (c. 1564–69), Istituto Nazionale per la Grafica, Rome

and on the ceiling."[32] Chattard (1766) identifies these artists as Stefano Pozzi and his assistants.

There is no documentary evidence for the work that supposedly was done in the reign of Gregory XIII to raise the level of the floor around the altar with the consequent loss of a strip of fresco at the bottom of the *Last Judgment*. In Ambrogio Brambilla's 1582 engraving showing the Sistine Chapel during a papal mass (fig. 31)—and the same is true in a first state by Vaccari in 1572—there are four steps leading up to the altar, as there are today, while according to Paris de Grassis, papal master of ceremonies in the first decades of the sixteenth century, there were only three. As John Shearman (1972) has pointed out, however, the increase in the number of steps, which certainly happened, does not necessarily imply that the level of the floor changed. We find confirmation of Shearman's observation in the fact that the plaster of Michelangelo's fresco overlaps the marble architrave of the door to the right of the altar, which now connects to the sixteenth-century staircase going down to St. Peter's Basilica but which, at the time of Alexander VI (Rodrigo Borgia, 1492–1503), whose coat-of-arms appears on the door

frame, led into the sacristy.

The doorway to the left of the altar can also be dated to the fifteenth century by the decorative elements of its frame. It is documented from the time of the election of Innocent VIII (Giovanni Battista Cibo, 1484–92) in 26–29 August 1484, when it appears on a plan of the conclave. The arms on the frame, however, are eighteenth-century, and belong to Clement XI (Giovanni Francesco Albani, 1700–1721); they were inserted there, however, after the original arms had been removed. Here too—despite what has been written previously—Michelangelo's plaster overlaps the marble architrave, proving that the level of this door has not changed at least since the *Last Judgment* was completed.

The situation is different inside the antechamber to the sacristy. Here the entranceway was radically changed when its floor was raised to the level of the altar platform, in order to create a space beneath the room for the staircase leading to St. Peter's. The Del Monte coat-of-arms over a second door in the antechamber suggests that this renovation probably occurred under Julius III (Giovanni Maria Ciocchi Del Monte, 1550–55). The decoration of the stair below,

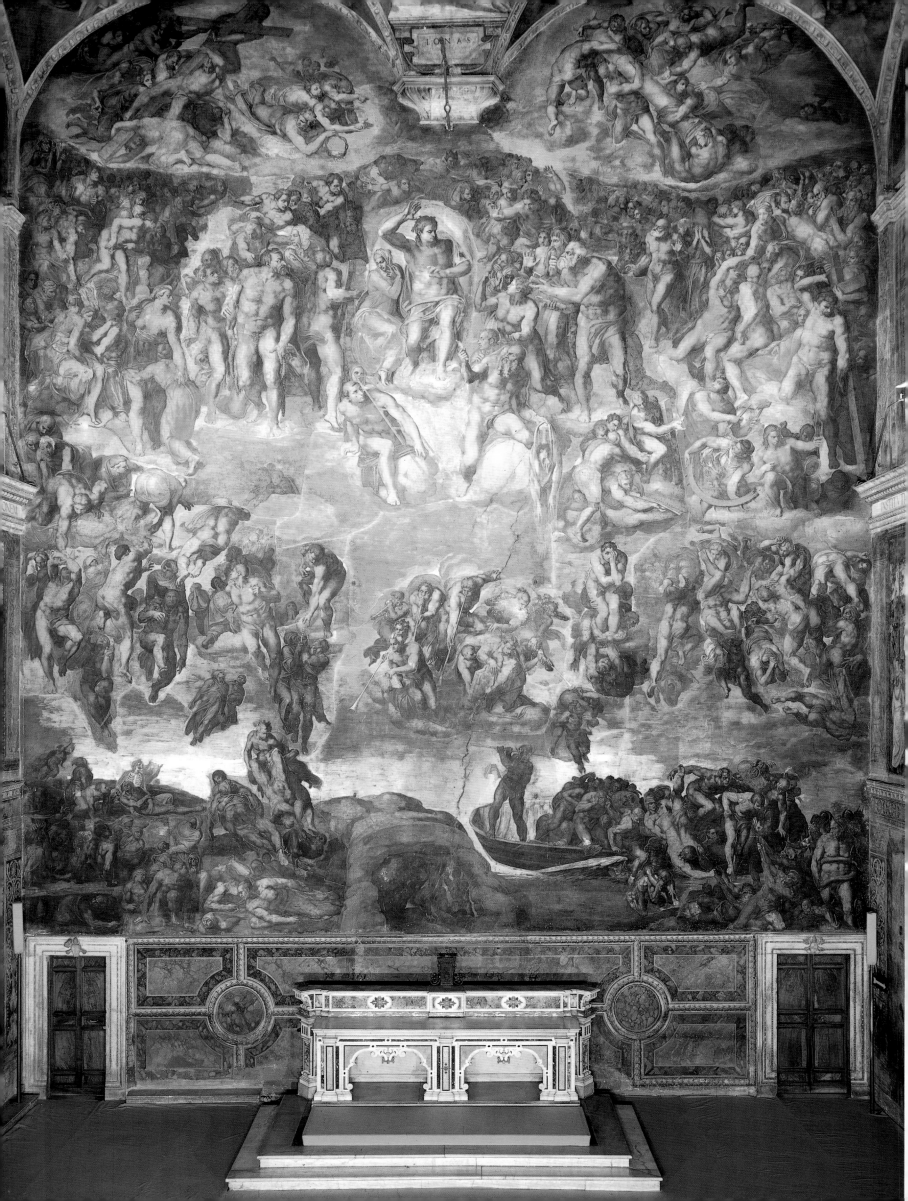

however, was undertaken under Sixtus V (Felice Peretti, 1585–90).

The fact that the level of the two doors flanking the altar has not changed since Michelangelo executed his fresco indicates that the height of the existing painting base below the *Last Judgment* (generally dated to the eighteenth century, but quite possibly older) probably occupies the same area as the base which must have been painted after Michelangelo's masterpiece had been completed. The commission for this decorative element was first given to Perino del Vaga, who worked on it in the "big room above the Belvedere loggia." A document dated November 1542 records a payment for "cloth . . . for the cartoon made by Master Pierino painter of the base running underneath the painting of Master Michelangelo in Sixtus's Chapel."[33] According to Vasari, Perino never finished the work; it remained in the Belvedere until the eighteenth century and was then transferred to the Palazzo Spada in Rome where parts of it survive today. These were identified and published by Voss in 1920. According to Davidson the reason Perino never finished his cartoon was that he was reluctant to have his own work compared so directly with the Sistine frescoes. It may also have been abandoned, however, because of the strong contrast between the subtle elegance of Perino's invention and the intense drama of Michelangelo's crowded composition.

It seems unlikely, then, that the *Last Judgment* was mutilated in the way that past comparisons with Venusti's copy of the fresco (1549) (fig. 32), now in the Capodimonte Museum in Naples, have suggested. Indeed, Venusti evidently had to make some modifications in adapting Michelangelo's invention to his own compositional space. The present state of the fresco seems to vary little, moreover, from what was recorded by Bonasone and Ghisi in their prints after the *Last Judgment* (figs. 33, 34), both executed in the second half of the 1540s.

Some restructuring of the area around the altar did take place after the sixteenth century. Between 29 November 1662 and 4 April 1663, work was carried out on the "marble stairs . . . of the throne and the altar of the chapel,"[34] although it seems that the preexisting arrangement was not changed.[35] The altar was redone in its present form in 1725.

The documents are so far silent on any restorations of the *Last Judgment* in the seventeenth century. Lagi's work in the Chapel between 1625 and 1628 involved only the fourteen scenes from the lives of Moses and Christ, the figures of the popes above them, and the backs and the chiaroscuro bases of the seats below.[36] Mazzuoli's intervention in 1710–12, like Lagi's and the others' under Clement XI, apparently did not include the altar wall. Mazzuoli worked on the biblical narratives on the walls, on the popes, and on the ceiling, while Germisoni and Pietro Paolo Cristofani repaired and repainted the fictive damask curtains on the lower part of the walls.

According to eighteenth-century sources, however, a restoration of the *Last Judgment* was planned. Taja gives us some extremely important clues about the fresco's state of conservation at that time. He wrote, "Certainly the saltpeter, the dust and humidity (if corrective measures are not immediately undertaken) could in a few years reduce these excellent paintings to an irreparable state, as has evidently happened from year to year, especially in the *Last Judgment*, which is cracking and producing at various places ugly stains of white niter, calcinating the color itself."[37] It is not clear, however, what Taja was referring to when he described these effects, or exactly what was happening "from year to year." Nevertheless, since it is impossible that seeping rain water was the problem, one might assume that he was noting the same problems Vincenzo Camuccini identified in 1825. The latter remarked on damage especially in the area of sky above the group of souls rising from the dead and Charon's ferry. He reported this to the Academy of St. Luke, advising specifically that "there was once a time when unintentionally they tried to destroy this masterpiece by applying a strong corrosive agent."[38] The recent restoration has confirmed that a corrosive agent was indeed applied, and that it caused

179

fig. 35. The *Last Judgment*, before restoration

damage that is still visible. When this happened, however, is not clear. If the white stains that resulted from its use are those that Taja identified, then they were caused by an undocumented restoration in the seventeenth century. If Taja intended something else, then perhaps the stains originated in the additions that Richard noted in 1762 in his *Description historique et critique de l'Italie* and which might be linked to Stefano Pozzi.[39]

Camuccini made his observations after a test cleaning on the group of angels carrying the column of the Passion in the right lunette, undertaken with a possible project to clean the entire fresco in mind. Called on to evaluate the artist's work, the Academy of St. Luke rejected the project, not so much because its members questioned the results of the test, which they judged positively, but because they feared that a full-scale cleaning would make more visible the damage produced by past restorations and noted by Camuccini himself. After this attempt to clean the *Last Judgment*, the only one actually documented, the subject of further restoration was not raised again until the present day. Seitz's work in 1903 and Biagetti's in 1935–36 were only intended to consolidate the plaster. Indeed the accusations that Biagetti had accentuated the white "scorch marks" in the background by too forceful a cleaning are totally unfounded, since no cleaning was undertaken.

THE PROJECT TO RESTORE THE *LAST JUDGMENT*

The restoration of Michelangelo's *Last Judgment* officially began immediately after the conference held in March 1990 to discuss the results both of the cleaning of the Sistine ceiling and lunettes and of the first tests executed on the *Last Judgment*. These were undertaken as the first step toward understanding the technical characteristics of Michelangelo's masterpiece as well as the problems associated with it. The purpose of the preparatory phase of the cleaning was to ascertain on one hand, the fresco's state of conservation and the technique that Michelangelo employed to paint the altar wall, and, on the other, the ideal method for cleaning the work. This part of the project took more than a year and included tests done both in the laboratory and on the fresco itself.

The examination of the *Last Judgment*'s state of conservation and the technique used in its execution began in October 1989 when, taking advantage of the scaffolding used to clean the ceiling, the first data were gathered. This information would be examined and discussed at the conference scheduled for the end of March 1990. A first meeting to evaluate the situation was held on 23 November, and was attended by Carlo Pietrangeli, Director General of the Vatican Museums and Restoration Laboratory; Pasquale Rotondo, former director of the Istituto Centrale di Restauro, who was present in his role as consultant to the restoration; Fabrizio Mancinelli, Director of the Departments of Byzantine, Medieval, and Modern Art at the Papal Museums, and director of the restoration project; Nazzareno Gabrielli, head of the Scientific Research Department and supervisor of research and technical analysis on this project; Gianluigi Colalucci, Chief Restorer of the Paintings Laboratory of the Vatican Museums and technical supervisor of the project; and the restorers Maurizio Rossi, Piergiorgio Bonetti, and Bruno Baratti.

The scaffolding used to clean the ceiling was dismantled at the beginning of January 1990 so as to allow the photographic documentation after restoration to be completed. A new scaffolding with seven work platforms, structurally the best suited for work on the *Last Judgment*, was assembled between the end of February and the beginning of March. In the days following, a series of specimens were taken, and precautionary tests and analyses run. Test cleanings were undertaken primarily on a small group of the elect located in the background on the left (fig. 36). Small trials were also made on the sky in both lunettes in order to have a first evaluation of the problems the blues might present, and on the figures of SS. Blaise and Catherine, which had been heavily reworked by Daniele da Volterra in 1565.

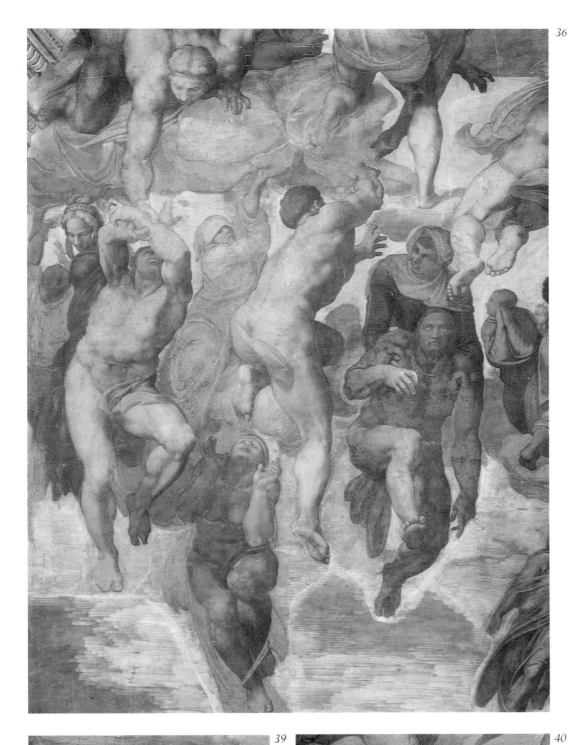

36

37

38

39

40

fig. 36. The *Last Judgment*, detail before restoration

fig. 37. The *Last Judgment*, detail of damage to the sky before restoration

fig. 38. The *Last Judgment*, detail of one of the angels holding up the cross, before restoration

fig. 39. The *Last Judgment*, detail of the group of elect to Christ's left, before restoration

fig. 40. The *Last Judgment*, detail of one of the angels around the column of the Flagellation, before restoration

fig. 41. The *Last Judgment*, detail of the brown retouchings on the shoulder of the figure identified as St. Andrew or St. Philip, before restoration

fig. 42. The *Last Judgment*, detail of the damage suffered by one of the trumpeting angels at the center of the fresco, before restoration

fig. 43. The *Last Judgment*, detail of some of the *giornate* seams and the *a secco* retouchings of a restorer meant to mask them

fig. 44. The *Last Judgment*, detail of decolorized crystals of lapis lazuli from the sky as seen under a microscope

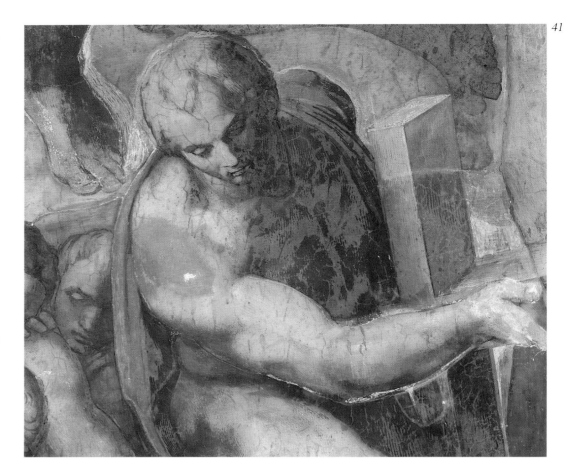

182

On 27 March the project was temporarily halted, and the results obtained to that point were presented to the conference attendees in two separate papers by Gianluigi Colalucci and Nazzareno Gabrielli. At the end of the conference work began again with the completion of the preliminary photographic documentation of the fresco. The campaign to photograph the entire frescoed surface of the wall under ultraviolet light and on infrared film was carried out between 24 April and 31 July. This work had by necessity to be done at night and, in the case of the ultraviolet photographs, involved exposures of more than an hour.

A photogrammetrical relief of the *Last Judgment* had been made in 1987, and it was from this that the drawings used to record data about the execution of the fresco and its state of conservation were derived. After the end of the 1990 conference, tests in the laboratory and in situ were begun again; this time both were extended over the entire painting in order to gain a broad sense of the work's condition. Among the problems facing the restorers was the fact that the *Last Judgment* was an indivisible unity unlike the ceiling which, because of its painted architectonic structure, could be divided into different operational sectors. Because it was painted on a vertical wall surface and because of the particular location of that wall, the fresco had been tampered with over the centuries. Obtaining a balanced level of cleaning across the surface of the painting depended, therefore, on a complete understanding of the fresco's state of conservation from the beginning of the project, and not just of a single area but of the entire painted surface.

Beyond an in-depth examination of the fresco itself, a complex series of experiments and laboratory analyses were undertaken at every stage of the project. These were intended especially to determine both the nature of the foreign matter deposited on the painted surface and the pigments which Michelangelo used. To analyze the foreign matter, high performance liquid chromatography (HPLC), thin-layer chromatography (TLC), infrared spectrophotometry (IR), and Fourier transform infrared spectrophotometry (IRATR) were used.

The responsibility for microbiological tests for fungi, bacteria, and yeasts present, especially on the upper parts of the wall, was entrusted, as it had been for the ceiling, to a team from the University of Rome including Gianfranco Tarsitani, Riccardo Montacutelli, and Oriana Maggi. Another outside team, Marisa Laurenzi Tabasso and Ernesto Borelli of the Istituto Centrale di Restauro, were assigned to make, as they too had also been for the ceiling, the colorimetric measurements designed to provide an objective evaluation of the chromatic variations produced by the film of foreign matter deposited on the original colors. They were also charged with creating a data bank to be used to evaluate any future alterations produced by the accumulation of other substances, especially airborne particles, on the painted surface. Pigment analyses were undertaken with atomic absorption spectrophotometry with a chemical flame (AAS) and with a carbon furnace (AAHGA). Other information was obtained by examining polished sections under the microscope.

STATE OF CONSERVATION

The surface area of the *Last Judgment* measures 180.21 square meters (as calculated by the computer based on the photogrammetrical relief). Its state of conservation was extremely irregular because of the many alterations made over the centuries. This irregularity was most evident in the tonal discontinuities across the painted surface. The lowest level of the composition, with the resurrected souls and the damned disembarking from Charon's barge, had darkened significantly, especially in comparison with the sky above, which had been greatly lightened in the past by the corrosive agent noted by Camuccini (figs. 36, 37). The central area of the composition also appeared to have darkened considerably, particularly in the peripheral groups of figures surrounding Christ and the Virgin. The lunettes above, on the other hand, were much lighter and more legible. The fact that the lunette with the column was easier to read can certainly be attributed to Camuccini's cleaning

of this area in 1825. Such a cleaning might also explain the state of conservation of the left lunette, as well as the much retouched group of the elect behind St. Peter, even though Camuccini stated that he had worked only on the group of angels in the right lunette.

Besides being extremely dark, the painted surface had also been stained and made opaque by foreign substances, predominantly animal glues, which had provided ideal conditions for microorganisms to thrive. Colonies of fungi were especially prevalent on the upper part of the wall (fig. 38). Since the fungi had penetrated as far as the layer closest to the pigment, removing them left small, round stains lighter in color than the surrounding area.

Past restorers had added small amounts of vegetable oil to the glue—or more correctly to the glue water—that was used to brighten the darkened colors, since oil both made the glue easier to work and helped revivify the pigments. In some cases it seems that oil alone was applied to the fresco, again to intensify the chromatic tone. Where the plaster was more porous, the oil was absorbed, but in many places it remained on the surface, creating dark, irregularly shaped stains and channels along the craquelure of the plaster (fig. 39).

The film of such foreign matter across the *Last Judgment* was very irregular. Where it was the heaviest, the surface of the painting appeared dark and vitreous; where it was thinner, the fresco seemed light and arid. Fortunately, as noted above, the painting did not suffer from leaking water because the wall was protected by the sacristy rooms immediately behind it. This is probably the reason that past restorers applied less glue there than on the ceiling. The layers on the wall were therefore noticeably thinner, especially in comparison to the layers on the lunettes.

Numerous areas of retouching were obvious throughout the fresco, all of them of poor quality. There were also many visible patches of test cleanings or traces of earlier attempts to clean the painting. With the exception of Camuccini's, none of these are documented, and it is impossible, therefore, to date them,

even though they are probably of relatively recent date. The retouchings can be divided into two general categories. The first consists of those executed in full-bodied colors; they frequently cover Michelangelo's *pentimenti*, or corrections, and create dull, chalky masses of dark brown color (fig. 41). The second category includes retouchings executed with small, dark, monochromatic, and semitransparent brushstrokes intended to reinforce shadings and to reinforce the modeling of figures flattened by the distorting layers of glue and other build-up (fig. 40).

The plaster itself is in very good condition. The only area where it was seriously detached from the wall was under the marble corbel. The absence of the bronze and brass clamps that were so numerous on the ceiling confirms that the wall has always been free of static problems, with the exception of those in the sixteenth century that affected the architectural structure itself. These early problems most likely explain the long crack that runs across the painting at a slight diagonal. The crack begins at the lower center of the fresco, splits in two at several points, and finally branches out into little cracks that end near the group of angels carrying the column. Here, as on the ceiling, these cracks were sealed with a black putty of wax and hard resin, perhaps at the time that Daniele da Volterra and Girolamo da Fano made their additions to the fresco. The uneven and varied condition of the painted surface might suggest that the original painting had greatly deteriorated; however, for the most part, Michelangelo's fresco was preserved in excellent condition.

The group of angels blowing trumpets and holding the book of the Last Judgment had suffered some mechanical damage (fig. 42). The rings that held the metal supports of the baldachin which until the middle of this century normally hung over the altar on solemn occasions can still be seen beside the angels. The poles used to raise the baldachin and the edges of the fittings themselves scratched and abraded the entire area, especially the angels on the right, and in particular the one holding his trumpet over his shoulder. The black lines of the

under-drawing are now visible in several of the damaged areas on the face of this figure.

The broad expanse of blue sky that serves as a backdrop for the *Last Judgment* presented an extremely complex situation. Here the color was divided into zones, noticeably different in form and tone, by very light lines corresponding to the seams of the *giornate* (fig. 37). Scholars and experts have often debated the possible reasons for these whitish lines, and the issue has never been convincingly resolved. Recent examinations revealed, however, the important fact that there are *secco* retouchings along these seams; some of them seem to be original while others, because their color does not match its surroundings, are clearly later additions (fig. 43).

The sky was painted in fresco with lapis lazuli, an extremely delicate pigment, and then finished *a secco* with the same color. Only a few traces of the *secco* finishing work remain, and they now appear almost black, in part because of dirt and in part because of the deterioration of their glue binder. The sky, for reasons explained above, is lighter in the upper part of the composition; this zone is clearly demarcated by the undulating seams of the *giornate* below it. The central area of sky is darker, tending toward gray. The lowest zone, just above the horizon, is very light. The surface, as compact as slate, is striated with horizontal brushstrokes that are dense and fine toward the middle of the fresco, but lower on the wall become wider and lighter in tone until they are almost white where they touch the figures crowded on the earth below (figs. 36–37).

Based on the reports of Taja and Camuccini, it was originally thought that these striations, which have virtually no thickness at all (a phenomenon formerly attributed to the action of the lime undercoat), might be due to the application of an acidulated substance brushed on during a restoration in the seventeenth or eighteenth century to clean off the deposits of foreign matter on the sky, and thus to reinforce the modeling of the figures. Since wine had been used to clean Raphael's frescoes in the nearby *Stanze* and those on the

Chapel's ceiling, it was suggested that the substance responsible for the damage to the *Last Judgment* was wine that was turning to vinegar. Observed under a microscope, the lapis lazuli crystals did indeed appear to be discolored, ranging in tone from blue-gray to pale gray. Yet further experimentation disproved this theory, since it was shown that an acid as weak as vinegar is not capable of discoloring lapis lazuli (fig. 44). Recent research and observations suggest that the striations are the remains, or better, the imprint, of lost *secco* finishing work which must, originally, have been intended to strengthen certain areas of the sky and, especially at the bottom, to mask the seams between one day's work and the next. This *secco* work must have had a certain thickness to it; it may have been lost in part during the cleanings in the seventeenth and eighteenth centuries, and in part by the abrasion of periodic dustings of the fresco that continued until the present century. Chiari suggested another hypothesis, by which the damage was the result of a cleaning undertaken not with an acidic substance, but with an alkaline product such as the lye contained in damp ashes which, since it was semi-solid, could have been applied with a brush without the risk of dripping. When dried it would have been brushed away along with the dirt, leaving horizontal marks resembling brushstrokes, in which there is no color, only the absence of dirt.

To the list of damages to the blues we should add those suffered by the pigments applied *a secco* and by those used in fresco that did not adhere properly to the wall. In both cases, past cleanings precipitated considerable losses of color. Damage of this sort can be seen in those parts of the Virgin's mantle that are in shadow, and it gives the effect of an inversion of values between the highlights and the shadows. The slight flaking of pigment in the areas repainted by Daniele da Volterra was caused, on the other hand, not by past cleanings but by the contraction of the glue layer due to variations in the climatic conditions in the chapel. The different technique Daniele used to apply his color was also a contributing factor.

1. Ernst Steinmann, *Die Sixtinische Kapelle*, Munich, 1905, vol. 2, p. 479; Pierluigi De Vecchi, *Michelangelo pittore, scultore, architetto*, Milan, 1984, p. 123.

2. G. Vasari, *Lives of Seventy of the Most Eminent Painters, Sculptors, and Architects*, New York, 1902, vol. 4, p. 132.

3. John Shearman, "A Note on the Project of Pope Julius," in *Michelangelo e la Cappella Sistina. Atti del Convegno internazionale di studi*, vol. 3, Novara, 1994. See also G. Vasari, *Lives*, vol. 4, p. 145.

4. Vasari 1902, vol. 4, p. 141.

5. Ibid., vol. 4, p. 138.

6. Ibid., vol. 4, p. 135.

7. Michael Hirst, *Michelangelo and His Drawings*, New Haven, 1988, pp. 123–24.

8. Anna Maria de Strobel and Fabrizio Mancinelli, "Documenti relativi ai lavori michelangioleschi nella Cappella Sistina," in *Michelangelo e la Sistina: la tecnica, il restauro, il mito*, Rome, 1990, pp. 270–71. The original text reads, "supremum Architectum Sculptorem et Pictorem eiusdem Palatii nostri apostolici . . . ac nostrum Familiarem cum omnibus et singulis gratiis rerogativis honoribus et antelationibus quibus alii nostri familiares utuntur et uti possunt seu consueverunt. . . ."

9. Ibid. The original text reads, ". . . pro depingendo a te pariete altaris Capellae nostrae pictura et Historia ultimi Iudicii, . . . et ceteris operibus in Palatio nostro, a te si opus fuerit faciendis."

10. De Vecchi 1984, p. 126.

11. Ibid.

12. Vasari 1902, vol. 3, p. 337.

13. Deoclecio Redig de Campos and Biagio Biagetti, *Il Giudizio Universale di Michelangelo*, Rome, 1944, vol. 1, p. 105.

14. Deoclecio Redig de Campos, *Michelangelo. The Last Judgment*, New York, 1978, p. 29.

15. For the documents relating to Michelangelo's *Last Judgment* see especially Steinmann 1905, vol. 2, pp. 742–68; Karl Frey, "Studien zu Michelagnolo Buonarroti und zur Kunst seiner Zeit, III," *Jahrbuch der koniglich preuszischen Kunstsammlungen*, 30 (1909), pp. 139–67; Leon Dorez, *La cour du pape Paul III*, vol. 2, Paris, 1932; Paola Barocchi and Renzo Ristori, *Il carteggio di Michelangelo*, vol. 4, Florence, 1979; De Strobel and Mancinelli 1990, pp. 270–76.

16. Vasari 1902, vol. 4, p. 141.

17. Redig de Campos and Biagetti 1944, pp. 105–13.

18. For a first analysis of the technique Michelangelo used to paint the *Last Judgment*, see Fabrizio Mancinelli, Gianluigi Colalucci and Nazzareno Gabrielli, "Rapporto sul Giudizio," *Monumenti, Musei e Gallerie Pontificie. Bollettino*, 11 (1991), pp. 219–49. See also, Mancinelli, Colalucci, and Gabrielli, "The *Last Judgment*: Notes on Its Conservation History, Technique, and Restoration," in *The Sistine Chapel, A Glorious Restoration*, New York, 1992, pp. 236–55.

19. Vasari 1902, vol. 4, pp. 141–47.

20. For the *Last Judgment* and its iconography, see Carla Lanckoronska, "Appunti sulla interpretazione del Giudizio Universale di Michelangelo," *Annales Institutorum*, 5 (1932–33), p. 125; Charles De Tolnay, "Le Jugement Dernier de Michel Ange. Essai d'interprétation," *Art Quarterly*, 3 (1940), pp. 125–47; Leo Steinberg, "Michelangelo's Last Judgment as Merciful Heresy," *Art in America*, 63 (1975), pp. 48–63; Ruth Feldhusen, *Ikonologische Studien zu Michelangelos jungsten Gericht*, Unterlegenhardt-Bad Liedenzell, 1978; Romeo De Maio, *Michelangelo e la Controriforma*, Bari, 1978; Maria Calì, *Da Michelangelo all'Escorial*, Turin, 1980; Pierluigi De Vecchi, "Michelangelo's Last Judgement," in *The Sistine Chapel. The Art, the History, and the Restoration*, New York, 1986, pp. 176–207; and De Vecchi 1984, pp. 123–68.

21. De Vecchi 1986, pp. 204–5. For the identification of Michelangelo's self-portrait, see Francesco La Cava, *Il volto di Michelangelo scoperto nel Giudizio finale*, Bologna, 1925.

22. Redig de Campos 1978, p. 31. For the letter from Urbino to Michelangelo of 16 September, see Barocchi and Ristori 1979, vol. 4, pp. 82–84.

23. Robert Klein and Henri Zerner, *Italian Art, 1500–1600*, Englewood Cliffs, NJ, 1966, pp. 122–23.

24. Vasari 1902, vol. 4, pp. 139–40.

25. Lodovico Domenichi, *Facezie, motti e burle, di diversi signori e persone private*, Florence, 1564, p. 263.

26. The original text reads, ". . . tam picturas testudinis [volta] et parietis [Giudizio] praedictarum in dicta capella Sixti iam confectarum . . . a pulveribus et aliis immunditiis praefatis mundare et a mundatis . . . tenere omni cum diligentia."

27. De Vecchi 1984, p. 168, n. 40. The original text reads, "Picturae in Capella Apostolica copriantur, in aliis autem ecclesiis deleantur si aliquid obscaenum aut evidenter falsum ostendant."

28. Vasari 1902, vol. 4, p. 174.

29. De Strobel and Mancinelli 1990, p. 281.

30. Ibid., p. 278. The original text reads, "Laboreriorum [sic] per ipsum de anno 1565 factorum in tegendis partibus pudendis figurarum Capelle pape Sixti."

31. Ibid.

32. J. Richard, *Description historique et critique de l'Italie*, vol. 5, Paris, 1766.

33. De Strobel and Mancinelli 1990, p. 280.

34. Arnold Nesselrath, catalogue entry in *Michelangelo e la Sistina* 1990, p. 240.

35. De Strobel and Mancinelli 1990, p. 288.

36. Ibid., p. 287.

37. Ibid., p. 298.

38. D. Cialoni, "Il dibattito sul restauro del Giudizio Sistino tra gli Accademici romani, 1824–1825," In *Bollettino. Monumenti, Musei e Gallerie Pontificie*, 11 (1991), pp. 189–218.

39. Richard 1766, vol. 5.

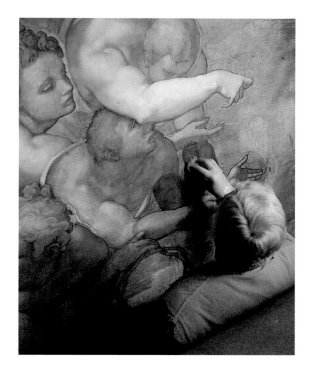

Gianluigi Colalucci

TEN YEARS
ON THE
SISTINE CHAPEL'S
SCAFFOLDING:
REFLECTIONS
ON THE
RESTORATION OF
MICHELANGELO'S
FRESCOES

"Technique, Restoration, and Reflections"

Gianluigi Colalucci

THE LONG and painstaking restoration of Michelangelo's frescoes in the Sistine Chapel concluded on 8 April 1994 with the solemn Mass celebrated by Pope John Paul II. This Mass was said in front of the huge fresco of the *Last Judgment* which, for the first time, was visible after having been cleaned.

Four years earlier, the conclusion of work on the ceiling frescoes was marked by an international conference held at the Vatican to study and discuss the results of the restoration. In October of 1985, when the cleaning of the lunettes was finished, a seminar was held at the Wethersfield Institute, and included two papers given in New York City, one at the Metropolitan Museum of Art and the other at the Frick Collection. The project that the media had proclaimed the "restoration of the century" began on the morning of 16 June 1980, when, the scaffolding in the Sistine Chapel having already been erected in front of the Eleazar-Mathan lunette, the first contact was made with Michelangelo's masterpiece.

Rereading the words I wrote that first day in the workshop diary to describe the fresco's state of conservation, it strikes me that they are as sparse, cold, and detached as professional objectivity demanded. Yet the emotion and anxiety that those present shared can be glimpsed in the brief note that I made about removing the dust and lampblack from a tiny part of the painting with the corner of a handkerchief—moistened, not very scientifically, with saliva. All those who saw it were amazed that beneath the layer of blackish, gummy material lay an unexpected yellow of sustained timbre in spite of the obstinate layer of dirt adhering to it.

Separated now from the event by many years and far from the uproar and the debates that accompanied it, writing these pages has led me to reflect on the long road traveled and on the change this truly exceptional task, the restoration of the Sistine frescoes, has wrought in my life. Suddenly, after thirty years of working quietly and far from the routine imposed by everyday life, I, who had been known only to a few specialists, was thrust center stage and into the spotlight because most

189

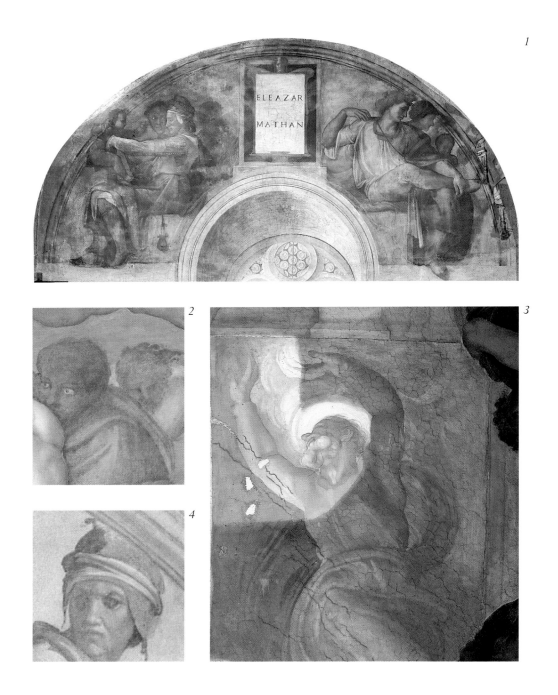

2

3

4

of the world was now following, and felt emotionally involved in, the progress of this restoration.

I am conscious of how fortunate I have been in my life. My fortune comes, however, not from notoriety, which can be pleasant but is also ephemeral, but rather from the fact that I was able to trace, brushstroke by brushstroke, the path that Michelangelo traveled in his arduous experience as a painter. It is often said that a person's destiny is written in the stars. This may be true or it may not, because even though our lives are made up of a series of connected events, our destiny is also in our own hands. Perhaps it was foreordained on that first day in October 1960, the day I began my ca-

reer at the Vatican Museums, that twenty years later I would climb the scaffolding in the Sistine Chapel to unveil Michelangelo's frescoes. It seems more likely, though, that the sky that night was as dark as a blackboard leaving me to write my own destiny there, day by day and hour by hour. Yet none of this is important; what is important is the result of the work, the recovery of the authentic appearance of Michelangelo's paintings. And perhaps there is also some significance to what we, a small group of specialists at the Vatican Museums who worked so closely with the frescoes, were able to convey of what we have seen and studied so closely.

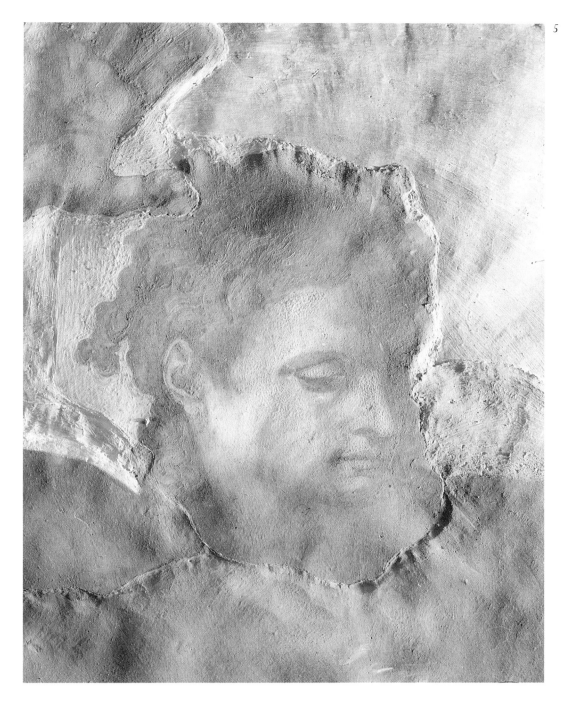

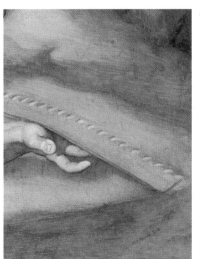

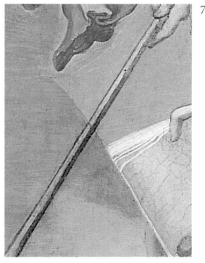

fig. 1. Sistine Chapel ceiling, *Eleazar-Mathan* lunette before restoration. The restoration of the ceiling frescoes began with this lunette

fig. 2. The *Last Judgment*, detail

fig. 3. Sistine Chapel ceiling, the *Separation of Light from Darkness* during cleaning

fig. 4. Sistine Chapel ceiling, the *Zorobabel-Abiud-Eliachim* lunette, detail of the headgear of the figure on the right

fig. 5. The *Last Judgment*, detail in raking light which shows very clearly the seams between *giornate*

fig. 6. Sistine Chapel ceiling, *Ozias-Ioatham-Achaz* lunette, detail of the right hand of the male figure in the group on the left

fig. 7. The *Last Judgment*, detail of the group of trumpeting angels

fig. 8. The *Last Judgment*, detail of the group of martyrs

THE EXTRAORDINARY NATURE OF THE RESTORATION

I believe there are five factors that make this restoration, on which we labored for fourteen years, from June 1980 to March 1994, both extraordinary and unique. The first is the artistic, spiritual, and religious majesty of Michelangelo's work. The second is its sacredness, or better, the myth which has always surrounded the frescoes and the personality of the great

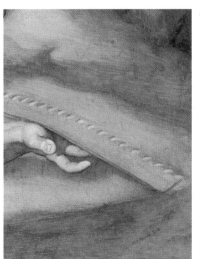

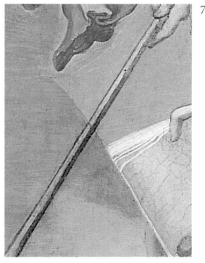

191

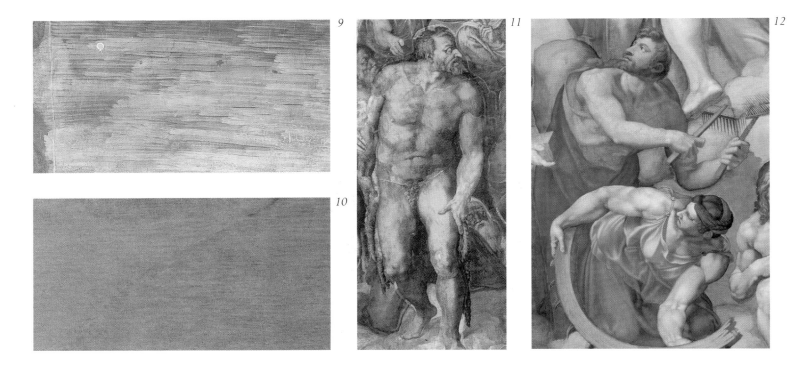

Tuscan artist, a myth that he himself created and nourished. The third factor is the lore surrounding the frescoes, which over the last three centuries—after the memory of the frescoes' true colors had been completely lost—took root, and drew its lifeblood from the dark and tormented tones of the Sistine paintings. The fourth factor, which is linked to the third and is perhaps the most important and the least often considered, is that all of Michelangelo's frescoes exist in only one place, in the Sistine Chapel and the adjacent Pauline Chapel. If we had been able to make comparisons with other frescoes by the same artist that had survived in different and less dirty conditions than those in the Vatican, then the problems of this cleaning would not have been posed in the same rigorous and dramatic terms that we encountered; nor would we have had the same violent reactions from those who tried to influence public opinion against the restoration. The fifth factor that made this cleaning unique lay in our uncertainty about Michelangelo's working method. The condition of the frescoes was such as to allow almost any hypothesis about his technique, from the idea that they were painted in half-fresco to the suggestion that they were executed with resinous glazes. No one suspected that they were painted in true fresco, that is, *buon fresco.* Only Biagio Biagetti, who directed the work to consolidate the plaster in the 1930s, understood the inconsis-

tency of the theories regarding Michelangelo's technique, and that the paintings' true colors were of a completely different tone and timbre than was generally thought, hidden as they were as if behind smoked glass.

The frescoes came to be in this condition because earlier techniques of restoration, a field in which formerly almost every practitioner was a painter, favored applying substances to paintings to revivify their colors, and repainting. Cleaning, which in the best of circumstances could only be done crudely and with rudimentary and aggressive methods, was rarely attempted. After several cleanings—although Mazzuoli's eighteenth-century intervention with Greek wine appears not to have included the *Last Judgment*—and heavy applications of liquid animal glues mixed with oil and gum arabic, as well as repaintings and retouchings, Michelangelo's frescoes acquired the dark and stained appearance for which they were famous, and through which it was difficult to recognize the fresco technique. Serious essays have been written, even relatively recently, on Michelangelo's techniques, which have the same sense of approximation and unreliability as earlier studies on the technical methods of the old masters that were published by artists who based them only on their own experience and the distant observation of the works. Now, we who have completed the recent restoration

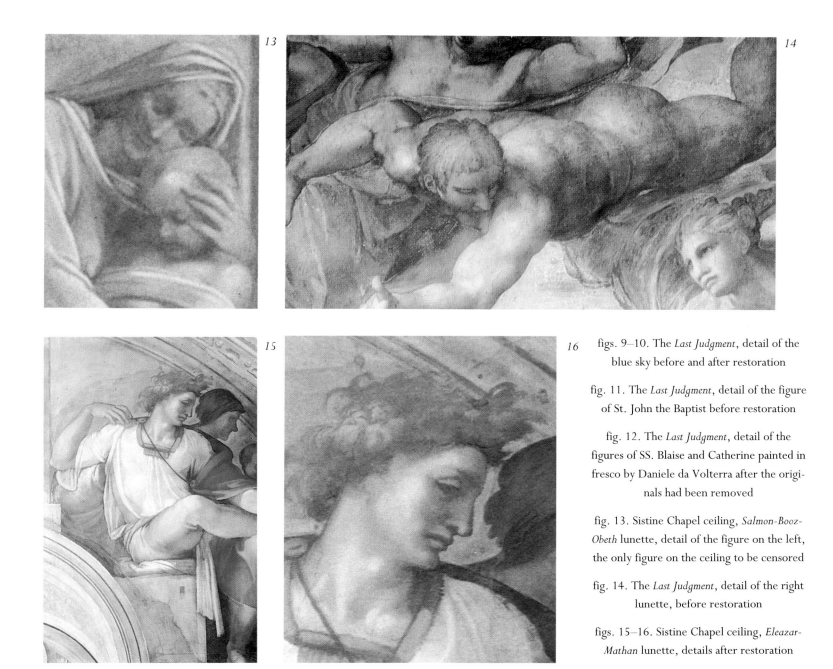

can affirm, based on objective data supported by scientific analyses, that both the ceiling and the *Last Judgment* were painted in *buon fresco,* with only a limited number of areas painted *a secco,* that is, on the dry plaster. We can also state that the *Last Judgment* was executed in 449 *giornate,* that is, 449 areas of surface produced by one day's work—and that the *intonaco,* the fine layer of damp plaster to which the colors were applied, was composed of lime and pozzolana (volcanic ash).

Michelangelo made best use of the time that the fresco technique requires for perfect carbonization of the hydrated lime, thus creating frescoes of the highest technical quality. Moreover, he took advantage of the purity of the pigments and the possibilities offered by the juxtaposition of color and chromatic modulations made with brushstrokes that were sometimes liquid and sometimes heavily loaded. Any recourse to painting on the dry plaster was very rare. Its intentional use is found more often on the *Last Judgment* than on the ceiling. We find it, for example, on some of the red drapery and some of the instruments of torture that the martyrs display, on the trumpets that are painted across several *giornate,* and on Charon's oar. There are also unpremeditated *secco* passages; the large size of the composition forced Michelangelo to make numerous small adjustments or corrections where the perspective was not correct, especially in the legs of the larger figures and the torso and upraised arm of the Judging Christ.

The sky presented different problems. It was painted

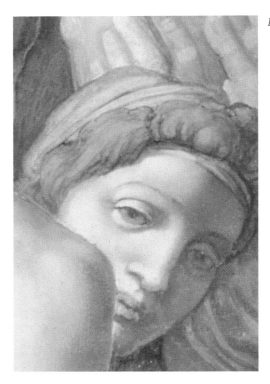

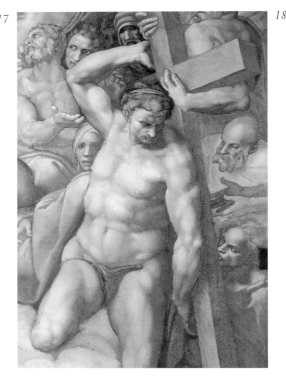

with lapis lazuli (ultramarine blue), partly in fresco, which is what we still see of it today, and partly *a secco*. Because of the very delicate nature of this pigment, only a few traces of the *secco* passages remain. Their loss occurred over the course of the centuries, through periodic cleanings, perhaps beginning with Domenico Carnevali's first restoration of the painting in 1566. This date and the initials "D.C." were found on the handle of Charon's oar, which had been completely repainted over the outline of the lost original. The *Last Judgment* contains another kind of *secco* painting, although not executed by Michelangelo. I am referring to the well-known, censorial draperies—the so-called *braghe* or loincloths—which cover forty-one of the nudes.

Michelangelo's *Last Judgment*, the composition of which seems so different from the traditional iconography of this scene and which was conceived in terms both new and unusual in the general scheme of contemporary painting, was full of "indecent" nudes and "a thousand heresies." Indeed it produced such a scandal that in 1563 the Council of Trent ordered that the fresco be immediately emended. In 1564 the commission decided to have the nudes retouched. This task fell to Daniele da Volterra and perhaps Girolamo da Fano, and then to Carnevali. All the sixteenth-century draperies,

twenty-three in all, were executed in fatty tempera with the exception of those of SS. Blaise and Catherine. These figures were censored in a more definitive way. They were actually repainted in fresco, after it was decided to sacrifice the originals. In subsequent centuries another eighteen loincloths were added, always in tempera, until in the nineteenth century the total number reached forty-one. On the ceiling, on the other hand, there is only one, late censorial intervention: the covering of the bare breast of the woman nursing a child in the Salmon lunette.

Past interventions of three types have left their mark on the Sistine frescoes. These include many restorations, from the earliest, Carnevali's of 1566, to Seitz's in 1903; various acts of ongoing maintenance, like those executed by the *Mundator*, an official instituted by Paul III as a painter-restorer responsible for cleaning the chapel's frescoes; and the measures taken to consolidate various areas of plaster in the 1930s undertaken by the Paintings Restoration Laboratory of the Vatican Museums.

Especially in the case of the *Last Judgment*, the many failed cleanings masked by new layers of dirt left their mark, as well as a darkened, irregular, and stained surface, a film of animal glue infested with black fungus, and abundant, microscopic tears in the pigments. The

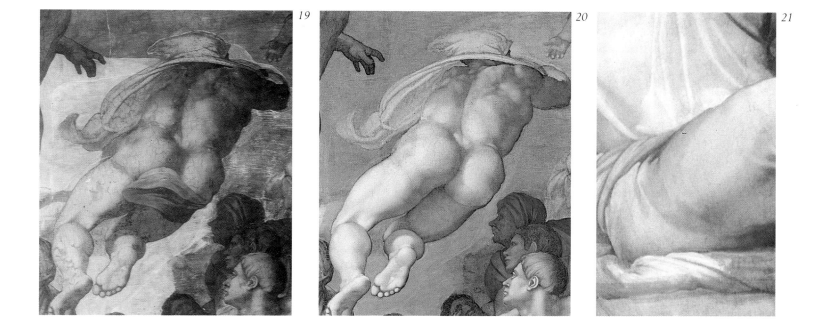

most sensational of the earlier interventions was Vincenzo Camuccini's attempt in 1825 to clean the upper right part of the composition, which was called to a halt by the Academy of St. Luke.

Having ascertained that the original color of the frescoes was different from what was visible, Carlo Pietrangeli and Fabrizio Mancinelli, in consultation with Pasquale Rotondo and based on critical and historical assessments, considered the possibility of undertaking a restoration. After technical, scientific, and conservation evaluations, they decided to proceed. Initially, the restorers worked on the Eleazar-Mathan lunette alone, and only afterwards, after having obtained the consent and encouragement of scholars and of public opinion, was the project for the ceiling and the *Last Judgment* drawn up. This was done on the basis of established knowledge and with the experience gained from the cautious cleaning of that single lunette. The decision to clean the frescoes was both difficult and courageous, but it was bolstered by an awareness of the excellence of new conservation techniques which, at the end of the 1970s, had brought a sense of innovation and of greater knowledge and awareness to restoration.

Restoration, an old field and methodologically always consistent, began in the 1940s to move away from simple trial-and-error, and to make use of new techniques supported by systematic scientific research. At the end of the 1970s, after a number of major technical advances that had alternated with phases of reevaluation and testing, it had reached a very high standard. This new standard permitted what had been unthinkable for a long time: the possibility of working on Michelangelo's frescoes. The margin of safety was ample, and the level of risk, which was eliminated through the caution and experience of the technicians and the prudence of a responsible management, was minimal.

Work began slowly, cautiously, and gradually. The technical and scientific standards in place at the Paintings Restoration Laboratory of the Vatican Museums, already at a high level at the end of the 1970s, grew even more stringent, and were perfected over the course of the next several years.

Beyond the technical problems, the restoration, or better, the cleaning of Michelangelo's frescoes raised historical and critical questions of the legitimacy of trying to recover the original appearance of the paintings, which, as we have noted, were covered by a layer of foreign material that had accumulated on their surfaces as time had passed, or had been left there by the empirical restorers of the past. One point of view, albeit both conservative and not entirely consistent, held that all that these works had suffered, even as a result of arbitrary interventions and the degradation of various foreign materials applied to the paintings, were part of the natural aging of the frescoes or should be seen as historical fact. In contrast, the art historian Cesare Brandi

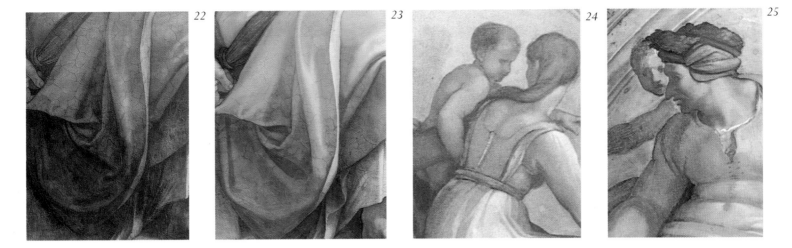

figs. 22–23. Sistine Chapel ceiling, the *Erythraean Sibyl*, detail of drapery around her feet, before and after restoration

fig. 24. Sistine Chapel ceiling, *Achim-Eliud* lunette, detail of the group of figures on the right

fig. 25. Sistine Chapel ceiling, *Ozias-Ioatham-Achaz* lunette, detail of the group of figures on the left

argued that what he called "historical application" permitted careful intervention.

Having ascertained the danger to the quality and integrity of Michelangelo's frescoes posed by the animal glue, which was causing extensive areas of microscopic tears in the film of pigment, the decision to clean the paintings seemed obligatory. Cleaning, however, is an abstract concept, which needs to be defined and made concrete by choosing the "level" of cleaning. The "level" of cleaning is not an exclusively technical problem, or at least it only becomes one once the process is under way. In fact, the theoretical decisions are more important; they concern art criticism, and they are always subjective and tied to the culture of the moment—especially as regards paintings on panel or canvas. These decisions, therefore, are open to the dialectics of a variety of points of view.

For the Sistine frescoes the factor of choice was reduced, because the decision to proceed with the restoration became an obligatory one after the scientific investigations undertaken by Nazzareno Gabrielli and the test cleanings showed that only the full recovery of Michelangelo's painted fabric, with its sensitive modeling and its refined coloring, could give meaning to the project. Old compromises like the "half-cleanings" of the past made no sense on the level of pure conservation, since they would not have eliminated the cause of the degradation, which was now known to be the contraction of the animal glues on the surface. A full restoration also made sense on an aesthetic level, because the original painting would not be recovered in its entirety otherwise. Leaving a dark and irregular veil—not a patina, which is something else—on the surface would have altered the original modeling of the nudes. Furthermore, leaving a residual layer would have required a rebalancing of the painting with the addition of artificial glazes and new materials, which would deteriorate relatively rapidly.

Beyond experimenting to find the best method for the cleaning and then identifying and recording its desired level, I, in planning this intervention and as the one responsible, also had to keep in mind a problem not at first obvious but of primary importance. This was the risk that a cleaning executed by several hands would result in an uneven and unbalanced restoration given the vast surface of the frescoes and the long period of time the restoration would demand. I resolved this purely technical problem by adopting a safe, harmless, and completely satisfactory method of intervention—published many times, including while the work on the frescoes was proceeding—which was simplified as much as possible so as to avoid any evidence of separate hands at work. To do this I ruled out all methods—which at the end of the 1970s were still much in

use—that had to be constantly adjusted and adapted according to the personal interpretation of the restoration by each conservator. This is not to say that we proceeded blindly or mechanically with only one method, especially since the cleaning of the *secco* passages required real variations in procedure that had to be reconsidered in each specific case.

In the case of the *Last Judgment*, I considered a cleaning method that would be compatible with the presence of vast areas of blue painted with lapis lazuli. Even the limited number of restorers—four, including me—was a choice that yielded good results. Perhaps this decision was unpopular with the many able conservators it excluded, but it was necessary to maintain careful control of the work and a uniformity in the hands working on the fresco.

The restorers who worked on the project were Maurizio Rossi, who had worked on the left side of the ceiling, including the figures of Joel and Ezechiel; Pier Giorgio Bonetti, who had worked on the right side, including the figures of Daniel and the Cumaean Sibyl; Bruno Baratti, to whom, among other technical duties, I had entrusted the cleaning of the fictive architecture and the monochromatic medallions of the ceiling; and I, who, on the ceiling, had worked essentially in the central area of the vault with its scenes of the Creation. At the end of the restoration we found that our working method, with its restrictions, had entirely lived up to our expectations.

The gelatinous solvent mixture we used was left on the area being cleaned for three minutes; it had an emollient action on the foreign matter fixed to the fresco's surface, loosening it and thus allowing us to remove it with a sponge soaked with distilled water. The *secco* passages, which had, of course, been identified beforehand, could not be cleaned with water, and so we used, wherever possible, methods based on non-water-based volatile solvents. Where it was necessary, however, to use water-based solvents, we employed complex procedures that called for the temporary waterproofing of the pigments applied *a secco*.

To clean the *Last Judgment* we used a water-based solvent consisting of only one element and applied it to the fresco for as long as twelve minutes. The cleaning of the sky, done with this same solvent, required a special application because of the delicate nature of the pigments.

The difficult issue of whether to save or remove the many areas of censorial overpaint required in each case a decision based on a historical and critical choice. There was no problem in the case of the figures of SS. Catherine and Blaise, since the original passages had been completely scraped away and repainted in fresco. However, the question of the *secco* overpainting prompted serious debate. There were those who wanted to recover Michelangelo's original work in its entirety; others thought that all the drapery should be preserved. Although it has the appearance of a compromise, the solution finally arrived at came from careful analysis and from, in my opinion, the correct interpretation of Cesare Brandi's concept of the two antithetical ideas contained in a work of art, what he called *istanza estetica* and *istanza storica*—aesthetic character and the historical character. Thus the censorial interventions of the sixteenth century were conserved, because they were considered historical documents of real importance to the Council of Trent and the Counter-Reformation. Later draperies were generally removed, because they were not seen as historical documents, since nothing survives to indicate the source of the decision to add them. Some of them, however, were retained, to document these late interventions. To put this decision into action it was necessary to identify which of the *braghe* belonged to the sixteenth century and which were later. Dating these interventions, however, was not easy. Chemical analyses of the pigments in the loincloths enabled us to identify some that were only used in the second half of the eighteenth century and afterwards.

The ancient art of fresco is famous for being the most durable painting technique. Its permanence is due to the resistant materials used in the process—sand or

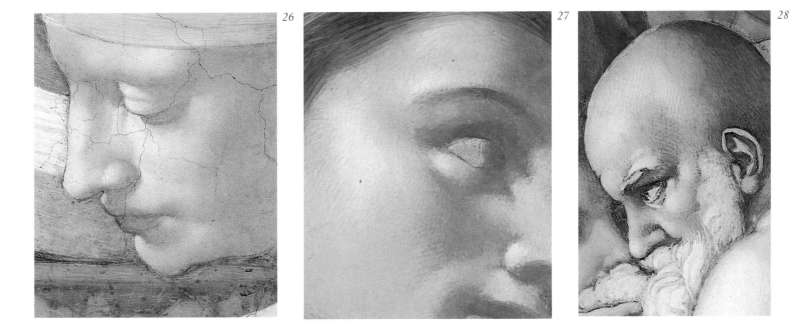

fig. 26. Sistine Chapel ceiling, detail of the face of the *Libyan Sibyl*

fig. 27. Sistine Chapel ceiling, detail of Adam's face in the *Creation of Adam*

fig. 28. The *Last Judgment*, detail of an elect soul

fig. 29. The *Last Judgment*, detail of the figure among a group of martyrs who appears to lean on the real marble cornice of the chapel

fig. 30. The *Last Judgment*, detail of a group of martyrs

fig. 31. The *Last Judgment*, the trumpeting angels

pozzolana, for example—which are joined firmly together by the calcium carbonate produced by the oxidation of the calcium oxide or lime. In fresco the artist uses predominantly natural colors such as ochres and oxides. Fresco, however, has one great enemy, and that is salt, which water, whether rain or moisture absorbed by the masonry, can dissolve in the mortar or the bricks of the wall and then carry through the plaster to the surface of the painting. Once on the painting's surface, the salt corrodes the paint, tearing it, or causing it to flake off. Michelangelo's frescoes were being damaged by salt, which had triggered a number of destructive restorations, the results of which have been much discussed. Because of the high quality of the materials Michelangelo used and his splendid technique, the damage his works suffered was actually very small. Indeed, the frescoes can be considered almost whole.

The problems caused by the slight detachment of the pigment encountered in the areas of lapis lazuli (ultramarine blue) in the *Last Judgment* and in the few colors heavily exposed to salt damage were resolved by using a light fixative. Specifically the C80 method was used because it does not leave a resinous residue on the surface of the painting.

In order to assure the continued conservation of the frescoes well into the future, it was necessary to provide a protective system in the chapel which, after the restoration, would reduce or eliminate the agents that might damage or contaminate the works. Consequently, we decided that an air-conditioning system should regulate the air coming into the interior of the chapel. After monitoring conditions in the Sistine Chapel during a yearlong study of its microclimate, a large air-conditioning and filtering system was installed, one which changes the 10,000 cubic meters of air in that huge space 1.7 times an hour. The air coming from outside the chapel is filtered several times until it contains no polluting agents. It is also brought to a relative humidity of between fifty and sixty percent and a temperature of between eighteen and twenty-five degrees centi-

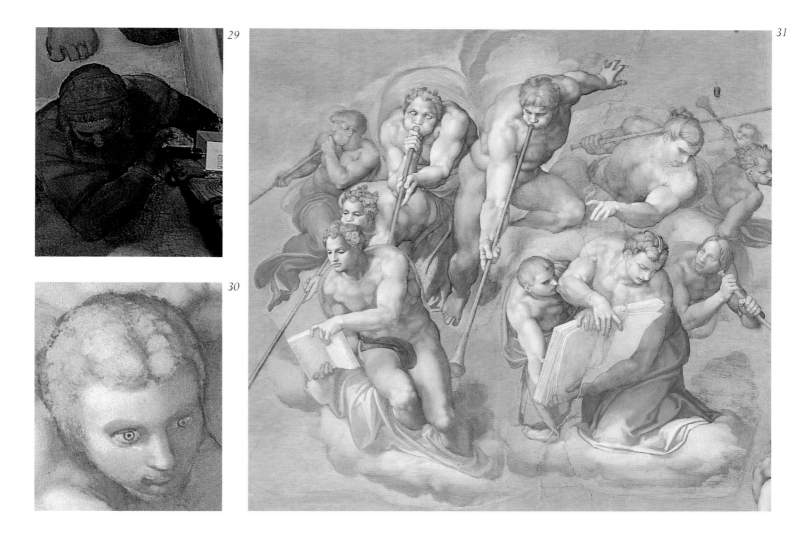

grade. The old problem of the leaking roof had been definitively resolved by structural work at the beginning of this century and in the 1970s.

A restoration today must accomplish the primary function of conserving the work of art, yet at the same time it offers an opportunity to investigate the work's material structure, and perhaps also to reread the work itself. The restoration of Michelangelo's frescoes has in a substantial way accomplished all three of these functions, and the painting is now available anew to scholars after a long period in which it seemed there was little novel to say about it.

The most obvious result of the restoration is the colors of the frescoes. Michelangelo's palette here was unexpected, even though it is in accord with the colors used in Italian painting in the fourteenth and fifteenth centuries. The only difference between the two is the vast areas over which Michelangelo distributes his colors and the accentuated, volume-defining function he gives to the technique of color-change or *cangiante*.

The debate over the cleaning took as its point of de-

parture the removal of the black shadows around the figures which had given them their sense of plastic relief, although in a monochromatic key. Some considered them authentic, because they seemed to respond to the sculptor's sensibility. We will see instead that the volumes created by a chiaroscuro without color, as if they were drawings, were far from Michelangelo's pictorial ideas. These black shadows were added by past restorers in order to restore the modeling of the figures and to accentuate a chiaroscuro effect where they had faded beneath an accumulation of foreign material or had been flattened by timid and summary cleanings. We have now discovered that Michelangelo was well aware of the eternal rules that govern painting and that he interpreted them correctly in composing and constructing his figures, by juxtaposing colors from which black was almost wholly excluded.

The chromatic weaving of Michelangelo's brushstrokes was another of the real discoveries made by the restoration. Especially on the ceiling, the brushwork has an obvious optical function related to the modeling

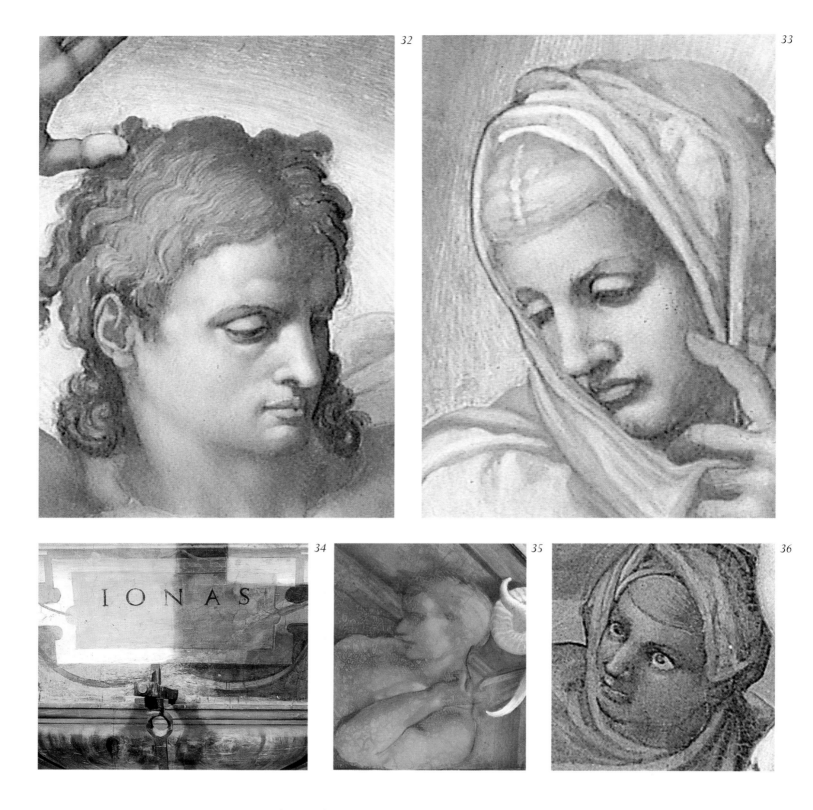

fig. 32. The *Last Judgment*, detail of the head of Christ

fig. 33. The *Last Judgment*, detail of the head of the Virgin

fig. 34. The Sistine Chapel ceiling, detail of the cornice above Jonah's throne

fig. 35. The Sistine Chapel ceiling, detail of the bronze nude on the left above the *Punishment of Haman*

fig. 36. The *Last Judgment*, detail of a group of the ascending elect

of the figures and their placement in space. As in a photograph, the large figures have some parts in focus and others that are not. Those that are in focus are sharp and luminous, having been executed with dense, neat brushstrokes that make them seem closer to the viewer because the details are so easily discernible. Those parts painted with a liquid, soft brushstroke and no detail seem unfocused, giving them the illusion of being

farther away from the eye. This technique allows the strong sense of volume which one reads in the figures on the ceiling.

There is yet another optical device at work in the frescoes, although it is linked more to a sense of space than to the volume of the figures. This was discovered when two narrow bands of sky were revealed at each end of the ceiling. This detail allowed us to understand that Michelangelo's fictive architecture was conceived as a vast hall, open to the sky, in which the figures of the seers are seated. The walls of this hall are joined by open arches through which, in the heavenly space beyond, we see the story of the Creation. Michelangelo emphasized the sense of disjunction between the interior and exterior by resorting again to a subtle optical effect. This time, however, he translated into paint his technique for finishing marble statues, reproducing with tight, dense brushstrokes the highly polished and waxed surfaces of the stone, and with broader, cross-hatched brushstrokes the rough finish obtained in sculpture with the claw chisel. The effect of a smooth, polished surface was used for figures inside the hall while those treated as if they had been worked with the claw chisel are placed outside that space. At a distance of twenty meters—the height of the vault in the Sistine Chapel—the rougher-looking surfaces appear to be farther away from the viewer than those that are polished and more detailed. Even the famous "*non finito*"—the unfinished quality—of Michelangelo's sculpture is found in the painted figures, an obvious sign that it was indeed a premeditated, artistic choice. Perhaps through the paintings it, too, will find a new interpretation.

The opening of the ceiling to the sky conceptually anticipates the dissolution of the altar wall where the *Last Judgment* was represented. It is clear that in painting the ceiling Michelangelo maintained the architectonic plan of the walls in order to modify it and to open it up. The same is true in the *Last Judgment* where, even though the wall itself has been eliminated, the artist has neither forgotten the architectural structure of the chapel nor rendered it void. This is evident in the red-clad figure near St. Sebastian, who leans his hands on the actual marble cornice that crowns the scenes from the New Testament on the side walls of the chapel. Why would the artist have included such a detail, if not to underline both the temporal and material continuity between the *Last Judgment* and the rest of the chapel? Michelangelo's total negation of the altar wall creates the feeling that one might be swallowed up in that void, and it exposes the faithful to a vision of that terrible event, thus giving it a sense of absolute drama that cornices or other architectonic elements connecting it to the chapel walls would have rendered banal.

The twenty-five years that separate the execution of the ceiling and the *Last Judgment* are apparent in the development of Michelangelo's painting, in the conception of the huge composition, and in the use of color and the manipulation of the brush. Yet the technique, and the way the artist understood painting, are the same as on the ceiling. In the *Last Judgment* there is more fury; the brushwork often communicates a sense of rapidity, and the strokes of color are dry and violent in a way that they never are on the ceiling. There, even the free and immediate execution of the lunettes has a composure not found again on the altar wall. On the ceiling, order and rationality are palpable, accentuated by a composition divided into bays, and a perspective constructed with multiple vanishing points. But even the pictorial execution, in perfect fresco technique, seems to be subsumed by a project of micro-architecture which presides over the order and the juxtaposition of the brushstrokes. So, too, are the areas of color regulated, as Leonard Bernstein observed when he visited the scaffolding, by a far-reaching and general sense of order that distributes them and alternates them in the pictorial space—the yellows, the greens, the reds—just as Debussy arranges the musical themes in his compositions.

In executing the *Last Judgment* Michelangelo used the same techniques as he had on the ceiling, but he also added new ideas and different working methods. For example, the figure of the Virgin next to the Judging

Christ, which, with the figure of the first man in the *Creation of Adam*, is one of the most extraordinary passages in the entire chapel, and which was executed with the same care and technique as the Prophets and Sibyls of the ceiling, was painted with dots of color, a technique used in only a few of the figures in the *Last Judgment*. In the Virgin's face the colors are separated as they are in a divisionist painting; white, red, and pink are all applied with the tip of the brush as in, *ante litteram*, a true pointillist technique.

Studies begun during the restoration and concerned with the form of the scaffolding, the organization of Michelangelo's workshop, and the much-debated question of the order in which work on the ceiling progressed were interrupted by the premature death of Fabrizio Mancinelli, the project's director. Because it is a unified composition, painted almost without any interruptions, the issue of the order in which the *giornate*, or areas painted in each day's work, were painted in the *Last Judgment* is not problematic. The 449 *giornate* begin in the left lunette, and then move across the wall to the right one, before proceeding to the level of the Judging Christ below. They then move again across the wall, this time from right to left. Below, on the level with the trumpeting angels, the *giornate* proceed from left to right, and then from right to left on the lowest level with its representation of Hell. On the ceiling the problem is more complicated, if not unresolvable, because the composition is divided into bays with lunettes, spandrels, and pendentives, the architectural frames of which interrupt a reading of the succession of each day's work.

According to a study of mine, about which Mancinelli had some reservations, Michelangelo, after a difficult beginning, evidenced by the scene of the *Flood*, planned the whole composition of the vault geometrically, executing first and in a single campaign the cornice that crowns the wall with the thrones of the Seers. This hypothesis is supported, I think, by the continuity of the *giornate* and the uniform tone of the cornice, which sometimes does not perfectly match that of the thrones below, which were painted at a later date. There is another element that favors this thesis, and that is the correction made to the shading of that part of the cornice that runs above Jonah's throne. Here the shadow was moved from left to right. This correction was made later and *a secco*, to reconcile that part of the architecture to the entire composition. It indicates that the cornice was painted first, and according to a design no longer operative in that area, where the light came from the right and not the left, just as it does on the right side of the vault with the figures of the Libyan Sibyl and the prophet Daniel.

It has been observed that part of the uniqueness of Michelangelo's frescoes lies in the homogeneity of their execution and in the absence of different working methods that characterizes the presence of shop assistants. In fact, the frescoes seem to have been executed by a single hand, although the problem of assistants remains an open one. Michelangelo must have made use of them, if only in a very limited role, given that there are figures, like some of the bronze nudes and some of the pairs of monochromatic putti, which would be difficult to attribute to the master himself. There are qualitative discrepancies too, and perhaps in greater number, in the *Last Judgment*. Nonetheless, the variety of working methods Michelangelo employed, and the force of his personality in the workshop, in the midst of plasters, pigments, and brushes, make problematic, if not hazardous, any hypothetical attribution of one particular figure or another to an assistant. Michelangelo's paintings have a conceptual complexity that makes them absolutely unique, and even more so now that the restored colors reveal his artistic roots more clearly, and show the essence of what was a model for the painters who came after him.

Michelangelo's paintings, with the deceptive joyfulness of their colors, and the disconcerting discontinuity in the proportions of the figures, are works that shrink from emotiveness and passion. They are transcendental paintings, in which the human figure in its absolute value rises to the representation of the very essence of hu-

manity. The absence in the frescoes of any object not necessary to the composition, of elements related to the symbolism so prevalent at the time, of any concession to contemporary taste of different workshop methods, of realistic references to space and architecture, and the rigorous conceptual logic in the distribution of color fields, and in the technical intelligence of the form of the brushstrokes—all of this makes Michelangelo's painting an overwhelming masterpiece.

Artists like Raphael, Titian, and Rubens, who were born painters and who themselves defined painting, knew well how to be captivating, knew by instinct how to hold the eye, how to amaze and to fascinate with color. Their work is inviting; it induces serenity and leaves the soul feeling light. Michelangelo, on the contrary, constrains the viewer to introspection before allowing him or her a profound pleasure that is like listening to a Bach cantata.

Michelangelo's pictorial vision is a long path of reflections. In it, human beings are at the center of all things; they are seen as images of the eternal, as thought and conscience, as expression of freedom and faith, and as a means to reach God. In this context, color detached from form can only be an instrument; it does not represent the ultimate end of artistic expression. Today, now that Michelangelo's work is again wholly visible, it is clear how distorting that dark and irregular veil of discoloration had been. It extinguished the colors and confused the forms as it dampened their impact. It revealed only monumentality, and that false, dark melancholy that had a facile hold on the human soul.

Selected Bibliography

Barnes, Bernadine, "Metaphorical Painting: Michelangelo, Dante, and the *Last Judgment*," *Art Bulletin*, 77 (1995), 65–81

Bynum, Caroline, *The Resurrection of the Body in Western Christianity. 200–1336*, New York, 1995

Chastel, André, et al., *La Cappella Sistina: I primi restauri, la scoperta del colore*, Novara, 1986

Cialoni, Donatella, "Il dibattito sul restauro del Giudizio Sistino tra gli accademici Romani," *Bollettino. Monumenti, Musei, e Gallerie Pontificie*, 11 (1991), 189–218

Condivi, Ascanio, *The Life of Michelangelo*, trans. and ed. by Alice and Hellmut Wohl, Baton Rouge, 1976

Davidson, Bernice, *Mostra di Disegni di Perino del Vaga e la sua cerchia*, Florence, 1966

De Maio, Romeo, *Michelangelo e la Controriforma*, Bari, 1978

Einem, Herbert von, *Michelangelo*, trans. by Ronald Taylor, London, 1973

Greenstein, Jack, "'How Glorious the Second Coming of Christ': Michelangelo's *Last Judgment* and the Transfiguration," *Artibus et Historiae*, 10 (1989), 33–57

Hall, Marcia, "Michelangelo's Last Judgment: Resurrection of the Body and Predestination," *Art Bulletin*, 58 (1976), 85–92

Hartt, Frederick, "Michelangelo in Heaven," *Artibus et Historiae*, 13 (1992), 191–209

———, *Michelangelo*, New York, 1964

Hibbard, Howard, *Michelangelo*, New York and London, 1974

La Cava, Francesco, *Il Volto di Michelangelo scoperto nel Giudizio Finale*, Bologna, 1925

Manca, Joseph, "Sin, Sadomasochism, and Salvation in Michelangelo's *Last Judgment*," *Source*, 13 (1994), 20–26

Mancinelli, Fabrizio, et al, "Rapporto sul 'Giudizio'," *Bullettino. Monumenti, Musei, e Gallerie Pontificie*, 11 (1991), 219–49

Michelangelo e la Sistina: la tecnica, il restauro, il mito, Rome, 1990

Partridge, Loren, *The Art of Renaissance Rome 1400–1600*, New York, 1996

———, *Michelangelo: The Sistine Chapel Ceiling, Rome*, New York, 1996

Pietrangeli, Carlo, et al., *The Sistine Chapel: The Art, the History, and the Restoration*, New York, 1986

Redig de Campos, D., *Il Giudizio Universale di Michelangelo*, Milan, 1964

Redig de Campos, D., and Biagetti, B., *Il Giudizio Universale di Michelangelo*, Milan, 1944

Riess, Jonathan, *The Renaissance Antichrist: Luca Signorelli's Orvieto Frescoes*, Princeton, 1995

——, *Luca Signorelli: The San Brizio Chapel, Orvieto*, New York, 1995

Saslow, James, *The Poetry of Michelangelo*, New Haven and London, 1991

Shearman, John, *Raphael's Cartoons in the Collection of Her Majesty the Queen and the Tapestries for the Sistine Chapel*, London, 1972

Shrimplin-Evangelidis, Valerie, "Sun-Symbolism and Cosmology in Michelangelo's Last Judgment," *Sixteenth Century Journal*, 21 (1990), 607–44

Steinberg, Leo, "Michelangelo's 'Last Judgment' as Merciful Heresy," *Art in America*, 63 (1975), 49–63

——, "A Corner of the *Last Judgment*," *Daedalus,* 109 (1980), 207–73

——, "The Line of Fate in Michelangelo's Painting," *Critical Inquiry*, 6 (1980), 421–36; reprinted in *The Language of Images*, ed. W. J. T. Mitchell, Chicago and London, 1974, 85–128

Steinmann, Ernst, *Die Sixtinische Kapelle*, 2 vols., Munich, 1901, 1905

Tolnay, Charles de, *Michelangelo*, vol. 5, *The Final Period*, Princeton, 1960

——, "Le Jugement Dernier de Michel Ange: Essai d'Interprétation," *Art Quarterly* (1940), 125–46

Vasari, Giorgio, *La Vita di Michelangelo nelle redazioni del 1550 e del 1568*, ed. Paola Barocchi, 5 vols., Milan and Naples, 1962

Zeri, Federico, *La Galleria Spada in Roma, Catalogo dei Dipinti*, Florence, 1954

Photograph Credits

All of the photographs of the *Last Judgment* are by Takashi Okamura © NTV, Tokyo. Other illustrations in the essays were supplied by the authors, with the following exceptions:

Essay by Loren Partridge
Drawings on pp. 10–11 are by Peter Schmitt and on pp. 152–53 by Janice Eklund, all four of which were modified by Carolyn Van Lang; fig. 3: © CAMERA-PHOTO-Arte, Venice; fig. 4: Archive Franco Cosimo Panini Editore, Modena; fig. 5: Professor Giantomassi, Rome; figs. 6–7, 11–14: SCALA, Florence; fig. 8: Niccolò Orsi Battaglini, Florence; fig. 9: The Metropolitan Museum of Art, New York; figs. 15–16: Alessandro Angeli, Rome for ULTREYA Archive

Essay by Fabrizio Mancinelli
figs. 1–6: Instituto Geografico De Agostini, Milan; figs. 9, 44: Vatican Museums Photo archive; figs. 16, 32: SCALA, Florence; figs. 24, 28, 29: Archivio Giunti, Florence; fig. 31: Biblioteca Apostolica Vaticana, Rome

Essay by Gianluigi Colalucci
fig. 1: SCALA, Florence; fig. 5: Vatican Museums Photo archive